JOHN HEDGECOE'S ADVANCED PHOTOGRAPHY

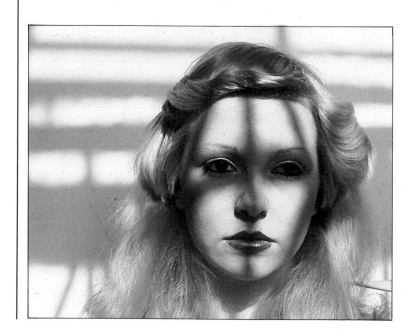

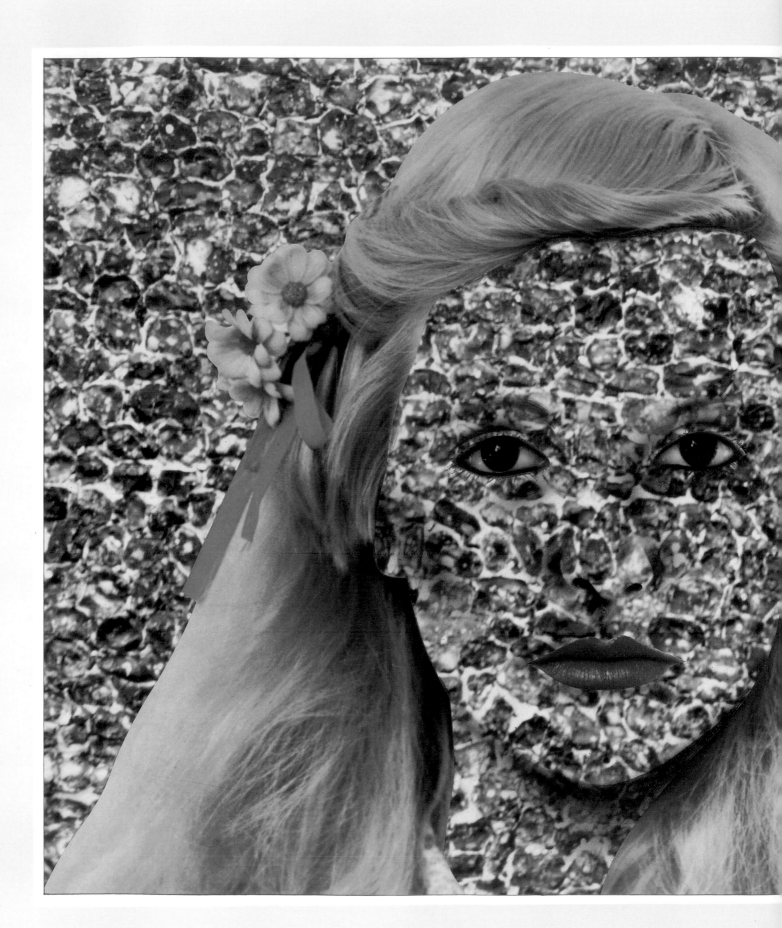

JOHN HEDGECOE'S ADVANCED PHOTOGRAPHY

Mitchell Beazley

Contributors

Antony Parks
(Darkroom Section)

Adrian Bailey
(Associate Author)

Rex Hayman
(Technical Consultant)

Managing Art Editor
Mel Petersen

Technical Editor
Lionel Bender

Assistant Editors
Ian Chilvers
Donald Clarke

Editorial Assistant
Margaret Little

Executive Editor
Jack Tresidder

Retouching and makeup
Roy Flooks

Editor
Frank Wallis

Senior Designer
Chris Meehan

Designer
Linda Abraham

Production Manager
Barry Baker

JOHN HEDGECOE'S ADVANCED PHOTOGRAPHY was edited
and designed by Mitchell Beazley Publishers, Mill
House, 87–89 Shaftesbury Avenue, London W1V 7AD

© Mitchell Beazley Publishers, 1982; Photographs © John Hedgecoe, 1982;
Text © jointly by John Hedgecoe and Mitchell Beazley Publishers, 1982

Typeset by Vantage Photosetting Co. Ltd. Southampton
Reproduction by Gilchrist Bros. Ltd., Leeds
Printed in the Netherlands by Koninklijke Smeets Offset b.v., Weert

ISBN 0 85533 383 9

Contents

Introduction

This book is intended both to stimulate creative ideas and to explain the photographic techniques that enable these ideas to be conveyed to the viewer. Whereas the techniques are common to all photographers, whether advanced amateurs or professionals, the ideas and approach to the subjects are purely personal. The pictures reveal the extent to which the individual should be able to exercise considerable versatility over a wide range of subjects and special techniques.

Success in all the visual arts – and photography is no exception – depends on seeing things in a fresh way and then being able to translate your awareness into the final image with sufficient skill to realize your vision. Advanced photography involves not so much an increased knowledge of techniques (especially now that cameras are becoming more and more simplified) as increased sensitivity and powers of observation and imagination. It requires the capacity for lateral thinking, together with a recognition that the creative process is a state of continuous flux.

Behind every successful photograph is a basic idea springing from a need to convey a particular mood, to express a feeling or to establish an atmosphere. But ideas are flexible and may undergo many revisions or outright rejections before the final formula is reached. When I have devised the initial concept of a picture I let my mind wander over and around the subject, and very often my preconceptions change and I end up with something entirely different. One example of many in the book is the shot of a feather and bulb on page 99. The picture is a visual pun on the term "light as a feather", used as an exercise for a group of students. My initial idea was to use montage techniques to show the feather imprisoned within the bulb. I tried this with variations of the two images, using two projectors, but finally rejected the original intention in favour of the more interesting juxtaposition of the light bulb balanced on the tip of the feather.

Pictures that puzzle the eye and provoke the question "How was it done?" are especially important in the field of advertising. Commercial photography aims always to communicate a message reflecting the company's marketing policy, but to achieve this the picture must arrest the attention of its viewers, intriguing and challenging them and involving them emotionally. The photographer will also communicate his or her own feelings, personal point of view and style; photographers are chosen for their intuitive, individual approach to putting the message across.

Throughout this book you will discover not only how a picture was taken or printed but why it was done in that particular way. You will also discover that even the most complex techniques, when broken down to their component parts, are in fact very simple. Every good photographer keeps pace with the latest developments in equipment, since technology is the servant of creativity, and the professionals are usually the first to use the prototypes. The book therefore includes relevant information on the most recent cameras and equipment, techniques and processing procedures, as well as a detailed instructional glossary of terms. Yet while it is true that technique is the medium through which your ideas are conveyed, it is worth stressing again the importance of ideas. Technical expertise alone rarely makes for good photographs, whereas a grasp of fundamental techniques linked with inspiration can elevate the ambitious photographer to the ranks of the top professionals.

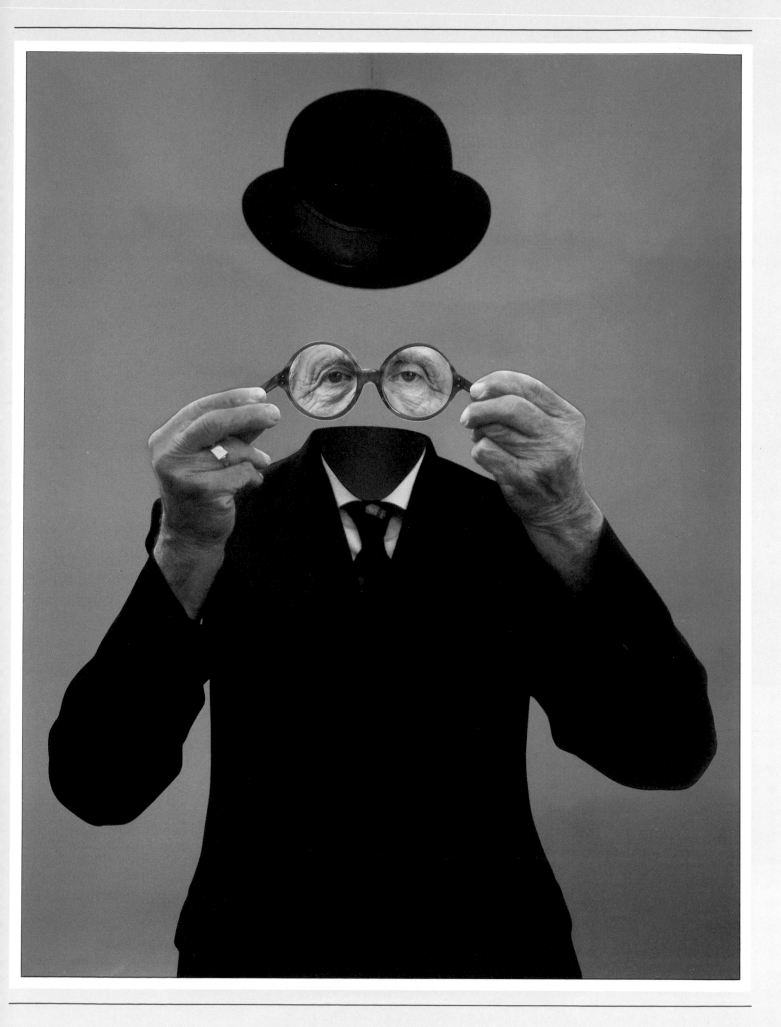

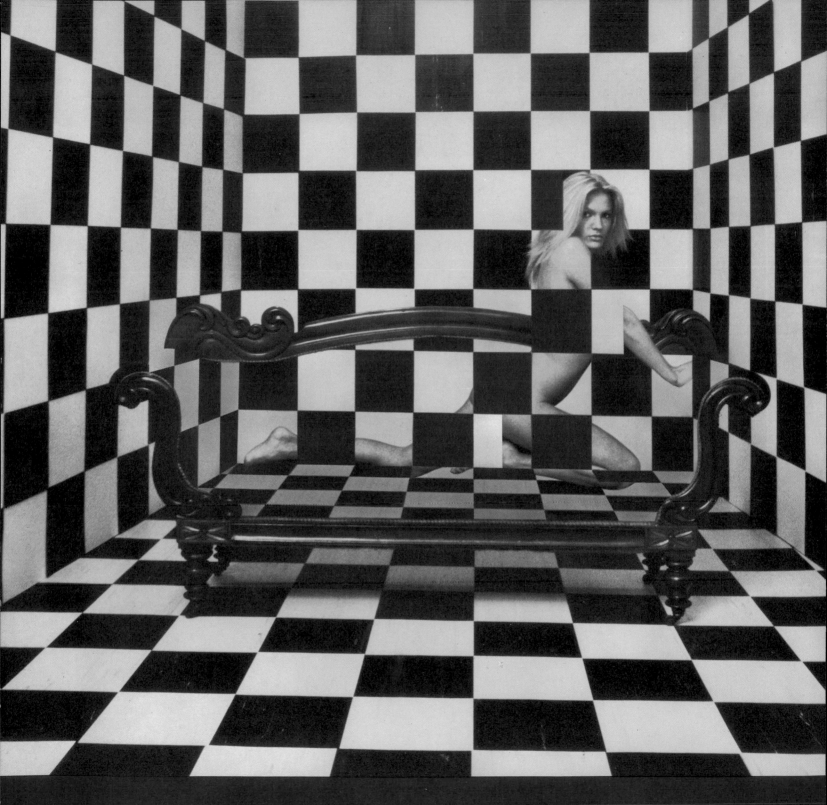

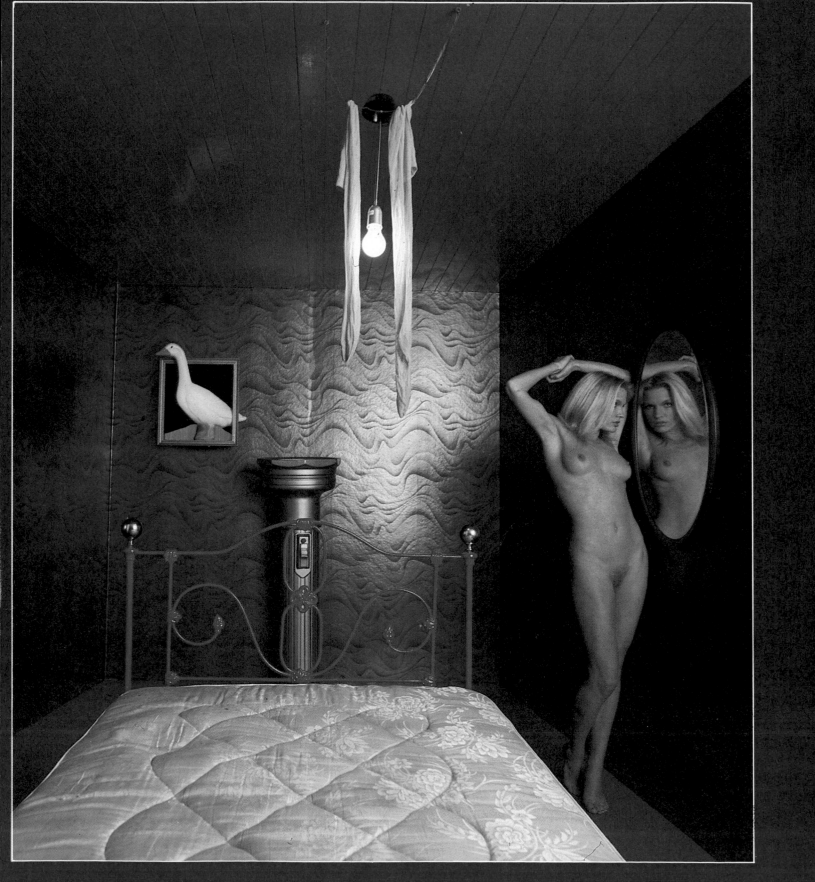

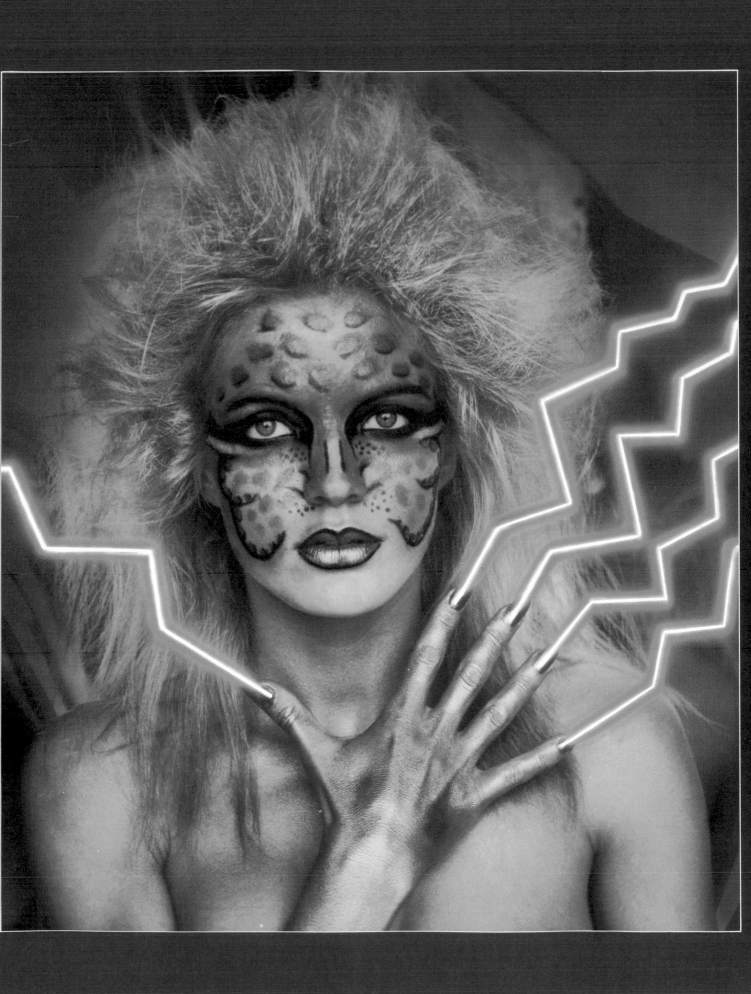

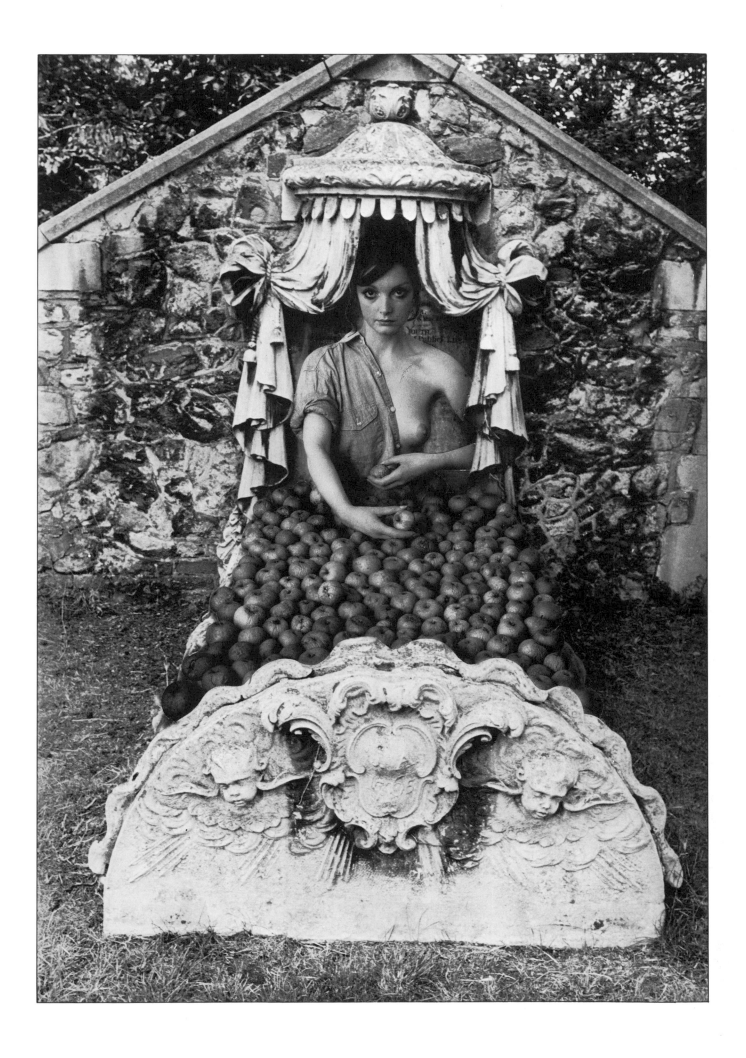

CAMERAS AND EQUIPMENT

A thorough working knowledge of the latest cameras, lenses, accessories and films is essential for the professional photographer and useful to the advanced amateur, since it helps to extend technical skills and thus contributes to the making of better photographs.
In the past, breakthroughs such as fully automatic exposure controls and instant film have profoundly influenced the way photographers work, and today progress in photographic technology is accelerating rather than slowing down. Recent years have seen the introduction of black and white films that use a method of image formation borrowed from the world of colour to produce a fine-grain dye image and a very high emulsion speed. A similar cross-pollination between different areas of technology has led to a system for recording still pictures on a magnetically coated disc, and to automatic focusing detection. None of these developments has on its own changed the face of photography but each has challenged old assumptions. This opening section offers a guide to some of the most useful recent developments and is a convenient reference point for situations in which a particular problem can be solved by using a special piece of equipment.

Small-format cameras 1

At one time, printers of photographs for reproduction in books, magazines, calendars or colour supplements insisted on working from medium- or large-format originals, but with the vast improvements in film emulsions and printing technology and in the image quality from computer-designed lenses, the majority will now work from 35 mm – a nominal format of 24 × 36 mm. Consequently, because of the advantages in portability and versatility (as well as cost) over larger formats, the 35 mm camera has been adopted by a very large number of professional photographers and advanced amateurs – particularly for colour. The popularity of 35 mm cameras is reflected in the wide variety of films available for them, much greater than for any other format. Apart from various simple non-reflex models primarily of interest to novice photographers, there are two main types worthy of consideration for advanced photography: the non-reflex coupled rangefinder; and the single-lens reflex (SLR). Various other types have been tried, including a 35 mm twin-lens reflex, but are now discontinued.

The simpler mechanisms for viewing and control of the lens diaphragm make the rangefinder slimmer, lighter and less complex than its SLR counterpart, and it is also very much quieter in operation, with little or no vibration from its mechanical components. Because there is no mirror mechanism, the subject can be viewed throughout the exposure, and since the viewfinder is not lens-dependent, its image remains bright regardless of the aperture of the lens or any attachments fitted to it – an especially useful feature under poor lighting conditions. The Leica is undoubtedly the foremost non-reflex 35 mm camera, renowned for its superb engineering and optics and having a wide range of lenses and accessories – including motor-drive and bulk film back. Leica lenses range from 21 to 135 mm and most are focused through a coupled rangefinder. Longer telephoto lenses can be used, but require a special reflex housing for focusing.

Although the rangefinder has many devotees, the 35 mm SLR is undoubtedly the most popular type of camera for advanced photography because of its supreme versatility. The rangefinder, as we have seen, has certain advantages over the SLR, but the SLR compensates for this because its viewing system is such that the image seen in the viewfinder is exactly the same as the image that will record on the film. It is thus possible to judge directly the effects provided by any lens or optical attachment fitted to the camera, and also possible to undertake precision close-up work, which is impossible with a rangefinder because of parallax error.

The viewfinder system of the average SLR consists of a reflex mirror behind the lens, a condenser focusing screen, pentaprism and rearsight correcting optics. The reflex mirror springs out of the lens/film light path when the shutter is released and automatically returns once the exposure is completed. The focusing screen usually incorporates a Fresnel lens so that illumination extends evenly into the corners, together with some form of focusing aid, most usually a split-image rangefinder "wedge" that divides a part of the image when it is out of focus, the two parts aligning when that part of the image is sharply focused. Others include an arrangement of microprisms that appear to "shimmer" until the image is correctly focused, a ground or etched area, or a combination of some or all of these. Viewing/focusing screens are interchangeable on the more sophisticated SLR models, and some SLRs intended for professional use also have provision for replacing the pentaprism with various aids. These include a hood for waist-level viewing (ideal for low-level work), special magnifiers for close-up work on subjects involving great detail, or even eye-level finders suitable for use by photographers unable to get their eye close to the rearsight – as when wearing spectacles, goggles, a crash helmet, or when the camera is within a protective housing such as underwater. For the majority of spectacle wearers, however, a dioptric attachment of the same prescription as their spectacles can be fitted to the rearsight of most SLRs. Built in to the viewing system is an exposure meter the sensing cell(s) of which "reads" the light (or a portion of it) passing through the lens to the film. The meter is programmed with the speed of the film in the camera by means of a film speed dial turned to the appropriate setting, and is coupled to the shutter and/or lens aperture. Many recent models have provision for automatic setting of shutter speed and/or aperture.

SLRs have focal plane shutters consisting of a pair of fabric or metal blinds that travel across the focal plane horizontally or vertically. Differing lengths of exposure are achieved by varying the width of the gap between the two blinds and the speed at which they travel. Mechanical control and the timing of the different shutter speeds is now being replaced by electronics coupled to the exposure system. Focal plane shutters tend to be more accurate at high speeds than bladed ones, and also enable lenses to be changed without any need for additional capping to protect the film from light. For all but the simplest SLRs, an electric motor-powered autowinder or motor-drive unit is available to advance the film automatically after each exposure, either one frame at a time or continuously while the shutter release button is depressed. Recently, SLRs with built-in autowinders have begun to appear, such as the Konica FS-1. This camera advances film automatically to the first frame once a new film has been loaded and the camera back closed; it has no film wind-on lever.

The Leica M4-P is one of the latest in a classic line of rangefinder cameras stretching back to the first 35 mm camera, produced as a prototype in 1914 by Oskar Barnack, a designer at the firm of Ernst Leitz. Leitz began to market Leicas in 1924, and they became the first cameras to have a system of lenses and accessories designed for them.

Today the Leica rangefinder system is the largest available. It includes an f1.0 lens (shown on the M4-P in the right-hand picture, below), which is faster than any current SLR lens. Most Leica lenses couple with a rangefinder for focusing, the viewfinder's bright line frames indicating the picture area for various focal lengths.

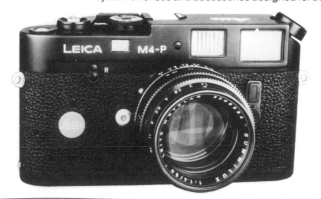

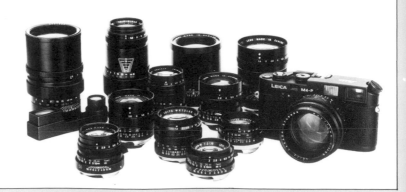

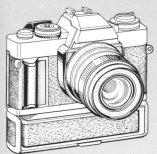

Winding on of film on SLRs is carried out manually with the film advance lever or automatically by means of an autowinder or motor-drive fitted to the bottom of the camera. The rate of film advance varies, six frames per second being the maximum available except for specialized high-speed cameras.

A waist-level viewfinder can replace the standard unit on several advanced SLRs. When not in use, the hood can be folded down so as to protect the focusing screen.

The standard viewing screen for SLRs has a microprism collar surrounding a split-image centre-spot. Other options include an entirely plain screen, shown behind.

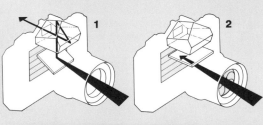

Exposure metering in all modern 35 mm SLRs is carried out through the lens (TTL), photoelectric cells being small enough to fit comfortably inside the body of the camera.

The mirror in an SLR reflects light passing through the lens up to a pentaprism that turns the image the right way round for the eyepiece (1). On pressing the shutter release, the mirror flips up (2), then the shutter opens to permit exposure (3).

Focal plane shutters in SLRs are either horizontal or vertical running. Most SLRs have a maximum shutter speed of 1/1000 second, but on some models intended for professional use the fastest shutter speed is 1/2000 second.

1 **2** **3**

Leica's SLR system is one of the finest available, but several of the leading manufacturers produce systems that are comparably good. Canon, Minolta, Nikon, Olympus and Pentax, who are the world's five biggest manufacturers of SLR cameras, all have systems that are outstanding for both quality and comprehensiveness. Other firms, although not producing full-scale systems, make superb cameras, some in the forefront of today's technology – Konica, for example, pioneered the built-in autowinder, and Ricoh the use of solar energy as a supplement to battery power as well as autofocusing lenses. When choosing a camera, it is wise to think of the equipment that can be built up around it to form a complete camera system.

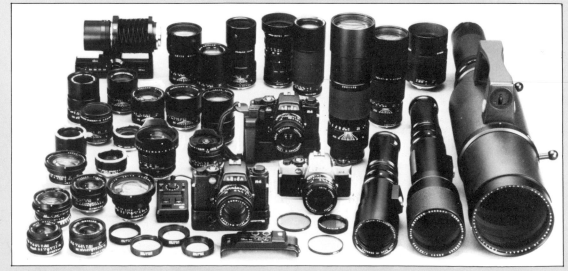

Small-format cameras 2

Most SLR manufacturers offer a wide range of lens focal lengths from wide angle to long telephoto; the range available often extends from fisheye to mirror constructions and includes special-purpose lenses, such as those for scientific photography. Lens fitting is almost universally by bayonet mount, because this is the most precise means of conveying information to the camera; the latest Mamiya system, for example, has eleven electronic contact points at the lens/body meeting point. Virtually all lenses for SLRs now have diaphragms that are automatically at full aperture for viewing/focusing until the shutter is fired; a number of companies are now making lenses with built-in automatic focusing as well. Most manufacturers have designed their own ways of doing all this, so there is little interchangeability.

Lenses from independent manufacturers are often cheaper than those from the SLR makers, but they do not always compete in terms of performance. The most common complaint about them is that they are not robust, and easily go out of adjustment. Occasionally, however, they offer a focal length or some other feature not to be found in a camera maker's range; and some independent makers still offer interchangeable camera mount adapters.

Miniaturization of electronic circuitry has made it possible to incorporate exposure control systems in SLR cameras. There are several different ways of designing these systems; the chief differences among types of sensor cells are in power consumption, spectral response and "memory" for light of high intensity. It is not a bad idea, when taking a series of readings, to be sure that the cell's memory has recovered from a very bright light before immediately taking another reading.

There are three types of exposure automation: "aperture priority", where the user selects the aperture and the meter automatically selects the right shutter speed; "shutter priority", which is the other way around; and "programmed", where the system selects both according to light conditions and the speed of the film in the camera. Most cameras have at least one mechanically operated shutter speed which can be selected in case of battery failure. The exposure, whether set manually or automatically, is usually indicated one way or another in the viewfinder, typically by a needle or system of light signals. Because of their power consumption, circuits having illuminated indicators or liquid crystal displays often incorporate a switch which automatically reduces unnecessary battery drain.

Facilities for flash synchronization are usually provided by means of suitable electronic contact on the accessory "hot shoe", and/or a 3 mm coaxial socket for the flashgun's lead. There is always some means of over-riding the exposure system for difficult subjects or lighting conditions, even if only by changing the film speed setting in order to fool the meter. Most SLR cameras have a means of delaying the shutter so that the photographer can include himself in his own picture, a preview button for reviewing depth of field through the viewfinder, and a cable or electronic release socket for the shutter. Some have a multiple exposure button which enables the photographer to re-cock the shutter for a second (or subsequent) exposure without advancing the film. Many automatic SLRs have some means of closing the viewfinder rearsight to prevent light from affecting the metering system while the camera is on a tripod or otherwise away from the photographer's eye.

In the future, automatic focusing for interchangeable lenses could well become standard. The setting of film speed could be automated by means of a code on the film or on the cassette. Loading of film cannot be automated without redesigning the whole 35 mm system, but winding the film back into the cassette may eventually be abandoned one way or another. A recent innovation to prolong battery life is the use of a solar cell for "trickle charging"; this or something similar could become standard. Another new idea is the provision of buttons or switches on top of the camera for easier exposure adjustment in very cold weather or when wearing gloves.

Film reminder
Most SLR cameras have a pocket of some sort on the back, for insertion of a tab from the film packet as a reminder to the photographer of the type of film in the camera.

Needle
Manual cameras in particular use needle devices such as this. The aperture and shutter speed have to be selected by the photographer, and the needle indicates whether the combination will be successful.

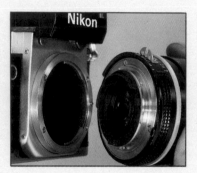

Bayonet mount
Bayonet mounts for systems of interchangeable lenses have made screw-thread mounts obsolete, because they are better able to impart information to the camera, increasingly necessary with electronic complexity. A flange (bayonet) on the lens slots into a groove on the body and locks into position when given a short twist.

Multiple images
It is difficult with an SLR to make multiple exposures like this unless it has a multiple exposure button, which enables the shutter to be cocked without advancing the film. The problem can be overcome by holding the shutter open and covering the lens between shots – a procedure that invites error unless flash is used to control exposure times. The positioning of the images is also a problem.

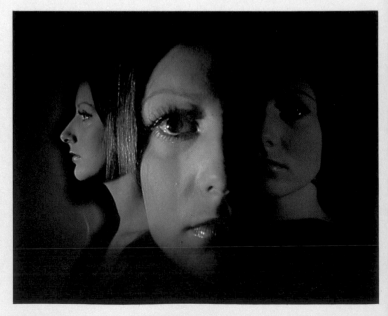

Preview button
In close-up work, depth of field is critical. An SLR meter may indicate a combination of shutter speed and aperture that does not give sufficient depth of field. By focusing wide open (top right) and then using the preview button (bottom right) the photo-grapher can judge if the combination gives him the depth of field he wants; if not, he can obtain it by selecting a slower speed and a smaller aperture. The button can also be used to select an aperture giving less depth of field.

LEDs
In this display, a light emitting diode gives a signal. When the middle dot lights up the exposure is right; there are indicators for slight underexposing and overexposing as well.

Aperture readout
In this display the recommended aperture is indicated by a needle. Some recent models, for example from Mamiya and Canon, have an LED digital readout of both aperture and shutter speed.

Focusing screen

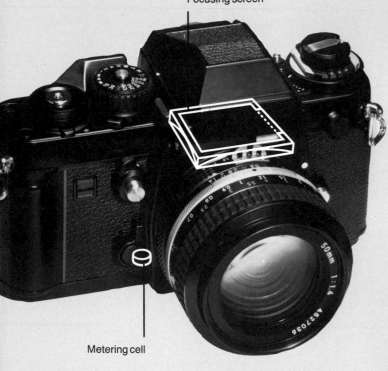

Metering cell

Pentaprism cell
A sensor cell is at the heart of a light-metering system. In the most common system in SLR cameras, the cell reads the light as it comes through the pentaprism and as it falls on the viewfinder screen. The cell works off a small low-voltage battery.

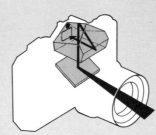

Transmitted light cell
An alternative sensor system takes the reading from light transmitted through a semi-silvered portion of the reflex mirror and reflected to a cell in the camera body by a second mirror. When the shutter is released, both mirrors flick up out of the way. No reading is taken while the shutter is open.

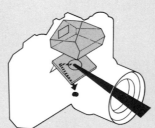

Off-the-film reading cell
Some sensors use transmitted light to give an approximate exposure reading and then correct this to an accurate reading by metering the light falling on the film itself or on a scientifically designed pattern printed on the shutter blind. The reading at the film is taken at mid-range or slow speeds.

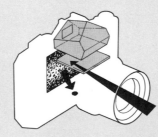

Autofocus lens

Manual over-ride
When shooting against the light it is useful to be able to over-ride the light meter to modify the exposure. Of the two pictures at right, the nearer represents the accurate meter reading; the other has been over-exposed to capture the background. In bright light, slight underexposure gives warmer colours.

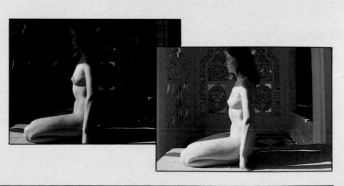

Medium-format cameras

The medium-format camera probably comes nearer than any other type to the impossible ideal of a "universal" camera – one suitable for every subject and technique. Although almost as portable and versatile as the best 35 mm cameras, the medium-format camera produces much larger negatives that can approach in quality those from cumbersome technical cameras. A considerable range of films is available, and transparencies are large enough to be viewed unaided. The term medium-format is usually applied to any camera taking roll-film and producing a negative or transparency of between approximately 6 × 4.5 cm and 6 × 9 cm. The three main types are the eye-level non-reflex, the twin-lens reflex and the single-lens reflex, all taking 120 roll-film. Most will also take 220, which is twice the length of the 120 roll but has no protective backing.

Non-reflex models are limited in number but are rugged and easy to operate, with large viewfinders and rangefinder focusing. There are two main types, the more common of which, exemplified by the Plaubel Makina, is rather like a scaled-up version of a 35 mm non-reflex camera. The second type is a "press" variety, with provision for interchanging not only lenses but also the film back to take roll, sheet or Polaroid instant-picture film.

The twin-lens reflex (TLR) is so-called because of its pair of lenses mounted vertically on a common focusing panel, the upper lens providing the image in the viewfinder while the lower lens records the picture. Although matched for focal length, the viewing lens is usually of simpler construction than the taking lens and often has a larger aperture to provide maximum illumination of the viewing screen and reduced depth of field to aid focusing. The large waist-level focusing screen enables pictures to be composed as two-dimensional images; the image is reversed left to right on the screen, but some photographers see this as a positive aid to composition rather than a hindrance. Drawbacks of the TLR are parallax problems when shooting in close-up and, in most models, the fixed focal length of the lens. Because of these drawbacks the TLR, for many years the standard camera for press, fashion, portrait and wedding photography, has lost popularity in favour of the medium-format SLR, but the TLR still has many supporters; its mechanical simplicity makes it extremely reliable, it is quieter than the SLR because it has no moving mirror, and it is very much cheaper than the SLR while producing images of the same high quality.

Like its 35 mm counterpart, the medium-format SLR offers total interchangeability of units, with a wide range of lenses and accessories. Two types are available, an eye-level model and a three-unit waist-level type that enables the photographer to put together a camera best suited to his individual requirements. Lenses range from fisheye to long telephoto and zooms, and accessories include extension tubes, bellows, powerwinders and viewfinder heads, some of them with through-the-lens exposure meters. Interchangeable film backs provide different formats and the opportunity to swap colour, black and white and instant-picture materials, a sheath protecting the film when the back is removed.

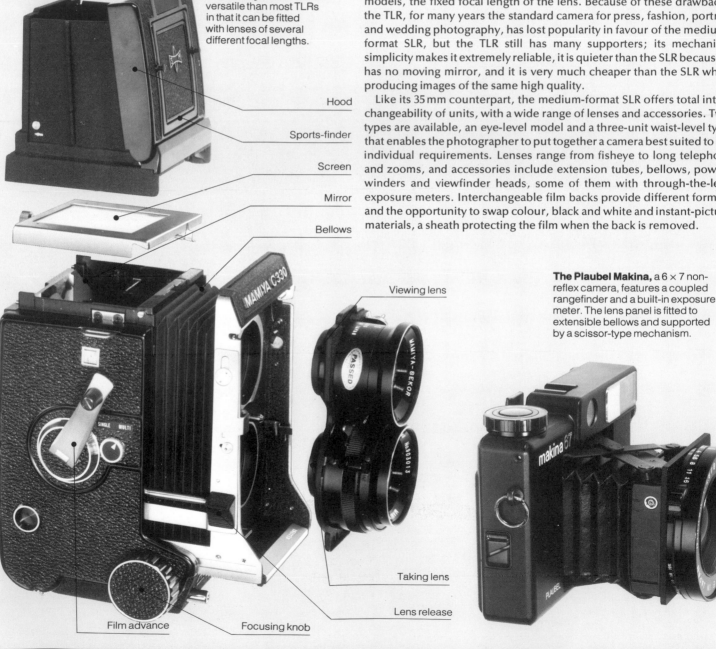

The Mamiya C330 is more versatile than most TLRs in that it can be fitted with lenses of several different focal lengths.

Hood

Sports-finder

Screen

Mirror

Bellows

Viewing lens

Taking lens

Lens release

Film advance

Focusing knob

The Plaubel Makina, a 6 × 7 non-reflex camera, features a coupled rangefinder and a built-in exposure meter. The lens panel is fitted to extensible bellows and supported by a scissor-type mechanism.

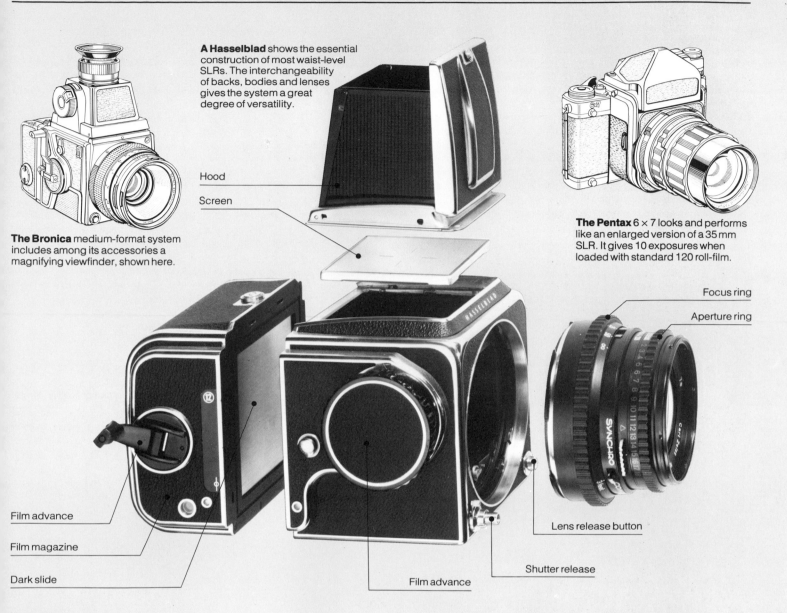

A Hasselblad shows the essential construction of most waist-level SLRs. The interchangeability of backs, bodies and lenses gives the system a great degree of versatility.

Hood

Screen

The Bronica medium-format system includes among its accessories a magnifying viewfinder, shown here.

The Pentax 6 × 7 looks and performs like an enlarged version of a 35 mm SLR. It gives 10 exposures when loaded with standard 120 roll-film.

Focus ring

Aperture ring

Film advance

Film magazine

Dark slide

Lens release button

Shutter release

Film advance

Hasselblad is probably the best-known name in medium-format cameras on account of the firm's very high reputation for quality and the extensive range of the complete system, some of which is shown at right. Waist-level SLRs like the Hasselblad (of which there are four models currently available) usually have lenses with between-the-lens shutters but may also have a focal plane shutter. The standard lens for a medium-format camera has a focal length of about 80 mm, which is equivalent to a 50 mm lens on a 35 mm camera. Interchangeable backs on Hasselblads allow the use of three different formats: standard 6 × 6 cm; an oblong 6 × 4.5 cm; and a square $1\frac{5}{8} \times 1\frac{5}{8}$ in format called "superslide".

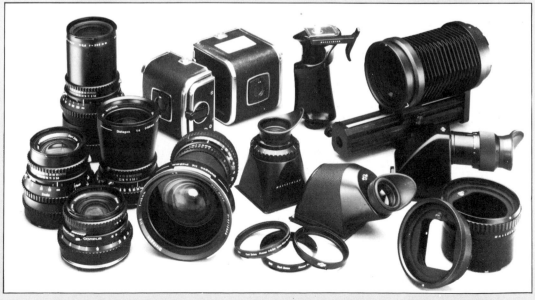

Large-format cameras

For total control of the image – shape, focus and depth of field – large-format technical cameras cannot be beaten. Such control demands movements of the lens and/or film around the optical axis and these can be achieved only when the lens and film are on independent supports linked by tubular light-proof bellows.

The other great advantage of these cameras is the size of film they can take, since ultimate quality in big enlargements can generally be achieved only with large-format negatives. The most popular sizes are 5 × 4, 7 × 5 and 10 × 8 in, though many older and traditional sizes, such as quarter-plate ($3\frac{1}{4} \times 4\frac{1}{4}$ in), half-plate ($4\frac{3}{4} \times 6\frac{1}{2}$ in) and whole-plate ($6\frac{1}{2} \times 8\frac{1}{2}$ in), as well as metric sizes, are still available. As the viewfinder is directly behind the lens, the focusing screen (either ground or etched) shows an inverted and laterally reversed image the same size as the film. This is a great bonus for accurate viewing and composing. Focusing

hoods can be used to aid viewing and also to help prevent reflections on the glass itself, though most photographers prefer to use a light-proof cloth to surround the screen and cover the head, especially when examining depth of field with the aperture stopped down.

There are two basic types of large-format camera: the monorail (of which there are numerous variations) and the field or baseboard camera (top right). The former (below) is the more popular and consists of lens and focusing screen/film holder assemblies mounted on rigid support units (or standards) that may be moved along the length of a rail as required. Each support unit has facilities to tilt or swivel round its axis and, often, the separation between lens and film can be further increased by changing rails and fitting additional bellows units.

Monorail construction allows the photographer to build up his camera as required for any particular type of subject. Some very sophisticated

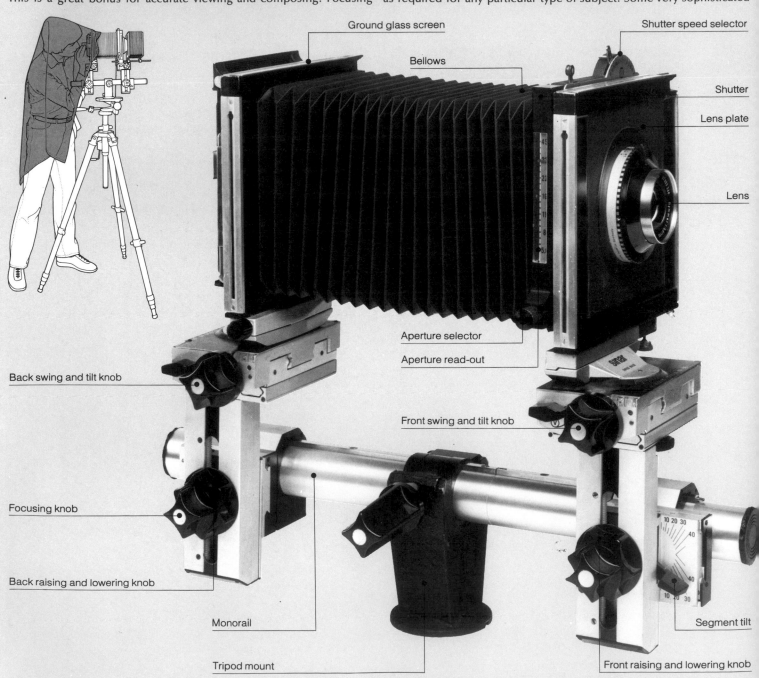

Ground glass screen

Bellows

Shutter speed selector

Shutter

Lens plate

Lens

Aperture selector

Aperture read-out

Back swing and tilt knob

Front swing and tilt knob

Focusing knob

Back raising and lowering knob

Monorail

Segment tilt

Tripod mount

Front raising and lowering knob

models offer a wide range of rails of different lengths or even sectional units for slotting together. To these are fitted matching standards that accept either lens or screen/film assemblies connected by any number of bellows that are simply clipped together.

So called "studio" cameras were designed primarily for formal portraiture, where large negatives provided scope for retouching and other after-work. These cameras have very restricted movements, limited to slight horizontal swing of the front panel. The whole camera can be tilted or raised by external controls, while the back can be adjusted for image magnification and the lens for focusing. As the heyday of formal portraiture is over and the demand is now for more candid and relaxed shots, and in colour – where little or no after-work can be done on the negatives – the modern photographer tends to use a medium-format roll-film reflex camera for greater flexibility and manoeuvrability.

The shutters on large-format cameras are usually simple, mechanical types, consisting of overlapping leaves and generally mounted between the elements of a lens. Thus each lens has its own integral shutter and the entire unit is fitted to a panel that is slipped or snapped into the front standard of the camera. Alternatively, an independent leaf shutter may be built into a separate panel and mounted between the lens and the bellows. These shutters rarely have speeds in excess of 1/300–1/500 sec, but do have an invaluable range of slow speed settings down to one or more seconds. In addition to these and B (brief time) there is also a T setting that opens and closes the shutter for composing and focusing.

Used with care and practice, large-format cameras are ideal for all studio and outdoor photography of non-moving objects, but they can also be used for many other types of work including portraiture and fashion, as long as subject movement can be strictly controlled.

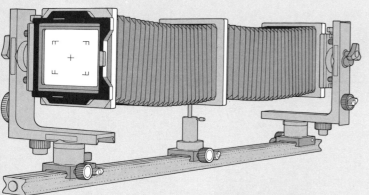

Supplementary bellows
Square extending bellows (above) link the lens with the rear standard carrying the focusing screen, which can itself be rotated to a vertical or horizontal position. Special bellows units (right) are also available for use with wide-angle lenses where lens and film are relatively close together. These bellows are not pleated like ordinary bellows, but are sufficiently voluminous to allow a good degree of lens movement without the risk of cutting off the image. Very long or very short focal length lenses can therefore be accommodated and the camera can be used for extreme close-up work.

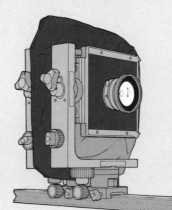

Baseboard cameras
These are also known as field or view cameras because they derive from studio cameras portable enough to be used for landscape work.

Their movements are sometimes restricted to rising and falling front, but may include shift, swing or tilt. Front and rear sections fold flat forming a compact unit.

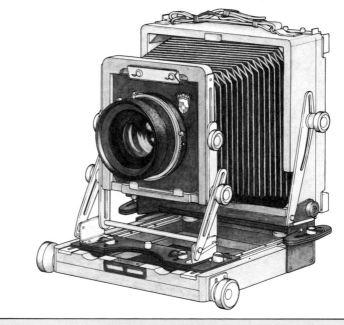

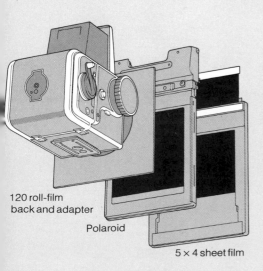

120 roll-film
back and adapter

Polaroid

5 × 4 sheet film

Film holders and special backs
Large-format cameras use individual sheets of film loaded into slim holders and protected by a sheath that is removed once the shutter is closed. After exposure the sheet is replaced, the holder taken out and the film processed. Double holders with film loaded back to back are also available. Special backs to take standard 120 or 220 roll-films can be fitted. These are basically large-size cassettes on an adapter backing plate and offer a choice of relatively inexpensive films and the ability to make a number of exposures for identical processing of subjects demanding the movements of a technical camera. Polaroid or Kodak instant-picture films can also be used in special backs and allow tests to be done before the sheet film is exposed, an invaluable aid in studio photography.

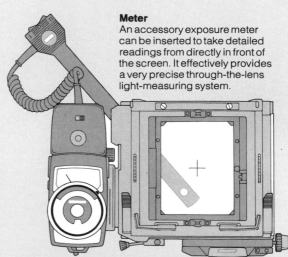

Meter
An accessory exposure meter can be inserted to take detailed readings from directly in front of the screen. It effectively provides a very precise through-the-lens light-measuring system.

Special cameras 1

No camera can cope with all aspects of photography; consequently many models, not all of them expensive, have been developed with highly specialized features to handle specific photographic assignments, to cope with unusual conditions, or to simplify picture-taking.

Baseboard technical cameras

A collapsible large-format camera can have its lens panel support attached to a rigid baseboard, enabling the camera to be hand-held if necessary. When the unit is closed, the baseboard fully protects the camera and the lens/shutter/bellows assembly. These cameras allow movement of both the lens panel and the film back and their lenses can be changed rapidly. Focusing is usually done by means of a coupled rangefinder visible in the viewfinder, and interchangeable film backs permit choice of format and of sheet, roll-film or instant-picture materials. These cameras are ideal if a wide range of large-format work is to be undertaken in or out of doors, with or without a tripod. A camera especially intended for photo-journalism may have a large optical viewfinder, with a suspended bright-line frame for delineating the picture area with different focal-length lenses, and/or an open sports finder. There may also be a built-in moulded hand-grip or some other means of support, leaving the other hand free to operate and adjust the various controls.

Panoramic and wide-angle cameras

A panoramic camera, designed to shoot wide scenes or large groups, takes in an area of 140–360° in a single exposure. There are two main types: those in which the lens rotates in an arc within the camera and those in which the camera rotates as the film advances. Details of their mechanisms are given overleaf.

In various aspects of architectural or survey work where a wide-angle lens is essential, space may be limited and the ability to hand-hold the camera may be essential. Symmetrical lenses with short back-focus are required in order to obtain optimum quality with wide-angle coverage, in situations where reflex focusing must be sacrificed, so special shallow camera bodies have been developed for roll-film and 35mm formats. Typical of these are the Hasselblad Super Wide C/M, which has a non-interchangeable 38mm lens; the Linhof Technorama (format 170×60mm) (see overleaf); the Cambo Wide (5×4in) and the novel Sinar Handy – the front unit of a Sinar technical camera mounted on a hand-grip and fitted with a wide-angle lens.

Disc cameras

The most recent development in cameras dispenses with what had seemed to be fundamental – film and chemicals. The Sony Mavica system is based on a still video camera in which the image is recorded on a magnetic disc and viewed on a television screen or as a print-out from the television set. The camera, which looks like a conventional SLR, has a maximum aperture of f1.4 and a speed range of 1/60 to 1/2000. The electronic system provides a speed rating of about ASA200. Resolution is 350 tv lines – better than that of available video movie cameras, but not as good as that of film.

A parallel development by Kodak uses a disc of conventional film. Each disc has 15 frames, smaller than 110 format but with an emulsion that will permit enlargements up to 10×8in. The camera itself is three-quarters of an inch thick and both exposure and film advance are automatic. On most versions the fixed-focus lens gives depth of field from four feet to infinity. The camera, in which a small motor rotates the disc and operates the exposure mechanism, is claimed to halve the chance of underexposure and reduce camera shake to less than two per cent. Aimed at the amateur photographer who seeks a foolproof system at low cost, the film/disc may replace the 110 format. A long-life battery provides automatic flash with rapid recharge.

Miniature cameras

Minox's EC ("Electronic Control") is said to be the world's smallest camera. The film format is 8 × 11mm in a special Minox cartridge, in 15 or 36 exposures from 25 to 400 ASA. The 15mm lens is fixed-focus and fixed-aperture (f5.6), and shutter speeds are from 1/500 to 8 seconds. A push-pull motion of the camera's case advances the film and cocks the shutter; when closed the camera is only a little over 3 in long. It carries one battery and weighs about 2 ounces; a tiny flashgun can be fitted. The same company also makes a full-frame 35mm camera which is only about 4 in long and 1¼ in thick when closed.

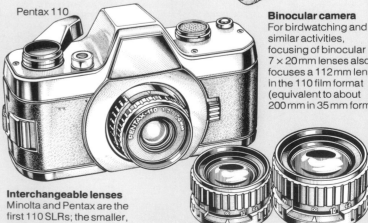

Minolta 110 Zoom SLR Mark II

110 format with zoom
This Minolta combines the handy 110 cartridge film with SLR viewing. The metering system is aperture-priority and the camera is fitted with a versatile zoom/macro lens of 25 to 67 mm focal lengths – equivalent to 50–135mm in the 35mm film format.

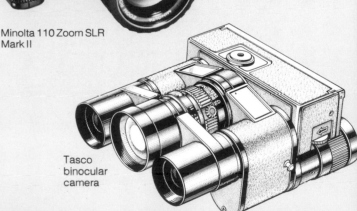

Tasco binocular camera

Binocular camera
For birdwatching and similar activities, focusing of binocular 7 × 20 mm lenses also focuses a 112 mm lens in the 110 film format (equivalent to about 200 mm in 35 mm forma

Pentax 110

Interchangeable lenses
Minolta and Pentax are the first 110 SLRs; the smaller, lighter Pentax has three interchangeable lenses.

Instant pictures

Instant-picture camera backs, based on the Polaroid film pack, are now available for many technical and baseboard large-format cameras, medium-format cameras such as the Hasselblad, and some 35 mm SLRs. They provide instant "proof" of lighting set-ups and, in some black and white applications, a recoverable negative for making more prints. They are used with multiple lens/shutter arrangements to make up to four exposures on one piece of film, for passport-type photographs. With interchangeable lenses, they can do close-up work; the unit used with the Olympus OM2 and a fibre-optic endoscope can take pictures of, for example, the inside of the human body.

Kodak EK160

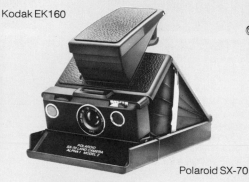
Polaroid SX-70

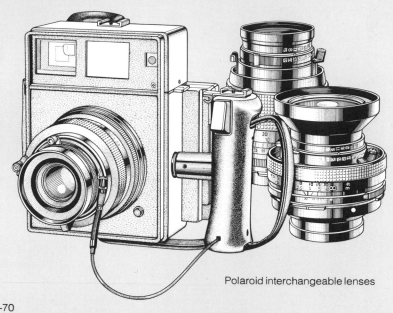
Polaroid interchangeable lenses

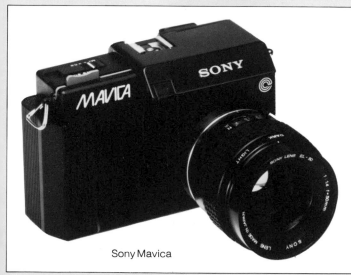
Sony Mavica

Filmless camera

Sony's new Mavica system (MAgnetic VIdeo CAmera) eliminates film and processing. A Charged Coupled Device (CCD) microchip converts the light into an electronic signal which is recorded on a magnetic disc, to be viewed on a conventional TV screen. The disc itself is not sensitive to light, and so can be removed and reloaded anytime; it can also be erased and re-used. Holding 50 images, it will be cheaper than 50 conventional slides or prints. Prints can be made from the disc by a method similar to photo-copying, and the images can also be transmitted over telephone wires, a development which will affect the information industry.

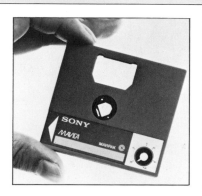

Video still cassette

The magnetic Mavipak, 3 mm thick, has an automatically advanced disc exposed via a "window" at the top. The frame counter is lower right.

Stereo pictures

The stereo adapter (near right) is fitted to an SLR and, using mirrors, allows two exposures on one 35 mm frame. These can then be mounted and viewed in stereo.

The Nimslo four-lens camera is about the size of an SLR and makes four exposures on two 35 mm frames. The film and developing are normal, but the printing is a radical departure: a computer-operated printer enlarges the images and divides them into strips 1/6400 in wide; the printing material is a piece of extruded plastic forming a series of lenses, each 1/200 in wide; eight copies of a strip from each exposure (32 in total) are printed under each lens, resulting in a print that gives the illusion of depth without the need for any special viewing device.

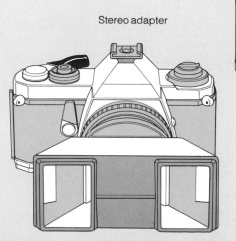
Stereo adapter

Pentax viewer

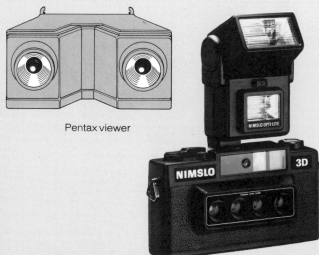
Nimslo 3D camera

Special cameras 2

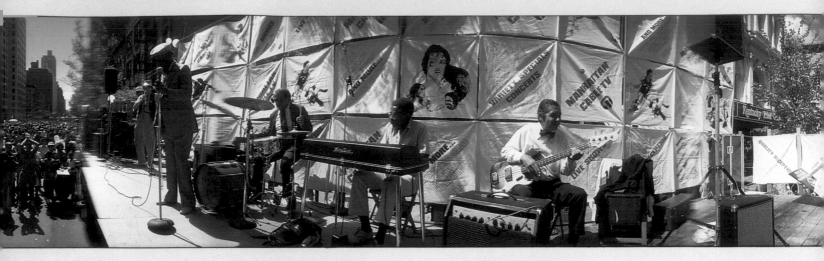

Panoramic cameras

Panoramic cameras take in an area of 140° to 360° in a single exposure. One type (see the Vinten 751, right) has a rotating lens moving anti-clockwise across curved film, which is transported clockwise; the second (left, and illustration above) revolves on a tubular handle and exposure is made through a slit, using a combination of aperture and speed of rotation. The Globuscope (left) is driven by a clockwork motor and uses 35 mm film: the shot above was recorded on a strip of film 11 in long. The camera's lens, which has a maximum aperture of f3.5, gives a 60° vertical field and the shutter has speed equivalents of 1/400, 1/200 and 1/100. The Vinten is principally intended for aerial photography, enabling a series of wide-angle (180°) photographs to be recorded on one continuous length of 70 mm film, which can be passed through the camera at a maximum velocity of 100 in per second.

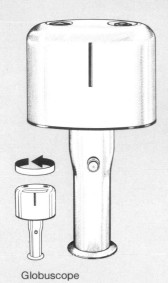

Globuscope

Very wide-angle cameras

The Vinten 751 (below) is intended for aerial photographic reconnaissance and can take up to 10 frames per second. More conventional wide-angle shots, such as that of Blickling Hall, Norfolk (bottom), can be taken on cameras such as the Linhof Technorama (below right). The lenses of these cameras cover 90° to 120° without the distortion inherent in quasi-fisheye or true fisheye lenses, but because of their design (the rear element of the lens is only a short distance from the film) cannot be fitted to an SLR system. The cameras are thus provided with simple optical viewfinders and focusing is done by distance scale settings. The Technorama uses 120 roll-film.

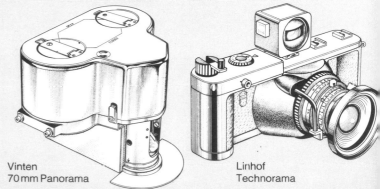

Vinten
70 mm Panorama

Linhof
Technorama

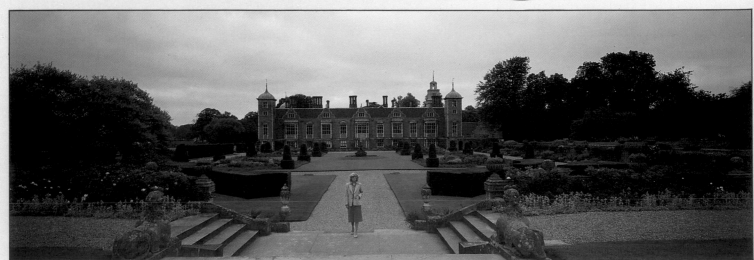

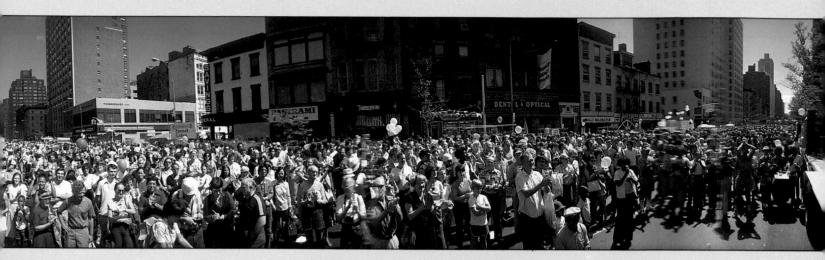

High-speed cameras

The demands of bodies as diverse as defence ministries and newspapers have led to the creation of high-speed cameras. The 35 mm Vinten LR1 (right) was built to the specifications of the British Ministry of Defence for missile range recording. It can take up to 300 frames per second at 1/7200 and has a capacity of 16,000 frames.

The Hulcher Model 112 (below right) uses 35 mm film, has speeds between 1/25 and 1/13,000 and is capable of taking either 10, 25, 45 or 65 pictures a second. Examples of its work are displayed below. It can hold 100 ft of standard film or 150 ft of thin-base film, and an adaptation is available to take a 400 ft magazine. Lenses for

this camera are interchangeable, on a standard Nikon-type bayonet mount, and continuous through-the-lens focusing is provided (except with the 400 ft magazine adaptation) by means of a beam splitter providing 70 per cent of the light to the film and 30 per cent for focusing. The camera weighs only 3½ lb and operates on a 12-volt battery.

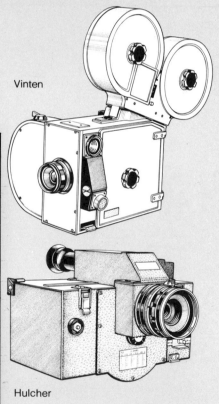

Vinten

Hulcher

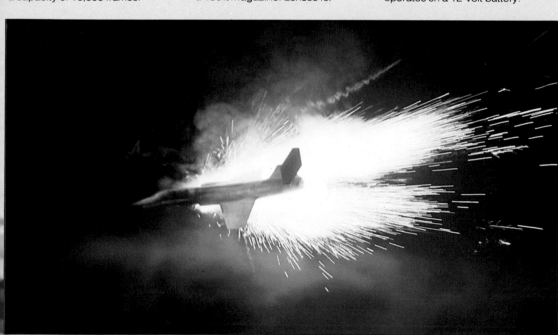

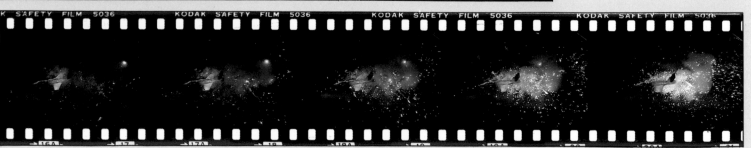

Lenses 1

Lenses are usually divided into three main groups – standard, wide-angle and long-focus. The standard (or normal) lens for any particular format has a focal length approximately equal to the diagonal of the film, producing an image that corresponds most closely in angle of view and recession of planes to normal human vision. What is considered the standard lens for a format is, however, dictated as much by tradition as by logic; the diagonal of a frame of 35mm film actually measures about 43mm, but lenses considered standard for the format generally come within the range 45–55mm, 50mm being the most common. For medium-format cameras the standard lens is normally about 75–105mm and for 5×4in large-format cameras about 200mm. Wide-angle and long-focus lenses have respectively a shorter and longer focal length than a standard lens. The terms long-focus and telephoto are often used interchangeably, but a telephoto lens is strictly one having a particular kind of optical construction that makes it physically shorter than its focal length. Telephoto construction makes use of two groups of elements – converging at the front of the lens, diverging at the rear. The rear group lessens the convergence caused by the first group, and the cone of light that reaches the film therefore appears to converge from a point in front of the first group. This gives the same effect as a longer lens in which the front elements are farther from the film.

While the focal length of a lens determines the character of the image, a lens's suitability for a particular format is determined by its covering power – the maximum area over which it is capable of producing an image of acceptable quality. A 200mm lens for a 35mm camera will have insufficient covering power to cover a 5×4in film, whereas a 200mm lens designed to cover a 5×4in film will easily cover smaller formats, for which it will act as a long-focus lens.

The design and construction of lenses is an extremely complex and skilful procedure. Factors such as the number, shape and arrangement of the elements and the refractive and dispersive qualities of the various types of optical glass used must be balanced in such a way that aberrations are reduced to a minimum. In general, the wider the maximum aperture, the greater the degree of correction that will be required, since many optical aberrations are eliminated (or at least reduced) at the smaller lens openings. Very narrow apertures, on the other hand, risk image degradation through diffraction, when the light is deflected and sets up interference patterns. Consequently, the minimum aperture found on lenses for 35mm cameras up to about 135mm is usually no smaller than f22. Longer focal length lenses, or those designed for a larger format, usually have smaller minimum apertures – f32, f45, f64, or even f90 for some large-format cameras. The f numbers are reciprocals of the lens's focal length. Thus the aperture marked f2.8, for example, passes twice as much light as the aperture marked f4 and four times as much as the aperture marked f5.6, regardless of the focal length of the particular lens.

In theory, only the point on which the lens is focused will be sharply resolved and recorded, but in practice there is a zone of sharpness extending in front of and behind this point. Apart from the subjective criterion of what constitutes acceptable sharpness for a particular photograph (that is, the diameter of the permissible circle of confusion), the extent of this depth of field depends on three factors: focal length; aperture; and the distance from the camera to the point focused. The effects of varying these factors are set out in chart form on the opposite page. Depth of field is often confused with depth of focus. The latter term refers to the degree of tolerance in the positioning of the image plane – in practical terms, the accuracy with which the film has to be positioned in the camera.

Wide-angle lens
Two important aspects of the wide-angle lens are shown here – the extensive area it "sees" and its great depth of field. The picture was taken with a 28mm lens, which is one of the most popular focal lengths. It produces very little of the distortion noticeable with extreme wide-angle lenses.

Standard lens
Standard lenses usually have larger maximum apertures than any others available in the same format. They are thus particularly suitable for work in low light levels. The 50mm lens shown here has a maximum aperture of f1.4; some SLR manufacturers make even faster f1.2 standard lenses, which are extremely expensive.

Long-focus lens
The 135mm lens, below, is one of the most popular and versatile focal lengths. It is a favourite for portraiture as it renders the features without distortion. The comparatively shallow depth of field makes it possible to blur unwanted background detail – here, using an aperture of f8, the books are only slightly blurred.

Zoom lens
Zoom lenses encompass a variety of focal lengths, and are thus particularly useful in situations where there is no time to change lenses or set up a shot carefully. They also make it possible to frame a shot exactly. Drawbacks are usually greater weight, smaller maximum aperture and lower optical quality compared with fixed-focus lenses.

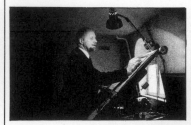

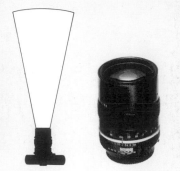

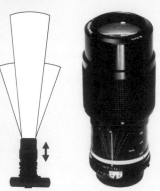

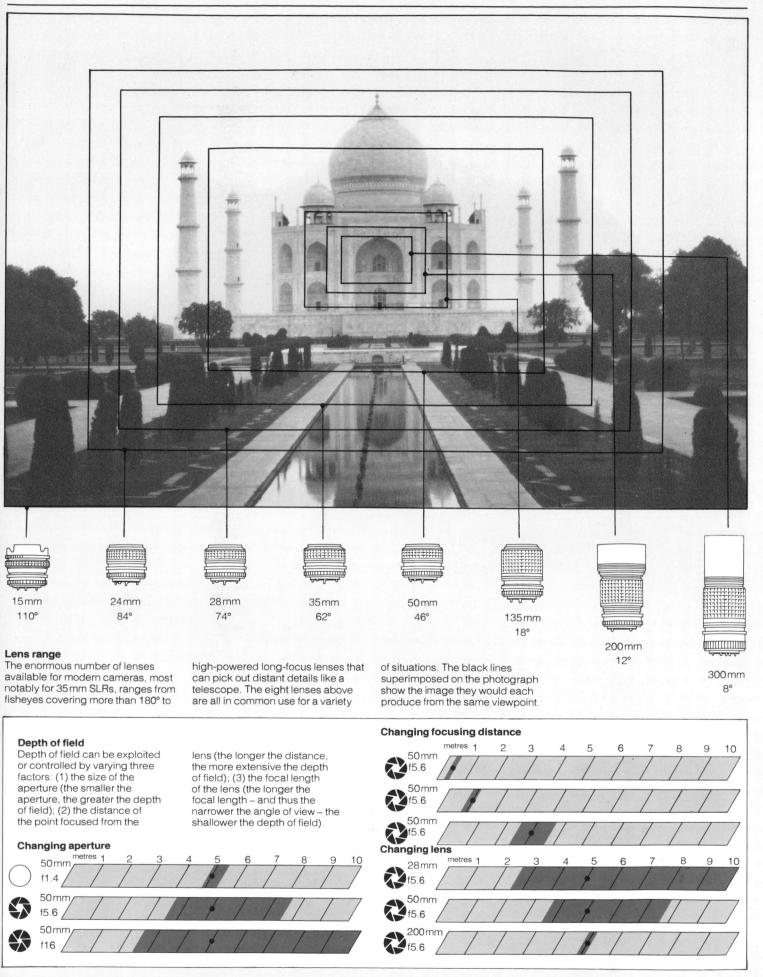

15mm
110°

24mm
84°

28mm
74°

35mm
62°

50mm
46°

135mm
18°

200mm
12°

300mm
8°

Lens range

The enormous number of lenses available for modern cameras, most notably for 35mm SLRs, ranges from fisheyes covering more than 180° to high-powered long-focus lenses that can pick out distant details like a telescope. The eight lenses above are all in common use for a variety of situations. The black lines superimposed on the photograph show the image they would each produce from the same viewpoint.

Depth of field

Depth of field can be exploited or controlled by varying three factors: (1) the size of the aperture (the smaller the aperture, the greater the depth of field); (2) the distance of the point focused from the lens (the longer the distance, the more extensive the depth of field); (3) the focal length of the lens (the longer the focal length – and thus the narrower the angle of view – the shallower the depth of field).

Changing aperture

50mm f1.4
metres 1 2 3 4 5 6 7 8 9 10

50mm f5.6

50mm f16

Changing focusing distance

50mm f5.6
metres 1 2 3 4 5 6 7 8 9 10

50mm f5.6

50mm f5.6

Changing lens

28mm f5.6
metres 1 2 3 4 5 6 7 8 9 10

50mm f5.6

200mm f5.6

Lenses 2

Because no single lens is capable of recording the enormous variety of photographic subjects, lenses of many different types are made for users of interchangeable lens cameras besides the "conventional" lenses discussed on the previous two pages.

The inherent tendency of a lens to distort the image it produces as its angle of view is increased is deliberately exploited for dramatic pictorial effect in the fisheye lens. Many of these lenses have an angle of view of 180° and the inescapable barrel distortion, or even curvature of field, from which they suffer is most apparent on straight line parts of the image close to the edge of the frame.

Wide-angle lenses are often used for architectural subjects in confined spaces, but tilting the camera upwards to include all of a tall building will result in converging verticals. Shift, or perspective control lenses are so constructed that the lens axis can be moved a few degrees to help to correct the distortion. They are generally made for small- or medium-format cameras, notably 35mm and roll-film SLRs.

The split-field lens, which fits over a normal lens, enables the photographer to focus near and distant parts of a scene in a situation where otherwise there would be insufficient depth of field. It consists of a half-circle of glass and thus creates a line, which has to be disguised, across the centre of the picture.

The reflex lens uses mirrors to encompass a long focal length within a short physical space. The result is a compact lens having a focal length of between 250mm and 2,000mm. The disadvantage of the design is that the lens cannot be fitted with a conventional diaphragm and exposure has to be controlled by the shutter or neutral density filters.

Without lens With lens

Split-field lens
To disguise the fact that a split-field lens has been used, the photographer must rotate it until its glass edge is aligned with some suitable part of the picture. In the shot above, a dark shadow falling across the glass proved satisfactory.

Split-field lens

Fisheye lens
The 8 mm fisheye lens below produces a circular image on the film. The camera's reflex viewing system and through-the-lens metering continue to work when the lens is in use (with some fisheyes the mirror has to be locked up and a special viewfinder used) and the lens has its own built-in filters. It covers an angle of view of 180°. Some fisheyes cover 220° – enough to let them "see" slightly behind themselves. Fisheyes were originally developed for special scientific and industrial applications, such as photographing the interiors of pipes, boilers and so on. Increasingly, they are being used for dramatic effect in advertising and commercial photography.

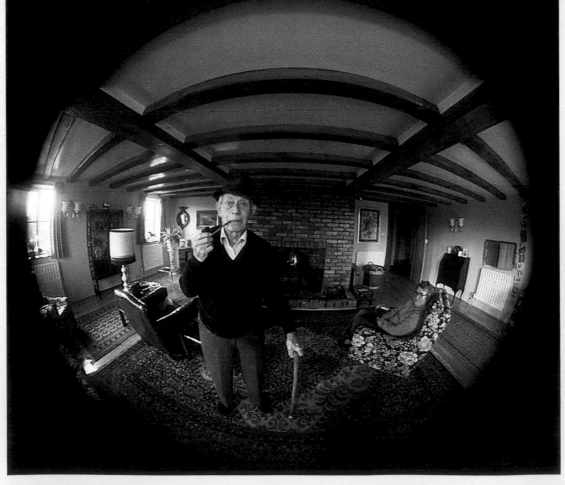

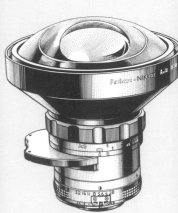

8 mm fisheye

Reflex (mirror) lens

The reflex lens is based on the catadioptric principle (below), which uses a combination of lenses and mirrors to give a lens that is compact and lightweight compared with long telephoto lenses of equivalent focal length. Some offer magnifications 40 times that of a normal lens and are equipped with built-in filters and a peepsight that helps the photographer to locate his subject. The doughnut-shaped out-of-focus highlights are characteristic of the lens.

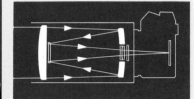

Catadioptric principle

1000 mm reflex

Shift lens

Shift lenses are usually made in 28mm or 35mm wide-angle focal lengths and are principally intended for architectural photography. They do for the 35mm and medium-format camera what a rising and falling front does for a view camera; and one model is also equipped to provide the equivalent of a swing and tilt front. The lenses are constructed so that they can be shifted off-centre by up to 11mm. They can be used not only to straighten out converging verticals, but also to eliminate unwanted foreground. The model that provides a tilt front can also be used to increase depth of field. None of the lenses at present available can be used with automatic aperture control.

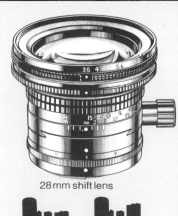

28mm shift lens

Centred With shift

Without shift

With shift

Black and white film

Choosing the most suitable film for black and white photography (or colour) is, these days, very much a matter of personal judgement and taste. There is a vast selection not only of individual makes of film, but of emulsion types, and each type of emulsion has its own range of inter-related characteristics. Copying film emulsion, for example, is sensitive to the ultraviolet-to-blue end of the spectrum only. Orthochromatic film extends to green and panchromatic is sensitive to all colours. The results you get from any one film will obviously depend on the subject, the available light and the exposure given. But using special developers, such as "fine grain", "high acutance" and "speed increasing", can also dramatically alter the results. This is why it is often very difficult to tell the difference between prints of the same subject made from very different films. Some very fast emulsions require special developers that do not give optimum results with slow films, while others intended for slow films may cause stains or even chemical fog if used to process ultra high-speed emulsions.

An emulsion thickly coated with large-size grains will be "faster" or more sensitive to light than one thinly coated with smaller grains, and will quickly show evidence of the emulsion's granular structure on enlarging. An advantage of fast film over slow in hand-held shots, especially in poor light, is that shutter speeds do not need to be slowed to the point of risking camera shake, so the result may well be sharper. Very slow film can be useful, but generally needs a tripod and long exposure, except under very bright lighting. It will show less granularity in even-toned parts of the print, such as sky, and generally gives better image sharpness than fast film because its grains are on average smaller.

Nonetheless a fast film without a granular structure would obviously be the ideal – and it looks as if the new chromogenic film may be precisely this. In this type of film the dye image is produced on development and the original silver grains are removed by bleaching. The amount of dye produced is in direct relation to the exposure and so the "speed" of film can be varied to suit the subject/conditions. The lower the speed rating used, the denser will be the image and vice versa. Thus a high-speed emulsion is available with considerable enlarging potential since only the minimum of dye is produced and the negative contains no silver "grains" to become obtrusive. The fourth pair of photographs on this page gives a striking demonstration of the capacity of this film. Although for amateurs it presents processing problems similar to those of colour film, it may to some extent replace the use of fast film.

Changes are under way in the system of rating film emulsions at the specific "speeds" that are taken into account when ascertaining correct exposure. A recent international agreement has combined the two most widely used systems into the single unit ISO. The arithmetical system devised by the American Standards Association (now the American National Standards Institute) and known as ASA halved or doubled the number to indicate a halving or doubling of the film's speed, while the logarithmic system, DIN, of the Deutsche Industrie Norm, reduced or increased the number by three to indicate a halving or doubling of the speed. A packet of medium-speed film with a rating of ASA 125 and 21° DIN is now rated ISO 125/21°. Slow film is generally in the region ISO 25 – 64/15 – 19°, medium film ISO 80 – 125/20 – 22°, while fast films are rated above ISO 200/24°.

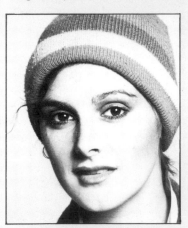

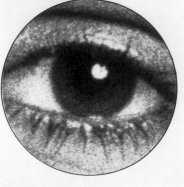
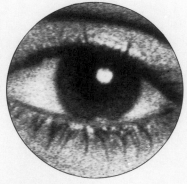

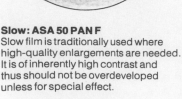

Slow: ASA 50 PAN F
Slow film is traditionally used where high-quality enlargements are needed. It is of inherently high contrast and thus should not be overdeveloped unless for special effect.

Medium: ASA 125 FP4
Medium-speed film is the best all-purpose choice as it is not as contrasty as slow film yet has sufficiently high resolution for most average subjects.

Fast: ASA 400 HP5
Fast film is ideal when lighting is poor or when you want to freeze movement by using a fast shutter speed. Grain will be apparent with enlargements of more than about ×8.

"Grainless": XPI rated at ASA 400
This new chromogenic film has many advantages. The image is produced by development in direct relation to exposure, so "speed" can be varied and enlarging potential retained.

Sheet film

This whole page is set within the dimensions of a frame of 10×8 in sheet film; and the camera illustrations are set within the dimensions of the film they use. Colour film comes in the same formats. The 10×8 format offers superb quality, but its use is now restricted mainly to advertising. The 5×4 in camera (right) is in general use for studio and architectural work. Film holders (below) are for use in large-format cameras. For each shot, a sheet has to be inserted, though some holders carry one each side.

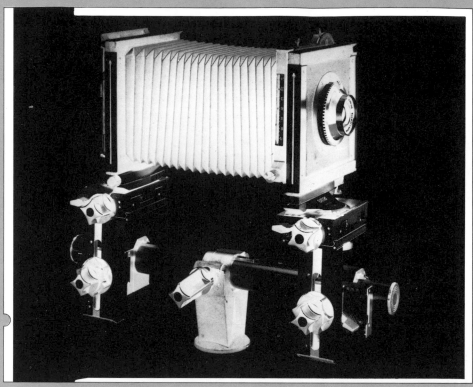

5 × 4 ins

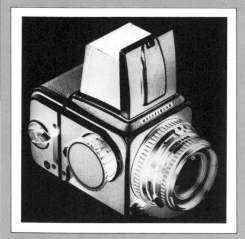

6×6cm

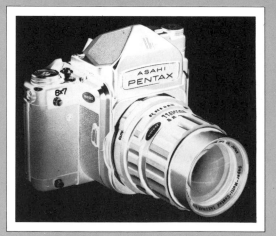

6×7cm

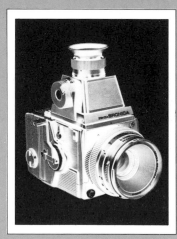

6×4.5cm

120 roll-film

The number of pictures on a roll-film depends on the format of the camera. The cameras above are shown in borders of their negative sizes (6×6cm, 6×7cm, and 6×4.5cm). 120 film is wound on a spool with a protective backing and needs no cassette.

135 mm cassette film

35 mm films are loaded into light-tight cassettes which usually contain enough material for either 20 or 36 exposures. The exact size of each is shown on the right. Ilford now produce one emulsion on a very thin "plastic" base and so can pack sufficient film for 72 exposures in a standard cassette. Special bulk film backs for more sophisticated 35 mm SLRs will allow up to 250 exposures.

35 mm

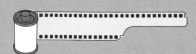

Colour film

The principles behind the two basic types of colour film are much the same even though their immediate results are quite different. Colour negative film, when processed, gives a negative image of the subject in complementary colours from which positive colour prints can be made, whereas colour reversal film gives colour transparencies for direct viewing and projection. Colour transparencies can be made from colour negatives by copying and colour prints can be made from colour transparencies using various processes including reversal colour printing. You can therefore choose the end product whichever one you start with, though it is obviously more straightforward and cheaper to decide at the beginning whether you want a print or a transparency.

As colour negative film is projected through an enlarger on to the tripack emulsion of a printing paper, it is easier to control the final image during the printing process itself, and there is some latitude for correcting under- and overexposure as well as the final colour balance. Volume printing is relatively cheap and some consider that negative film also gives the best prints. In a transparency, the subtractive dyes that affect the final image are produced during the development process itself, so there is no real scope for controlling the image. On the other hand, transparencies have versatile uses in copying and projection and are preferred by editors for photomechanical printing.

Emulsions of all films suffer with age, but more so in colour films because their different dye layers age at different rates. A badly stored or out of date colour film may have a pronounced colour cast on subsequent development. Colour films primarily for professional use should be refrigerated until required, and then allowed to reach room temperature. Film primarily for amateur use can be kept at room temperature, but should be refrigerated if not required for some time. Colour films shold be processed as soon as possible after exposure or regression of the latent image will take place at different rates within the different emulsion layers, again leading to a colour cast when the film is subsequently developed.

Colour films differ from black and white materials in that they are sensitized to produce "correct" colour only when exposed to light of a particular colour temperature. The eye has difficulty in detecting the colour of different types of "white" light, but colour reversal films, in particular, are sensitized for either daylight, electronic flash or blue flashbulbs, or for artificial light from either photofloods or studio lamps. Colour negative films are virtually universal, any moderate imbalance of colour being corrected by filters during the colour printing stage. Unless you are printing yourself, the results may be variable, so it is worthwhile finding a colour printer who understands your individual needs. Strict control of all stages of processing is important to avoid colour imbalances or casts, and considerable control over the final colour can be exercised in printing from negatives.

As with black and white, colour film is available in different speeds with the same basic choice between sensitivity and enlarging potential, though with colour film the actual colour rendition of the different emulsions also has to be considered (see right). In storing colour film, remember that there is a high risk of a fungus forming on colour slides, especially on those that are mounted between protective colour glasses or in acetate sleeves. To some degree this can be prevented by keeping the slide storage box well ventilated and having silica gel crystals in the box to absorb moisture. When they are saturated the crystals can be baked in an oven to dry them out.

Infrared colour
Infrared film, while used chiefly for scientific purposes (see p.182) can also be used creatively to alter our perception of the "real" colour of objects. Used here with a yellow filter, it has turned green leaves magenta, red flowers yellow.

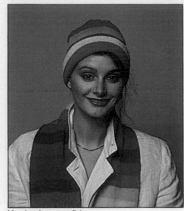
Kodachrome 64

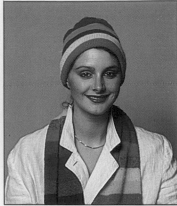
Fujichrome 100

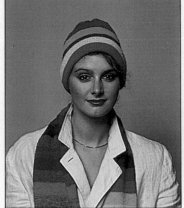
Ektachrome 64

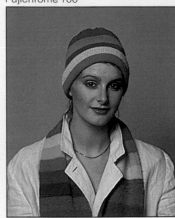
Agfachrome 50

Transparency colour
Reversal (slide) films reproduce colours objectively to the extent that they do not depend, as print films do, on filtration judgements. But the dyes used by different manufacturers give different results.

Infrared film

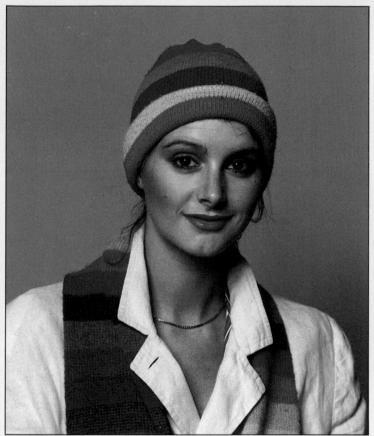

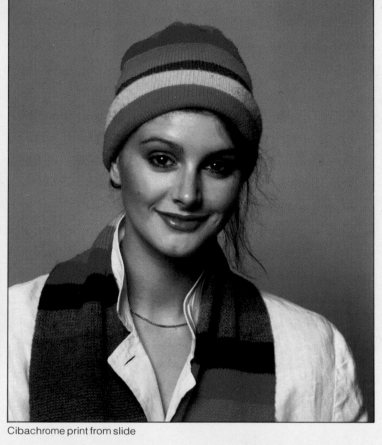

Kodak print from negative

Cibachrome print from slide

Print colour

Producing prints from slides, or vice-versa, inevitably changes the colour quality. The print above left was made conventionally from a negative, whereas the Cibachrome print above right was made from a transparency. A strong, punchy result has been achieved with the Cibachrome print, but with some loss of colour accuracy. The dark purple stripe in the girl's scarf, for example, has come out as almost pure black.

Instant colour

In instant-picture films, dyes are mingled on an image-receiving layer that is in direct contact with a negative layer. Each of the three sensitive emulsion layers of the negative has a layer of primary-absorbing dyes immediately below it and the molecules of these dyes are linked to molecules of developer compound. After exposure, the film Is pulled from the camera or driven by a motor through rollers and a liquid is released, which sets development in motion. According to exposure, the various dyes are either immobilized or work their way up to the image-receiving layer. When the negative is peeled away, the final image appears as a print within a minute or so. The relative expense and restrictions of the film type are offset by the appeal of instant results. Reasonably priced cameras are not very versatile, but instant picture backs, available for various advanced cameras (mainly medium- and large-format) are useful aids.

Black and white filters

The tones of grey in which black and white films record colours do not always agree with our perception of the brightness or darkness of those colours because the spectral response of modern panchromatic film does not match that of the human eye. Filters are used to correct this. They are also used to emphasize certain features of the subject, to increase contrast of similar colours (or of different ones that would be reproduced as a similar tone), to absorb ultraviolet radiation, to transmit only a narrow waveband (such as infrared), to reduce or cut out unwanted reflections, and even to reduce the amount of light reaching the emulsion.

In theory, filters transmit light of their own colour only, while absorbing other radiations. In practice, a green filter will transmit not only its own colour, but some blue and some yellow/orange, and an orange filter will transmit its own colour plus red, yellow and some green. Transmitted colours will register heavily on the film and thus appear pale on the print, while those that are totally absorbed will not register on the film and will be dark on the print. Filters, therefore, selectively modify the tonal rendition of the subject by lightening certain areas that are of about the same colour as themselves and darkening those colours that are complementary.

Filters are made in three grades: technical filters, the very highest quality both optically and as regards spectral transmission; camera filters, of good quality; and ordinary filters, for uses other than image recording – for example, in front of a light source. They are usually made of gelatin, glass or plastic. Gelatin filters are of the highest optical quality, but are flimsy and easily damaged. Normally supplied as squares cut to the required size, they need a special holder to attach them to a lens; or they may be mounted between a pair of optically flat cover glasses. They are susceptible to damage by damp and heat, and should be discarded when no longer perfect.

Glass filters are normally discs and are fitted into frames or mounts that usually screw into the rim of the lens. Plastic filters are usually square, made of carbon resin or acetate, and fit into a frame or holder that can simultaneously hold two or more filters and a lens hood. The holder fits to the front of the lens by means of an interchangeable screw-in adapter and different-sized adapters permit one set of filters to be used for several lenses.

Because filters transmit only a portion of the light, exposure has to be adjusted. Makers usually quote factors by which exposure must be increased, that is, ×1·5, ×2, ×5 and so on. Cameras having through-the-lens exposure control are often considered to need no adjustment for the exposure increase factor, the assumption being that the built-in meter will automatically take into account the density of the filter. This is usually so with many pale filters, but the spectral response of the meter's cell should also be considered, since these cells usually have a greater response to wavelengths at the red end of the spectrum than to those at

An ultraviolet filter cut heavy haze that lay over this country scene, producing a printable negative. Without it the middle distance would have lacked all detail. Haze is particularly troublesome at high altitudes or near the coast and an ultra-violet filter is sometimes essential in such situations.

Uses
1 Reduces haze
2 Protects lens
3 Can be used with both black and white film and colour film

A red filter added contrast to this landscape, bringing to it the sense of an impending summer storm. Because the filter had a factor of ×8, the aperture had to be opened by three stops. The filter also darkened both the shadows and the green foliage – but in compensation lightened the distant brickwork.

Uses
1 Turns blue sky and water very dark
2 Increases contrast and deepens shadows
3 Cuts haze
4 Lightens red objects

the blue end. Tests should be carried out to determine the extent to which the meter can be relied on, especially when using deeply coloured filters. You should also bear in mind that a filter's effectiveness will vary according to atmospheric conditions: a pale filter used in very clear conditions can produce an effect normally associated with a much deeper toned filter. Such variations are often noticeable when travelling in unfamiliar climates.

Most films are sensitive to ultraviolet radiation, which reproduces in black and white as atmospheric haze that obscures distant detail. It can be virtually eliminated by using a clear UV-absorbing filter, which requires no increase in exposure. Polarized light – light from a clear blue sky which is "scattered" by particles of dust or moisture in the atmosphere – produces unwanted reflections at 30° to 40° from non-metallic surfaces, such as the surface of the sea. It can be eliminated by using a polarizing screen or filter. This is held to the eye, or viewed through an SLR system, and rotated until the reflections disappear. Polarizing filters can block flare more effectively when working with flash if a screen is fitted over the flash unit as well as the camera.

When lighting conditions are too bright and beyond the scope of the camera's exposure controls, the intensity can be reduced by fitting a neutral density filter. Under normal conditions this also gives the photographer the opportunity to use either a larger aperture or a slower shutter speed for special effects.

Filter attachments may be as simple as a threaded mount that screws into the lens front (below right) or more complicated devices that hold two filters and permit them to be rotated. Right is the Cokin universal filter holder; below, the Kodak Porte-Filtre Professional No 2. Both, unlike the screw-in filter, will fit different-sized lenses.

A green filter provided greater contrast in the tones of the green foliage and the girl's green dress, which otherwise would have been rendered very similar and may even have merged. It also deepened the skin tones, contrasting them with the pale sky.

Uses
1 Lightens foliage
2 Slightly darkens sky
3 Darkens red objects
4 Deepens skin tones

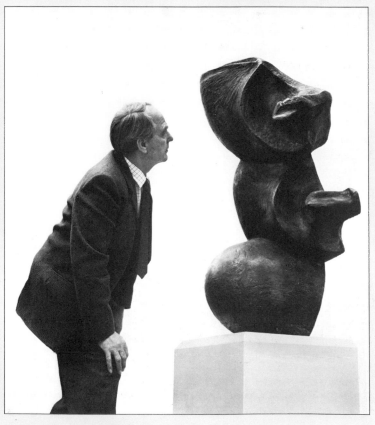

A yellow filter produced natural tones in this shot of sculptor Henry Moore examining his own work. The filter, which has a factor of ×2, is the best all-round filter, doing much to correct the imbalance of modern panchromatic emulsions by rendering blues darker and yellows lighter in tone.

Uses
1 Darkens blue sky to acceptably normal tone
2 Renders stone, wood, fabrics, sand, etc, naturally
3 Lightens foliage

Colour filters

The effects of coloured filters on the tonal values of black and white film are shown below. The light red filter darkens blue and green but makes red pale. The light green filter lightens green and darkens red, and the light blue filter slightly darkens yellow and red, but lightens blue.

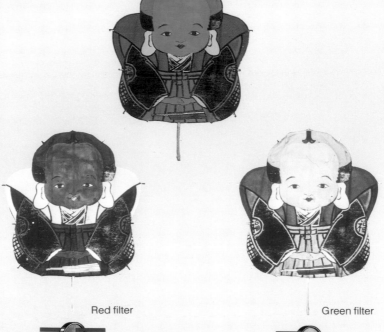

Original

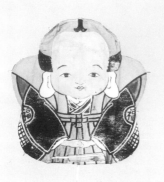

No filter

Red filter

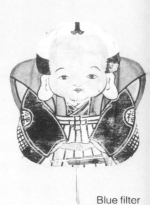

Green filter

Blue filter

The effect of coloured filters on black and white film, described on the previous two pages, is selectively to lighten or darken some of the tones in the final print. Used with colour film, however, coloured filters affect the whole image. Only those filters neutral in colour, such as polarizing screens and neutral density filters, can be used without greatly altering the hues of the picture. A polarizing screen can render blue sky a deeper blue, thereby increasing the contrast between sky and clouds. A neutral density filter merely decreases the total amount of light entering the camera; this effect is also encountered when coloured filters are used, but is usually compensated for with cameras that have through-the-lens light meters. For other types of cameras, filter factors, varying according to the absorption of the filter, must be applied, a factor of 4 representing a two-stop increase in exposure.

Coloured filters achieve their desired effect on both black and white and colour film because of the multi-coloured composition of white light. They act by the selective absorption and transmission of the different colours that together constitute white light. Except where special effects are sought (see pages 168–169), coloured filters are generally used with colour films to compensate for unwanted biases in the light source, whether it be natural or artificial. They are particularly useful with transparency film, which has little latitude for colour correction during processing.

While the human eye is adapted to recognizing and balancing colour differences whatever the light source and its intensity, colour films have no such flexibility. They are balanced to give their optimum response in specific lighting conditions and unless those lighting conditions prevail when the film is exposed, imperfect colour reproduction results. Coloured filters may be divided into three classes: light-balancing (colour-correcting) filters, colour-conversion filters, and colour-compensating filters, all varying in the degree to which they influence the balance of colours in light reacting the film.

The colour of light is defined by colour temperature and is measured in Kelvins (K). On the Kelvin scale, daylight-balanced colour films are balanced to 5500K and artificial light films to either 3400K (Type A) or

3200K (Type B). However, both natural and artificial light vary in colour balance or temperature. Sunlight is reddish (or warm) in the early morning and the late afternoon, and bluish (or cool) in the middle of the day. Light-balancing filters such as the Kodak 82 series, which are blue, have a cooling effect and filter out the reddish bias of early morning and late afternoon light; conversely, the yellow 81 series reduce the midday bluish bias. Artificial lights vary similarly in colour temperature, the reddish element of the radiation increasing as the intensity of the light decreases, as the tungsten element ages, or as the supply voltage drops. Whether you use a colour-compensating filter is entirely a matter of choice, because such colour balancing is a subtle affair, even if sometimes decisive in establishing the mood of the picture.

Colour-conversion filters are much darker than light-balancing filters and should be used to adjust the radiation of a light source that differs substantially from the light requirements of the film being used. Tungsten film is, compared to daylight film, relatively insensitive to red and yellow light and if exposed in daylight produces a deep blue cast. This can be avoided by fitting a yellow-orange filter to the lens. Daylight film, on the other hand, is over-sensitive to the yellow and red bias of tungsten light and, if exposed in those conditions, assumes a strong orange cast. The tungsten light can be filtered to meet the requirements of daylight film with a deep blue filter, provided that there remains adequate light for exposure. These two filters produce a major change in the colour quality of the light reflected from the subject before it reaches the film and effectively serve to convert tungsten film into daylight film and vice versa.

Colour-compensating filters permit the satisfactory use of tungsten and daylight films in other lighting conditions, such as fluorescent light. The Kodak FLT and FLD series filters can be precisely selected according to the colour temperature of the light source. Such colour-compensating filters come in graded densities of the three primary and three secondary colours and with care can also be used to correct minor inherent colour biases in film. A light blue compensating filter, for example, will reduce a slight green or red colour bias.

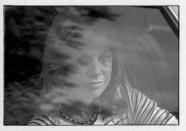

Unwanted reflections (left) can be cut with a polarizing screen to give an acceptable result (below).

Diffusion screens scatter light, so softening the edges of the final image.

Diffraction screens break up points of white light, producing streaks of colour.

Coloured filters transmit light selectively, altering tonal or colour balance.

Refraction screens can blend colours by producing multiple images as do prisms.

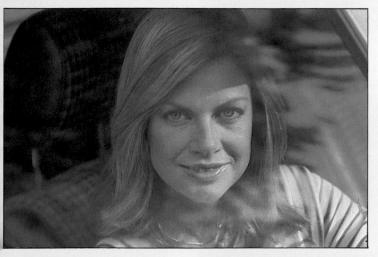

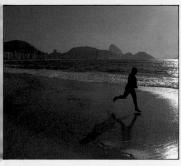

Late afternoon sun often produces an excessively yellow tinge on transparencies. Light-balancing filters are available in graded series and should be selected according to the degree of colour modification called for. The picture on the right was the result of choosing a blue 82B filter, which compensated for the yellow tinge in the sunlight and produced a more normal result.

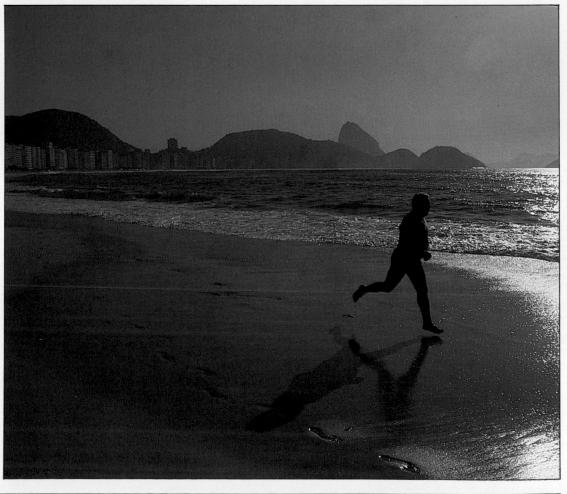

Studio flash and tungsten lights

The basic intention behind all artificial studio lighting is to make the subject appear as if it has been lit naturally – except, of course, on those occasions when a contrived lighting effect is deliberately sought. In the early days of studio photography, most photographers used premises with glass roofs and controlled the intensity of the light with blinds and reflectors. Electricity brought greater control over lighting set-ups and today all studio set-ups have a main light together with various fill-in lights and reflectors. The desired effect is obtained by varying the power of the lights, the types and shapes of their reflectors or diffusers, and their distance from the subject. There are two basic types of artificial lighting for photography: tungsten and flash. The former works by running an electric current through a filament of tungsten – a metallic element with a very high melting point; the latter provides a very brief burst of intense light by passing an electric discharge through a tube containing an inert gas. Tungsten light has a redder or "warmer" quality than flash or daylight, and if it is used with daylight colour film, correction filters must be used to match or "balance" the colour temperatures.

It is possible to take both black and white and colour photographs by the light of ordinary household bulbs, but as such bulbs burn at different colour temperatures, colour shots will show distinct colour casts. This problem is overcome by using special tungsten lamps designed to burn at a fairly constant colour temperature. Photoflood lamps, available in 275W and 500W ratings, give an intense light of about 3,400K, but last only two or ten hours, depending on type. Longer-lasting studio lamps, intended for use by professionals, are available in 500W and 1,000W ratings. They have larger glass envelopes and burn at a slightly lower colour temperature than photofloods, but usually last about 100 hours. A recent development, the tungsten halogen lamp, operates at an extremely high temperature, which helps to reduce loss of tungsten from the filament. During its life of about 50 hours, this lamp has a stable intensity and constant colour temperature (3,400K) and is thus ideal for colour photography.

The light from photofloods and studio lamps can be directed only by placing them in reflectors. The larger and more shallow the reflector is, the greater will be the area covered by the lamp and the more diffuse its light. A deeper reflector gives the light more direction and intensity. Intensity and the area covered are also affected by the lamp-to-subject distance. Floodlights give a general light over a large area; spotlights sharp, narrow and intense beams of light. Floodlights are often mounted in banks and, because of their heat, so connected that they can run at reduced voltage during setting-up. Reflectors can range from sheets of white card to silvered, umbrella-like diffusion reflectors.

Keylite

Rear of Keylite

Evenlite

Softlite

Snoot

Barn doors

Slats

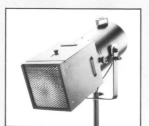
Honeycomb

Studio flash unit
A professional studio will almost invariably be arranged around a lighting set-up based on electronic flash. Window or bank lights such as those on the right give a broader coverage than single lights (left), but because they are diffused give a softer shadow; though diffusers, made of heat-resistant glass or plastic, can also be placed in front of single lights in order to soften them. The umbrella reflector (below right) also creates a soft light, but doesn't spread it as effectively and may create a central hot-spot. Flash lights (left) can be fitted with various devices, such as snoots and barn doors, to restrict, direct or diffuse the beam.

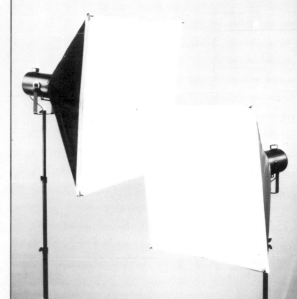
Diffusers

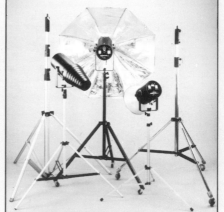
Lighting stands

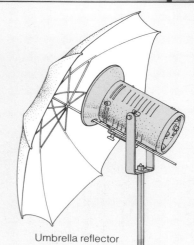
Umbrella reflector

Developments in electronic circuitry have led to the manufacture of high-power electronic flash units for professional studio use – indeed, these have more or less taken over from conventional tungsten filament lamps as main light sources. Called strobes in the USA (strictly, strobe or stroboscopic lighting is a regular and rapidly pulsed emission), studio electronic flash modules are similar to portable flash units except that they are bigger, emit considerably more light, and are usually run from the mains supply. They have a colour temperature of about 5,500K to 5,600K. They cannot be used for setting-up, so each unit must incorporate a modelling lamp. This is usually a small, low-wattage lamp sited close to the unit. Because these give only an approximate idea of the coverage of the flash unit, and no indication of its intensity, more recent units now incorporate a separate tungsten halogen modelling lamp in its own optical reflector. Each flash unit may have its own controls and be run directly from the mains; alternatively, a number of units may be connected to a central console. Only one unit, or head, needs to be connected to the camera's shutter: the others can be triggered by individual electronic sensors (known as slaves) that detect the flash from the main head and immediately fire the heads to which they are attached. Although costly to install, electronic studio flash is efficient, cheap to run, and enables daylight film to be used indoors.

Quad system

The power unit below is the heart of a typical professional lighting set-up. It can be linked with up to three other units to increase output. The unit offers less than two-second recycling. The strength of the modelling lamp varies with that of the flash. The photograph below shows some of the lamps and accessories available.

Head unit

Power unit

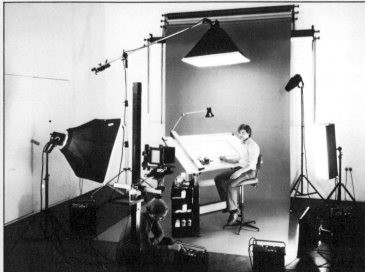

A professional studio flash system

Tungsten

Studio flash units are expensive and most amateurs, especially those who are undertaking studio work for the first time, will find it cheaper to use tungsten lamps. These can be as simple as a photo-flood bulb with its own built-in reflector or as complicated as a spotlight with a Fresnel lens to focus the beam and barn doors to concentrate it. Tungsten lighting has some disadvantages. It draws much more power than flash lighting and the amateur must thus check that his set-up is safe. It generates much more heat, sufficient to wilt flowers or cause a sitter discomfort. And the bulbs may diminish both in intensity and colour temperature with age. On the other hand, tungsten lighting permits rapid shooting, without the need to wait for a flash power unit to recycle.

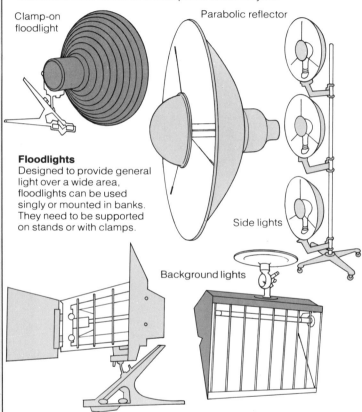

Clamp-on floodlight

Parabolic reflector

Side lights

Floodlights

Designed to provide general light over a wide area, floodlights can be used singly or mounted in banks. They need to be supported on stands or with clamps.

Background lights

Spotlights

The sharp, narrow and intense beam of light from a spotlight is ideal for lighting restricted areas of the subject. A snooted spotlight is frequently used in portraiture to lighten the background or to highlight a feature, such as the sitter's hair.

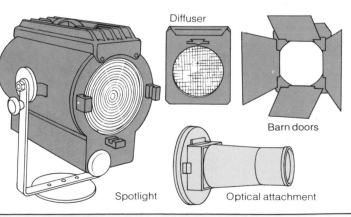

Diffuser

Barn doors

Spotlight

Optical attachment

Meters and portable flash

Modern 35mm single-lens reflex cameras, with built-in exposure meters which measure the light coming through the lens, have the advantage that a built-in meter automatically takes into account attachments which could reduce the light reaching the film. Hand-held exposure meters, however, used with older cameras and large-format cameras which have no built-in system, are also useful accessories in complicated lighting situations. They enable several readings to be taken to determine an average for exposure purposes, and they allow reading of incident light (from the source), as well as reflected light.

Of the varieties of hand-held light meter, the Weston Master, though recently discontinued, is still one of the most widely used. Its large photo-voltaic selenium cell achieves accurate readings at low levels; a light baffle is fitted which is removed for reading low levels, when a separate low scale also comes into use. A needle on the scales indicates a figure from which shutter speeds and apertures can be calculated, using a calculator dial on the meter's body. A translucent dome (the Invercone) is used for reading incident light; the Invercone can also be used

Types of light meters
The Weston Master (below, left) has been one of the most popular types of hand-held light meter. Its photo-voltaic cell does not require batteries, as it generates a current when exposed to light. The reading on the scale is used to calculate the shutter speed and aperture on the dial/calculator. The Lunasix 3 (second from left) is one of the CdS types, with a cadmium sulphide cell which requires batteries. Third from left is a spot meter, which measures a precise area of a subject; and last is the flash meter, for calculating amounts of flash required.

for reading incident light through a built-in metering system, by holding it in front of the camera's lens.

Another type of meter uses a CdS (cadmium sulphide) or SPD (silicon photo diode) cell in circuit with a small low-voltage battery. Again a needle indicates a figure which is transferred to a calculator, and again a small dome is slipped in front of the cell to read incident light.

Reflected light is usually measured from an area which is approximately equal to the angle of view of a standard lens, by aiming the meter at the subject from the position of the lens. This allows a number of readings to be taken, if necessary, of highlight and shadow areas, so that the photographer can average them, or calculate an exposure for a high- or a low-key effect. Incident readings, taken by aiming the meter at the source rather than at the subject, are useful in certain unusual lighting set-ups, such as when using a strong back light, or when shooting with the sun in the frame.

The third type of meter is the spot meter, which takes readings from a narrow, selected portion of a subject.

A spot meter covers only a very narrow angle, usually about one degree, thus permitting accuracy over a distance, such as when using long focal length lenses covering a reduced area of a subject. Spot metering is sometimes done with a normal CdS type of meter, by fitting an attachment in front of the cell to narrow its acceptance angle, but the true spot meter uses a silicon cell, and has a viewfinder for accurately aiming it at a particular part of a subject.

Portable electronic flashguns have become virtually indispensable

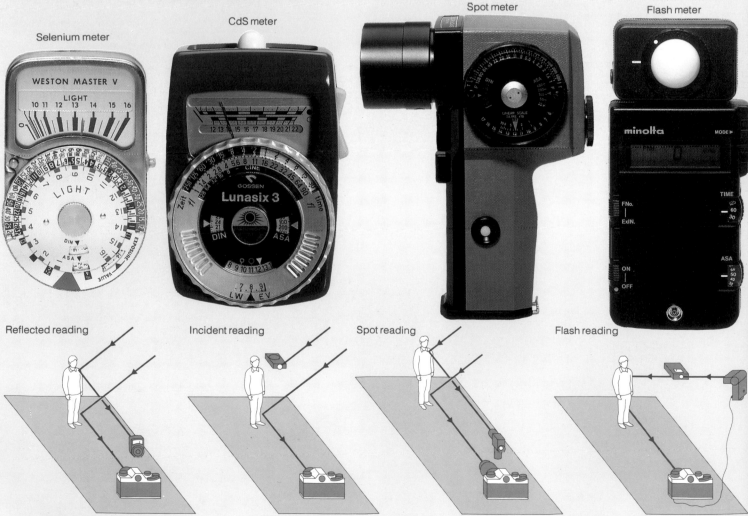

Selenium meter CdS meter Spot meter Flash meter

Reflected reading Incident reading Spot reading Flash reading

tools of photography, not only to supplement available light, but also to illuminate shadowed areas, or back-lit subjects. Off-the-camera flash-guns and those with tilt or swivel heads can be used to "bounce" the light, thereby softening it; some can "zoom", directing the light in a narrow angle of direction, or can diffuse it across a wider angle, which also has the effect of softening it.

The electronic discharge is provided by a gas-filled tube; the gases are carefully selected, and the tube given an amber or gold coating, so that the colour temperature of the flash is approximately equal to that of daylight. Because flash is very brief and it is essential to expose the whole frame simultaneously, focal plane shutters cannot be used with flash at settings faster than the speed at which the blinds are fully open (about 1/90 second, which is usually quite adequate). Those cameras fitted with bladed shutters can usually be synchronized for electronic flash up to their highest speeds.

With the simple flashguns, the exposure is calculated by means of the camera-to-subject distance, using the manufacturer's instructions. "Computer" units have a sensor which automatically quenches the flash when a predetermined level of flash reflected from the subject has been reached; this type can be programmed to operate at reduced power when working at short distances, to reduce the recovery time of the unit's charging device. In the most sophisticated of modern 35mm SLR cameras, the camera's own metering system controls the output of flash; in this case, where the electronic contacts and circuitry work together, the flash is said to be "dedicated" to that camera.

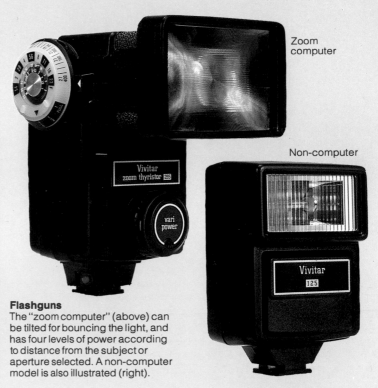

Flashguns
The "zoom computer" (above) can be tilted for bouncing the light, and has four levels of power according to distance from the subject or aperture selected. A non-computer model is also illustrated (right).

Non-computer "Dedicated" system Computer

Types of flashgun
The simplest type of flash system (above left) provides a standard burst of light for which the aperture must be calculated according to film speed and camera-to-subject distance. The latest development is the "dedicated" flash (above centre), which uses the camera's built-in meter to regulate flash duration. In the more common "computer" system (above right), the flashgun is adjusted according to film speed and aperture, reads the reflected flash by means of its own sensor, and "quenches" itself as necessary.

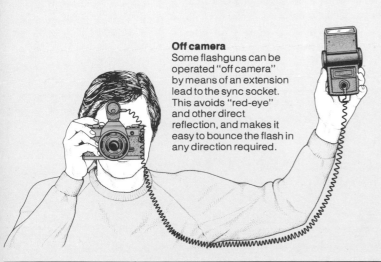

Off camera
Some flashguns can be operated "off camera" by means of an extension lead to the sync socket. This avoids "red-eye" and other direct reflection, and makes it easy to bounce the flash in any direction required.

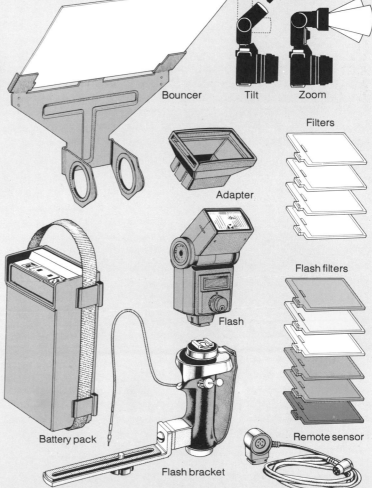

Bouncer Tilt Zoom

Filters

Adapter

Flash filters

Flash

Battery pack

Flash bracket

Remote sensor

Studio layout

Unlike a darkroom, which can be fitted into a room 3 metres by 2 metres, a studio needs space. Ideally, a photographer using a 35 mm camera should have enough room to shoot a full-length figure with a 135 mm lens – that is, at a distance of 6½ metres from the subject – and the studio overall should be half as long again to allow sufficient space behind both the camera and the subject. The floor needs to be hard, level and smooth, to provide a firm working surface that eliminates camera shake in tripod shots, and the ceiling should be as high as possible so that overhead lamps and the tops of backdrops are placed well out of sight of the camera lens and the photographer can adopt a high viewpoint if the subject demands it.

Two walls and the ceiling can be painted matt white, one wall matt dark grey, and the fourth matt black – these neutral colours provide readymade backgrounds without introducing colour casts. The studio needs plenty of power points, laid out to give the greatest flexibility with lighting, and good heating and ventilation. A red lamp mounted outside the studio will warn when it is in use. Ideally, no door from the studio should open directly on to the outside of the building, since a gust of wind or a shaft of daylight can upset or ruin work in progress.

All studios need a preparation area with a large working surface so that all the equipment needed for a particular session can be laid out to hand. The refrigerator used to store unexposed film can be located in this area.

A basic requirement in any studio is to keep as much of the floor as uncluttered as possible, so that there is ample freedom of movement. At the same time it can be inconvenient to have lamps, reflectors, props and so on located in separate areas outside the studio. The professional with space to spare will usually opt for a compromise, keeping reception and entertainment areas, workshops and dressing rooms outside the studio and equipment storage areas, permanent working props (such as kitchen units) and makeup tables inside. The aim is to differentiate between the "sharp end" of the business where the actual work takes place, and other areas that (like a model's dressing room) call for privacy, or (like the workshop) may create unwanted noise and dust.

Such a set-up implies, of course, an income sufficient to cover costs and return a profit. It does not, however, follow that the amateur must abandon all thought of achieving professional-like results from a more limited set-up. The principles of studio work – planned photography with maximum control over the final image – apply equally to amateur and professional. The amateur may have to work in a spare bedroom, but within the limits of the space at his disposal there is no reason why his results should not be of professional standard. A stool, lamps, and a roll of background paper are sufficient for portraiture; indeed, there is a case for keeping lighting equipment to a minimum when first setting out to undertake studio work. More lights mean a longer setting-up time and a greater likelihood of exposure error. There is also more risk of overloading a domestic electricity circuit.

A permanent studio can be equipped to handle everything from small still lifes up to room sets. Among the equipment basic to all studios are rolls of background paper (which can be mounted permanently on a rack if space permits), a step ladder to give additional height, reflectors and mirrors, a camera mount (which may vary from a simple tripod to a heavy wheelbase stand for a view camera), various lamps (window lights, spots, photofloods or flash units) and some form of power supply. To these a professional may add studio "flats" – painted scenic backgrounds which can vary from the wall of a house to an interior detail – overhead rails to carry permanent lights, a props cupboard, and a lightbox for viewing transparencies.

The images on these two pages show the professional studio at its most extended, at a size and with equipment that few amateurs can hope to match. The important thing to realize is that the studio, whether it be a temporary conversion of a garage or a purpose-built professional tool, exists only to give the photographer total control over the final image.

Room sets
Given a sufficiently large studio, a photographer can build a semi-permanent set – like the sets used to make movies – in order to get a particular shot. The set above right was used for an advertising feature on soft furnishings.

Car scoop
Photographing something like a car in a confined space may call for a continuous background made of plaster on a timber frame. It can be lit to give a seamless, shadow-less background.

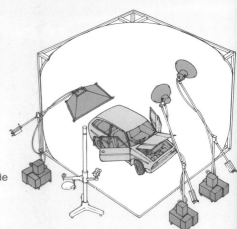

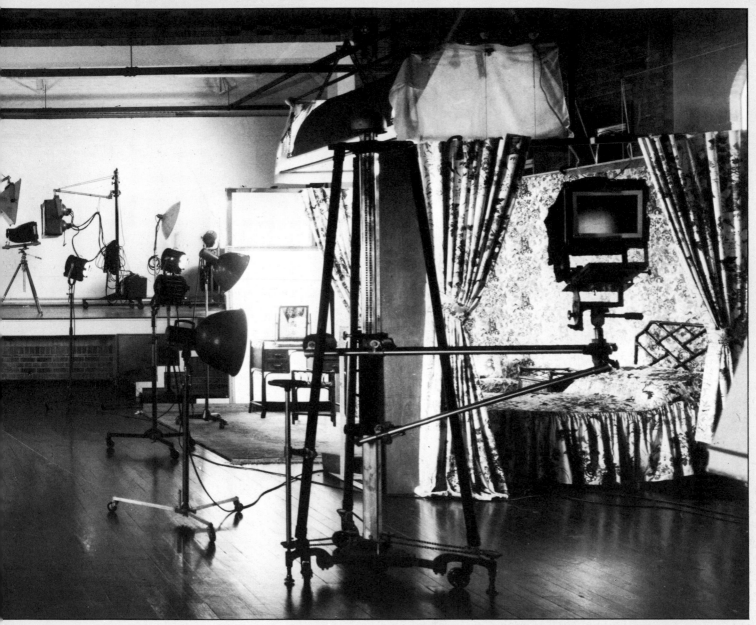

Preparation areas
Professional studios have specific areas set aside for equipment layout, preparing food, and makeup.

Food area
Specialists in food photography need an efficient kitchen. Food must be kept hot if it is to be reproduced faithfully.

Fashion area
Models need privacy to change and a well-lit table at which to make up. If there is no space for a dressing room, an area can be blocked off with movable screens. A mirror edged with naked light bulbs is standard for makeup.

Studio accessories

The studio is the photographer's workshop. Within it, images are recorded, ideas interpreted, and creative thoughts expressed in terms of light and shade, tone and colour. In addition to his basic tools – cameras, lenses and films – the photographer has available to him various devices that enable him to place a light, a reflection, a shadow or even part of the subject in just the right position to create the perfect effect. Such accessories vary with the needs of the photographer and the type of work that is undertaken. While it is best to have the largest studio you can afford, a lot of good work can be done in a limited area. Fashion and portrait photography, for example, may require little extra than a suitable space for lights, background, and a small combined storeroom, makeup room and loading room. The makeup area will need adequate privacy, good light, a full-length mirror and washing facilities.

Many studios use wide rolls of coloured paper supported on metal frames as backgrounds for photography. Usually supplied in widths of six, nine or 12 feet, these can also provide the floor for the subject and avoid the inevitable join between studio wall and studio floor, which otherwise would visually divide the picture. Even greater variety can be obtained by having a front-projection unit. By selecting suitable transparencies and projecting these in front of the camera, the subject can be made to appear in virtually any situation or environment. For example, a model wearing ski clothes may be superimposed on a skiing scene and appear part of it. Another could be shown lying on a tropical beach, yet not have moved outside the studio.

The best support for small objects is a table or desk-like frame with interchangeable surfaces so that glass, card or paper backgrounds can be used. With a glass table, objects can be lit in the normal way, but the background can be several feet away, giving a shadow-free image. Ideally the frame should have a back that can be raised or built up to support a background and the entire unit should be rigid enough to support weighty objects and be free from vibration.

Some studio lighting set-ups, especially when a number of different units are employed at varying distances, can make the calculation of exposure a problem. Usually several meter readings on the various areas are necessary. For electronic flash, a special flash meter is required. This is able to record the flash and to give an exposure reading by means of a deflected needle, light-emitting diodes, or a liquid crystal display. Another type of meter of particular value in the studio is the kind that measures the colour temperature of the light source. Such meters enable the photographer to maintain correct colour balance for the film being used and to avoid casts from mixed or ageing lights by putting a filter in front of the camera lens or light source. You can thus be sure of obtaining the most accurate possible reproduction of subject colours.

Rolls of Cellophane, coloured plastics and gels, which can be placed in front of lights, are invaluable for creating coloured lighting effects. Reflectors, consisting of white card, sheets of matt Perspex, polished aluminium and so on, can help to throw light on shadow areas. Even a small hand mirror can be used to alter the direction of light and reflect it towards a particular part of the subject. Muslin and other materials make useful diffusers in front of lamps – but leave an air space because of the risk of fire. And wire mesh can also be employed for creating patterns – its effect will vary according to its proximity to the light source.

Electronic flash can be bounced from white, silver or gold umbrellas to provide soft, diffused light free from harsh shadows – small clamps are used to hold these umbrellas to the flash head or to its stand. These clamps are among dozens of minor items of equipment to be found in the average studio – Bulldog clips, electric fans, trays for dry ice (which is used to create fog or mist effects), staple guns, junction boxes and a range of woodworking tools. An illuminated desk top or light table is useful for examining transparencies; the illumination should be provided by strip lighting or fluorescent lamps with a colour balance about equal to that of daylight. Finally, because studios involve people, it is essential that they have adequate heating (and adequate ventilation) and useful if there is a supply of hot or cold drinks and something – music, or perhaps magazines – to put the sitter or model at ease and to create a warm, friendly working atmosphere.

Large accessories
Some of the most useful studio accessories are the simplest. A stepladder, for example, enables you to choose a wide range of medium to high camera viewpoints. Several rolls of background paper mounted on a frame provide quick changes of colour; adjustable tables, especially those like the "Workmate", which can serve as a vice, provide security and stability wherever they are needed. The refrigerator keeps film fresh, and the folding screen can be used as a backdrop or to permit a quick change of costume.

Folding screen

Background paper roll

Studio stand

Adjustable table

Fridge

Flats

Stepladder

Hanging pole

Cobweb fan
Fitted into the chuck of an electric drill, a cobweb fan will spray a realistic net of cobwebs (made of rubber solution) across a set. In the shot above, the cobwebs and the tape-tied document speak vividly of the law's delay, of misdirected legacies, of muddied waters. . . .

Cobweb fan

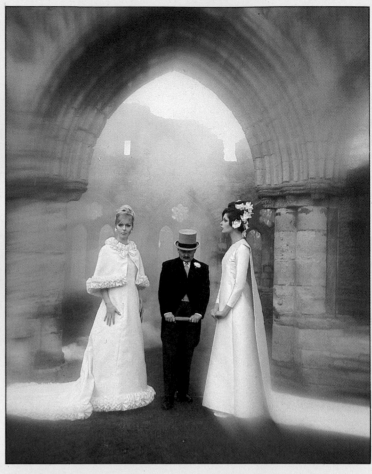

Wind machine

Small accessories
Almost anything can come in handy in a studio – modelling clay, cooking foil, a fishing line. A sense of order is needed if the right piece of equipment or the right tool is to be found when it's wanted – a peg-board, on which the outline of tools can be drawn, keeps big pieces in order and sets of drawers take care of things like drawing pins, rubber bands and tape measures. A hanging file cabinet, organized alphabetically, will help you to keep track of assignments, brochures and pamphlets on films, cameras and equipment, and general notes and correspondence.

Fog machine
Dry ice (solid carbon dioxide), packed in a box and stirred by a fan, produces realistic fog.

Fog machine

Front projector
With a front projector, any background desired can be added to the main subject. For more details, see pages 186 – 187.

Slide projector

Front projector

Camera supports and accessories

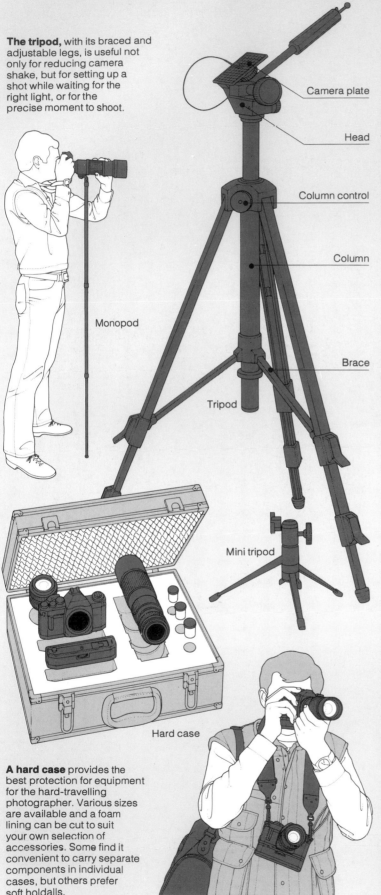

The tripod, with its braced and adjustable legs, is useful not only for reducing camera shake, but for setting up a shot while waiting for the right light, or for the precise moment to shoot.

Monopod

Camera plate

Head

Column control

Column

Brace

Tripod

Mini tripod

Hard case

A hard case provides the best protection for equipment for the hard-travelling photographer. Various sizes are available and a foam lining can be cut to suit your own selection of accessories. Some find it convenient to carry separate components in individual cases, but others prefer soft holdalls.

Accessories can be fitted to every camera, however specialized, but by far the greatest number of accessories is available for the already versatile single-lens reflex.

A hood for the lens helps to retain maximum image contrast. It should be deep enough to prevent extraneous light from outside the subject area reaching the lens. The depth required depends on the focal length of the lens. Wide-angle lenses need relatively shallow but wide hoods; telephoto lenses need deep and narrow ones. Square hoods tend to be better than round ones.

To enable a lens to be focused closer than its minimum focusing distance, extension tubes or a bellows unit must be fitted. Tubes, which can be used singly or in combination, extend by a fixed amount, whereas the bellows unit is variable within the limits of its minimum and maximum extension. Each enables the subject to be recorded life size or larger. Most bellows units can be fitted with an attachment for holding a slide or a negative for copying.

Close-up work of another kind, photomicrography, can be done by mounting a camera on a microscope by means of a special tube that fits into the camera's lens mount (see page 184).

In some work, delay in winding the film to the next frame can result in the loss of a valuable picture. Most 35 mm SLR cameras can be fitted with an autowinder or motor-drive, battery-driven devices that attach to the camera's base. The more sophisticated models can achieve five frames per second at high shutter speeds, and can be combined with a bulk film pack for up to 250 exposures. This may also be able to imprint a sequence of figures on to the film frame.

An autowinder is also useful in photographing wildlife, where the camera can be operated from a distance, sometimes in conjunction with an infrared or radio signal to fire the shutter. For slow subjects such as the opening of a flower, an intervalometer is fitted to fire the shutter at predetermined intervals. The same device can be used for data recording and progress work.

A matte box fitted in front of a lens enables various cut-outs and devices to be used to "frame" the subject. It also enables double and multiple exposures to be made, by providing selective masking of the picture area.

To overcome the problem of camera shake as the focal length (and weight) of a lens or the exposure time is increased, a tripod is an essential accessory. If it is fitted with telescopic legs and movable platform head, the camera can be adjusted for aim as necessary. Lightweight "pocketable" tripods are of use only with lightweight cameras, and then only in an emergency. Sturdy alternatives to the tripod are the monopod, the camera clamp or special hand grips. To further reduce vibration of the camera when firing by hand, a flexible cable, pneumatic or remote release can be used.

The case offered for most cameras provides no means of carrying even a spare roll of film, let alone a selection of accessories. Separate cases are available for lenses, flashguns, filters and so forth, but a holdall or "gadget bag" is more convenient.

Stiff leather or even metal cases with foam plastic compartments are heavy and expensive, but they provide the best protection for camera equipment, and they are much used by professionals. The modern vogue is for soft carry-alls, such as those used by climbers, hikers and travellers as hand luggage. These are lightweight and also are less recognizable as containing expensive camera equipment, and are thus less tempting to a would-be thief.

The selection of accessories for the 35 mm single-lens reflex camera system is immensely varied. Combinations of lenses and other equipment enable exposures to be made under almost any circumstances. The available equipment ranges from bulk film magazines to pneumatically operated, long-range cable releases.

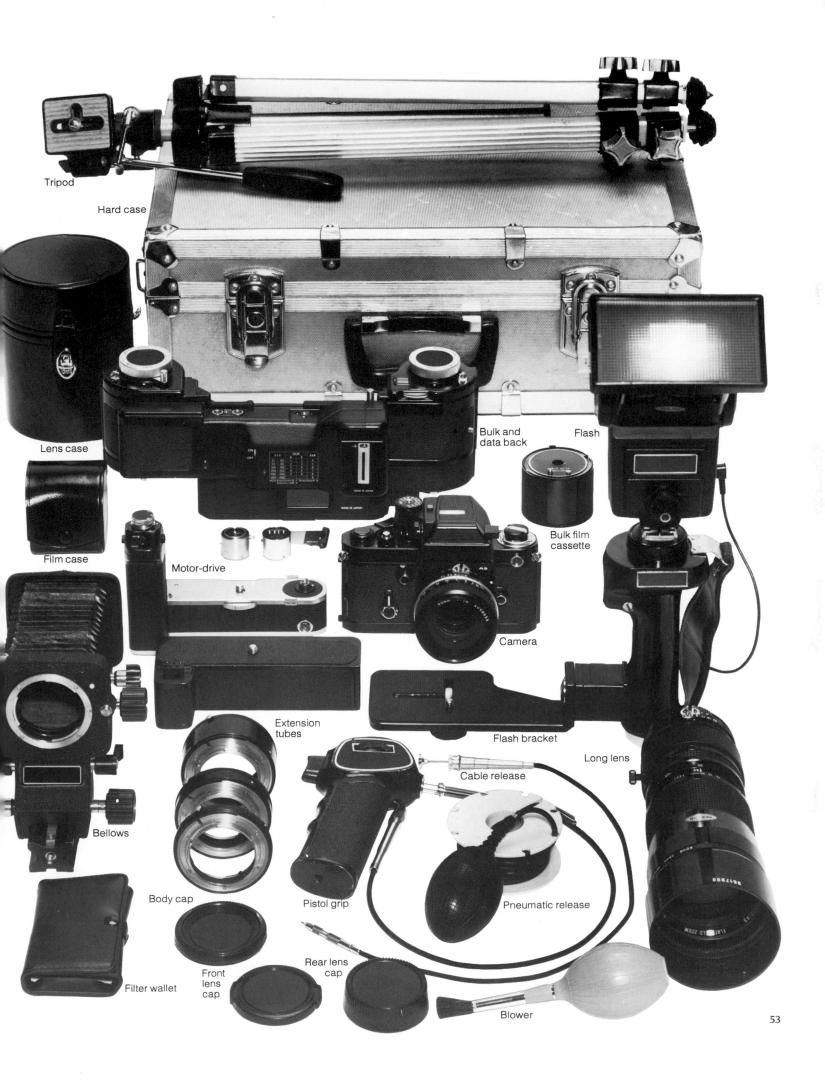

Tripod

Hard case

Lens case

Film case

Motor-drive

Bulk and data back

Flash

Bulk film cassette

Camera

Bellows

Extension tubes

Flash bracket

Long lens

Cable release

Body cap

Pistol grip

Pneumatic release

Filter wallet

Front lens cap

Rear lens cap

Blower

53

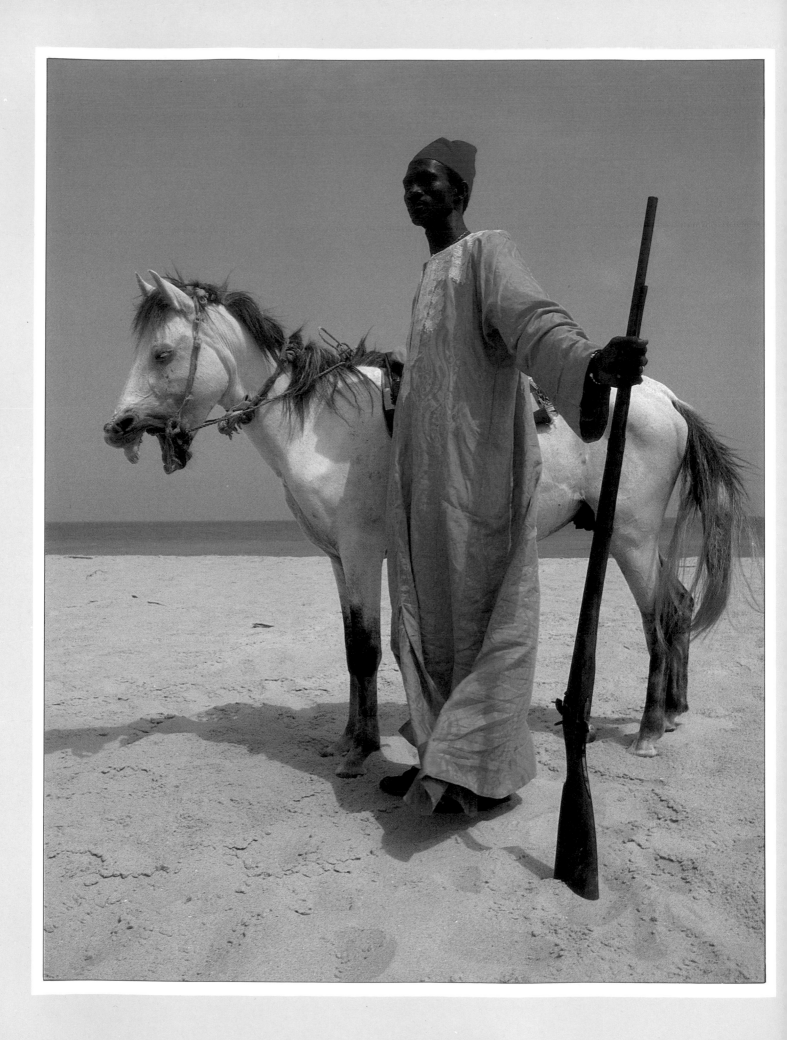

SELECTING IMAGE AND TECHNIQUE

In the following three sections of the book, photographic assignments are divided into three broad areas – Selecting Image and Technique, Controlling the Image, Changing the Image. Most of the pictures in the first section were not taken in unusually difficult circumstances and did not involve the use of specialized equipment or techniques. They are, on the whole, straightforward images – as most photographs are. It is a mistake to assume that "advanced" photography is concerned only with bizarre or technically complex shots. The test of a good photographer is often whether he can find fresh or effective pictures in everyday situations or where the subject has been photographed by many others.

The emphasis in this section is therefore upon selection – the photographer's choice of subject matter, viewpoint and treatment, from which will stem choice of technique. Whether you are an experienced photographer or a complete beginner, perception is what counts most. A convincing picture invariably reveals a sense of understanding between the photographer and the subject, and often a desire to render its basic essentials, which may, in turn, require a simple technique. The "portrait" of Henry Moore's hands on the next page shows that it is not so much the subject but what you do with it that is important.

Volte-face

Most people sense a close connection between a photographic portrait and reality. The photograph is, after all, as Elizabeth Barrett exclaimed in 1847: "the very shadow of the person lying there fixed forever!" It is hardly surprising, therefore, that people should be sensitive about being photographed, all the more so if they are aware of how much influence the photographer has over the "reality" produced by the camera. For the images we make vary enormously according to the angle of light, the viewpoint of the camera, the strength of the lens to search out detail and the capacity of a high-speed shutter to freeze the quiver of a mouth or the blink of an eye. Completely candid photographs – grab-shots – of people often appear to reveal hidden truths, but they are as prone to bias as the flattery of the studio photographer. It can be a demanding assignment to take a portrait which satisfies both the sitter and the photographer.

The frontal close-up offers, of course, the most searching disclosure of a person's physical appearance – and sometimes of personality as well. But we begin with a contrary image – a back view of Henry Moore with his hands clasped across his head. Moore himself makes a point that is sometimes forgotten in portrait photography: "How people sit and walk, the way they hold themselves, the pose of head on body, all reveal part of their character. The hands, after the face, are the most obvious part of the human body for expressing emotion." The importance of the face – particularly the eyes – in portraiture is undeniable, but it is remarkable how telling other details can be, and how much can be conveyed about a person by a portrait in which facial features are hidden altogether.

Relating people to their work, or to their environment, as in the shot (below) of Henry Moore inspecting one of his *Reclining Figures*, is often one of the most effective ways of identifying them and also of adding more information than could be provided by a straight portrait. At the other end of the scale is the concentration of interest upon a single revealing feature, as in the picture of Moore's hands. Recorded with the extreme fidelity of a Hasselblad 150 mm lens, the interlocked fingers themselves have an almost sculptural quality. They speak eloquently of the life and work of a highly tactile artist whose sculpture is based on an intense feeling for the forms of the human body.

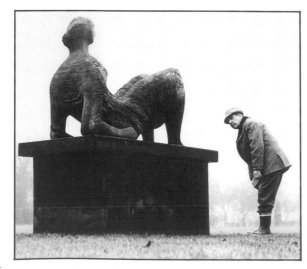

Portraits: the extra element

An "edible" hat with gaudy cakes gives the portrait of Lady Diana Cooper (left) a bizarre, witty quality. If a selection of shots is called for when photographing a personality, it is best to get a variety of them, from close ups to full-lengths showing the environment, so that an editor can choose.

Artist Richard Hamilton (below) ignores the camera, conveying the relaxed atmosphere of the session with his informal pose. A portrait does not have to concentrate on the head to get a "likeness", but may instead capture the body positions, the characteristic and revealing gestures.

The French designer Erté, a polite and elegant man (right), was rather jewel-like in the austere surroundings of a Paris apartment block. As he talked, light caught his monocle, and seemed to sum up his fastidious but sparkling personality. I exposed for the highlight, deepening the skin tones.

Creating a successful portrait is a great challenge for the photographer, for he has to try to remain true to the personality of the sitter while at the same time seeing him or her more abstractly as part of a visual image. The first qualities that any portrait photographer must have are an interest in people and an ability to get on with them, for the more relaxed the sitter the more easily a photographic session will flow. Nervousness on either side of the camera will show in the images produced, and the portrait photographer must be so confident of his technique that he can perform the mechanical operations almost without thinking.

When photographing well-known personalities, the photographer's problems are in some ways made easier, but in others more difficult. People who have gained a measure of fame will almost certainly be used to having their photographs taken and therefore be confident in front of the camera. The very fact that someone has been much photographed, however, means that you will have to strive harder than usual to come up with a fresh approach to win the attention of art and picture editors.

Often the unusual or unconventional angle or approach will succeed best when it is arrived at spontaneously, and often it is towards the end of a session that subjects become most responsive – as when Lady Diana Cooper (above) suggested photographing her remarkable hat, and Richard Hamilton (above right) surveyed the ceiling while expressing a point of view. You should not be content, however, simply to wait for things to happen. The photographer must be in charge of the proceedings (although he may have to express this very subtly or tactfully) and must be prepared to tell the sitter what he is trying to achieve and what he would like him or her to do. The picture of Mary Quant (right) is a good illustration of the kind of shot that can develop spontaneously from a session with a cooperative subject. She is caught moving away from the wall she had been leaning on, her hair echoing the folds of the table cloth in the painting; together with the almost hypnotic pattern of the floor and the enigmatic arrangement of clock and music stand, this sets up a near Surrealistic tension.

Unconventional portraits

The concept of a portrait should not be confined to pictures that produce a representational "likeness". Photographs far removed from conventional ideas of portraiture can express a mood or atmosphere and an impression of personality although the features may not be clearly visible, or may even be distorted. No orthodox portrait, however good, can capture all the mystery of human feelings, expressions, moods and thoughts. Perhaps it is because they, more than anyone, are aware of the limitations of supposedly factual representation that photographers have always experimented with unconventional compositions, poses, angles, and lighting or printing techniques. We will look later at a range of surreal portraits created by montaging techniques. But as the pictures here show, unusual images of people can also be created by fairly straightforward means without post-camera manipulations.

The large picture illustrates the power of an unconventional composition to achieve a sense of immediacy. The girl walking out of the frame gives the scene movement and depth, and the atmospheric quality is enhanced by the slight distortion caused by her nearness to the camera, which has elongated her eyes. Distortion is used more deliberately in the shot immediately below.

This puzzling image was made by setting a large mirror face down on two benches. The girl lay on top of supporting boards on the mirror and hung her head over the edge so that her hair fell downwards. The picture was then shot from underneath the mirror using a wide-angle lens to include both the girl's head and her reflection.

The face of aggression (above) was used on the cover of a university course book on psychiatry. Such exaggerated effects are useful for getting the message across quickly and with immediate impact. Use of a wide-angle lens at very close range has distorted the attractive model's face. In the shot on the right, the blindfolded girl was being prepared for a magazine illustration when another model walked past the tripod-mounted camera, making a dynamic composition which owes much to the abrupt change of scale. Pictures like this require an alert visual sense – a readiness to be on the lookout for unusual opportunities.

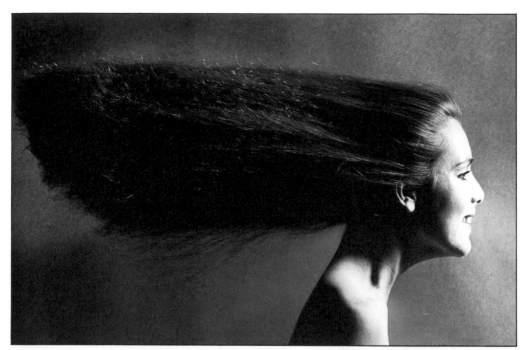

The luxurious mane of hair was shot for a magazine feature. Even at full power a wind machine failed to make much impression on these tresses, so the model lay on her back on a bench as in the diagram. Her face was lit by photoflood bounced off the ceiling and a white background paper was hung opposite the camera.

Faces masked, concealed or isolated are intriguing and sometimes startling, as in this shot of a man peering through a hessian screen, taken with electronic flash. His hands, framing his face as he strains to widen the hole, give the picture tension. Face and cloth are almost in one plane so the relationship between the rough texture of the hessian and the man's skin is well brought out. The fact that the subject's mouth is hidden lends an air of mystery to the portrait – is he serious, smiling, crying for help, or simply looking out, expressionless, at what lies beyond a world made of sacking?

Glimpses

Clarity, contrast and image sharpness are not necessarily the prime factors in portraiture, or in photographing people. In life, we seldom subject people to unblinking scrutiny, and our impressions of them are formed in all kinds of situations in which they are partly concealed or glimpsed through screens or windows in unguarded moments. You can cheat the camera's relentless eye for detail while at the same time creating a picture full of spontaneity by deliberately using an extra dimension such as glass to add subtle reflections or introduce an element of mystery. If the glass is misted, smeared or partially opaque the feeling of intimacy and privacy may be increased not lessened, since the camera has penetrated the screen and stolen a glimpse of the scene beyond. There are many applications in editorial photography for magazines and for calendars, book covers

and record sleeves, where an obscured, fuzzy image may help to tell a story and establish an atmosphere.

The girl in the car below is a basic visual idea that could inspire a whole series of similar pictures. You should try various combinations of selective focusing – bringing the glass into sharp focus while leaving the main subject out of focus, or having both glass and subject sharp, as below. Depending on the angle of light striking glass and

on your own camera position, reflections can be used to introduce shapes, accents and distortions, particularly if the glass is imperfect, that move the picture away from a straight image and into the world of illusion. Bear in mind that semi-opaque glass scatters lightwaves, producing a picture of muted colours, often with a predominantly blue cast, which may help to create or emphasize the particular mood you want.

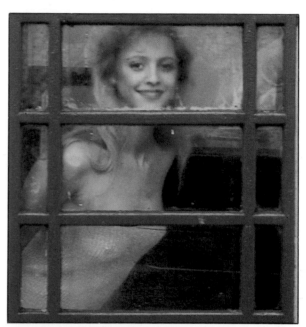

The haunting softness of the image (left) is created by traffic film smeared across a car windscreen by the wiper blades, acting almost like a diffusing filter.
In the shot of the same girl framed within the strong red rectangles of a telephone kiosk, her body slips into ambiguity as the panes of glass change from clear to opaque.

The candid shot of the old woman in the chair stresses her isolation because the photographer and camera are on the outside and she is alone in the room. The mood of isolation would be less evident without the reflections which suggest that she has been observed through a window sealing her off from the camera.

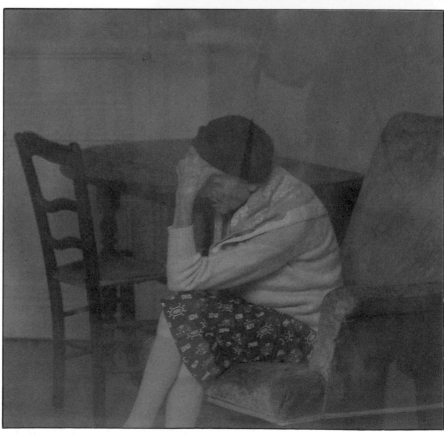

People in context

If one of the principal aims of portraiture is to convey something of the attitudes, life-style and characteristic flavour of a personality, then photographing people in their environments – whether at home or at work – will add a fund of telling information. Such pictures usually work best as candid or informal shots, giving the viewer the impression of an extra layer of truth – even when the scene is partially contrived.

The unassuming, even casual appearance of a person who believes that he or she is unobserved is often more convincing if the composition is off-balance and has certain irregularities. A shot that is carefully posed may well be pictorially successful, but an apparent collusion between photographer and subject can destroy any feeling of spontaneity. The photographs of Robert Graves (below) and Marina Warner (opposite) are obviously posed, but the striking relationship between figure and surroundings give both images a freshness that might have been lacking in more conventional formal shots.

It helps to know something about the domestic or working environment of the people you are going to photograph, because only by knowing and understanding what their lives entail can you decide what is the most appropriate time or place to photograph them. The district nurse (right) might have been photographed on her bicycle, or stepping from her car, but a more meaningful picture resulted from catching her at her work.

The difference between the artist observed and knowing it, and the artist observed and ignoring it, is exemplified by the shot of poet Robert Graves (above) among corn he planted near his home on the island of Majorca, and that of the painter Sir Stanley Spencer (right), working on his last painting, *Christ at Cookham Regatta*. Sir Stanley's *ad hoc* method of working, and simple life-style, are conveyed by intimate and endearing details – the dressing gown on the door, the tea cup, and the books supporting the canvas.

The SLR is ideal for informal portraits that have to be shot by existing light and in varied locations. In the shot of the district nurse (opposite) I used fast film, exposing for the shadow areas to minimize flare from the windows. The effectiveness of the photograph owes much to its air of spontaneity, exemplified by the way the nurse has turned her head towards the door.

Historian and critic Marina Warner was photographed in a dress that matched the furnishing fabrics of her room. The lighting was flash bounced off the ceiling. When faced with taking photographs similar to this one, a 28mm lens is often a good choice. It enables you to capture as much as possible of the props that surround the subject, and without too much distortion.

Light and the human figure (glamour)

In glamour photography, it is all too easy to follow concepts hardened by years of repetition in magazines and calendars. Glamour does not necessarily mean flawless makeup and leggy models in couture clothes – or unclothed, in provocative poses. Certainly an essential element in glamour is sexual attractiveness; both men and women enjoy looking at good pictures of pretty models. But even if the intention of a shot is erotic, the approach need not be sexually explicit; and there are more subtle and natural ways of expressing sensuality than by straining to appeal to specialist tastes.

Again, in glamour photography (as opposed to fashion) the model's body is the most important thing; yet paradoxically some of the best pictures treat the body as only one of the elements in a composition. Lighting and printing techniques can allow you to focus attention on the model's skin, highlighting its texture, or alternatively contrasting its smoothness with rougher natural textures – a sandy beach, or the grained wood of a chair or a window frame. A wide-angle lens can provide a fresh view of the human figure, by altering relationships of

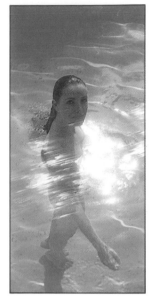

shape or line. But be careful about distortion: it needs to be handled with discretion or the result may be interesting without being glamorous.

It is almost a cliché to say that a partly clothed body can be more attractive than a naked one. Similarly, backlighting or sidelighting can lend an element of suggestive mystery by revealing only a portion of a figure, while harsh frontal lighting leaves nothing to the imagination. Look out for the subtle aspects of form and texture.

Give some thought to props, furniture or setting before you begin and visit the location in advance if you are shooting outdoors. Knowing what you want to try to do will help you get the model's confidence and cooperation, without which good glamour shots are quite impossible. You must create an atmosphere of relaxation, and this means seeing to the comfort of the model: if you are shooting indoors, make sure she is warm, and provide a private area for her to change and make up. If you intend to hire a model from an agency, take along your ideas and your portfolio; they will help you to choose an appropriate model.

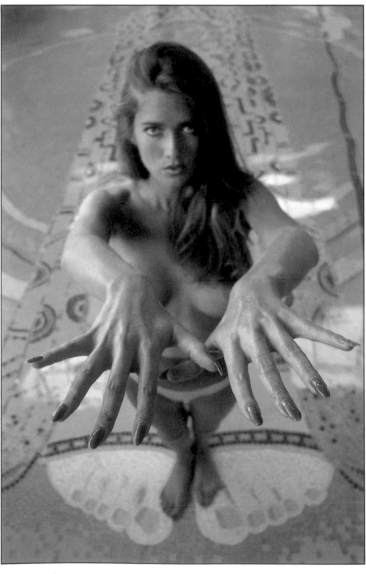

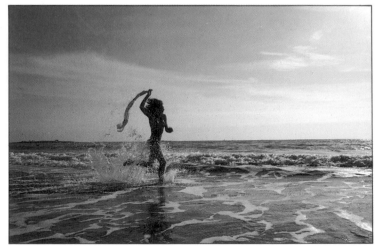

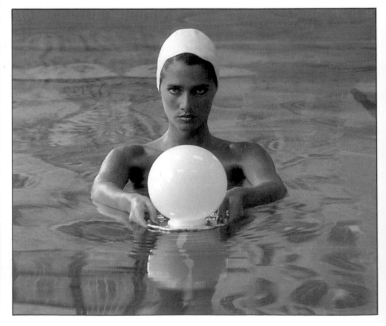

Glamour is to cheesecake what wit is to slapstick. It demands subtlety on the part of the photographer and intelligent participation by the model. Both must work together to create an image that evokes delight in the viewer instead of indifference.

Two of the photographs on the opposite page have a "literary" element. The shot far left is in part a joke – the model's spread hands pick up the feet mosaic on the bottom of the pool. But perhaps, like a child, the girl is also offering her hands to an adult for inspection, a gesture which, combined with her expression, establishes a sense of dependence between her and the viewer. The picture at bottom left evokes associations with an aquatic crystal-gazer.

The two remaining shots opposite demonstrate mood and motion: top left a girl's beauty enhanced by the fairyland sparkle of a diffraction filter; centre left an expression of freedom almost pagan.

Model participation is clearly revealed in the photograph on this page of a girl flicking her hair out of a pool. The idea was simple enough; but without an intelligent model, aware that speed was essential, aware that she had to smile, aware of the attitude of her body and aware, above all, of what effect the photographer wanted, the idea could not have been translated into reality.

Light and the human figure 2

The nude female figure, depicted by painting, sculpture or photography, is a sexual object however delicately presented. While artists have tended to concentrate on the nude as an objective exercise in the portrayal of form, and a source of inspiration, the sexual element is invariably present.

In art, the division between the graphic study and the erotic or pornographic sketch is broad and clearly defined; in photography it can be narrow indeed. This is because photographers do not generally consider the nude study as fundamental – you don't have to go to a life class to become a photographer, though studying the nude figure can help you to perceive and depict shape, form and texture in an attractive way. In addition, the camera has acquired a voyeuristic reputation, so that practically any nude study may be invested with erotic undertones. Try to convey sensuality without straying into banality or worse – the coy and awkward results typified by shots of inexperienced models in uncomplimentary lighting.

An experienced model is essential. It is advisable to choose her from one of the better agencies: they often help with the choice. Self-consciousness or insecurity will be revealed in the final picture, so pick a girl with a bright personality. She should also have a clear, un-blemished skin and a full, rounded body. The cost will be double that of hiring a fashion model.

Establish rapport with your model, inspiring her confidence by perhaps showing her previous examples of your work. Conversation and encouragement during the session are essential to break down any tension or reserve. When photographing, ask her to vary her pose, and concentrate on the subtleties of form and graceful movements that emphasize the elegance of the body. Generally, a furnished studio or a domestic interior creates a sufficiently sensual and romantic atmosphere, especially if coupled with minimal lighting and soft focus. If you want to show variations of form, depth of shadow, texture of skin and the more abstract aspects of the model's body, then keep the background simple and subordinate to the subject. Cropping the figure by framing the torso depersonalizes the model and renders the image less subjective – nude pictures are pushed towards the erotic by provocative facial expressions, which serve to rob the shot of any aesthetic qualities it might otherwise have possessed.

If your aim is to stress sensual qualities without entering the realm of the overtly erotic, then a hint of a garment or a simple prop will produce the right balance between the abstract and the realistic.

The naked, female figure, with its graceful, subtly defined curves, sharply defined highlights and sensuous areas of deep shadow, can be appealing without being explicitly erotic. In this pose (right), reminiscent of classical sculpture, concentration on the torso alone, with simple side-lighting, has moved the image towards the abstract. The picture below, for which a domestic background was used, with a couch to support the model, has a stronger element of the erotic. This is due to the arched pose, the use of a soft-focus lens, and soft lighting.

The photo-journalist creates picture stories of people and events, either as one of a team of photographers and journalists on an assignment for a magazine or newspaper, or as an individual writer-photographer. Apart from technical ability, it is necessary to enjoy travelling and working alone, often in uncomfortable circumstances when you might prefer to be relaxing.

Magazine editors who have commissioned a photo-interview do not expect to see hackneyed pictures of celebrities, so to find an original angle the photo-journalist must be prepared to work in a flexible way and be both determined and able to get along with people at all levels of society. The ability to develop a sense of the unexpected, to make the most of any opportunity, is particularly important when the assignment is not a standard press conference for a politician or film star but a photo-interview in which you are setting out to reveal the background and personality of a subject such as a novelist or artist. As the best photographs often come

The inset portrait of Marx (left) was taken with a 105mm macro lens to provide a clear, straightforward shot that would familiarize readers with the subject of the photo-interview. It might well be used by a magazine art editor in combination with a close-up background picture such as the one shown here – the famous mosaic pavement designed by Marx for the beachfront at Rio de Janeiro. The powerful three-dimensional quality of the serpentine swirls has been emphasized by the use of a 28mm lens closely focused on the mosaic. Another aspect of Marx's work is shown in the picture below – one of his landscaped gardens in Rio. Slight underexposure has helped to offset the midday sun and saturate the colours of Marx's variegated plants.

when your subjects are engrossed in a favourite topic, it is sensible to carry out some preliminary research into their interests and achievements. Encourage them to participate in suggesting locations and shots, and try to work quickly in available light. You will need a variety of shots from close-ups to long views, formal and informal, and in both vertical and landscape formats to help the magazine layout. The sequence of photographs must hold together as a story as well as stylistically, each shot telling more about the subject.

The pictures on these and the following two pages represent a series for a story on the South American landscape architect Roberto Burle Marx, also a renowned botanist, expert on orchids, painter, textile designer and raconteur. Now over eighty, Marx is still active. To show him in relation to his work, life-style and surroundings and to reveal the range of his interests from landscaping to costume designing, the pictures were shot with several cameras and different lenses.

Sequence pictures can give added liveliness to a photo-interview. Here, Marx is seen arranging a hairstyle and harlequin costume, then posing with the girl in a bull's-head Mardi Gras costume of his own design. The marble arch is used as a formal frame for a shot that illustrates several of the subject's talents and also reveals his sense of fun.

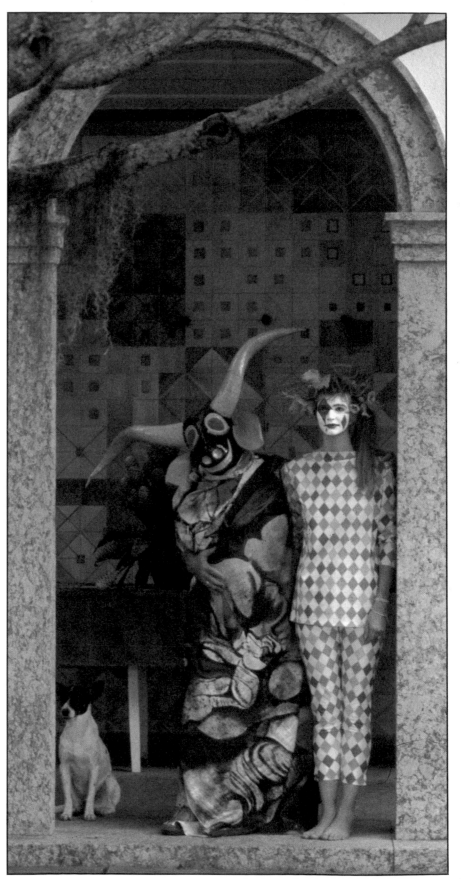

Photo-interview 2

A professional photographer never goes on assignment with just one camera, but usually takes three or four. Cameras do go wrong at vital moments, and for an amateur doing a special, carefully arranged picture it is equally a good idea to have two 35 mm SLRs loaded with identical types of film, and to make extra shots on the spare camera in case of processing errors. Since you will be working fairly fast, see that your cameras are clearly marked: a square of masking tape printed with a large "C" for colour and "B" for black and white will avoid errors under pressure. Have a different lens on each camera to save time changing lenses.

Having done some preliminary research you will know more or less what to expect, and the type of location, but in any event you will need several lenses. Aside from a normal 50 mm, take a long-focus 135 mm, or perhaps a 105 mm macro for close-up shots of heads and hands together with a 35 mm wide-angle. A 28 mm shift lens, and an extreme wide-angle 15 mm are useful for shots of rooms, buildings and landscapes. Flash equipment will be needed for dark interiors, and some portable means of bouncing the flash, such as a white card reflector.

Remember to take a roll of masking tape to stick on each cassette or roll of film, to carry information about the shots. The cassettes can then be numbered, and the reference entered in a notebook – where you took the shot, time of day, apertures and speeds, lenses, and relevant information about the subject. This is important, since you will need to identify specific shots for the magazine's picture editor if you intend to sell a sequence of photographs.

An extreme wide-angle lens is invaluable for interiors where you want to embrace the whole scene, as in the picture below left, taken with a 15mm lens. Distorted foreground scale is used here deliberately to show off the tablecloth, made, like Marx's shirt, from one of his own textile designs. The background painting is an early work of his; a new canvas is seen in the making in the picture below right. Further evidence of Marx's versatility are his sculpted and painted busts – useful details for a magazine editor planning a layout. In the other interior (right) the centrepiece is a Marx floral arrangement. This too was taken with a 15mm lens and with bounced flash to support the interior lights.

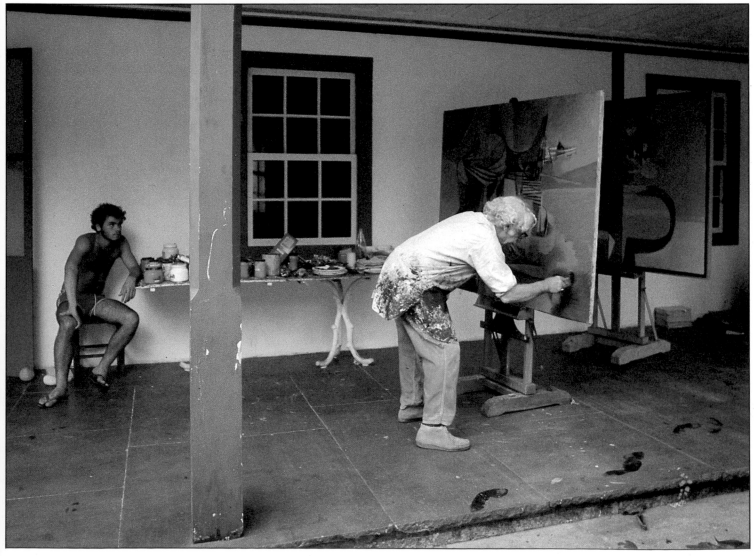

On location 1

Travel photographs have an unusually broad range of applications – in books, magazines and newspapers, on postcards and calendars, for travel brochures and commercial advertising. With the growth of the package tour industry, the market is expanding and at the same time it is becoming increasingly difficult to produce original work that does not simply repeat what has been seen many times before.

Conventional travel pictures tend to acknowledge popular clichés – rain in Ireland, sunshine in California, snow in Scandinavia. A travel feature on the Caribbean, for instance, could hardly avoid at least one picture of a sapphire sea lapping shores of silver sand beneath an azure sky. This is the photography of wish-fulfilment, inviting viewers to transport themselves, if only in fantasy, to faraway places. But the best travel pictures manage to evoke an atmosphere that is the sum total of many parts – the climatic or scenic character of the location, the drama or beauty of landscape or seascape, the characteristic style of architecture, the distinctive life-style of the people, all summed up in an image that captures the unique spirit of a place, both identifying it and making it pictorially memorable.

The ability to capture this sometimes elusive quality depends on patient observation, especially of the way that light changes the character of a location throughout the day. Modern skyscraper cities, for instance, often acquire a harsh beauty in the setting sun, when long shadows are cast down the glass and concrete canyons. By contrast, the clarity of light in a mountain village may be most apparent just after dawn. Early morning is always a marvellous time for travel photography. Your experience of any location is transformed by studying the way that half-light and shadows give mystery to the familiar and by observing the delicate chromatic range of hues as the light grows brighter and the planes of the landscape begin to separate. A moment of anticipation, almost suspense, sometimes arrives when the colour range seems perfect and you are just waiting for the inclusion of the one element – perhaps a figure rowing a boat out across a still lake – that will complete the picture.

As in any landscape shot, travel photographs need a motivation. The key to developing your skills in this branch of photography is to look for scenes that will test your perception and powers of interpretation. Study the effects of linear perspective or distortion achieved by switching lenses or camera viewpoints, and the way these changes may influence the mood of the picture by cutting off foreground to increase the intimacy or by emphasizing a lonely span of sky.

It is important to record the reality of a location as well as its scenic qualities; photograph the buildings but look also for the details that tell of human occupation – the graffiti on the walls perhaps. The element that unites the photographs here and on the following two pages is the breathtaking beauty of the Dal Lake in Kashmir. But the pictures sum up also the life-style of the lake inhabitants – their work and pleasures, their colourful forms of transport, the lingering influences of Mogul art and design. For the travel photographer the search for the right approach is as much a matter of understanding and sympathy as it is of technical knowledge.

Two flower sellers in canoes called *shikaras* on the Dal Lake, Kashmir, sum up the idyllic and tranquil beauty of the lake. A strong sense of unity and calm balance is created by the direction of their eyes and the linking line of their poised, heart-shaped paddles. Overcast light has helped to saturate the colours. The life-style of the lake people, and in particular their folk art (the flowers and traditional boats, paddles and costumes) have roots in the Persian Empire and the Mogul dynasty of the 16th century, when exotic flower gardens, such as the famous Shalimar Gardens, were established on the shores of the lake.

On location 2

In travel photography, people are always an important part of the surroundings, an integral element giving life and scale to the picture. At the same time they should not overpower it or distract attention from its pictorial qualities. To maintain this balance of interest, it is usually best to avoid photographing people staring straight at the camera and instead to show them in everyday situations, engaged in the daily business of their lives. The aim of the picture should be to suggest a continuum rather than a static moment.

Begin by making a thorough exploration of your location and using guide books or the advice of hotel staff or local people to find out as much as you can about local crafts and industries, houses or gardens and methods of transport to reach sites that may provide unusual viewpoints. Kashmir, for example, has probably changed very little since the pioneer English landscape photographer Samuel Bourne photographed the Himalayan range in 1864, and if you want to avoid treading well-worn paths it is necessary to be acutely aware of all that is going on from dawn to dusk. Your chances of making the most of any pictorial opportunity will be improved by travelling with as much equipment as you can handle.

An ideal outfit is two identical 35mm cameras and a set of five interchangeable lenses to fit both bodies: 15mm or 18mm, 28mm, 50mm standard, 135mm, 200mm or zoom with macro facility, and a ×2 converter. If this amount of gear is beyond you, the ×2 converter is a useful alternative to the longer lenses. A medium-format camera, say a 6×6cm and three lenses, 60mm, 80mm and 150mm, may be needed if your shots are to be enlarged considerably – as travel posters for example. Although most of your pictures will be taken by available light you should, for safety's sake, be sure to equip yourself with two small flashguns and spare batteries as well as a tripod, lens hoods and filters.

A lightweight leather case is useful, plus a smaller soft leather or plastic bag for carrying cameras on location. As long as you have a base from which to operate, such as a hotel, you can leave the bulk of your equipment in safe keeping and plan day-to-day excursions with selected equipment. If you are travelling in rural areas and unfamiliar territory, take a complete stock of the various films you expect to use, since film may be difficult to obtain. You will need a selection of medium to fast films if you are photographing in countries with a hot climate. It might seem hard to reconcile strong sunlight with the need for fast film, but the light is accompanied by intense heat which means that social activities usually take place at dawn and dusk or in the shade. Remember that in a humid climate, condensation will form on your camera when you leave an air-conditioned environment. You may need to acclimatize the camera by leaving it in the shade outdoors, perhaps on the balcony of your hotel room, before using it. Always carry a roll of plastic bags, keeping every group of films on one subject, or each individual roll, in a separate bag, labelled and numbered. Make out a full description of the location, subject details and exposure in your notebook. Eventually, when your pictures are reproduced, you will find that you are expected to supply appropriate information about them.

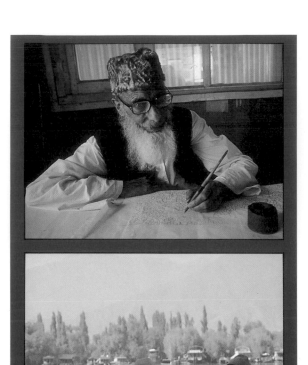

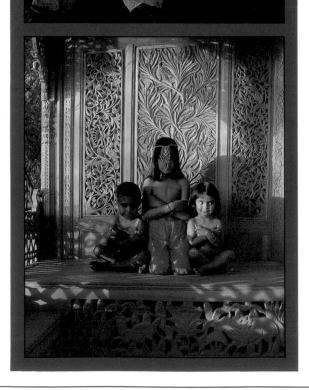

Varied aspects of Kashmiri life on the Dal Lake are revealed in this sequence of pictures, most of them taken in the early morning or late afternoon with a Pentax and a limited selection of lenses. A Hasselblad was used only for the shot of the children at bottom left, which was intended to be enlarged as a poster picture and required maximum definition. Low viewpoints are also easier to achieve with this type of waist-level camera, which can be placed on the floor. For the top picture of a carpet designer at work in his houseboat, open aperture and 200 ASA film were used to exploit the available light. The houseboat lights at top right were shot through a refraction filter to spread reflected lights at dusk. Low morning sunlight has brought out vivid yellows as it slants into the group of assembled water taxis in a shot taken with a 135mm lens. The longer view of the lake and the final picture of a group of villagers gathering reeds were also taken early in the morning. Here, hazy, more gentle light suggests the slow, contemplative life of lake dwellers coexisting with brisk tourist trade.

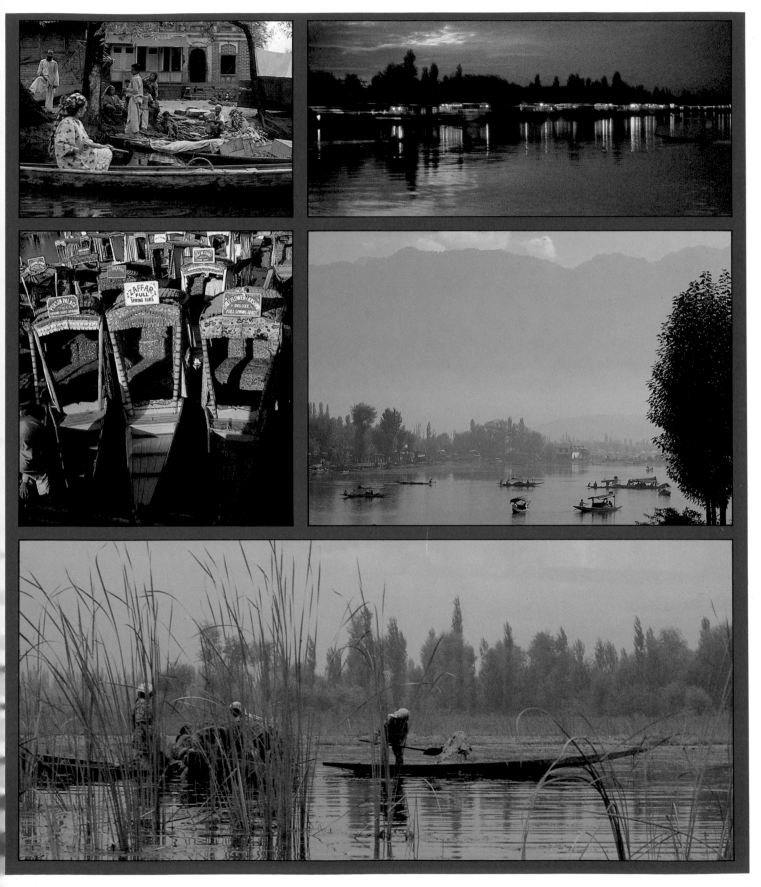

Changing light

All location pictures, especially those commissioned by a client, must be planned and related to weather conditions and time of day. Amateurs, and many professionals, often ignore these vital aspects of photography, but they are fundamental; they can make or break a picture, and must always be given the most careful attention. Ideally, you should first view your subject through all the hours of the day, noting the position of the sun and taking into account the weather, which is at its most variable during the changes of seasons. Adverse weather conditions are pictorially very rewarding, although you

Copacabana Beach, Rio de Janeiro, was photographed looking north from dawn until sunset, and the change in the quality of the light is here related to a colour wheel that alters radically from a yellowish tone in morning haze through the white of midday to the pink and warm orange light of dusk.

may have to wait days – even weeks – for the ideal situation to occur, an opportunity that may last only ten or fifteen minutes.

An exciting aspect of landscape photography is the chance element of light and atmosphere that brings the whole scene alive, particularly with summer storms, as shown on the opposite page. While a large-format camera will record fine detail and subtle variations of aerial perspective, the light and versatile SLR is better adapted to catch the swiftly changing moods of the weather in conditions such as this.

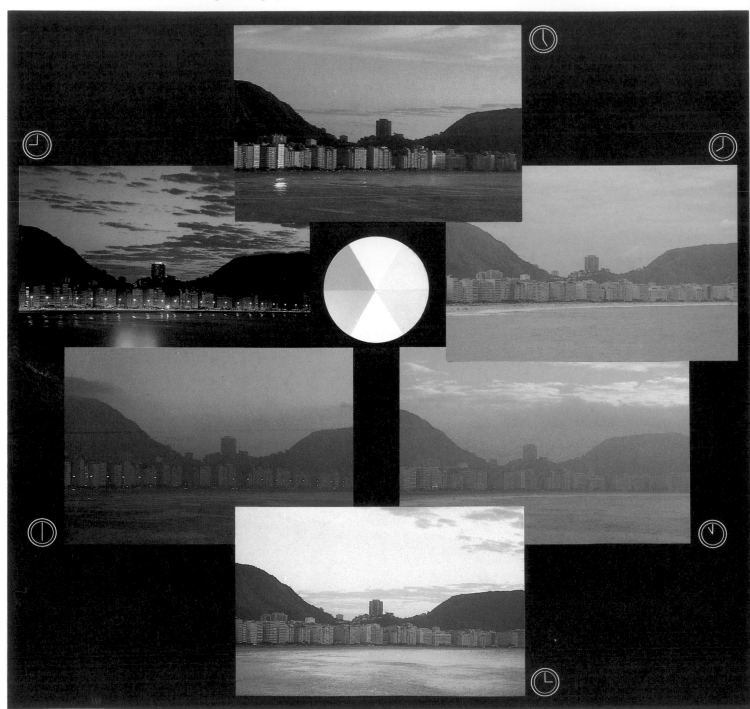

Sunrise shots are always fairly predictable, creating sharply defined silhouettes against a vivid sky, but with some foreground detail to give a sense of depth. The first picture was taken from Copacabana Beach at 5 a.m., looking east. In the second picture, shot two hours later, slightly to the left of the previous one, the arrival of some storm clouds has softened the light and has separated the range of mountains, giving an excellent example of aerial perspective. By 10 a.m., the view in the final picture had become totally overcast, and the background misty, except for the brilliant patch of sunlight – lasting only a second or two – that gave vitality and contrast to the scene. The three pictures were all taken with a long-focus lens, and a 35 mm Pentax camera on a tripod.

The grand scale

Some landscapes have a vastness and spaciousness that is hard to convey through the medium of photography, often because it is difficult to establish a concept of scale, or because flat or harsh frontal light has destroyed any impression of perspective and depth. When processed, your photograph is not the scene as you had originally visualized it, and has lost much of its impact. Successfully interpreting landscape on a grand scale may depend upon a singularly impressive element that leads the eye, and the imagination, into the picture: an area of vivid colour for example, or a shaft of light catching a distant building.

Many of the best landscape pictures are those in which you can clearly identify a foreground element that supports the main scene – a hillock, shrub, roof of a house, anything that sets the scale. Obviously, the most important feature is the light and the way it influences depth by aerial perspective, or by selectively illuminating a distant object. There may be only a fleeting moment when the entire scene before you is lit in such a way that space, depth and scale are satisfactorily related.

A wide-angle lens, such as the 28mm used for the powerfully atmospheric shot of Rio de Janeiro, left, will both accentuate the grand scale and the impression of space, especially where there are clouds in the sky. The lens exaggerates linear perspective, so that the image becomes distorted – and larger – nearer the edges of the picture, objects towards the centre appearing farther away. This has the effect of making clouds sharply recede towards the horizon, emphasizing depth.

Wide-angle and long-focus lenses help to establish different concepts of scale, where a normal 50mm lens would have failed to capture the grandeur of the scene. A view of the sea (left) from the hills behind Rio de Janeiro was shot with a 28mm lens, which helped to accentuate the feeling of space and distance by exaggerating the perspective. The picture at right was shot from roughly the same point of view, but with a 200mm lens. This has brought up the high-rise building and by narrowing the angle of view shown the relationship between the city and the scale of the landscape.

The classic site 1

There are no lotus flowers or fat carp in the long pool that leads the eye to Akbar's tomb at Sikandra – just a litter of tin cans and fruit peel. The only way to re-create an atmosphere of devotion and mystery was to wait until sunset, having discovered earlier that the sun would set behind the tomb. The light was then sufficient to reveal the symmetry of the design in silhouette, giving substance to the foreground without exposing the attendant litter.

The world's great monuments, often sited by their builders in places of impressive grandeur and natural beauty, may be difficult to photograph so that they appear as if isolated from modern influences and surroundings. An ancient building, seen in relation to a car park, a tourist information centre, and the tourists themselves, loses much of its romantic and solitary appeal, especially if the photograph is to be used in a travel magazine or calendar. So unless you intend to exploit the relationship between ancient and modern, you should contrive to eliminate the surroundings.

Only in remote areas will you find sites as they might have appeared originally. Yet even the fortified city of Machu Picchu (below) in the Peruvian Andes, a five-

hour journey from the nearest town, is visited by tourists in brightly coloured anoraks during all but the early hours of the day. The panorama shown here, shot with a wide-angle lens, was captured before the tourists arrived. The choice of a high viewpoint which included an area of the sky, helped to stress the Olympian setting of these Inca ruins; pictorially, the clouds and mountain peaks are as important as the ruins themselves. When shooting in distant locations, you will need to take as much photographic equipment as you can manage, in order to cover all eventualities, but most of all you must have a firm idea of what you are after; behind every advanced photograph – even the apparently spontaneous – there should be a considered plan of action.

The ruins of Tintern Abbey are surrounded by railings, car parks and formal pathways, destroying any medieval atmosphere, so it was very important to find a viewpoint above the valley that would obscure the surroundings, even if it meant spending hours seeking out the exact location. The time of day was also a decisive factor; the warm light of sunset enhanced the natural colour of the weathered stone.

The classic site 2

The importance of having a personal viewpoint in travel photography can best be demonstrated by taking as a subject a building so famous that it has become almost a photographic cliché – the Taj Mahal. Works of architecture as sublime as this are inevitably photographed by thousands of visitors each year, yet it is still possible to find new or unexpected facets of the building if you are prepared to abandon preconceived ideas and react to the site in a fresh way. The picture opposite, for instance, responds to the surprising discovery that the Taj stands on the bank of a river with a wasteland opposite. A local taxi driver negotiated a passage to the far bank by means of a flimsy craft zig-zagging against the swift current, and the result was several unusual shots.

The strong light in India allows the use of slow film (25 ASA) with grain fine enough to give sharp detail on an enlargement from a 35mm format negative. All the shots for this assignment were taken with a hand-held SLR. Normally, a tripod is more suitable for architectural work, not only because of the long exposure and small aperture it permits but also because at a crowded site people tend to have more consideration for a photographer who has set up a camera on a tripod. Though local people in the view can often be a positive advantage in providing a building with scale and context, shoals of tourists do not help. As at Machu Picchu, they were avoided in this instance by the simple expedient of arriving early. The tourist buses begin arriving at 7 a.m. and by being there at 5 a.m. it was possible to work for more than an hour without interruption. The weaker light of early morning tends in any case to be the most appropriate for a building such as this with its almost translucent delicacy. Subtle changes of colour and modelling were constantly presented as the light shifted and spread. In long views against the sky it is best to take the exposure not from the building itself but from a foreground area of slightly darker tone.

Travel magazine assignments require a variety of views from which the picture editor can make a selection to suit the layout or convey the main message of an article. Conventional shots of the Taj Mahal show the approach to the Mausoleum with its splendid cypress-lined watercourse, but there is more to the building than this. What most interested me about the Taj was the contrast between this most beautiful example of Indian Muslim architecture and the harsh environment from which it arose. The pictures shown here are only a few of many views which attempted to relate the building to its surroundings and the daily life of the people who live on the banks of the Jumna River. The silhouetted boatman landed me on the far bank of the river, from which the large picture was taken. I used a 15mm lens to emphasize the texture of the cracked earth in the foreground.

Four lenses, ranging from 135mm through 50mm and 28mm down to the 15mm used for the picture opposite, will cover most eventualities in travel photography. The shift lens shown here is invaluable for shots of architecture.

The living landscape

While it may be useful for the landscape photographer to visualize the scene before him as a vast still life that needs careful lighting and composing, landscapes are not necessarily static subjects. Photographers of the night sky are aware that the earth's rotation alone will blur the moon and stars on a time exposure. By day, the landscape is alive with the constant movement of clouds, the rustling of foliage, the shifting patterns of sunlight and shade, water tumbling over rocks or reeds thrashing in the wind. Constable, the English landscape painter and astute watcher of the skies, made sketches full of spontaneity to reveal the essence of the living landscape.

Apt selection of the image – drifting mist, wind-tossed trees, light breaking from behind cloud – may be enough to evoke movement in a photograph. Alternatively, interesting effects can sometimes be achieved by zooming or moving the camera itself. More possibilities are offered by a judicious use of a slow shutter to capture the velocity of driving rain or snow (at about 1/30) or, best of all, river water. There is usually plenty of action in the upper reaches where water splashing over innumerable falls takes on a translucent, shimmering quality, as in the picture opposite. Equally, the calmer surfaces of lakes and ponds can bring a landscape to life when slight undulations or a shiver of wind across the surface creates trembling reflections of foliage along the banks or of clouds above, synthesizing the different elements of a scene and transforming it into a subtly textured whole.

The tree in sunlight was shot for a record cover, the brief stipulating an atmospheric picture of wintry branches silhouetted against the sun. Without its foliage, the tree would have made too stark a shape for an atmospheric shot, as there was no mist or haze to soften the image. The alternatives were to wait for misty conditions, to create artificial haze by using a smoke bomb, or to blur the image with a zoom lens. The latter proved the most practical method, and the shot was made at 1/15 with a Vivitar 100–300 mm zoom and the camera on a tripod.

Reflections of a weathered boathouse and foliage on the bank of an ornamental lake have been given the quality of tapestry by faint ripples on the surface that break up the shapes and mute the colours through diffraction and dispersion of lightwaves. Mirror images, especially in the early morning or evening when the movement of the water is slight, provide rich material for abstract or unconventional landscapes. An 18 mm or 28 mm wide-angle lens is usually best for this kind of shot, so that you can bring details of the reflection well into the foreground.

Cascading water has been given a brushed softness here by a shutter speed of 1/15 – slow enough to spread out the movement. Rivers vary so widely in their velocity that bracketing of shutter speeds is usually necessary to achieve the precise effect you want, though considerable blur will usually appear at speeds between 1/4 and 1/15. At the other end of the scale a speed of only 1/250 will stop a slow-moving river, while it would take 1/2000 to freeze the thundering power of Niagara itself.

Timeless landscapes

Photography, so successful at recording the present, is yet equally able to reach into the past. By a careful selection of elements, it can present to us scenes that appear unaffected by contemporary life and are rich in associations with a past in which we lived close to the earth, the sea and the sky. Perhaps the reason why such pictures are so often collected and framed is that they fill us with nostalgia for a rustic heritage that is vanishing and taking with it a certain calmness and stability.

Landscapes, especially if they resemble in some way places that we ourselves remember fondly, are particularly evocative. Often the essence of a timeless landscape is a softness of light and a sense of stillness – the fact that the photographer has, in some way, captured that silence in which, when we are completely relaxed, all our senses seem heightened, so that we are aware of the sights, smells and faint sounds of the countryside for which we normally have no time to pause.

While it is relatively easy to bestow a "timelessness" on a scene by isolating details so that you exclude any evidence of modernity – power lines, telegraph poles, buildings, vapour trails – a more convincing result will come from shooting wide, panoramic views where no modern influences exist. They are increasingly difficult to find, but worth seeking; so many good photographs are the outcome of many hours patiently spent looking and waiting for the right place, the right time of day. Apart from the unmistakable silhouette of Stonehenge, the pictures on the left include a coastline in Corsica, an olive grove in Spain and a cornfield in Portugal. In the first two, the sense of isolation is increased by the inclusion of a solitary figure shot against the light, and by the use of long-focus lenses to avoid intrusion into the scene. In the large picture, the camera acts almost as a time machine to remind us how much the quality of life has changed, for the peasants working the fields will soon be replaced by combine harvesters; even Stonehenge has now been fenced off so that you can no longer wander at will among the massive stones.

Colour is a further important factor in establishing a mood of stillness and nostalgia. The gold and black tones in the picture of the harvesters echo those sepia prints of photography's formative years; the sombre, almost monochromatic appearance of Stonehenge matches its monolithic austerity; the muted colours of the rowboat picture add to the sense of tranquillity. Only the scarlet poppies carpeting the olive grove break the spell, but they are a universal symbol of springtime and therefore of perpetuity.

Angle of view and softness of light contribute to the timeless quality of all these pictures. The Corsican fisherman was photographed at dawn when there were no ripples to break the mirror-like surface of the water, almost merging with the sky, and the calm atmosphere is heightened by the symmetrical placing of the boat close to the centre of the frame. Stonehenge was shot from a low angle against fading light, whereas the olive groves needed a high angle to bring out the patterned rows of trees and poppies. In the picture of the harvesters, the evocation of the nineteenth century comes partly from the subject matter itself – still common in some Mediterranean countries – and partly from the softened focus and limited colours, helped by the use of fast film and slight under-exposure which has left the figures shadowed.

Harsh conditions

A summer storm over Forte dei Marmi, Italy, lasted no more than twenty minutes, but while passing dramatically changed the entire scene. Before the storm, the sky was a cloudless and brilliant blue, the beach huts and deck chairs providing the main area of interest and a wealth of activity. With the storm, emphasis shifted to the sky, leaving the beach resembling a deserted stage set, the backdrops in silhouette. Extreme conditions such as snow and sand storms, and heavy rain, can be a gift, investing otherwise mundane scenes with power and excitement. Aware of the wonderful visual scope of Britain's ever-changing weather, the great landscape painter Turner used to snatch up his sketch book and plunge out into the teeth of the storm – the maxim for the photographer as well as the artist is ''Don't rush for cover but stay where you are and take pictures''. When shooting, exploit all the possibilities that the scene provides, such as the reflections from rain-washed surfaces, the way light patches of sky throw buildings and trees into silhouette. As a general rule, expose for the highlights: this will emphasize dark areas of the sky and lend a brooding, low-key atmosphere to the scene.

Atmosphere in architecture

Conveying the sense of scale of a building as immense as St Peter's is one of the great challenges of architectural photography. The small view (left), taken with a 28 mm shift lens, conveys maximum visual information, but by shifting the lens downward (far left) a more intense feeling of the sheer volume of the space was captured. The final shot (below) is the most selective and the most dynamic of all, the drama coming from the surging lines of the building and the flood of light.

Buildings are such powerful visual indexes both of history and of our own environment that architecture is inevitably a major subject area for both amateur and professional photographers. The range of personal styles and approaches varies widely, from the sometimes rather cold exactitude of photographs published by serious architectural journals to studies in which detail is less important than atmosphere.

When the primary aim is to make an accurate record, traditional methods, using a large-format camera, sheet film and relatively long exposures, are undoubtedly best. The movements of a view camera give control over definition, and the large negative allows sharp detail. The drawbacks to this method of working are that it is slow and requires heavy equipment. In public buildings special permission to set up a tripod may be required –

and often a fee as well. The technology of the modern SLR and shift lens, however, has made it possible to short-circuit cumbersome procedures and take exciting pictures in a fraction of the time.

Though luck plays some part in capturing light effects as spectacular as those shown here, the moments when they occur can often be anticipated by making a preliminary visit to the building. A hand-held camera has captured the overpowering splendour of the central space at the moment when shafts of light from Michelangelo's dome were flooding the cross above the altar canopy. The shafts would have been further dramatized had exposure been based on the highlights, but over-riding the automatic meter gave a more balanced exposure of 1/30 at f5.6, burning out the shafts a little and bringing up detail in the shadows.

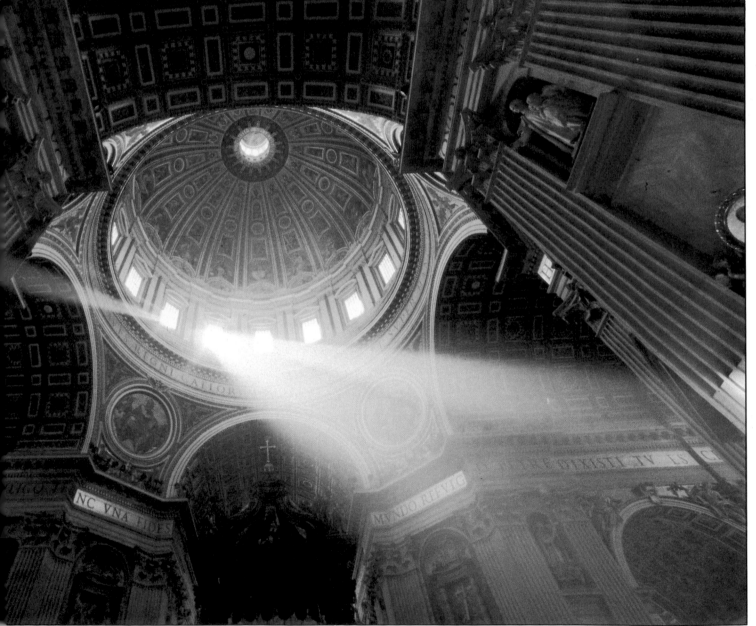

Modern viewpoints

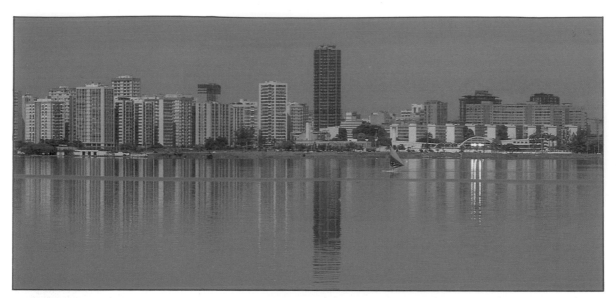

Distant reflections of Rio produce a shimmering, light and delicate mirror-image, conveying vital elements in the appeal of modern architecture – an appeal which relies on an expanse of glass, steel and concrete. When it proves difficult to emphasize this feeling in close-up shots, you may have to move some distance away from the subject.

The geometric severity of much modern architecture can often be softened and moderated, especially if you seek unusual aspects. When you can adopt an appropriate viewpoint and use the light to your advantage, you will find that areas of glass will create distorting images, contrasting with the structure's angularity.

Linear perspective can often be exploited to capture the most dynamic aspects of modern design – the steep, vertical lines and dizzy upward drive of high-rise buildings. This scene was shot directly downwards from a balcony, using a 28 mm shift lens. Note the effect of pictorial balance given by the horizontal lines across the top of the view.

The Peach Tree Hotel in Atlanta, Georgia, the world's tallest hotel building, is here seen through the roof of the swimming pool. As glass plays so great a part in modern architecture, you must decide whether to capture its reflective aspects or the transparency and sense of depth obtained by shooting through it. On most assignments involving modern buildings, you will need bright, hard light to convey the sharpness and linear thrust which are so often the source of their aesthetic appeal. The picture on the right, with its opposing diagonals, was made in bright sunlight with a 15 mm wide-angle lens.

CONTROLLING THE IMAGE

The exercises in this section are designed to take you through assignments in which the subject matter, lighting and setting must all be carefully preplanned. Emphasis is placed on techniques, showing how, in particular, the treatment of commercial subjects depends on a deliberate approach, from the initial idea through to the final picture, where the photographer may be part of a creative team, including editors, art directors, stylists and makeup artists. The assured, practical handling of an assignment comes with experience, yet each and every commission has its own inherent and unique problems, presenting a recurring challenge to the photographer's skills. Most commercial photographers specialize in a particular subject, rarely straying into other fields of interest, but the wide variety of pictures that follows will show you how you can meet the challenge to handle any number of diverse subjects by applying the same principles of control over each – a good picture often depends as much on stage management as on lighting, or a choice of lens, or a certain type of film, especially in the area of fashion photography, or the disciplined, formalized settings of food photography.

Lighting a still life

In setting up and shooting a still life, you will encounter most of the essential problems of controlling a photographic image. Everything is under your direct control – choice of objects, composition, lighting, background – and the result depends wholly on your skill and judgement. Choose your background first, then arrange the principal objects, adding the supporting accessories one by one, checking through the viewfinder for balance and proportion, and for the way in which forms and colours relate to one another. If the qualities you are seeking seem finally to be elusive, it may be necessary to dismantle the entire composition and start again.

The more objects you have to choose from, the better. Busy professional photographers often hire a picture stylist to collect accessories; the stylist will be in touch with shops and antique dealers willing to lend objects in return for a picture credit.

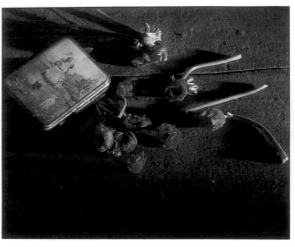

Childhood memories are the theme of a picture that uses creative lighting to establish the atmosphere. The delineation that would have resulted from even lighting was rejected here in favour of a low-angled directional light, which allowed deep shadows and autumnal tones.

Victorian wedding and engagement rings form a "period" still life (below). The jewellery and trinkets were shot for *Brides* magazine. Use of a large-format camera was essential, so that meticulous arrangement of the objects could be done through the viewing screen. The camera was a 4×5 Linhof, mounted on a tripod. The main lighting was reflected from the screen, as in the diagram (right), yielding soft shadows.

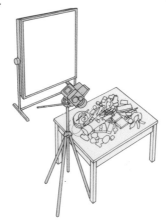

A court shoe, taken for a magazine cover (below), makes a simple shape contrasted with the more intricate shape in the background, but is linked to it by colour. A roll of paper used as a backdrop (see diagram, right) does not create a horizontal break in the composition. Space has been allowed in the arrangement for the magazine's title and other text; this can be marked in wax pencil on the viewing screen of the large-format camera.

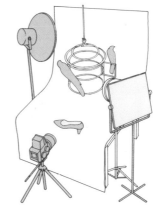

The feather and bulb (opposite) apparently demonstrate impossibilities: the feather supporting the bulb and the bulb burning without a source of power. They were mounted as shown in the diagram (below). Wires were soldered to the bulb terminals, and a stout wire support soldered to the bulb's base, the support being securely clamped behind the backing paper. The wires and support were hidden by the position of the camera. Similarly, the feather was fixed by a pin through the paper. In order to show both the transparency and reflectivity of the glass I used adjustable blinds in the studio skylights. The feather was front-lit with a reflector positioned for fill-in light. The exposure was calculated so that the glow from the filament would not obliterate the reflections in the glass. I stopped down to f16 and gave a 10-second exposure while flashing the bulb on and off.

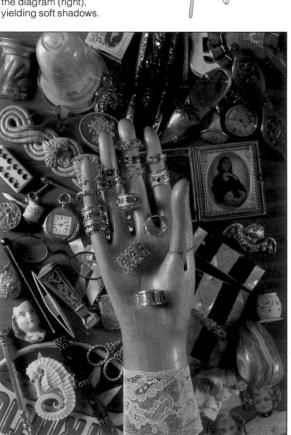

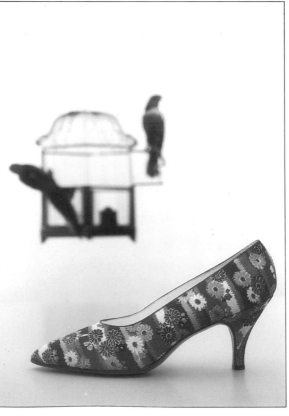

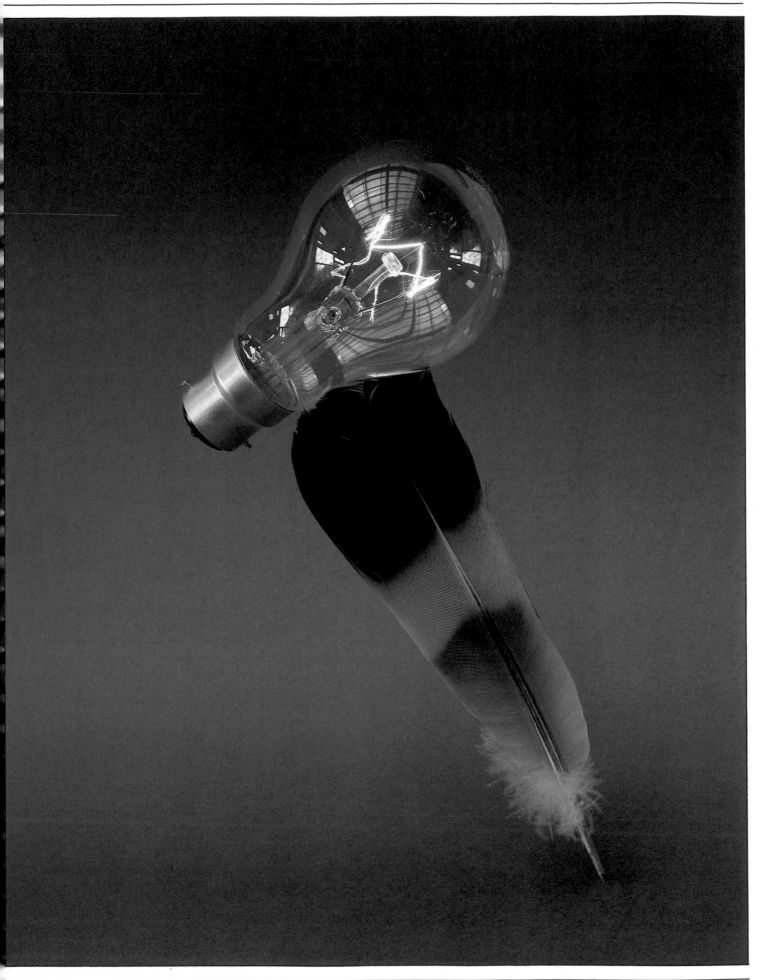

Still life: liquids and glass

Photographing glass and liquids can be challenging, because so many variations of colour and light are possible that each of a dozen photographs of the same glass may be subtly different. The lighting, background and composition must be chosen carefully, especially if you are shooting a single glass as an isolated subject, as in the shot opposite. Then you must arrange the elements for the right balance of masses and tones. Dark-coloured liquids may have to be watered down: red wine in a glass, for example, tends to look almost black in a photograph; if you compensate by using stronger light, the glass will be overexposed and burnt out, so it is better to dilute the wine and underexpose slightly, say one stop below normal. To emphasize the brilliance of glass, especially cut glass, you need to control reflections, covering windows and skylights with blinds and using reflectors to give the right degree of intensity to highlights while achieving backgrounds of sufficient tonal depth.

As backgrounds can so strongly influence translucent objects it is usually best to control the background lighting separately, and to place your subjects on a sheet of glass to allow this when shooting from a high viewpoint. Ice cubes create additional shapes and colours: some photographers use glass or plastic cubes for drink shots to ensure that everything remains constant. Backlighting will increase translucency and a fill-in light will lend delicate modelling to surfaces.

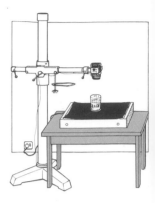

Making a splash (left) depends on the height of the stream of liquid and how much you want it to bounce, which in turn depends on the shape of the glass. In this shot the cascade was falling about 12 inches. Lights were bounced off a white background, as in the diagram (right). A flash freezes a falling liquid; you must anticipate the moment to shoot.

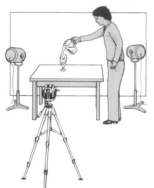

A cigarette with lipstick traces (below left) reflects the lyric of a romantic song; earrings, an orchid, two cocktail glasses and soft backlighting reinforce the suggestion of romance. The sherry bottle (below) conjures up sunny Spain – but was shot in winter against a mural in a swimming pool. Foreground diffusing screens enabled the background to be slightly overexposed.

Campari on ice (right) is a seemingly simple shot which actually required a careful balance of light and background in order to achieve the right feeling of inner glow and warmth. The glass was lit from below, using a light box with its translucent diffusing screen: the glass was placed directly over a hole cut in a grey card placed on the screen, as in the diagram (above).

Still life: food 1

Food photography and the fine art of still-life painting are directly linked – composition, the juxtaposition of shapes and textures and the balance of tones and colours are essential factors in establishing a harmonious picture and a sense of elegance and style. The best food pictures are, in a way, very simple, because the photographer has taken a direct approach and not allowed extraneous elements to divert attention from the food itself with all its flavour, colour and aroma.

Food needs to be chosen and prepared with practised discrimination. Being a natural product, it is best photo-graphed by daylight or by simple, one-source studio lighting that approximates daylight. Overlighting can make interesting dishes look flat and unappetizing, so if you are using flash take some preliminary Polaroids to check the effect. Pre-planning will also enable you to work quickly so that the food does not congeal or wilt when it is taken hot from the oven or crisp from the refrigerator. The angle and strength of the light may depend on whether you want to emphasize soft, crumbly textures or basted, crackly surfaces, as in the picture of Christmas fare at bottom right.

The Italian pasta was shot for a magazine feature, in order to illustrate the fascinating variety of different types available for recipes. The intricate composition was assembled on a grey-green back-ground card, with constant checks through the viewing screen of the large-format camera. To give the shapes substance and to record them with clarity, two electronic flashes were mounted in a light box; a large reflecting card was placed opposite, as it was essential in this composition to retain detail beyond the crisply lit edges.

A perfectly fried egg holds its clear shape against the black pan and the muted gleam of a reflective black background. The oats and the sympathetic forms of the eggs in the basket add interest, while supporting the theme of wholesome food. In addition the two states of the eggs – cooked and not-yet-cooked – help to knit together the composition. With a 5 × 4 technical camera mounted above, the arrangement needed clear, soft lighting to harmonize its various elements – a flash bounced in an umbrella reflector.

The cooking method itself had to be illustrated for this example of a cookery-book type of shot. The casseroled meat was simmered with vegetables in a pot sealed around the lid with a pastry crust. The casserole was taken hot from the oven in a studio and photographed with a 5 × 4 camera directly above a table covered with a check cloth, chosen carefully for its toning contribution. Simulated daylight was provided by a studio window light and a reflector.

This still life of an elaborate 18th-century Yuletide feast was shot for a magazine feature, and needed strong, even, directional light to pick up the glistening surfaces of the sucking pig, the fish and the lobster's carapace. To capture all this sumptuousness, I diffused the four photofloods with an opaque glass screen, placed a reflector opposite and used a dark back-screen, with pewter and stoneware to give the composition an antique mood.

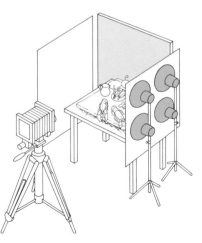

Still life: food 2

Fruit and vegetables have traditionally been favourite subjects for artists. A study of the subtleties of lighting and arrangement in their works can help still-life photographers, whether they are making conventional or abstract pictures. These "portraits", for instance, were inspired by the allegorical fantasies of Arcimboldo. Remember that unlike man-made still-life subjects, food is organic and needs to be chosen, handled and lit judiciously to capture its freshness. The delicacy of the bowl of fruit shown below was achieved with a fog filter.

The fruit face was made by arranging the food and foliage on an inclined board, butted against the barrel serving as a "hat". The picture was shot with the camera on a tripod, straddling the subject. Lighting was provided by photofloods bounced off the ceiling to soften the light and eliminate hard shadows.

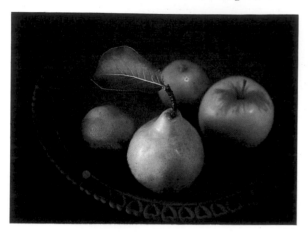

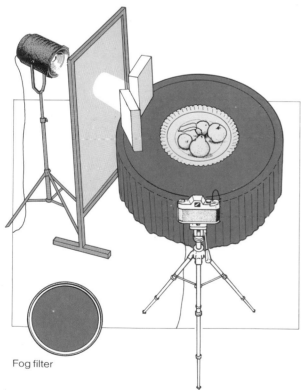

Fog filter

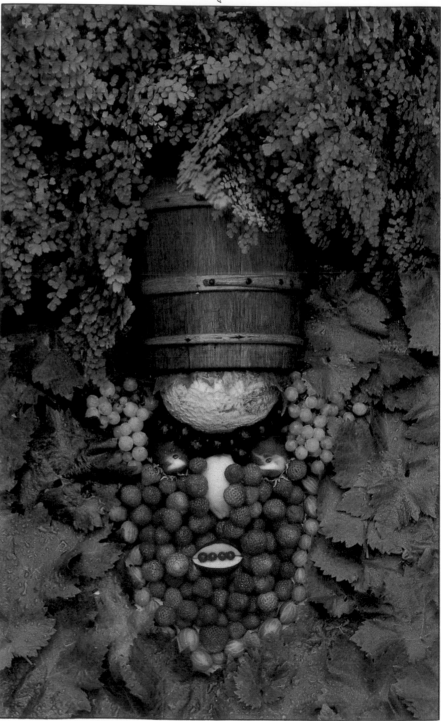

The diffused, slightly misty effect, which has given the top photograph a quality reminiscent of the still-life paintings of Courbet, was obtained with a fog filter over the camera lens, and a diffused spotlight. Simple arrangements of this kind need lighting that shows form and texture through subtle modelling. Small wooden blocks were put between the spot and the subject to cast background shadows and give added prominence to the highlights in the foreground.

The harvest head, placed in front of an eighteenth-century tapestry background, was carefully constructed on an armature of wire mesh, covered with modelling clay and plasticine half an inch thick. Lighting, as shown, came from two studio lights, and one floodlight angled towards the tapestry.

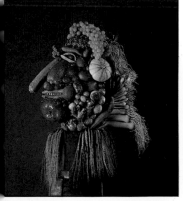

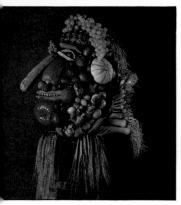

To construct an elaborate head, use a firm, studio workbench with enough space to allow you to set up lighting or change the background. For a magazine shot it may be necessary to take several pictures with varying backgrounds to give the art editor a choice, as above. Food can be kept in bowls of water to preserve its freshness while you build up the features, fixing each item in place with long hairpins tuck in the plasticine. Finally you can add "dew" with a diffuser spray before shooting. Light the head with soft, directional lighting as you would a nude, so that the light follows the form, showing the quality and texture of the skin. Still-life groups of fruit are enhanced by a soft light.

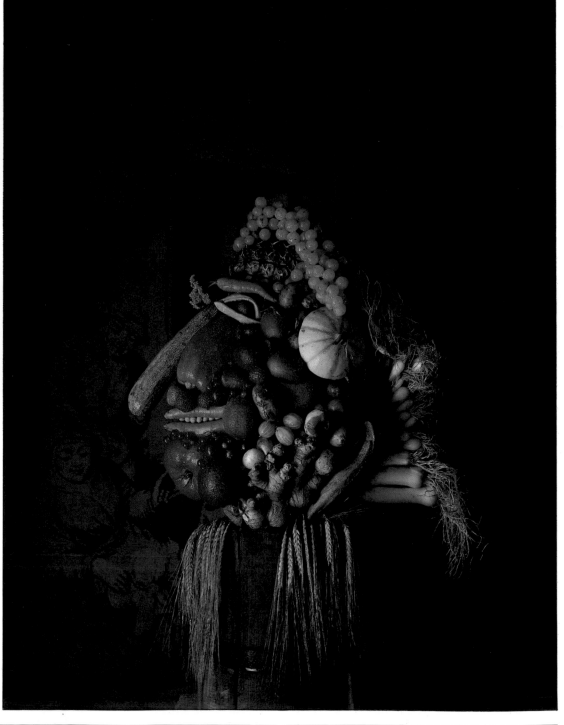

Food in a setting

Some of the most seductive pictures of food show it in relation to its place of origin – a hotel, a restaurant, a farmhouse kitchen, or perhaps a country garden. Indeed, ambience is so important in the presentation and enjoyment of good food that harmonious surroundings are often considered an intrinsic element, especially in advertising, travel brochures and the editorial pages of magazines. Photographers therefore need to show, in one picture, these two aspects – the food and the surroundings – and in such a way that they complement each other and appeal immediately to the reader.

This is an area of photography in which you should not be afraid of planning a grandiose set-piece – a shot of a chef with his assistants proudly displaying a chosen selection of the cuisine, perhaps, or a view of a restaurant with typical dishes superbly displayed in the foreground. To carry out such assignments you need some basic organizational skills as well as considerable powers of persuasion. Although hotel staff are generally cooperative they may need to be directed in much the same way as a film director deals with actors and technicians on the set. You must, in other words, dominate the proceedings. The first thing to decide is the range of dishes to be shown. In setting up an elaborate and impressive centrepiece remember that chefs often have their own pictures of previous creations, which may help you choose something that challenges both the chef's skill and your skills as a photographer.

Preparations should begin well before you take the shot. Whether you shoot inside or out will depend, of course, on the weather, the food and the proximity of the kitchen, but natural light is a great advantage. Restaurant or kitchen staff to be included in the shot will need impeccably clean overalls, polished shoes and shiny buttons. Let the waiters arrange the correct table setting while you decide the camera angle, any support lighting, background and props that would add to the atmosphere – flowers, mirrors, candlesticks, lamps, bowls of fruit. It is a help to have a second table, out of the shot, to hold these extra items while the main dish is being set up. Wide-angle lenses are usually the most effective for depth of field and definition.

The Sheraton Taj Hotel, Agra, India provides a setting of fabulous opulence, matching its exotic cuisine. As rich, sumptuous colour and exquisite decoration are part of Indian life and culture, not least in the presentation of food, the top picture deliberately emphasizes the element of bravura display. It shows members of the hotel's staff flanked by elephants and their mahouts in front of a table laden with typical dishes – fish from the lake, curries and chutneys in the bowls, Indian breads, a bowl of local flowers and a model of the Taj Mahal, symbolizing Indian art and architecture. There can be no doubt that this is India.

Where possible, food and surroundings should be shot either outside or with directional light through a window. If daylight is too weak, electronic flash can often be used to support it or simulate it without losing the effect of naturalness, as in the shot of the waiter apparently carrying food to an impatient Rajah (with bounced flash). The two shots of drinks convey the elegance of Udaipur's Lake Palace Hotel, while the large exterior shot, with its carefully balanced perspective, captures its blend of abundant hospitality and formal grandeur.

Interpreting a style 1

Successful fashion features in magazines depend not only on the fashion editor having strong ideas but also on the ability of a photographer to interpret them in an original and striking way. Unlike advertising photography in which photographers often have to shoot to very tight visual concepts, fashion photography is based usually on a looser concept and depends to a much greater extent on rapport between the fashion editor, the photographer and the model.

During the postwar era when the fashion world was dominated by the great Paris couturiers, elegance and detail were more important than mood, and the trend was for somewhat austere, low-key shots with static poses to show off every button and seam in sharp focus. But now the demand is for mood and atmosphere – for a style of photography closely related to the sort of clothes that are being photographed – which may be romantic, languid, or aggressively lively with plenty of movement and colour.

Whatever the mood, the point of a fashion picture is to make a woman feel that she too would look stylish in the clothes that are being shown; there is always a dream element involved. As fashion is linked to life-style, the choice of the right location or background is important.

As a general rule it should be in harmony with the garment – autumn tweeds against the soft tones of mist and heather, furs in snowy scenes.

For professionals, setting up a fashion shot usually involves much detailed planning, hire of props (or loan in return for a credit line), insurance against bad weather, a preliminary visit to check out the location and obtain any permissions to shoot on private property, and often the services of a hair stylist and make-up artist as well as an experienced model. The most natural-looking shots are sometimes carefully calculated, with pins to ensure a perfect fit at a given angle, or with nylon thread holding a skirt hem out in a swirl. High costs make it essential to check equipment frequently and safeguard film against loss or damage in processing by never sending all the shots in one batch.

If your budget is lower, the location may have to be improvised with seasonal props for mood and atmosphere. The mood can often be signalled quite simply – a tall, iced drink to suggest summer, and filtered flash to simulate warm sunlight, for instance. A simple and spontaneous approach is wise if you are working with an untrained model, as it takes experience to strike and hold more flamboyant poses.

A romantic mood (below) was the key to this pastoral symphony of colour – an advertising shot in which the car, clothes, food and drinks all help to create a dreamlike setting for the clothes. The picture was taken through a fog filter with the faintest smear of Vaseline to help mute colour and definition. A slight wide-angle view through a 35 mm lens allowed a close view that still took in the atmospheric surroundings. Maidenhair fern in the foreground was deliberately set up there to lead the eye to the centre of interest – the little group apparently caught quite naturally as they enjoyed a quiet rural picnic. For all that they may have a casual air, shots like this – full of mood, atmosphere and pastel colour – are really the result of organization, care and forethought.

The lively clothes at right were designed by a young graduate student to stress the combination of strong colours with quality fabrics. They seemed to demand an exuberant, unconventional pose from the model, so she was photographed jumping beside a placid statue with a disapproving eagle at its base. The juxtaposition creates an odd but arresting image full of life and energy.

The evening dress above suggested a fey mood which is created by a longer shot across a foreground of reeds and water, in which the girl's reflection adds an element of ambiguity.

For the inset shot on the right, the model has been posed in a vivid, almost storybook costume bang in the middle of a scalloped garden seat. With her red toes upturned and skirts ballooning she makes an assertive image perfectly complemented by the intricately carved seat.

Interpreting a style 2

The intense pressure on fashion designers to produce something eye-catchingly new is matched by a similar pressure on the magazines that report their triumphs and failures. The editors, art editors, writers and photographers of fashion magazines are constantly seeking not only new ways in which to display new fashions, but also new ways in which to display fashions that, if not old, are only variations on well-played themes. Because innovation is essential, the editorial team and the art department may sometimes decide on an approach that exploits only certain aspects of the clothes, or may even create a page of pictures that have more visual impact, mood and atmosphere than the clothes really possess. This is particularly important when individual garments are uninspiring but are being featured because of their topicality – rainwear or swimwear, for example.

In such instances the photographer and the art director will work together on a tight brief and the model will be shot with the eventual image design and page layout in mind: provided the brief is followed, the art editor can then give a particular "feel" to a whole section of his magazine featuring an individual style.

Sometimes the art editor will choose to repeat an image to give the subject a greater feeling of movement and excitement. The repeated image at the top of this page creates the feeling that these are different views of the same dress, and gives a certain vitality to an otherwise static shot. In the kaleidoscopic picture, right, the use of the mosaic background and the model's formal pose exploit the geometric character of the gown. Alternatively, the photographer might shoot the same model in different garments against the same background (below) to concentrate the magazine reader's attention solely on the range of clothes on display.

Composed of a single shot, printed five times, cropped and mounted, the image top right was designed to turn a relatively straightforward shot of a relatively straightforward dress into something that would catch a reader's eye. The mosaic middle right uses 15 cut-outs but only two basic poses, one of them reversed, and the montage below six cut-outs. Brighton Pavilion was used for the location of the shot on the opposite page. The repeated image (a print made from a negative reversed left to right) is designed as a visual trick to draw attention to the evening gown.

Masks for controlled effects

Using masks for dramatic effects is no new idea; in many primitive societies masks have always been imbued with a magic significance in religious ritual. The mask conceals individual human identity and allows its wearer to assume unhuman or idealized characteristics – it can be frightening, amusing or sexually provocative, and so encourage freedom from restraint and the liberating fantasy of a different identity.

Masks come in many different guises: there are those worn in the theatre since the days of ancient Greek drama to personify character types, there is the elaborate make-up traditionally worn by Japanese Geishas, and there are straightforward cosmetics used to hide or

transform the wearer's personality. In the early days of the cinema, Hollywood actresses wore thick masks of cold cream liberally dusted with cornstarch, because the hard studio lights otherwise emphasized every freckle.

The pictures below and right show the powerful and deliberate psychological contrast between the real and the artificial – the naked figure and the enigmatic mask above it, a combination that Is challenging because we want to penetrate the disguise, and also pictorially arresting. As we have stressed elsewhere in this book, the photographic process, however complex and involved, is but a vehicle of creative expression and subordinate to the idea that produces a unique or striking image.

Coloured scarves, shawls or veils are extraordinarily useful accessories both in conventional fashion work and in special effects photography. The wet blue silk (right) pulling at the girl's features and only half-defining them has the effect of a shroud, giving her face a gaunt, sculptured quality and creating an image both compelling and sinister. It is difficult to equate this portrait with the shots of the same girl masked.

Masked nudes have a particular power because, like a photographic negative, they reverse everything. The conventions of portraiture in which the face is uncovered and the body clothed are overturned, providing a jolt that is partly visual, partly psychological. In the picture below, the element of the bizarre is heightened by the formal setting with its ornate mantlepiece and framed portrait, the flamboyant hat adding the final touch to a photograph that already has surreal overtones.

The half-turned pose of the body is crucial to the success of both this shot and the picture of the girl in the swimming pool. Her generous figure with its warm brown skin tones contrasts strangely with the delicate artificiality of the mask, and the sense of dislocation and conflict this generates is increased by the deliberate awkwardness of her posture, her crooked shoulder adding to the sense of weirdness and tension.

Studio lighting

Shape and form are fundamental elements in the pictorial representation of the human figure, and the photographer must first and foremost light his subject to state its shape. That done, he must then light to bring out the characteristics of its form – its solidity and depth. In giving substance to shape, lighting can convey a wide variety of visual accents – texture, pattern, articulation, volume, mass – depending on the type of light used. The photograph below combines shape and form in a dynamic pose accentuated by the grip of the hand.

As a general guide, lighting should follow form. The best way to discover the most interesting and visually rewarding effect is to set your camera on a tripod, pose your model, and then explore the possibilities by moving the light source around, circling the model until you obtain the combination of elements with the desired degree of emphasis – but you must start with a basic idea of the effect you are seeking.

Black and white film is often preferred in experimental photography of the human figure, since it offers much bolder and more dramatic images than colour and is a graphic means of showing the subtle yet thorough delineation of form that can be achieved with directional lighting. Ideally, the light source should be one that can be controlled to illuminate selected areas: quite dramatic and powerful effects can be created by mere chinks of light produced by spotlights cut down by snoots or barn doors. Such shots can be set up with limited equipment and in limited space: all that is needed is a plain background, a spotlight, a photoflood, a reflector and a diffusing screen. As you will be concentrating on shape and form, keep props to a minimum.

The essentials of shape and form are conveyed, left, by exaggerating the pose and using oblique lighting. The dramatic effect was increased when I asked the model to strengthen his grip. I then used a diffuse sidelight to emphasize form, skin texture and the movement of muscles.

An unusual hairstyle, right, was emphasized by floodlighting. An extra spot picked out the highlights, contrasting the hair with the flat body tones. The girl, middle right, was silhouetted with a background flood, placed to one side and 6 ft away. Part of her face was lit by a spotlight with a snoot. A spot was also used to sidelight the girl, far right, regarding herself in the mirror. Overall light would have reduced the impact considerably.

Direct floodlighting from the side produced strong contrast of shapes, and tones well-balanced against each other, in the stylized pose right. High, oblique spotlighting is used to delineate rising or falling shapes, middle right. The spot threw a beam that followed the model's hair, shoulder and arm. Dramatic and selective sidelighting, against a black background, far right, revealed detail in hair and clothes. To get this effect, a studio spot was reduced to a narrow beam.

A spotlight placed about 60° from the model, right, lent her profile a delicate rim-light, enhancing the quality of skin tones and giving a soft, flattering effect to the photograph.

Constructing sets

Many of the elaborate interiors that appear in home magazines, and in furniture catalogues, are often specially constructed studio sets, designed to show off a range of furnishing fabrics, modern furniture or kitchen units. Set building is usually a preferable alternative to finding an existing location, since it enables you to work in more controlled conditions, in the familiarity of your own studio, with medium- to large-format cameras.

If a really accurate period atmosphere is needed, it may be more practical to hire existing premises or an empty house. Period props can be obtained from antique dealers – authenticity and attention to detail, where budgets permit, can make the world of difference to an otherwise sparsely dressed set.

First and foremost, you will need to make a number of flats from plywood or chipboard on a batten frame. They should have suitable doors and windows, be supported at the back so that they are free-standing, and preferably have some means of interlocking their edges to form corners. The windows should be provided with blinds or curtains. Flats can be wallpapered, depending on the type of interior needed and on the style of the furnishing fabrics used. You may not be able to include a ceiling, but some form of floor covering will be needed, such as plastic or carpet floor tiles, linoleum, or interlocking timber floorboards, which can also be used to simulate wood-panelled walls.

The type of lighting depends very much on the style of the interior. Bedroom and dining room settings are more realistic with low-key lighting, kitchens and bathrooms with high-key lighting. This is a matter of arranging reflectors in suitable positions and of bouncing light off walls and ceilings. Fake exterior views, seen through a window, add to the authenticity of the set, particularly if potted shrubs can be elevated to window height by boxes or chairs from the studio. If you intend to specialize in set interiors, it might be worth your while to invest in professionally painted backdrops as stock props.

The nursery (opposite left) was built of wallpapered flats, painted cupboard units and a matching felt carpet. An authentic farmhouse kitchen (opposite right) was used to show the style and quality of mosaic patterned floor tiles. The maker supplied the flooring, which was dry-laid over the existing quarry tiles. No additional props were required. Using existing locations saves the time and expense of building a set, but suitable ones can be difficult to find – sometimes the magazine that intends to publish the pictures will help.

Curtaining fabric was the subject of the catalogue picture on the left, the set for which was built in a country garden. The model, table and other props were arranged in front of false doors, hinged to two wallpapered flats coupled to an overhead batten. The fabric was pinned and tied back with ribbons. Large panels were used to keep sunlight off the "interior", and the curtains were lit by light bounced from reflectors.

The fantasy image opposite owes much of its mood and atmosphere to the painted backdrop. It was created for a record cover – an outlet that enables you to have a lot of fun learning to control the feeling of your pictures. Use poster or watercolour paints on lining paper, softboard or material, suspended from a wood or metal frame, and bounce the light. If your artistic gifts are limited, paint an abstract pattern of different tones and use a wide aperture to leave the background out of focus. Remember that, like theatre flats, a backdrop can be painted over again.

Camera movements

For controlled photographic work in restricted spaces and for maximum precision and image quality, the large-format camera is often invaluable because of the versatility offered by its movable front lens panel and rear film/screen panel. The panels may be able to pivot both horizontally and vertically, and to slide up and down and sideways, and the considerable flexibility of the camera is increased by moving one or both panels out of neutral alignment. By doing this you can control image shape, alter the plane of focus, increase depth of field, correct vertical and horizontal planes, and bring into the picture area those parts of the subject that might otherwise be excluded. In addition to these advantages, the large-format camera also gives remarkable quality and definition, especially in such subjects as still-life groups (right and opposite), where the movements enable you to get everything critically sharp throughout.

If you move the lens or film panel, or both, out of neutral alignment, the subject image changes. The term "covering power" is used to describe the maximum area of the focal plane over which the lens produces an acceptable image. Normally this is only slightly greater than the negative size of the format with which the lens is intended to be used, but lenses used for camera movements must have considerably greater covering power to accommodate the differences in alignment between lens and film that the movements produce, otherwise there would be cut-off at the edge of the film plane.

With the panels aligned at right angles to the lens axis and the lens focused on the model's head, depth of field includes the clock but does not extend as far as the plaque on the wall behind.

As a supplement to stopping down, swing the front lens panel. This will alter the plane of sharp focus and increase the depth of field: the plaque is now in focus.

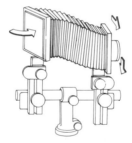

Space was limited in the studio of sculptor Henry Moore. The camera was placed in the doorway, but by a combination of movements, including swinging the back and dropping the front panel, I was able to get a top view of the table and other surfaces, and at the same time include most of the small room with good depth of field.

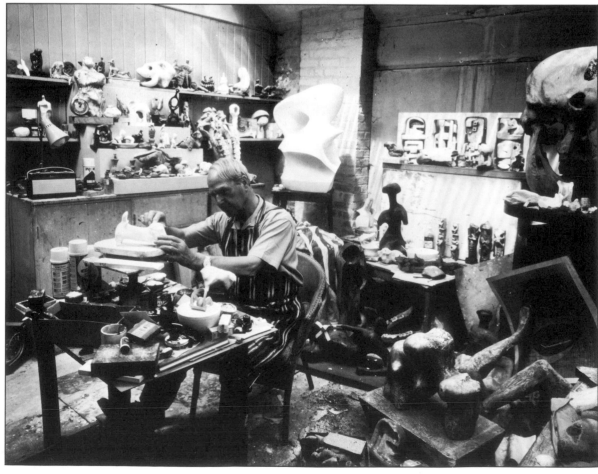

Professional photographers make considerable use of movements, and the versatility that technical cameras offer, because movements allow extension of the sharpness range and permit correction of the image without obvious distortion. The main movements are swing, tilt, rise and fall and shift.

Swing involves the movement of the panels about their vertical axes. If you swing the front panel, the plane of sharp focus is changed and depth of field improved, since part of the lens is brought marginally nearer the subject. Swinging the back panel either vertically or horizontally will alter or distort shape and, when the camera is pointed obliquely at the subject, correct perspective. Tilt refers to the movement of the panels about their horizontal axes. By doing this you can dramatically increase the coverage of the area of sharpness. In rise and fall, the front and back panels slide above and below the axis of the lens. The movements can be used, for example, to maintain verticals without their appearing to converge, which would happen if you simply tilted the camera to include, say, the top of a tall building. Rise and fall also make it possible to exclude unwanted foreground objects, and similar lateral adjustments can be made with shift (or cross) movement, in which the panels slide either to the left or the right. This effectively shifts the subject image sideways and thus enables you to eliminate objects in the frame or to include parts of the subject just outside the normal field of view.

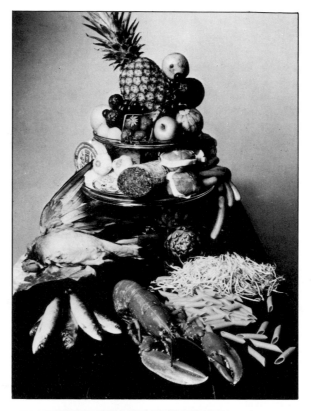

The still life left was shot by tilting the lens panel forward to match the plane of the subject as shown below. This technique makes use of the Scheimpflug principle, named after the Austrian surveyor who discovered it. The principle states that maximum depth of field is obtained over the subject plane when it, the lens plane and the image plane are inclined so that they would all meet at a common point if extrapolated. If tilt is taken to extremes, image distortion may occur in objects nearest the lens.

Combination movements are often a great help in restricted situations. Shooting down the stairwell was easier with the camera tilted as far as possible in combination with the rising front, which gave an extended viewpoint without distortion. The rise and fall enables the camera to stretch and "peer over" foreground obstacles such as walls and railings.

Interiors 1

Spacious interiors, though sufficiently lit for general visibility, may be too contrasty or too dark for detail to be recorded on film. The technique that architectural photographers call "painting with light" takes some practice, but the principle is simple enough. The camera, loaded with slow film, is mounted on a tripod for a long exposure, during which the photographer, wearing dark clothes, moves around firing bursts of flash, or using battery-operated floodlamps, in the shadowed areas. The combination of long exposure and slow film allows time for the required number of flashes and prevents anyone appearing in the picture.

The number of shadow areas to be lit can be easily assessed, but beyond that calculations are complicated by the fall-off of light according to the square of the distance from the flash, and by the probability of reciprocity failure if the exposure lasts too long. It is mostly a matter of experience and practice in taking readings from the darkest and the lightest areas, overlaying the two, then estimating the strength of the required number of flashes to make the total amount of light.

It is generally better to underlight slightly than to overlight. Overlighting will look artificial, whereas some gloom may be appropriate in a large interior.

The Great Mosque at Cordoba, Spain, was lit insufficiently, so six flashes were used during an exposure of one minute at f22. The diagram (left) shows how it was done. The skill lies in maintaining the illusion of natural light in the highlight areas while still managing to record detail in the shadows.

Cordoba was the Moorish capital of Spain until 1236; the Great Mosque was begun in 785. Its great hall is a forest of arcades; the alternating arches of red brick and white stone are supported by columns of onyx, jasper and marble.

Palladio's Monastery of San Giorgio Maggiore, in Venice, did not require the fill-in flash technique since there was plenty of available light. But I needed to shoot at a time of day when the light gave an even balance and a full tonal range to compensate for the simple, almost monochromatic setting. This proved to be late afternoon, with sunlight streaming through the windows. The figure helps to establish the scale of the interior; the exposure was 1/8 using a 28mm lens at f16.

The Gallery of Mirrors, Palazzo Doria Pamphili, Rome, was strongly lit only through the side windows, leaving heavy shadow areas. I had to "paint with light" to capture the rich detail of the Baroque ceiling, and used 12 flashes at f32.

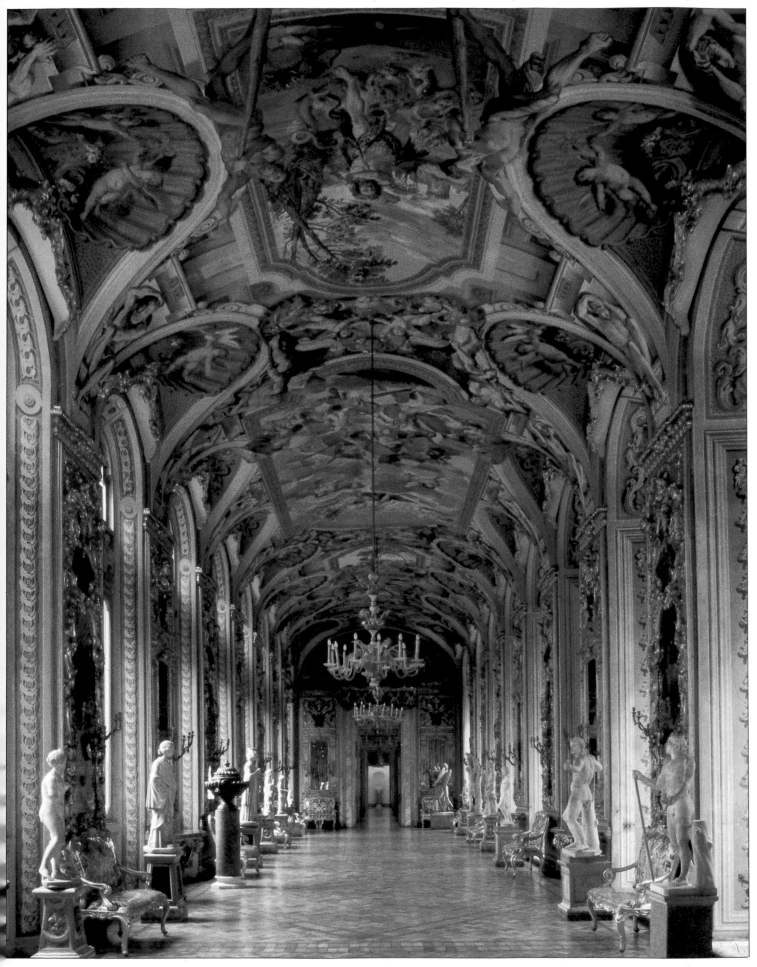

Interiors 2

Photographing in a confined space like a room demands a carefully selected camera position if you are to include all the essential features. The single eye of the lens has to take in as much field of view as your own two eyes, with their naturally wide angle. The only way round this may be to use a lens that gives the impression that the room is larger than life – a wide-angle lens will inevitably create some distortion, but will at least show that the room is, in fact, a room and not merely a corner. The effects of using very wide-angle lenses need to be understood: a 15 mm, especially, will enlarge foreground objects and distort perspective, so choose a camera position that takes in the important areas and features and check through your viewfinder to see that perimeter and foreground objects do not appear too abnormally large. Pieces of furniture

and decorative objects can usually be rearranged without disturbing the character and atmosphere of a room, although you may not need to rearrange everything. The double bed in the picture, below right, is not as wide as it looks but its lateral stretching is not immediately noticeable and the distortion is acceptable. The relationship between foreground and background objects can be dramatically altered by changes of camera angle.

If you include people in your picture – the usual occupants of the room – make sure that they are in a central area of the scene; about one-third from the centre towards the edges is as far as you can safely go without distortion. Lighting should be simple and appear natural. Use flash fill-in, bounced off the ceiling, or off a large reflector that can also act as a diffusing screen.

The Palace Hotel, Bucaco, Portugal, below left, was built in the 19th century as a royal palace. The symmetry created by floor and windows was more pronounced with the camera set in a central position. The camera, a Pentax with a 15 mm lens, was mounted on a tripod while flash was bounced off the ceiling. The model, below, is seated about as far towards the edge of the photograph as is desirable if distortion is to be avoided – and only her dressing table is elongated.

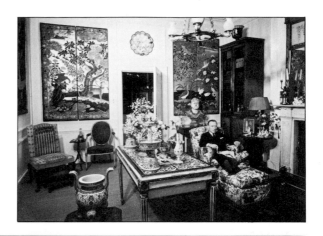

The style of theatrical producer Oliver Messel's dining room (left) suggested a stage set. Two lights, hidden behind the curtains, were bounced off the ceiling to give even illumination. The collection of antiques (right) called for the utmost clarity to bring out detail. I used a 5×4 in camera, an aperture of f45, and bounced electronic flash. The combination gave knife-edge sharpness from foreground to background.

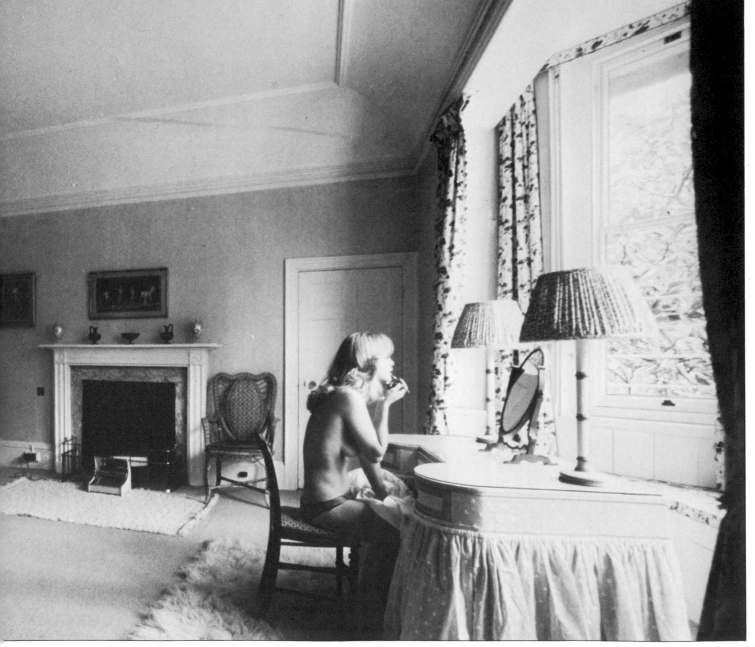

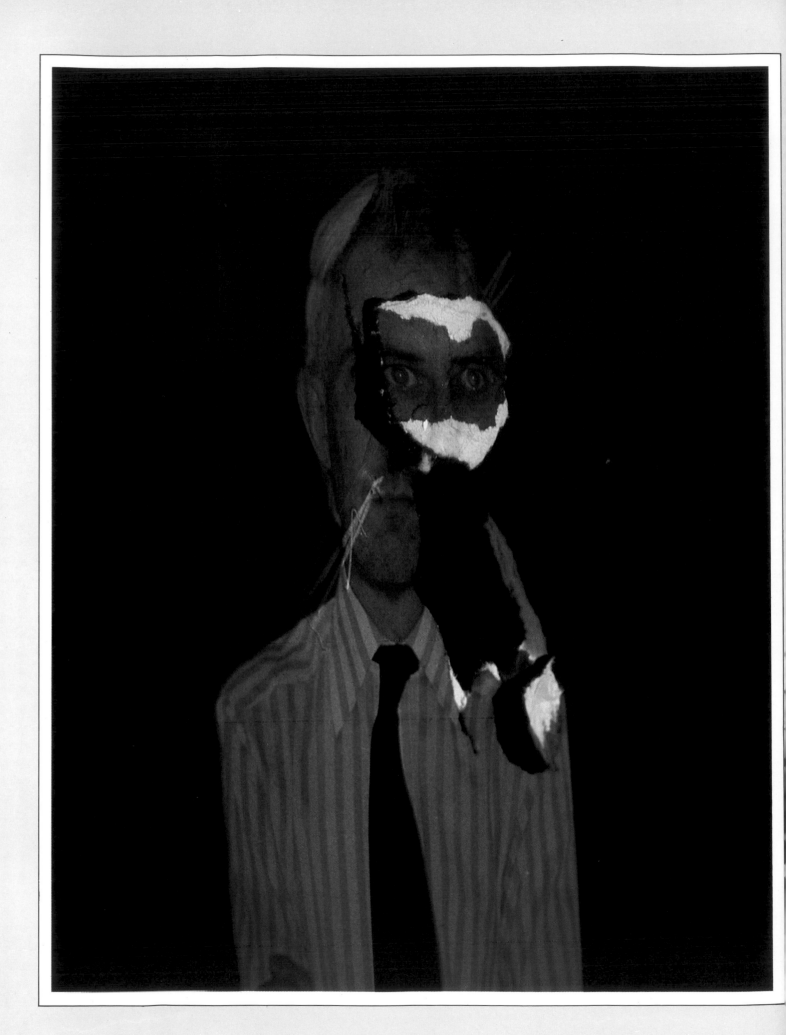

CHANGING THE IMAGE

This section looks at some of the many ways in which equipment, technique and approach may be used to move the image away from reality into the world of illusion. This is an area of photography where you can let your imagination run free to lead you where it may, but it is also an area where a coherent idea of the final result is needed in order to achieve the imagery that supports the fantasy. The phrase "trick photography" implies that there is some secret technical knack in creating pictures that are a blend of fantasy and reality, but the special effects are often the result of painstaking experiment between the original concept and the final picture.

It is precisely this type of photograph that can display your future promise or your acquired mastery of creative photographic processes, giving you the freedom to be surreal, subversive, funny or fantastic. The section that follows includes ways of exploiting the medium by means of unorthodox ideas and techniques. Discovering how the pictures were done should encourage you to establish your own ideas and to devise ways of changing the image to convey your flights of fantasy through the medium of the camera.

Multiple-image portraits

From its earliest days, photography has been prized for the astonishing fidelity with which it can record the world around us; but photographers were quick to discover that the camera could also be used to deceive the eye, to transform the everyday world and to make the impossible seem possible. Manipulations of scale, viewpoint and time, together with such techniques as montage and retouching, could expand the range of the art, and give it greater imaginative scope. Almost all good photography, of course, involves a degree of imagination, but there are some areas where it is much more important than in others, and where the photographer has greater freedom to express his ideas. Whereas a painter is able to realize on canvas whatever

fantasy he may envisage, the photographer must master a whole range of techniques to give rein to his imagination and inventiveness.

Certain fields of advertising and design are perhaps the areas most readily associated with original imaginative work in photography, for bold excursions into unconventional imagery, at times verging on abstraction, have proved a means of arresting and holding public attention in a fiercely competitive market. Often the finished image involves an enormous amount of work, especially in the darkroom and studio, where techniques such as montage, posterization and solarization make possible a variety of dazzling effects. Since the 1960s the pop music scene has been a stimulating and

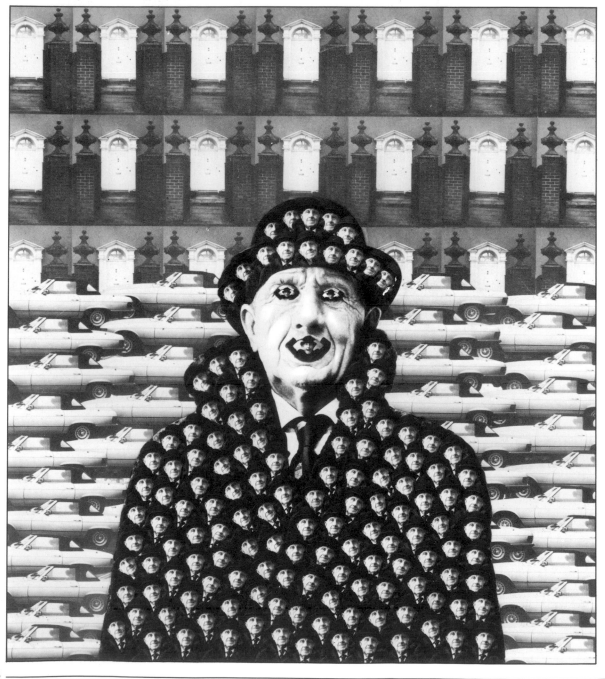

The man in the bowler hat (left) required 160 printings of the same image. The car and the architectural features were, similarly, straightforward shots that were printed the required number of times. All the images were mounted on white art board to be re-shot. The avenue of trees made from human heads (top right) and the multiple-head picture below it were made in the same way, with prints cut out, mounted and rephotographed. To help create a sense of depth, the trees in the background were lightened during printing, subtly suggesting aerial perspective. 121 separate cut-outs were used to make the multiple-square portrait (bottom right). The original portrait was lit so as to provide strong contrast of light and shade and built as a composite picture that can be read horizontally or vertically. Finally, the seemingly towering girl (far right) is a composite image made up from photographs taken from three different view-points, creating an effect of disquieting eroticism.

liberating influence on related fields of creativity, and stunning visions have been produced for record sleeves and both book and magazine covers.

The pictures on these and several following pages all take the subject of portraiture as a jumping-off point for imaginative exploration. The multiple-portraits here, made by enlarging or reducing photographs and mounting them into composite images to be rephotographed, required a clear preconception of the final result. As in all work of this sort, it is essential that vision and technique go hand in hand: imagination without sufficiently polished technique can produce crude-looking results, and technique without imagination can lead to repetition or empty virtuosity.

Distorted portraits

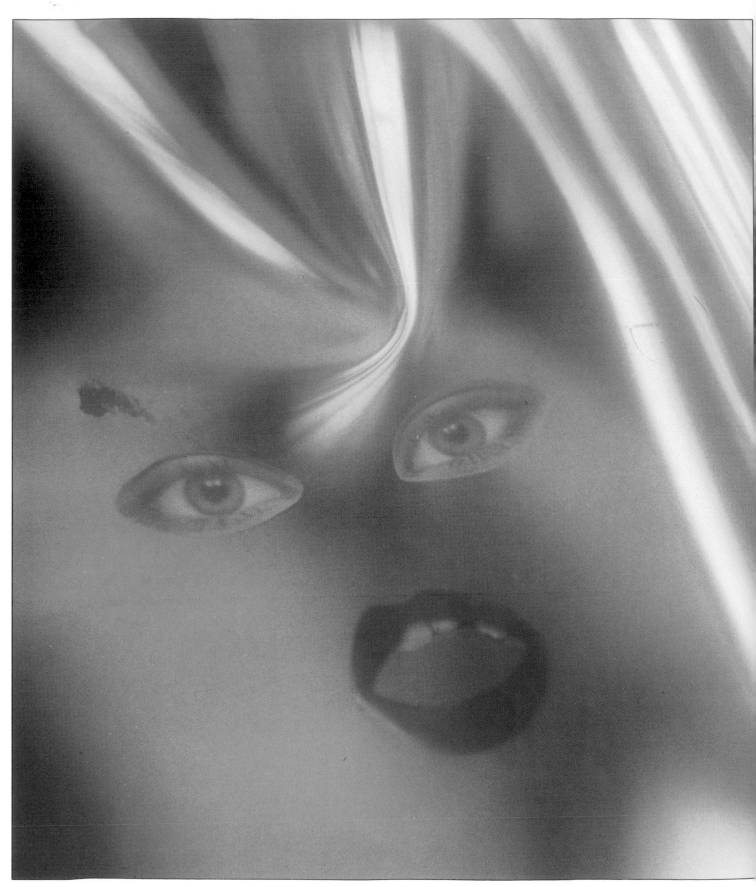

Deliberately distorted faces upset our conventional ideas of beauty and regularity. They can excite fear, humour or concern – but never indifference. This is particularly true when distortion is exploited by the camera, since we associate photography with reality and the representational and are bound to feel disturbed when what is clearly a photograph is also clearly unreal.

Wide-angle lenses will, of course, distort the subject, especially in close-up, but the effect is no longer novel. Mirrors, tin cans, reflectors, torn fabrics, metal foil, projected photographs and transparencies, montage and darkroom techniques offer a far wider range of distortions or manipulations. Of the pictures shown here, the first, left, is a deliberate distortion of a portrait photograph while the second is a "found" image – a torn poster with graffiti added. The distortion in the third is accidental, caused by a tear in the film leader. The fourth is an abstract construction, part montage.

What value and application have such images to practical photography? First, because they are unconventional and disturbing they can be of considerable importance in graphic design, catching the eye in a situation where one image has to compete with hundreds of others. Second, they reflect the skill and imagination of the photographer, whether in building up an image from scratch or in recognizing the potential of those accidentally created or found. It is one thing to spot a potentially interesting distorted or abstract image, such as the torn poster below, and to keep it in mind for future use; quite another to create your own images, where you need to start with a fairly good idea of what you are after. A client's brief can often provide the stimulus. The picture on the opposite page, for instance, responds to a brief calling for an abstract or depersonalized face to illustrate a book dealing with abnormal psychological states and the nature of dreams.

A haunting image (left) was made by sticking features on a chrome glazing sheet which was distorted in a flexible plastic mirror. Two cylinders of metal foil provided further reflections.

A flybill covering part of a fashion poster (top) had been torn off leaving a space too tempting to go unmarked. The resulting pencilled face made a "found" image more arresting than the original poster.

The sinister shot above was pure accident born of parsimony. It was made before the counter had registered the first frame, and was caught and damaged in the film clip during processing.

The soulful eyes and mouth far right were montaged on plastic outlined with beeswax so as to guide a downward flow of viscous brake fluid.

Surreal portraits

Bizarre special effects in portraiture can often be created by fairly straightforward means, the idea being more crucial than the actual technique. The eerie image at the right, a book jacket illustration for a thriller set in a mountain village, is a simple montage of four elements made disturbing by their juxtaposition. A more laborious process led to the portrait of Queen Victoria as a young girl (left), for which the contents of a teapot and fragments of a souvenir Prince Charles mug were used. A tracing of the Queen was placed under illuminated white opal glass and with this as a guide the shape of her head was brushed in with tea. Details were added by arranging pieces of the mug and adding tea-leaves placed with a pair of tweezers. Top lighting was used for the final shot, with the light under the glass turned off.

Magritte's surrealism, with its witty visual ambiguities, was the inspiration for the pictures (left and right) in which the mirror images seem to escape from their frames. The girl's legs and arms, the clock and the sideboard were all montaged on separately, while her face was photographed straight as a reflection. Shadows added with an airbrush complete an ideal birthday card for a secretary with one eye on her makeup, the other on the clock. Less extreme tricks with reality are played in the picture of the man holding a shirtsleeved mirror montage, yet the element of surprise is almost as great, as the apparently normal image is re-read in a double take. The larger picture (far right) was created by carefully cutting a portrait print into strips, pasting them on a tin spiral and rephotographing with a hand holding the spiral. The result is an image of skin-deep personality – a head that seems to have been peeled like an apple.

Filters for fantasy

Composite images, normally requiring a complicated set-up, can often be simplified with a combination of filters and darkroom work, and without the use of expensive sets, backgrounds or locations. The inventiveness of filter manufacturers is evident in the very large range of patterns and colours available (see page 168), extending the scope for exciting pictorial effects, especially with coloured film. The use of these filters will enable you to compose scenes with an inventive eye, composing subjects with elements of fantasy, as in the picture below, or re-creating in the studio the atmosphere of an actual event, using filter attachments on the lens and on the lights (opposite page). The shot below was made on one frame with a double-exposure filter; although there is a definite division between right and left on the filter, enough light spills over so that there is no evidence of a join on the final image. As the shot was one of a series of experiments for Ford, I decided to elaborate, adding storm clouds and foreground waves.

The seascape was first shot with a double-exposure filter (shown above), exposing half the frame with the car in it. With the car removed and the filter rotated 180°, the girl leaped into the air. Montage elements were merged (below) by means of an airbrush.

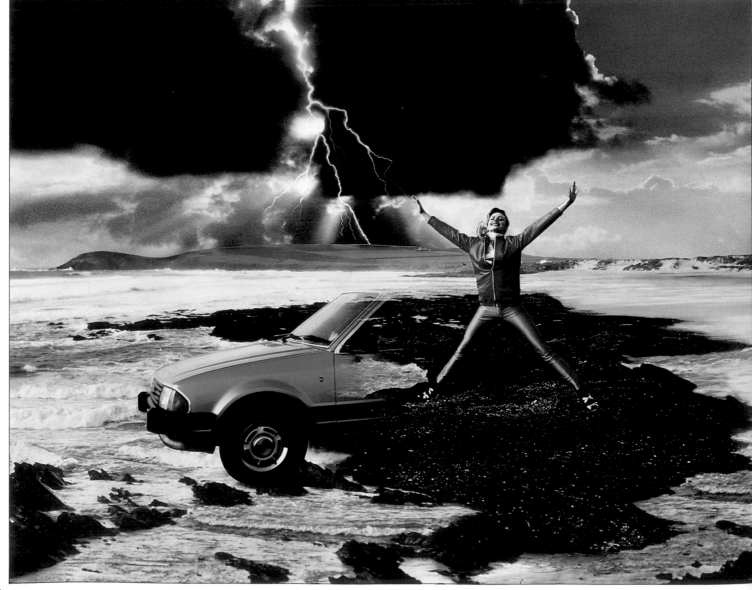

Pop concerts are difficult to shoot because of limited space, the crush of people and problems with lighting. In concert conditions, the performers are far too busy performing to strike the kind of pose that may be needed for a record cover or other commercial purpose. A more controlled effect can be achieved in the studio, where filters and coloured lights can produce dynamic visual effects. Liberal application of glycerine to performers' faces re-creates hours of perspiration. For this picture, diffraction and starburst lens filters were used, as well as four floodlights with coloured gelatin filters, two of them aimed mainly at the mirrored-foil background screen, as in the diagram (above).

Manipulated portraits

Unconventional materials – a cushion, a photo-copy, a computer print-out – were used to produce half the portraits shown here, and two others were specially screened. By choosing to manipulate the image, or by choosing an unfamiliar material on which to reproduce it, the photographer has been able to arrive at a result that is a creative interpretation of the original subject. At the same time, it is worth noting that the portraits have not lost much of their essential descriptive quality and are still reasonably good likenesses.

Screening a print can increase contrast or soften it. A form of screening is essential in preparing a photograph for reproduction in a newspaper, magazine or book – shooting a print through a half-tone screen yields a negative composed of tiny dots which can be photo-mechanically transferred to a printing plate. Size and spacing of the dots determine the density of the tone – highlights have few dots, shadows many.

The photo-copy portrait of painter William Scott, right, was produced by sliding a print across the glass of a photo-copy machine while the exposure was being made. Trial and error established the speed needed to produce the desired elongation.

Turning John Hedgecoe into a cushion cover involved making a tracing of the original print, above, and then enlarging it to the size of the cushion by means of a squared grid. The enlarged design was then transferred to art paper and coloured with crayons to resemble the final wool stitches. The final transfer to the cushion, right, can be done in other ways – by tacking through the tracing paper, for example.

Special screen effects using the half-tone process begin with a process camera, which photographs a print of the subject through a mechanical screen in contact with the film. Exposure produces a negative image made of fine dots or lines. Soft effects and detail in the shadows are obtained by a flash exposure (brief fogging). Screens such as the mezzo screen allow normal high-contrast results with normal exposures, far right. The step-tone screen creates a posterizing effect, right.

Detail, left, of the computer portrait below illustrates how the computer assigns a symbol to each tonal density, overprinting when solid blacks are required.

Computer portraits, shot by a video camera linked to a computer with paper print-out capability, require careful lighting so that there is a good range of tones and strong modelling. The result, below, is made up of computer symbols, which overprint to produce the solid blacks in the portrait. If an enlargement or reduction is required, then a copy negative must be made. The computer portrait produces such a convincing image because the brain interprets rather than simply records what the eye sees and constructs familiar patterns and shapes when it is given certain visual clues.

Inventive advertising 1

Advertising is a voracious consumer of ideas. To capture and hold the public's imagination – which, in commercial terms means imprinting a brand name upon the consumer's consciousness – the advertising agencies have constantly to produce new slogans and fresh images. In doing so they provide photographers not only with lucrative assignments but also with challenges both technical and imaginative.

The first step in qualifying for an agency commission is to submit a portfolio of work to the agency's art director. Apart from technical proficiency, the agency will be looking mainly for a unique way of seeing things – evidence that you have some flair and imagination – for many commissions require a team effort in which visual as well as editorial ideas are needed. One of the best ways of demonstrating your ability to come up with ideas is to submit fresh visual treatments for popular products for which new concepts are constantly sought.

Agencies maintain a budget to finance experimental photography on certain accounts and to encourage photographers to work towards inventive treatment of the product. This may range from a complex idea of the service and routes provided by an airline, as conveyed by the picture opposite, to an apparently simple "pack shot", such as the soft drink bottle below. Meticulous preparation and attention to lighting detail and camera angle usually lie behind the simplest-looking advertising photograph, however. The execution of the shot must be as convincing as the original idea or the agency is likely to ask for a reshoot at your own expense.

A composite picture can often convey more varied information than a conventional single shot. This is particularly true in travel advertising where the aim is to present a number of appealing images and ideas. The advertisement opposite for British Caledonian Airways sums up the romance of faraway places. Here, it says, are tropical beaches, exotic food, relaxation, nightlife – all due to the superb service of BCA.

The soft drink advertisement (left) was designed to express the idea of health and vitality. The girl was photographed posing in a pool of orange water coloured with vegetable dye and this shot was montaged with one of a bottle with a torn label, then rephotographed.

The pure juice concept (below) was implemented by cutting a bottle in half and sealing the openings with plastic plugs. Sliced sections of fresh orange were fixed to the plugs with adhesive: knowing that complex and inventive images attract close attention, and that details have to be right, I cut dozens of oranges until I found a perfect specimen. The bottle halves, filled with orange juice, were juxtaposed with the single fruit and shot as a group. Dripping juice was airbrushed on to the retouched print.

Inventive advertising 2

One of a series of shots for a calendar, this picture, taken in the grounds of Syon House, near London, was intended to provoke a feeling of mystery and tension, leaving the viewer to decide the nature of the relationship. Vaseline smeared on the lens gave a sense of movement. The cover of *Radio Times*, opposite, combined the Albert Hall, a symbol of London's musical life, with typically English landscape. The image was made by masking out the Albert Hall on a print of the landscape (right) and then printing it in. Some minor retouching was necessary.

The purpose of an advertisement – and of a book jacket – is to arrest your attention and to deliver a message. Until recently it was considered essential to convey the message as rapidly and as simply as possible, and advertisers liked to quote the example of a viewer passing a poster in a car or train – if the message failed to come across instantly, then the poster was not working. While book jackets tend to follow this principle, because each has to compete with a bewildering display of other jacket designs on the bookstalls, some types of poster have lately become less aggressive and instead have revealed a teasing or surreal approach.

The choice of a bizarre, offbeat or amusing image allows more scope for the imagination – both of the viewer and the poster's designers – and escapes from the conventional and often boring "pack-shot" of the product. To get across the hidden message that relies on the triggering of an unconscious response, art directors and editors are encouraging more sophisticated designs, and demand from photographers and artists a hard-working yet imaginative series of pictures. A range of commissioned advertising work is shown in the pictures on these pages, some of which combine techniques of double exposure, front projection and sandwiching to achieve their particular effects. It is worth including some more surreal imagery in any portfolio you take to publishing houses and advertising agencies – even if your pictures do not meet the art director's requirements, they may give him confidence in your imaginative skill and ability. For this reason it is important for all photographers, the newly fledged and the seasoned professional alike, to be aware constantly of current trends and ideas. Keep an up-to-date scrapbook of pictures clipped from magazines and from newspapers, using them as a stepping-off point for your own ideas.

The book jackets, right, show a variety of techniques. Clockwise from top left: (1) front projection, with the silhouette made by exposing for the background; (2) superimposed images made by projecting with a zoom lens and copying; (3) images of micrometer and model (lit with masked spot) projected and re-photographed; (4) a jigsaw pattern sandwiched with head and re-photographed.

RadioTimes

Our country's music

The 1977 Henry Wood
Promenade Concerts
start at the Royal Albert Hall
with a celebration
of British music,
The First Night of the Proms,
Friday BBC2 and Radio 3.
Back feature:
conductors talk about
Britain's summer festival

Record covers

Over the last 10 or 15 years, Tin Pan Alley – and its more serious neighbours – has provided photographers with one of their most creative outlets and one of their steadiest sources of income. The pop music business has become so competitive that album covers have to fight for attention in the record racks; and even the most serious music is now packaged for commercial appeal. Long gone are the days when a label stuck around the spindle hole conveyed everything that was to be said about a record, or when a white slip cover with "Beethoven's Sonatas"

printed on the outside was considered eye-catching enough to attract prospective buyers.

Pop music undoubtedly provides the photographer with his best chance of doing something off-beat. Serious music favours serious covers, and these are often made up of stock landscapes or portraits bought in from photo libraries, though EMI, for example, does commission photographers to shoot portraits of famous performers or of newcomers the company wishes to promote. But the very nature of pop

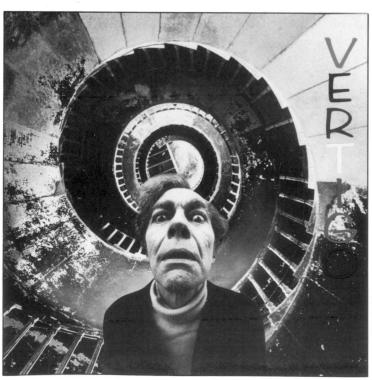

music calls for a vigorous style. Of the five photographs on these two pages, only one can be considered "straight" – the portrait of pianist Alfred Brendel. All the others are imaginative exercises, varying in the degree of technical complexity and the amount of sophisticated equipment needed to achieve the desired result.

The shot at top left is a direct photocopier "portrait", obtained by placing the subject's face against the glass screen of a photocopier and then hand-colouring the result. The planet top right is a scale model, shot against a black card background pierced with holes and back-lit – the blurred effect was produced with a zoom lens. A 15 mm wide-angle lens was used for the head at bottom left, which was then montaged on a print of the staircase. The girl's head, below, was shot on 35 mm slide film and then projected on to a screen. The screen image was filmed on a video camera and electronically processed by a colour separation overlay unit to create a posterization effect. This image was rephotographed to obtain the final slide.

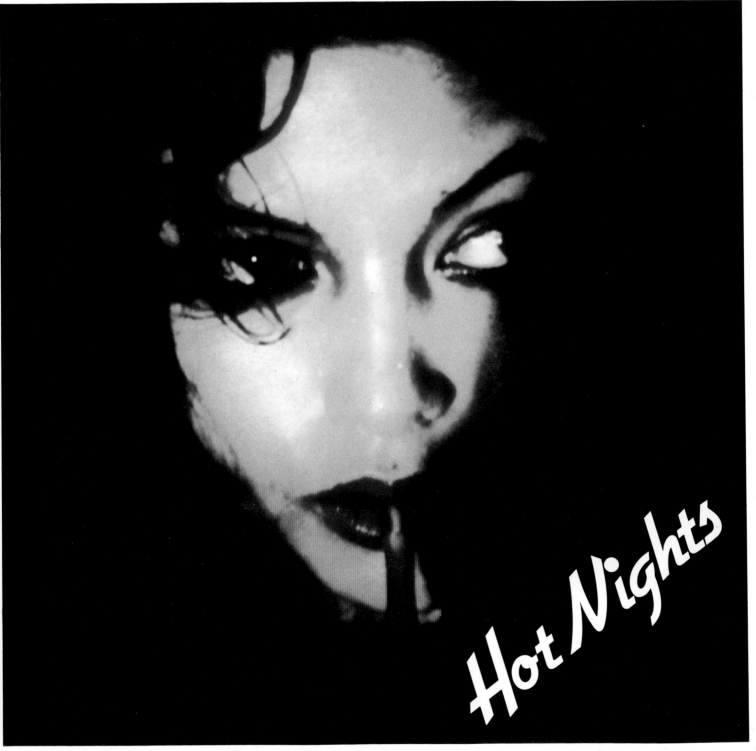

Hot Nights

Surreal nudes

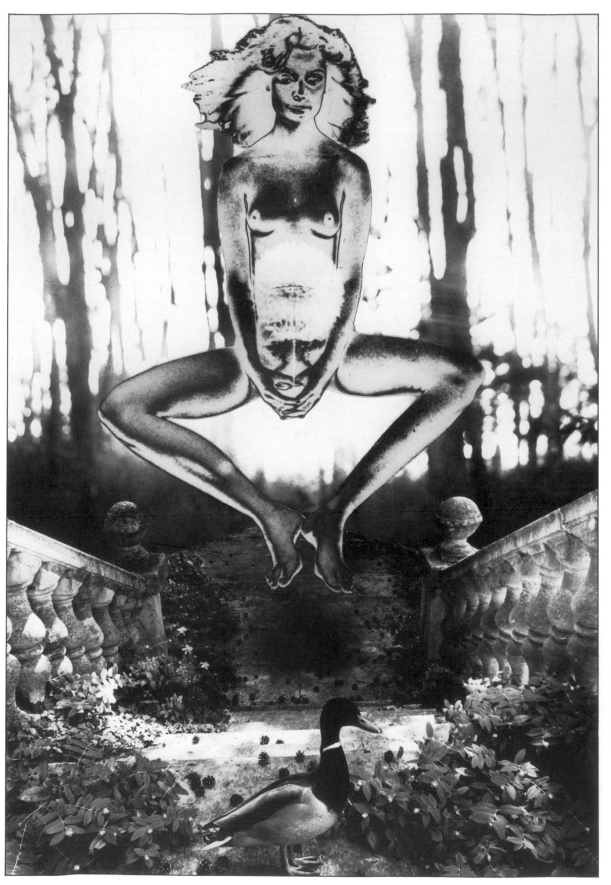

Enhanced images of a main subject, such as the solarized print of a model (far left), may need a supporting background. The staircase was chosen first, then the image of the trees, overexposed about 100 times, was montaged on to the steps. The duck provided a foreground element to lead the eye into the picture. Constant experimentation, using a selection of images, is needed to achieve harmony between different elements – or a forceful picture based on a conflict of elements.

A china hen (above left), juxtaposed with the model's contorted figure, provided a straightforward yet carefully arranged shot. The upper half of another girl (left) was cut from a print and inserted into a slit made in the background print. This was then rephotographed and retouched. The montage of selected prints (bottom left) was made from cut-outs, the edges of which were carefully chamfered and blackened so that they blended together.

The eerie power of the right-hand picture derives partly from the imagery itself and partly from conflicts of perspective and scale. With careful selection from your stock shots you can create an almost unlimited number of fantasies as long as the elements are blended so that they work together. Try to avoid light from too many directions. Here, shadows were added by retouching the body of the zebra-striped girl, shot originally in the studio. Other montaged elements are the planks, two different skies, the bird and an interior view of the celebrated octagon at Ely Cathedral.

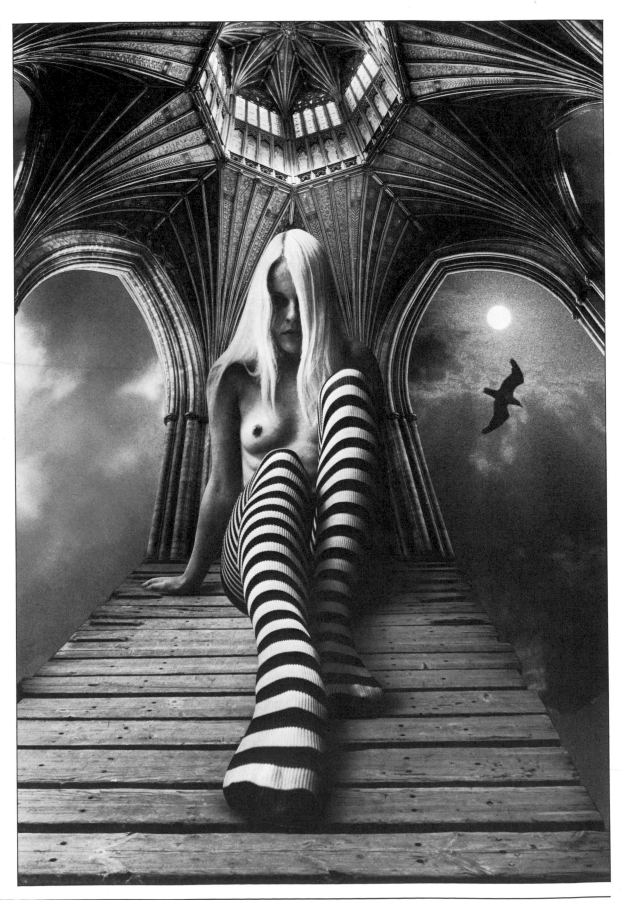

Experimental assignments

The ability to transcend reality is almost an essential part of advertising photography, in which even a straightforward shot of a can of beans becomes an excercise in imparting extra lustre to the metal or impact to the label. A more free-wheeling inventiveness is needed for those rare assignments in which, instead of producing pictures that will be used to sell products, the aim is to stimulate the advertisers themselves. As with many successful advertising photographs, the key element in these experimental shoots is fertility of imagination rather than technical expertise. The client is looking for new ideas and concepts: novel approaches that may subsequently be adapted to form the basis of magazine, film or television advertising campaigns.

Unlike most advertising work, in which the photographer has a tight brief and the shoot is supervised by an art director, experimental assignments allow complete freedom of action within an agreed budget to cover costs, including hotels, models or travel. For the shots of the Ford cars shown here, the brief from the creative director of the company's advertising agency was to produce half a dozen pictures unlike anything the agency had itself done. Apart from a series of associative words – speed, elegance, aerodynamics – suggesting the image the company wanted to promote, no directive was given, and the scope for humour and fantasy was therefore unlimited. Most of the pictures are the result of first photographing an evocative background and then using montaging techniques to produce fanciful images.

Working from a library of stock shots it is possible to arrange effective montages simply by cutting out prints of the various elements at suitable sizes. But pre-planning achieves more convincing results, with accurate matching of contrast and colour. Once each subject has been photographed at the appropriate angle, the size of print needed for each element of the montage can be worked out on a Grant projector (a piece of apparatus, used chiefly by designers, for reducing and enlarging images) using a tracing of the background shot. For the multiple image of the connecting rods it was necessary to use the more accurate positioning technique made possible by a Forox camera, a sophisticated type of bench camera designed to form complex images for audio-visual programmes. The original photograph was of a silver rod, toplit and shot on black glass to give a sharp black reflection, then copied to heighten the contrast. The Forox camera enabled this image to be exposed in 18 separate positions in precise register on a single 35mm transparency. From this, a large R-type print was made on which the car itself was montaged five times and the vapour trails finally added with an airbrush.

Recent technology enables unconventional photographic imagery to be produced without time-consuming steps that would once have been necessary. The apparently solarized images here, for example, were made by operating the controls of a colour separation overlay unit and photographing the results off the television screen. The various images were fed into the colour synthesizer by means of a video camera, which was used to photograph off a light box a series of 10×8 Ektachrome shots of a car.

The cars, or details of them, were shot at various angles to be montaged on to these selected backgrounds: Some images are too delicate to allow montaging without a good deal of airbrushing, as in the wind-blown tree. For this, a line positive was made of the tree from a black and white print and sandwiched with the vivid red sky. An airbrush also provided the vapour trails in the picture of the car flying with outspread doors, and in the connecting rod sequence as described in the text. The avenue of spare parts was made simply by printing the front and rear of the car with one-third increases in size. Angle of view was important in the picture of the car parked in a Tudor courtyard. The car was montaged on to a stock shot, then painted with motifs from the architecture. The reflection of the car in the river is a pale upside-down print, and a tracing of the car was used to work out the print sizes of the 28 balloons that carry it. Further play is made with car shapes in the two topiary pictures where shots of hedges or flowers were cut out and montaged with appropriate landscapes.

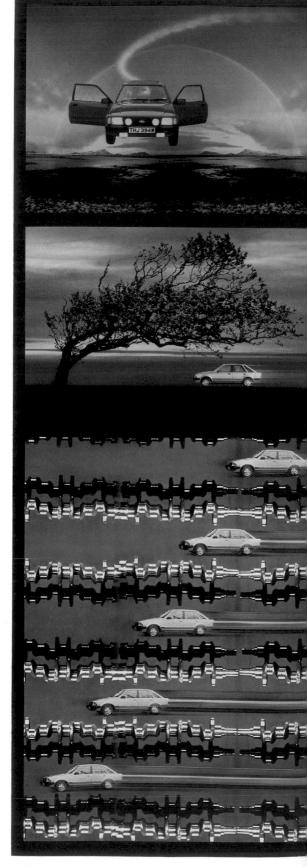

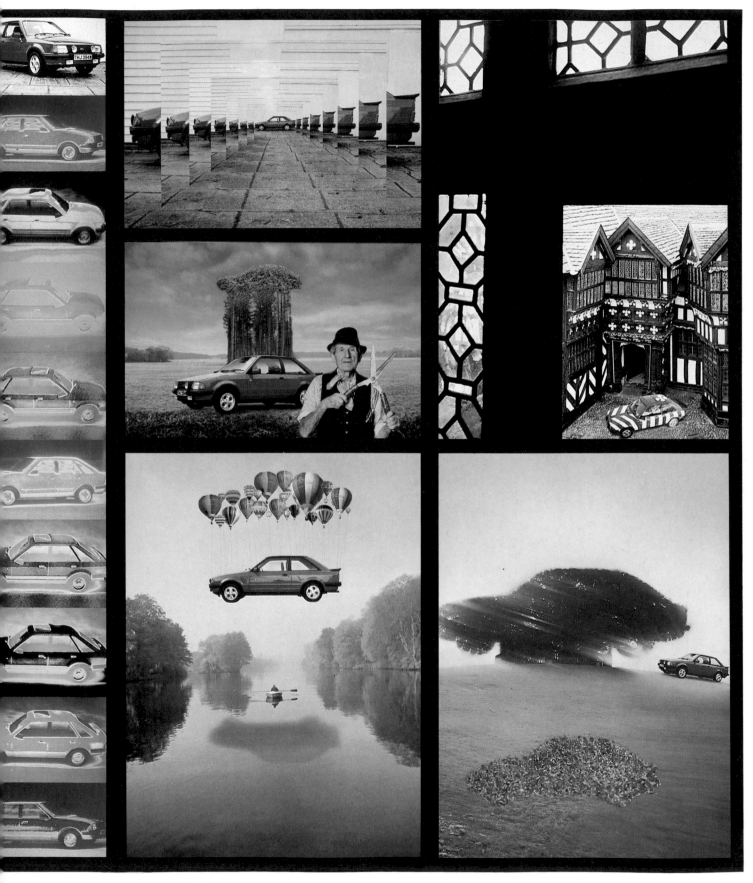

Dimensional variations

Apart from holography, which is not a photographic process in the normal sense, the most successful – as well as the oldest – method of creating an illusion of three dimensions on a two-dimensional surface is stereoscopy. Invented in the 1830s, this system represents an attempt to duplicate the binocular vision that gives us a sense of the roundness of objects. Whereas the normal camera has one fixed lens, and thus a fixed viewpoint, our two eyes communicate information from two viewpoints roughly 2.5 in apart. Stereo cameras similarly use two or more lenses to give slightly different viewpoints of the subject. The separate images fuse to give a 3D effect when viewed in such a way that they are seen respectively by only one eye. Currently, the Nimslo 3D system provides an integrated 3D colour image taken with four lenses and mounted beneath a thin plastic micro lens. Closely allied to stereoscopy is xography, in which a cylindrical scanning lens and a cylindrical "lenticular" screen over the film are used to record a subject as a series of left- and right-eye viewpoints alternating across the surface of the film – then viewed through a corresponding screen.

A further technique of giving depth to a subject is vacuum forming, which exploits printing distortions to fit a photographic image to a three-dimensional form. Conversely, periphotography involves moving around a three-dimensional object in order to record its complete surface in two dimensions.

Periphotography

Designed to photograph objects in the round, periphotography was devised at the end of the nineteenth century when an instrument called the Cyclograph was used to record all three dimensions of ancient ceramics, allowing studies to be made of the entire decoration in the form of a frieze. The results were valuable for the illustration of academic papers and books. Subsequent improvements led to the design of the R.E. Periphery Camera in 1961, and it has since been employed to record, for example, a fingerprint on a pencil, the periphery of suspect tyre treads in road safety tests and, through the medium of infrared film, the heat patterns of cylindrical objects. Whereas the periphotograph of the vase produces an image close to our expectations, the portrait at the bottom of the page shows the bizarre results of portraiture with this type of camera.

How periphotography works

The camera, a turntable and a control unit are mounted on a bench. The subject is centred on the turntable, which then rotates in precise synchronization with a roll of film moving behind a stationary slit. Objects of an irregular shape would normally produce a blurred image where the circumference varied markedly (as the radii would travel at different speeds), but corrective adjustments can be made to the width of the slit with some accuracy.

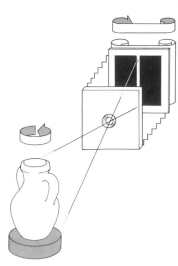

Vacuum forming
Vacuum-formed images are used for point-of-sale posters and displays to provide a greater advertising impact than could be given by a flat display card. They are made of uniformly stable PVC extruded sheet carrying a printed image of the subject, vacuum-moulded on to a forme or matrix – a rendering of the subject in relief, hand-made by skilled mould makers. After being photographed in the normal way, the print is manipulated so that allowances are made for stretching or distortion of the image to fit the matrix. The result is inevitably a compromise between the flat and the relief image, but skilled printers can achieve convincing images with limited distortions, as in this self-promotional image for a vacuum-forming company. It is not fully three-dimensional, as this would require considerably more artwork, but is designed to be seen from a fixed viewpoint.

Beam splitting (below)
A simple form of stereoscopy uses an attachment fitted over a normal camera lens to give accurate stereo pairs of a subject on a single frame of film. The image is split by means of a prism and mirror system on the adapter, which operates in such a way that the subject is seen from two angles simultaneously.

Left eye

Right eye

Stereo pairs
A stereo pair can be produced in an ordinary camera by making two exposures with fractionally different viewpoints. In the still life above, a sliding cradle was used to shift the camera sideways by 2.5 in. In the picture with the left-eye viewpoint, there is a distinct gap between the glass of wine and the bread-board, which the right-eye viewpoint has eliminated. Astronauts have made stereo pairs on the Moon by shifting weight from one heel to the other. Stereo mounts, viewers and projectors are available.

Inducing movement

Bringing action and movement into a picture normally means capturing a split-second peak of activity that sums up the whole event. To know when to release the shutter calls for experience and constant practice. A peak moment occurs in every non-static subject: even a conversation piece may prove to have plenty of activity in terms of facial expressions and gestures. Yet with all the experience in the world, you are bound to encounter occasions when you miss the peak moment, when a sense of movement must be suggested in something static, or when, for reasons of composition or impact, you want to strengthen the impression of energy and action. At such times you can create movement by using techniques such as those shown below.

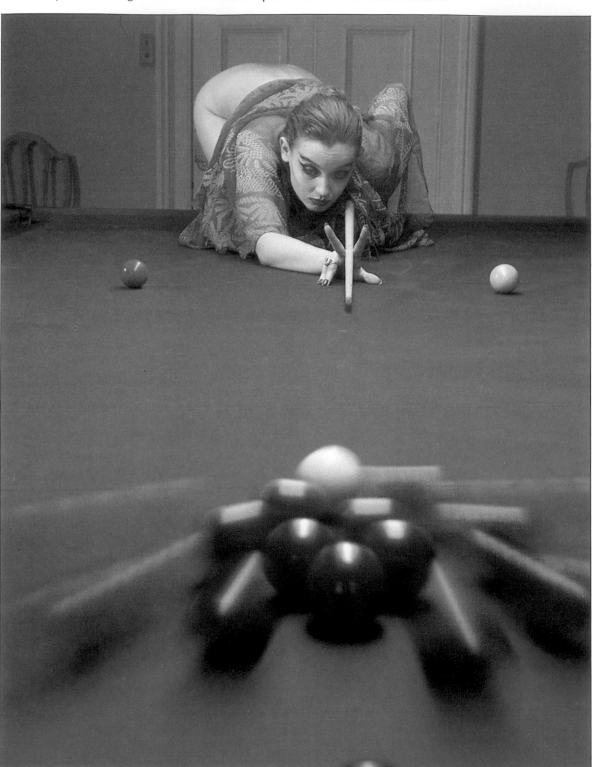

A masculine stronghold is invaded by the forces of feminism at their most informal – and a hard-driven white cue ball (neatly reflecting a trim white posterior) scatters the massed ranks of resistance. The model held her pose while an assistant, off-camera, rolled the white ball into the reds: the effect of movement was produced by using a slow shutter of 1/15 with the camera mounted on a tripod.

Galloping Berbers have been photographed many times. To enliven this familiar subject, I chose to use a slow shutter speed (1/15) and panned the camera. This technical combination blurs the background completely while leaving the centre of interest recognizable and, by spreading the colour, helps to intensify the impression of action.

This speeding Ford was in fact parked when photographed. The impression of movement was created by a prism filter. The filter works either vertically or horizontally, and best against a plain background. Though its creative use is rather limited, it can often create the feeling of action in an otherwise static shot. Prisms are available to repeat an image 3, 4, 5 or 6 times.

Three separate images were made of the gymnast by electronic flash. Then each was copied on to lith film and positives were made from the resulting negatives. Each negative and each positive was sandwiched with opal backing material, bottom-lit with a green filter, and shot by a copying camera on to a single colour transparency. The process is a neon effect via a lith conversion.

Rephotographing

A print made from a negative is by no means the ultimate stage of all photographs. You can experiment with your printed images to give unusual, manipulated effects, which can then be retouched and rephotographed. Montaged prints or an image combined with the same image reversed, are examples of manipulations that can be reshot to give you a master negative.

An experimental approach to the compound image is to exploit the possibilities of combining a print with the actual scene, a form of montage where the photograph or photographs can be physically related to the original subject, to the location, and to each other – the pictures of the tree on the left are examples of this technique. Another is to try for a "see-through" or layered effect. All these ideas can be used to amuse, provoke and upset visual preconceptions.

In the first photograph of the tree (above left) a print was rephotographed with the tree itself; in the second, a print of a section of the tree has been held so that it appears part of the original subject.

The double portrait at the left was made by mounting cut-out squares taken from prints of the subject on to wooden bricks. The black triangles add variety.

Making a life-size print of a section of the sphere was the first step in creating the shot at bottom left. A rectangle of black card, the same size as the print, was fixed to the sphere and the print glued to the fork.

The portrait below is a combination of two separate shots, a full-face portrait and a second with the sitter's hand over his face. The negatives were then printed on to a single sheet of paper.

The girl apparently ripping her own photo was first shot holding the loose paper. Then the print was rephotographed with a shot of her midriff placed behind the torn section.

 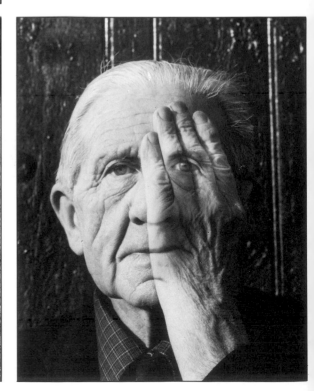

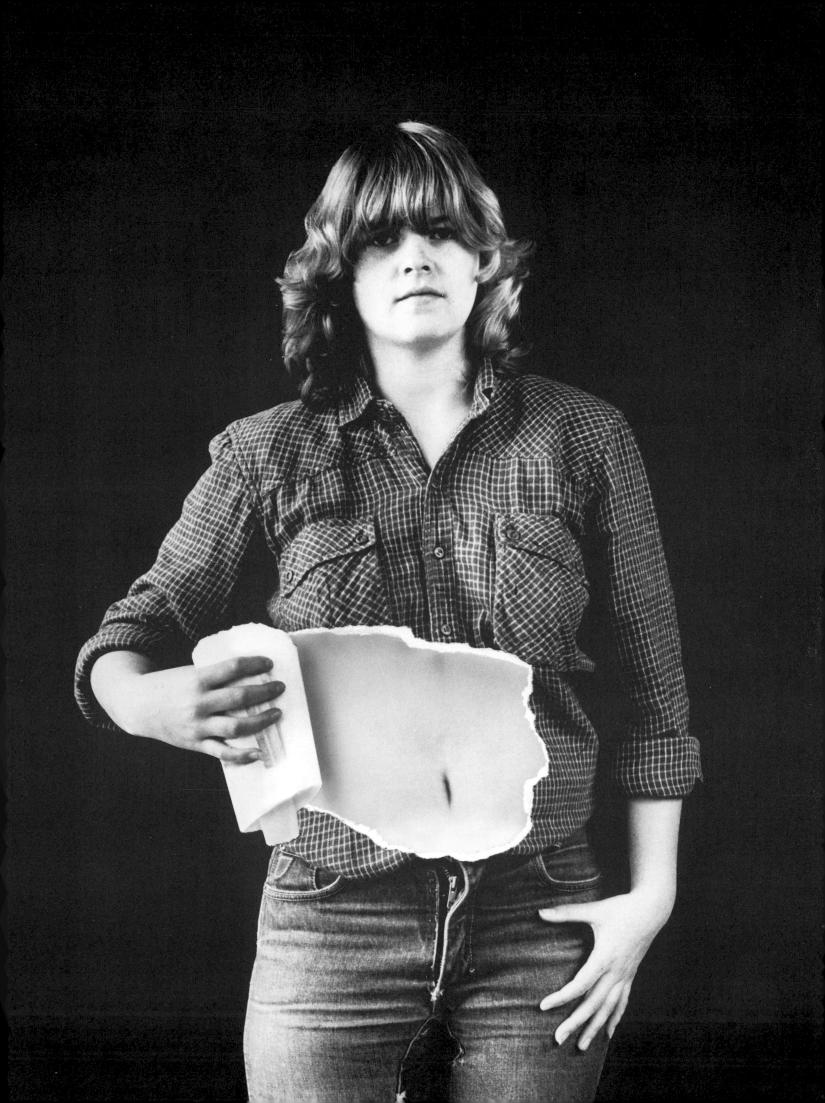

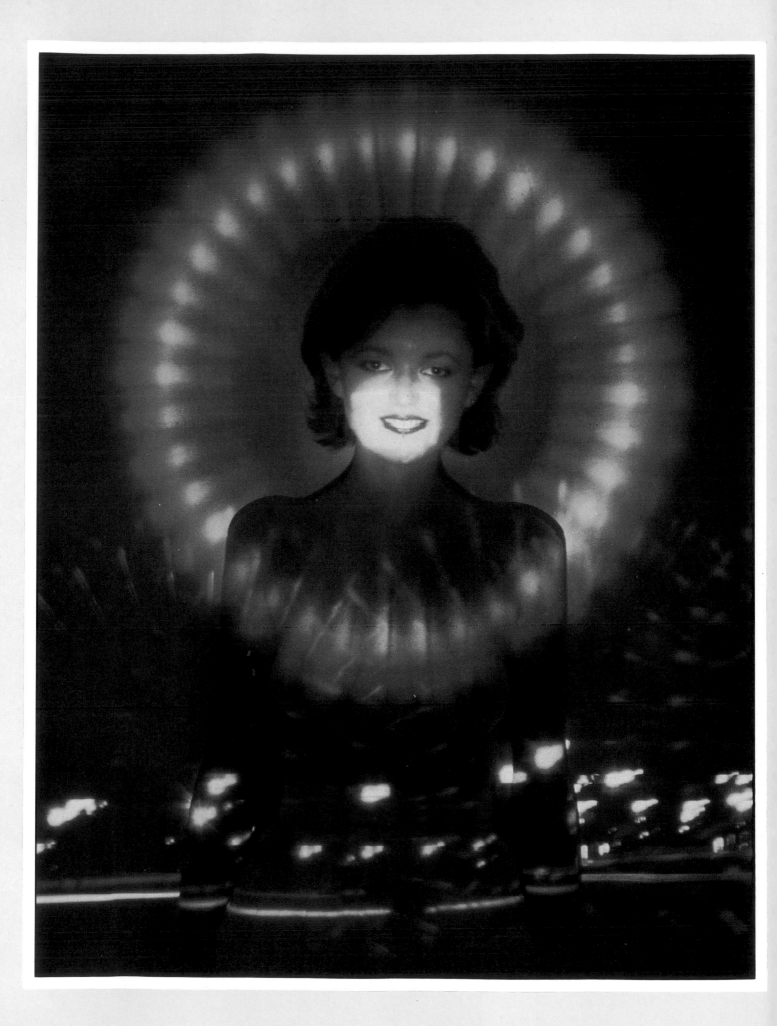

CATALOGUE OF TECHNIQUES AND EFFECTS

The primary emphasis of the previous chapters has been upon ideas, together with the techniques required to convey them. In this section, while visual ideas are by no means absent, the intention is to provide an informative survey of a wide range of camera techniques and specialist areas of photography for the experienced photographer who may be required to take pictures in areas with which he is unfamiliar. The photographic demands made by specialized assignments or by difficult conditions and locations produce their own unique problems, which are covered and explained in categories ranging from safari and underwater photography to scientific work and pictures of the sky at night.

Equipment already mentioned in the first section of the book is also discussed in greater detail here, with specific applications. Personal enthusiasms may lead you to specialize in one field of photography rather than another, yet it is always worth studying the techniques followed in these other areas and trying your hand at them. Versatility is a positive advantage in commercial work, and few subjects are beyond the scope of those prepared to study and practise the relevant skills or techniques.

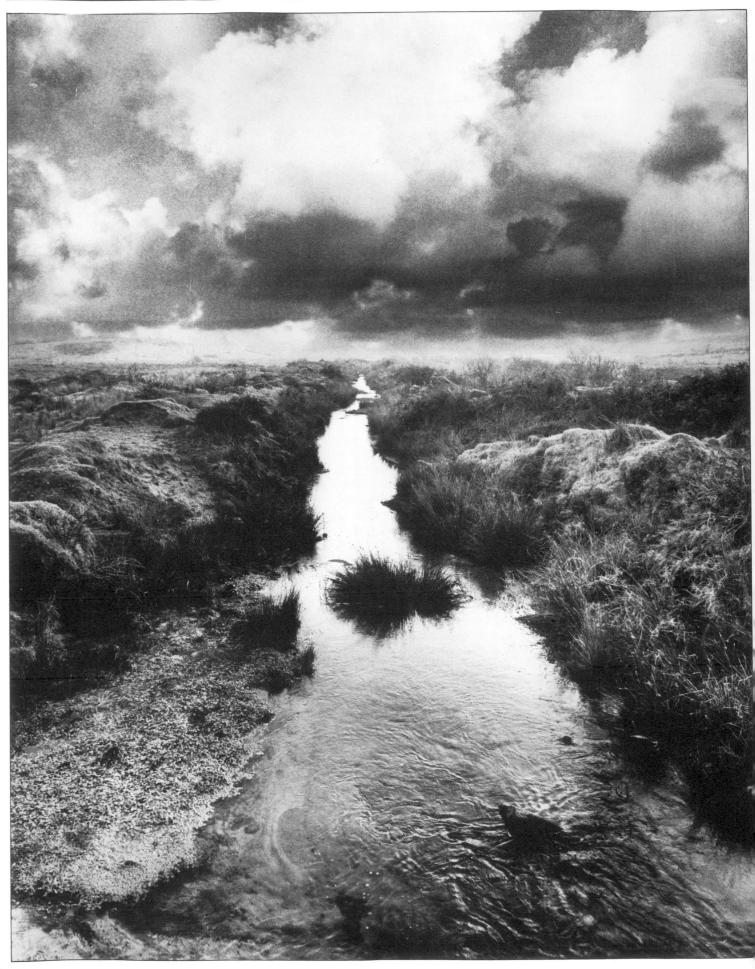

Exposure techniques 1

The latitude of a film is really a measure of how far a photographer using it can over- or underexpose and still create a usable negative or transparency. The correct exposure for any given situation is not always the same as the average exposure. To produce the best negative the photographer must be able to compare the brightness range of the scene he is shooting with the latitude of the film he is using and to do that he must use the exposure meter intelligently.

With the exception of spot meters, and some TTL meters, most meters read the whole scene before them and are arranged to give correct exposure to a middle grey in an average scene – consequently, they give false readings of particularly bright scenes (sky, sand and snow) and of those areas of normal scenes which contain extreme highlights or shadows. This inherent limitation in the meter, coupled with the narrow latitude of most colour films and slow black and white films, means that arriving at the correct exposure is not as simple as it may seem: quite often, in fact, the photographer is forced to make a creative decision about which section of the scene he is shooting he wants to emphasize and to adjust his exposure accordingly. He must also accept the fact that unless he is photographing a subject with a narrow brightness range on film with wide latitude, he may not be able to reproduce the full tonal range of the subject – either the shadows or the highlights will tend to lack detail.

One obvious way of overcoming the limitations of the ordinary exposure meter is to use it to read not the overall subject but specific parts of it – the shadows, for example. Reading shadows, highlights and something in between, and then averaging the readings, will give a better exposure than a general reading. And the handheld meter, unlike that built into a camera, can be used to read incident light: that is, the light falling on the subject rather than that reflected from it. This technique is invaluable if subject contrast is extreme – a white object in front of a black background, for example. A meter reading of light reflected from such a subject will invariably be false.

Through-the-lens metering systems have the advantage of reading exactly the light that will fall on the film, and of automatically compensating (with some limitations) for any filters fitted over the lens, but they are inherently no more accurate than handheld meters. You must understand precisely how your camera measures exposure, and what tendencies it has to distort, if you are to get the best from it. You also need to know what happens if you underexpose or overexpose the films you habitually use. With black and white films, overexposure will cost you highlight detail and underexposure shadow detail; and no darkroom tricks will replace what is not there. Colour films have even less latitude: more than half a stop out either way with transparency film and the results may begin to look unacceptable.

Average reading
Scenes such as the landscape opposite have a wide tonal range. The zone system (see below) is one way of ensuring that the exposure given will bring out detail across the range. Another is to take a series of readings of various areas of the subject and to calculate an average exposure. In this shot one reading was taken for the clouds (1/125 at f11) and one for the middle-distance ground (1/125 at f4), giving an average of the half-stop between f5.6 and f8. Because it was desired to bring out detail in the shadows, the aperture used was f5.6. The technique is valuable with handheld CdS meters and TTL spot meters, which tend to read only a portion of the subject.

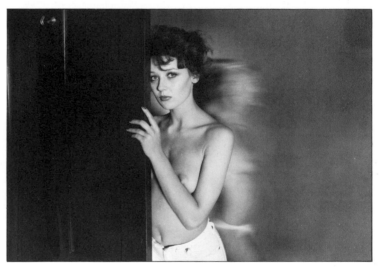

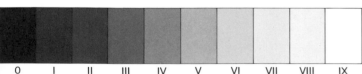

0	I	II	III	IV	V	VI	VII	VIII	IX

Zone system
The zone system, invented by US photographer Ansel Adams, is a way of ensuring, before a photograph is taken, that selected tones will appear in the final print. Exposure meters are designed to give an average reading, corresponding to zone V in the scale above. This may burn out highlights or block in shadows. By deciding which you wish to preserve, and by comparing the scale to the tonal values in the scene, you can determine how many stops over or under the indicated exposure will give the desired result. Each zone represents one stop difference.

Grey card
With an average subject, a middle grey (step V) reading can be taken from a standard grey card.

Aperture and shutter
A photographer's life would be relatively straightforward if all he or she had to do was produce correctly exposed negatives – unfortunately, creative photography calls for rather more. A sensible exposure for the shot above was 1/125 at f5.6 – a fast enough shutter speed to avoid camera shake and a small enough aperture to give reasonable depth of field. But then it was decided to record the second girl's movement. Selecting 1/30 of a second – slow enough to blur the second figure – meant stopping down to f11 to avoid overexposure. (The relationship between smaller apertures and slower shutter speeds is shown graphically, right – provided the combinations are kept in proportion, the amount of light reaching the film is the same.)

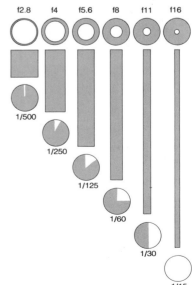

Exposure techniques 2

The atmosphere of a shot can be greatly altered by deliberate under- or overexposure. In a landscape scene in average bright daylight, for example, overexposure will produce pale, washed-out highlights and weak shadows, giving a soft, romantic feeling. Underexposure, on the other hand, will produce a heavy appearance with stronger colours, changing the normal daylight scene into a more sombre one. There are two general points to be made: first, the ideal subjects for such exposure modifications are those that show high contrast, with bright highlights and pronounced, dark shadows; second, the vivid, saturated colours of underexposed photographs are more acceptable to the eye than the somewhat pastel colours of overexposed shots. It must also be remembered that the exposure latitude of most colour films will allow only slight under- or overexposure if colour balance is to be maintained: filters can be used to compensate for this, but not always satisfactorily.

Altering the image when shooting can also be achieved by exposing specifically for highlights or shadows, or by changing your camera position to achieve back- instead of front-lighting. Shooting against the light and exposing for the light source can produce particularly interesting results with subjects suited to dramatic contrasts of light and dark and in which the shape of objects can be effectively stressed by silhouetting. With back-lit portrait shots, fine judgements of exposure can produce a halo of light around a face while still showing the features in detail. Because a change of even one stop can dramatically alter such images, particularly with colour film, be sure to bracket exposures.

These beach scenes were shot in evening light, all within a few minutes of each other. They show how you can dramatically change mood and atmosphere by shifting camera position and adjusting exposure: the light was constant throughout the session and the sky was cloudless, but with a slight haze on the horizon. The shot, left, was ½ stop underexposed to get more saturated colour.

Changing camera position to the other side of the subject and shooting against the light while exposing for the shadows gives an overall orange cast and warm atmosphere, helped by the setting sun. (Shot with Ektachrome 64 film, at 1/125 at f8 on an automatic Pentax with manual override.)

Striking effects in portraits can be obtained by deliberate over-exposure. It works best with subjects having dark eyes and hair, and dark lipstick. The burnt-out skin and lack of mid-tones contrasts with any dark areas of shadow. This shot, above, was overexposed five times.

Deliberate, slight under-exposure gives you strongly saturated colour. In this example, opposite top, I took a normal reading and then shot at one stop underexposed.

Atmosphere and mood are here intensified by taking a highlight reading from sun and sky – a reading of the sun alone indicated an exposure of 1/2000 at f8, which would have rendered the other parts of the scene as a black silhouette. The reading for the darkest area of sky gave 1/60 at f8, so I chose a mean between the two of 1/500 at f8.

Overexposure, right, gives detail to shadow areas. Exposure for an average reading would have created too much contrast and lost some of the delicate detail in the shadows. I took highlight and shadow readings, averaged the two, then overexposed by one stop, leaving the highlights to burn out expressively.

Exposure for highlights, far right, gave a strong visual image with plenty of contrast and textural detail. The model was shot in a studio in daylight. Blinds were used to control the light.

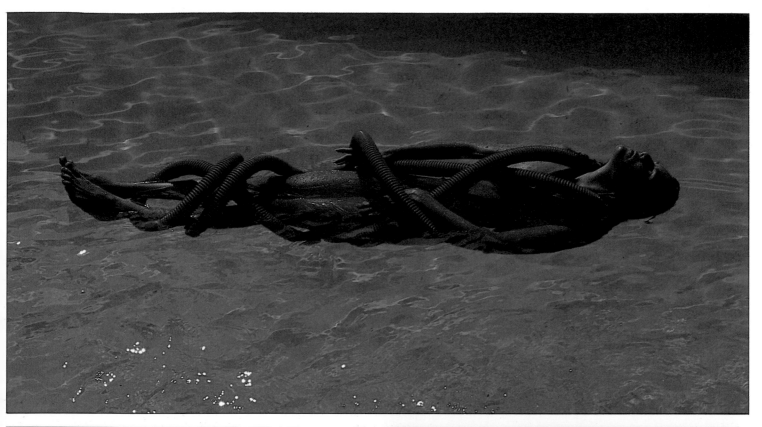

Exposure techniques 3

Black and white film gives the photographer the ability to control closely the contrast and tonal range of the picture. In monochrome it is easy to produce a high-contrast print in which there are few grey tones to distract from the bold subject outline, or a richly toned image which draws attention to detail or surface texture.

The tonal balance of the print can also be changed. High-key images are predominantly light in tone, and low in contrast. A low-key image, conversely, is dark and sombre. While these tonal qualities can be manipulated in processing, subject contrast, lighting and exposure are equally important factors.

Harsh, direct sunlight and studio spotlights produce strong shadows that result in high-contrast images. The direction of the light also affects the contrast – front-lighting is softer and less harsh than back- and side-lighting. To increase contrast even more, take an exposure reading from the bright part of the subject. This causes the shadows to be underexposed, so that they appear solid black in the print.

Soft lighting produces low-contrast pictures, so photographs taken under overcast conditions or by diffuse studio lighting are inherently low in contrast. Carefully averaging the exposure reduces contrast still further, because it retains the maximum amount of detail in both highlights and shadows.

The delicate filigreed image at left was produced by overexposing by one stop and increasing development by 50% to obtain a dense and contrasty negative. Mid-tones were removed with Farmer's reducer, and the print was made on high-contrast paper. The hill figure below was shot through an orange filter to darken the sky and grass and intensify the highlights. Development was increased by 20%, and high-contrast paper was again used for printing. The picture of the tree at right is an example of how exposure for the sun creates violent contrast and produces stark silhouettes. The lens was stopped down to f22 for a long exposure.

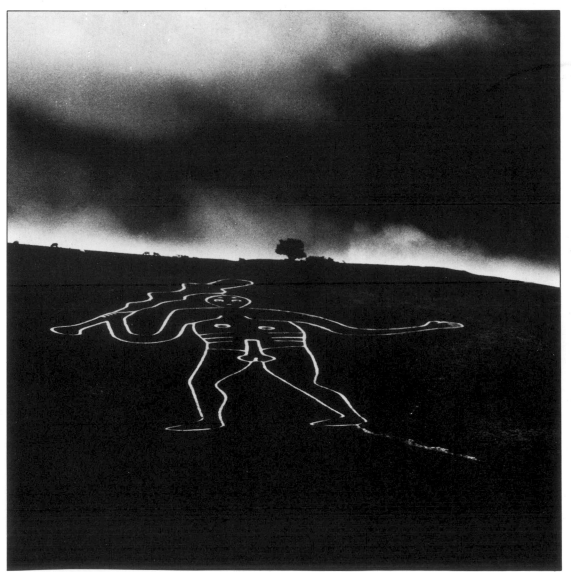

Controlling contrast
Image contrast can be altered at the shooting stage and in developing and printing, as set out in chart form below

Increasing contrast
Using a slower film, or working with contrast-enhancing filters

In an indoor subject, reducing fill-in lighting

In an outdoor subject, using strong, direct sunlight

In developing, increasing the development time, using a concentrated developer, making a copy negative or slide or using an intensifying solution

In the enlarger, using intense, concentrated illumination or shading the highlights and burning in the shadows

In printing, using hard paper

Decreasing contrast
Using a faster film, or working with balancing filters

In an indoor subject, using fill-in lighting

In an outdoor subject, using fill-in flash

In developing, reducing the development time, diluting the developer, pre-exposing the film or using a reducing solution

In the enlarger, using diffuse illumination or burning in the highlights and shading shadows

In printing, using soft paper

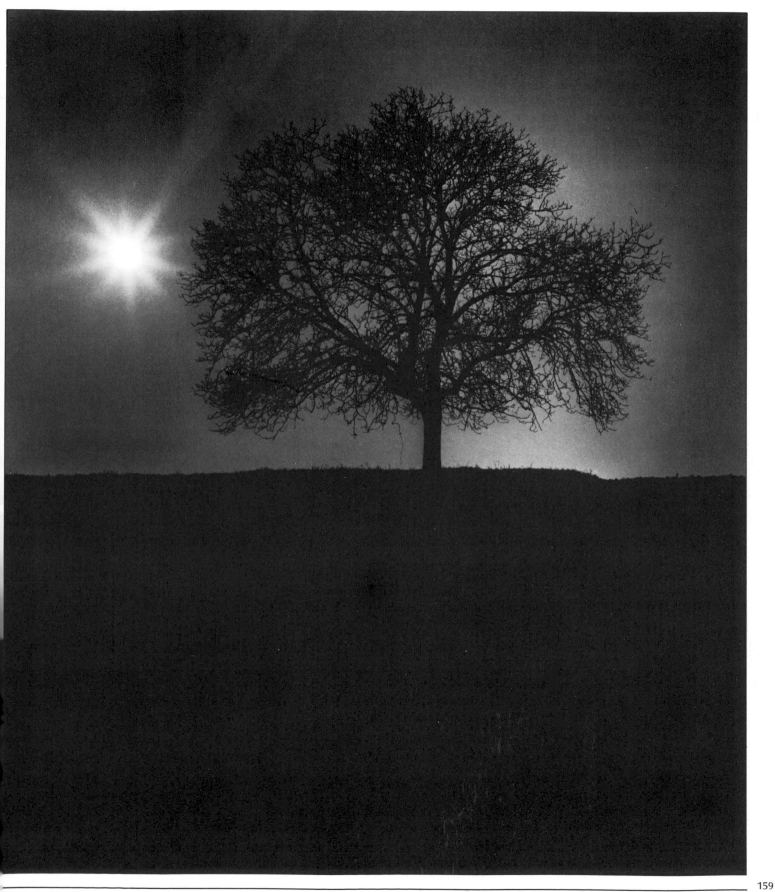

Colour transformation

There is no need rigidly to follow the rules and to pursue the creed of "natural" colour at all times – unusual colour effects can express a particular mood and atmosphere, and it is often better to exaggerate conditions, to manipulate or "go with" the colour than to take compensatory measures such as using flash to supplement daylight.

A blue cast, for example, may capture exactly the muted, cold and lost feeling of a winter scene more successfully than a high-contrast, glittering snowscape. The pictures immediately opposite were shot on daylight and Type B tungsten film respectively, the latter producing a bluish cast which underlines the romantic appeal of the subject. Colour film can be uprated or pushed beyond the normally acceptable latitudes of the emulsion, creating a warm orange or yellow cast. In principle, you should choose your film type according to the dominant light source – but don't be afraid to mix film types and colours.

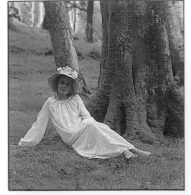

De-focusing with a zoom lens (far left) enlarged highlights and gave the city of Toledo a blue-green cast. The de-focusing was done very slowly, during an exposure of 15 seconds, to avoid streaks of light. The girl in the straw hat (opposite top) was shot on daylight and tungsten light films. The profile below, shot on Type B film, has a predominant colour cast from colour spotlights. The photograph of a dinner table conversation reveals an overall orange glow due to the effect of tungsten light on daylight film: the film was uprated 2 stops during processing, pushing it from ASA200 to ASA800. Daylight was the principal source of light in the shot of a Venetian restaurant (bottom left), so although the scale included tungsten lighting, I chose daylight type film. The model opposite was also photographed in a mixture of lights. She is posing by available light through a studio window, but the effect of sunlight striking her hair was created by a 2kW spotlight.

Flash techniques and extensions

Flash lighting is thought by some photographers to be harsh, unsympathetic and artificial when compared to the delicate nuances of tone and form gained from shooting by available light. But this need not be so – if used indirectly, either bounced or diffused by some means, flash can produce more subtle lighting and softer modelling effects. Recently, new types of flash have begun to appear on the market which work on the principle of "limited light" so that the flash provides some fill-in without destroying the atmosphere of dark or dimly lit scenes with a sudden burst of illumination.

Besides using flash to supplement poor existing light or to freeze motion, you can deliberately create bizarre effects by making it an intrinsic part of the image, as illustrated by the photographs above and top right on the opposite page.

Multiple flash units allow greater control of the subject and enable you to light a far greater area, as in architectural photography. As accessories you will need one or more long extension leads for off-camera flash, and slave units to synchronize the secondary flash guns with your primary flash source. If you want to specialize in the fields of advertising or scientific photography, ring flash and stroboscopic flash have specific applications and advantages.

Using a reflector
Weak light in this billiard room made flash essential. I redirected some of it off a plate (a billiard trophy) to reflect light on to the steward's face.

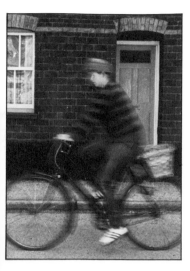

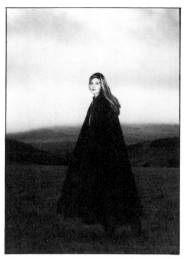

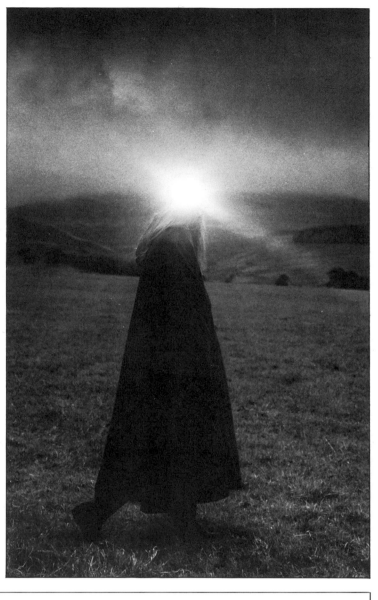

Flash and movement
Because of its extremely high speed, electronic flash tends to be used in action photography only to freeze subjects. Yet as the shot of the cyclist above shows, it can also be used in combination with a slow shutter speed (1/30) to provide a sharp image while existing light picks up movement to create blur. The same technique can also be used with interesting effects when flash is combined with tungsten lighting.

Experimenting with flash (left)
Flash can be used to deliberately produce powerful and unreal images. For the shot opposite, I positioned four flash units in the hedgerow, pointing at the camera to create flare, out of which I hoped the cyclist would emerge. The units were triggered by a remote sensor on the camera. The shot was experimental as it was impossible to predict to what extent the image would be obscured.

Flash for effect (above and right)
For the portrait above, a flash unit was set up on the ground near the model, directed up at her face to create a ghostly image. A further flash mounted beside the camera lit the foreground, and a remote sensor on camera triggered the flash on the ground. To obtain the unusual flare portrait right, I strapped a flash unit to the model's head and triggered it again with a sensor.

Stroboscopic photography
A pulsing stroboscopic lamp, firing at 30 pulses per second, was used (right) to analyse the performance of a bouncing ball. The degree of image overlap in stroboscopic photography depends on the speed at which the subject is moving as well as the speed of the pulse, which with some units may be varied between 1 and 50 pulses per second. A dark background, here of black velvet, helps to absorb extraneous light.

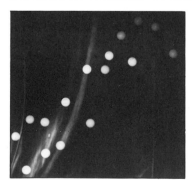

Ring flash
Dental, medical and scientific photography uses ring flash to provide even, shadowless light in close-up work where detail would be obscured in deep shadow cast by normal flash. There are other applications, such as in close-up nature photography.

Strobe lamp (left)
The lamp shown here links to a synchronizing box controlling several lamps. Slower pulse frequencies can be used with a motor-drive for sequence shots.

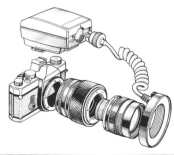

Ring flash unit (left)
The portable close-up model shown here has eight illuminator lamps in a circular tube and a power control unit that fits to the camera hot shoe.

Working with moving lights

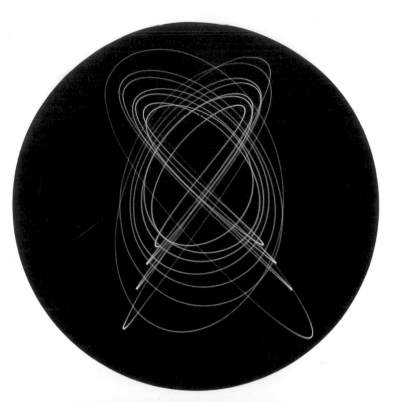

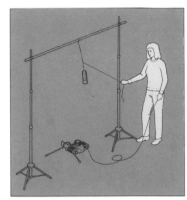

Fireworks (right)
Short-exposure shots of fireworks work only when a large number of simultaneous explosions produce a sudden great intensity of light. The best shots of firework displays are long or multi-exposures that record several fireworks on one frame. It is often best to choose a good vantage point and use a 90–125 mm lens. Use medium-speed daylight film, medium apertures and mount your camera on a tripod. For long exposures – in the shot right, the shutter was open for a minute – cover the lens between explosions.

Physiograms (above and left)
A physiogram is a photograph of the movement of a small light source, such as a masked flashlight swinging on the end of a pendulum. Working in a dark room, try placing your camera on the floor with the light source above it a metre or so away. Set the pendulum in motion and, using fast film and a small aperture, expose for several seconds. Vary the method of suspension and type of exposure – the shot, left, was a double exposure of 45 secs total duration.

Localized light (below)
When shooting a nearby object lit by a weak light source, or with localized bright light in a dark room, use a sensitive CdS light meter for accuracy and if possible work with a tripod and a cable release. Use the high contrast of such lighting to full effect. In the shot below, coloured spotlight illumination permitted a shutter speed fast enough for a hand-held camera (1/15 second) and the pose was held perfectly. Daylight film (ASA 160) was used at f2.

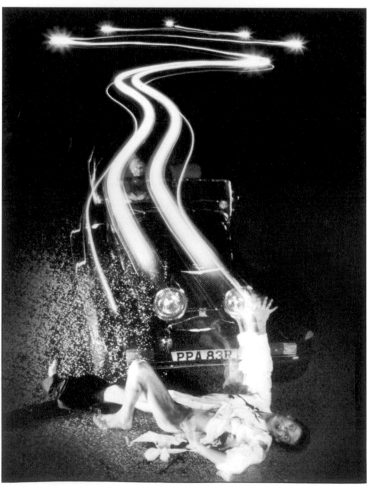

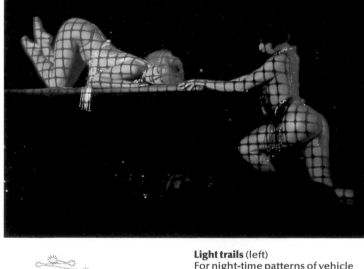

Light trails (left)
For night-time patterns of vehicle lights, use a camera on a tripod, small apertures for maximum depth of field and long exposures. Head- and tail-lights will record as parallel white/yellow and red trails tracing the path of the vehicles. In the shot far left, the accident "victim" was first placed in position, and lit for pose and focusing. Then, on time exposure, the car zigzagged towards the camera with headlights and both indicator lights in action. As the car reached the man the flash was fired. Ektachrome 64 film (daylight) was used to balance the flash and to give a strong orange cast to the car lights.

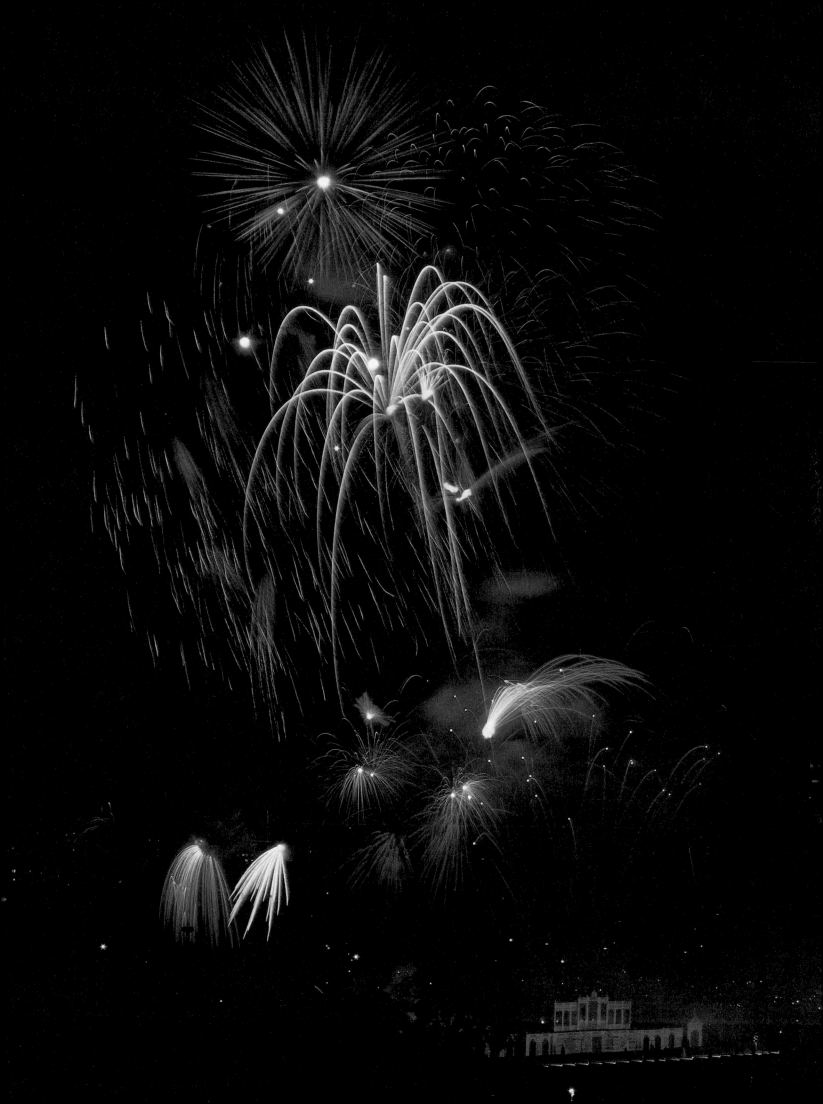

Macro lenses

The basis of close-up photography is increasing the distance between lens and film so that the image is larger. This can be done with a simple close-up supplementary lens, attached to the front of the standard lens, but image quality suffers. Reversing the standard lens gives better results, but the range of magnification is limited. The best solutions are to use extension rings, extension bellows or special macro lenses – or a combination of them.

Extension rings are cheaper than, but not as adaptable as, bellows and they can be used with any standard lens. However, in practice it becomes unwieldy to use more than three – which will give you an image slightly larger than lifesize. More convenient is a special macro lens, which has its own built-in focusing control, much like that of any other lens. Such lenses are available with focal lengths of 50mm to 200mm and they usually focus continuously down to half lifesize (so that the image on the negative is half the actual size of the subject). The longer focal length macro lenses are most convenient because they allow you to move back from the subject, and this makes lighting easier.

For macro pictures where the image on film is actually bigger than the object photographed, specially computed macro lenses are needed. These have no focusing mount, look and behave like an enlarging lens and must be used with bellows; they are sometimes called macro bellows lenses. In one sense, a 50mm macro lens is the best "standard" lens – the normal 50mm lens is optically corrected for infinity and therefore does not have a close focusing mechanism: the macro does. The disadvantage is that macro lenses are limited to a maximum aperture of f3.5.

All close-up work suffers from the problem of greatly reduced depth of field. Though this is dependent upon aperture, focal length and camera-to-subject distance, the real variable, once you have chosen your lens and the distance needed to give the required magnification, is aperture, and with a macro lens stopping down does not greatly improve depth of field. Lighting is also a problem and the reason for the development of telephoto macro lenses: using one of these it is possible to get sufficiently far from the subject to allow it to be lit adequately. A ring flash is a useful accessory for any kind of close-up work, because of its ability to provide even, shadowless light.

×**0.5** 50mm macro plus one ring

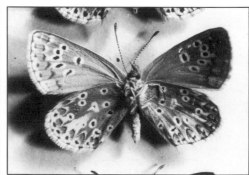
×**1** Standard lens plus three rings

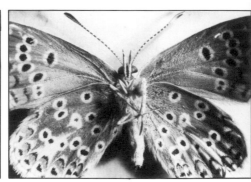
×**2** 50mm macro plus bellows

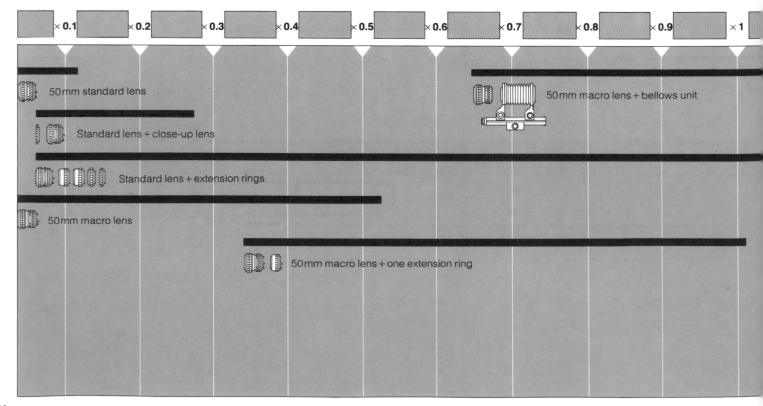

Increasing the distance between lens and film plane by adding extensions alters the exposure. It must be increased by one stop for the first 50mm extension of a standard 50mm lens. Divide the focal length of the lens into the length of extension: a 50mm lens on a 100mm extension gives a factor of 2, and this must be squared to give the stop. A normal reading of f5.6 on a 100mm extension thus calls for a corrected exposure of f2.8, because this is two stops up, or four times the light value, of the normal reading.

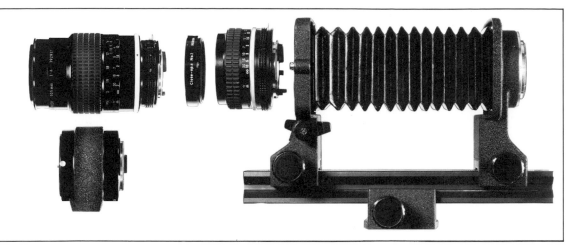

×**4** 20mm macro plus bellows

×**6** 20mm macro bellows lens plus bellows

×**12** 20mm macro bellows lens plus bellows and four rings

×3 ×4 ×5 ×6 ×7 ×8 ×9 ×10 ×15 ×20

20mm macro bellows lens + bellows unit

20mm macro bellows lens + extension rings + bellows unit

Photomicrography

Filters for special effects

Many special effect filters are more properly called lens attachments, as they do not filter the colour of the light reaching the film but change the image optically, often by bending the rays. Unlike correction filters, their effects are obvious, sometimes blatantly so, but used with imagination, they can sometimes create exciting images, especially in commercial photography. It is not easy, except by trial and error, to predict their effects, nor to distinguish between the scores of filters on the market. Most of them work best at wide apertures, although their effects at smaller apertures can usually be judged by looking through the viewfinder of an SLR equipped with a preview button. A range is demonstrated here.

 Graduated filters compensate for weak, unsaturated areas in landscapes or, as here, add colour interest.

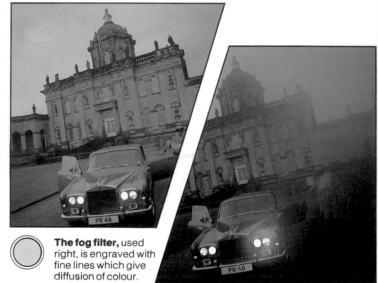

 The centre spot filter used here was a light grey. Stopping down would have hardened the central ring.

 The dual colour filter can be rotated to divide its two colours at any angle. Many colour pairs are available.

The fog filter, used right, is engraved with fine lines which give diffusion of colour.

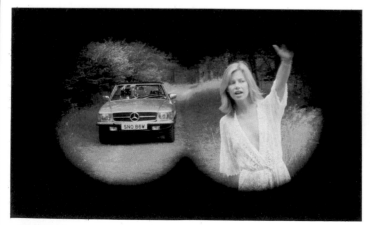

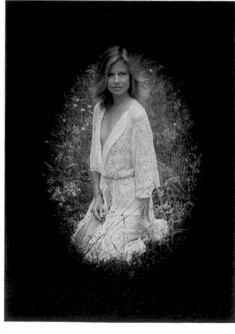

 The binocular view above was created with a masking type of shaped filter. You can make your own shapes (right) with thin black card and a scalpel, cutting the card to the dimensions of your lens. The shapes shown are only a few of the filter masks available commercially.

Combinations of several special effect filters can often produce intriguing images, though you may need to increase exposure. The old-fashioned vignetted effect shown at right was created with a sepia filter and an oval cut-out.

A diffraction filter has a ribbed surface (or diffraction grating) that produces the effect of a prismatic division of the spectrum. Various patterns are available, some with lines radiating outwards like the spokes of a wheel (left), creating a startling effect against dark backgrounds. It can be combined with a prism filter (right) to deform the image, or with grey or colour filters to increase contrast and emphasize the effect. If the wheel-type is revolved during exposure it will blur the spokes to bands of colour.

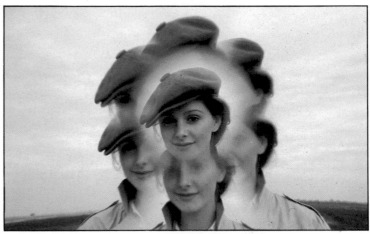

Diffusion filters create a halo effect around bright areas of the subject and produce romantic moods.

Cross-screen attachments, known as "starburst" filters, diffract light in rays from highlights.

Prism filters, which repeat part of the image on separate facets of the lens attachment, can be used to suggest movement, to create surreal images, or create patterns. Some (above) have a central hole that gives a sharp centre ringed by ghost images.

Most prism filters can be rotated to change the orientation of the image; a vertical alignment has elongated the girl above. The pattern on the right was made with an open aperture.

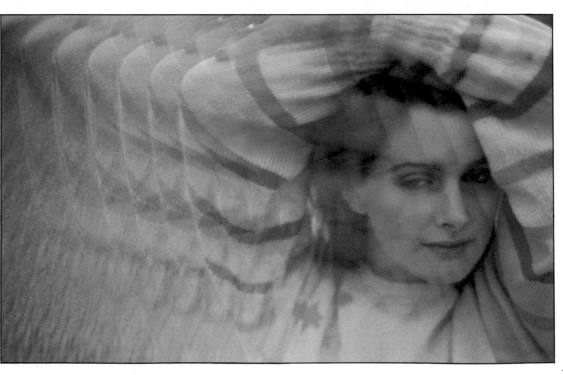

Scale models

Scale model photography can be as commercially demanding as the creation of an image for an advertising campaign, as creatively exciting as shooting the still equivalent of Star Wars, or as self-satisfying as persuading a viewer that a model vintage car is the real thing. There are two main approaches: the attempt to convey the impression that the model is real; and open admission that it is part of an elaborately staged set-up, perhaps an impressive fantasy like the extra-terrestrial landscapes on these pages.

The first of these approaches is the more difficult. It is hard to define why photographs of scale models almost invariably fail to look like photographs of the real thing, but it has something to do with mass, weight and distribution of tones. There are, of course, difficulties inherent in scale: even the best modeller cannot reproduce, say, rust bubbles on a car door if he is working at a scale of 1:72. So the easiest approach is to photograph a model so that it looks like a model, regarding it as you would any other still-life and perhaps using a macro lens to record detail.

If this seems to be dodging the issue, then the first thing to do in simulating reality is to avoid sharp definition. This may seem paradoxical, but though modelling detail supports illusion, photographic clarity tends to destroy it. A grainy image helps and it is a good plan to shoot on fast emulsions so that detail is not too sharply defined. The camera must adopt the position of a miniature viewer to achieve a convincing perspective, and point of focus, depth of field, the distance between camera and subject, and the distance between subject and background all must be adjusted to help the illusion of reality. Lighting is important: it must give the appearance of being natural – that is, of being realistic in scale, intensity and direction. To keep highlights and reflections in proportion, use small spotlights or even a flashlight.

Long-focus and wide-angle lenses neatly sidestep the issue of "reality". The wide-angle falsifies perspective and the long-focus flattens it while narrowing the angle of view. Finally, the techniques of double-exposure and (in the darkroom) of sandwiching help to provide ideal backgrounds and surroundings for models.

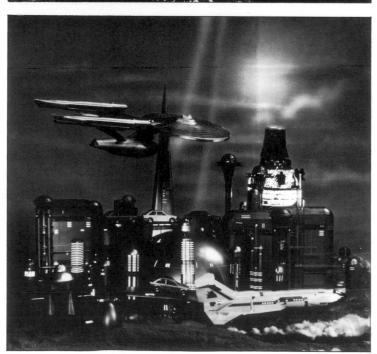

Futuristic images (left and below left) were sought by a car maker The spheres were made of polystyrene and the bridge of card, cut to give the illusion of diminishing perspective. A model of Saturn was hung against a black card background, which was pierced and backlit to create stars.

The celestial city was made of polystyrene and plastic kit models, and shot with a 150 mm lens against a background made of painted hardboard. The city lights were strips of beaded tape that shone when lit by a spotlight reflected weakly from a sheet of glass through which the shot was taken. Direct lighting would have lit the buildings as well. The tape is similar to the beaded material used to make slide projection screens.

Models of spacecraft (right) were shot separately to give slight variations in angles of flight. They were supported on fine nylon threads from an overhead frame. Two transparencies were printed together in the darkroom to give the final print. The upper half of the picture below is a model against a black card background; the slight blur was effected with a zoom lens. I exposed a roll of film on the model, re-wound, and then photographed (as a double exposure) the lower half of the picture, the shot of the sea, judging the remembered position and angle of flight of the model in relation to the beach and the waves beyond.

Nature photography 1

A good nature photographer should be a keen naturalist, as well as a skilled photographer able to select the right techniques and equipment for a given situation. Some subjects are less demanding than others – pets are obviously less timid than wild animals, for instance, and you can learn much by practising on them, or by photographing other animals within reasonably controlled situations, such as zoos and wild-life reserves – or even pigeons scrambling for food in a city park – before you launch into "safari" shots.

A 35 mm or 2¼ in sq SLR with interchangeable lenses and through-the-lens metering is the most useful camera for nature photography. For action shots it is very important to be able to watch your subject and focus it on the screen, and, if necessary, alter the aperture right up to the moment of exposure. A motor-drive unit is certainly a great asset in such work. For general habitat shots use a 50 mm or wide-angle lens, but you will find telephoto lenses indispensable. A 200 mm is sufficient for shooting the more approachable animals, but for safari or stalking shots you will need a 400 mm lens or longer. A 100–300 mm zoom lens is worth considering. You will need a monopod or tripod when working with telephoto lenses, or, if the camera is hand-held, a shutter speed of at least 1/250 to eliminate camera shake. For close-up shots a macro lens with bellows is useful, used in conjunction with a tripod and cable release. It is worth remembering that it is not just yourself but your equipment too that will worry some animals. A hide is often necessary, and also a blimp – a soundproof container for the camera, sometimes made of polystyrene, which enables a photograph to be taken without the noise of the shutter or wind-on mechanism reaching the subject. For more ambitious shots, or those that can only be taken late at night, remote control set-ups, automatic trip devices, computer flashguns and time lapse equipment (see below) are all useful extras.

ASA 400 black and white film and ASA 200 colour stock are the most versatile films to use in action work with telephoto lenses when you will need faster shutter speeds, with limited apertures to retain depth of field. For still-life shots use slower film matched to prevailing conditions. Infrared film is of particular value to nature photographers; by using it in conjunction with deep-red filters on flash units you can take photographs in complete darkness and capture foxes, badgers and other nocturnal creatures emerging from their lairs. Nocturnal photography can be a particularly rewarding field for the nature photographer with sufficient stamina and patience, revealing a fascinating and surprising amount of activity going on throughout the hours of darkness.

Using a hide

For close-up shots of birds and small mammals, work from a hide. A portable hide can be made from a wooden or aluminium tube box-frame and canvas. A scaffold can be built for it if you want to photograph a nest high up in a tree; build it over a period of days in order not to alarm the parent birds. Some birds, such as the painted storks landing in their nests (below), are less timid and can simply be photographed with a long lens from a car. When taking wildlife, note the subject species, weather and date for each shot.

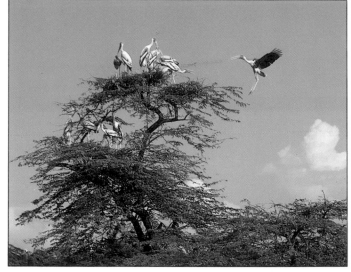

Time lapse

To record a sequence such as the gradual opening of a flower, as above, or the passage of clouds or the moon across the sky, fit your camera with an electrically driven motor-drive timed over a set period. If you are not working under constant light intensity, use a coupled electronic flash or a diaphragm unit that automatically sets the aperture to the prevailing light. This sequence was taken in a studio with the plant near a window. An electrically operated window blind, two floodlights and the camera motor-drive were coupled to the timer. At the predetermined intervals the blind came down, the lights went on and the camera shutter fired. Then the film wound on, the lights went off and the blind rolled up again.

Freezing motion
Computer flash units with a subject distance/aperture scale and remote sensor regulate the flash duration to suit subject distance and the working aperture and film speed. For close-ups this may be only 1/10,000 – fast enough to freeze the motion of a seed pod exploding, a frog leaping, or (right) the beating of a humming-bird's wings. As the subject was so close the flash was sufficiently bright to use a small aperture, giving great depth of field.

Mutiple flash
Following the sequence of an insect's beating wings or some similarly rapid motion poses several problems. Firstly, the direction of travel is unpredict-able; secondly, working in close-up means a very limited depth of field, and, thirdly, speeds of 1/20,000 are necessary. In the triple exposure shot below, the insect was sent through a glass corridor on which the lens was focused at small aperture. To compensate for the slow action of the shutter a trip device was used ahead of the plane of focus. A stroboscopic lamp fired every 1/25 second at 1/25,000.

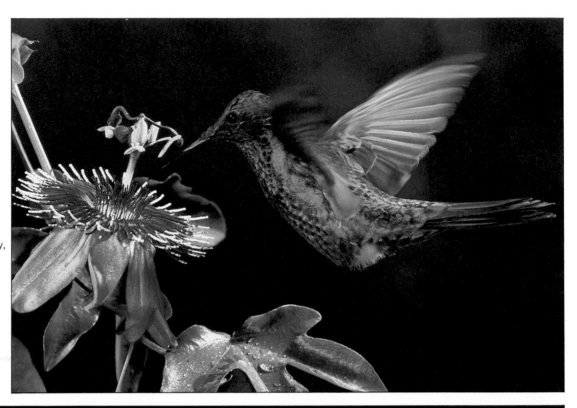

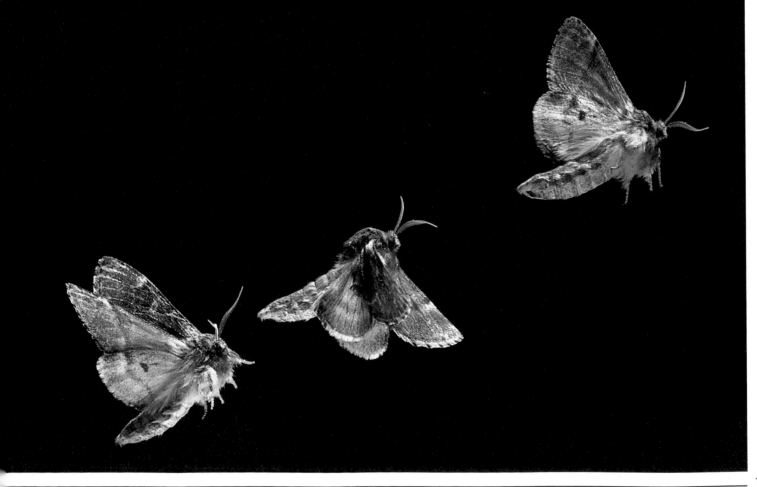

Nature photography 2

Plants, small animals and insects make marvellous subjects for the photographer. The combination of nature and advanced photographic equipment offers perhaps the greatest opportunities for bringing out textures and patterns in close-ups, for producing scientific records of species, or simply for studying the beauty of nature itself, as with time-lapse photography of the germination of a seed, or the opening of a flower.

The eye of the camera often reminds us that we take the world around us for granted; this is nowhere more true than in botanical photography. But beware of the slightest movement – plants are not as still as they seem. Wire struts can be used to hold a plant still; a white canvas windbreak in a simple folding wooden frame is a permanently useful addition to the nature photographer's bag of tricks. For additional subject interest, one simple device is to use something sweet and sticky, such as honey, on a plant as bait for a wandering insect. To bring out clearly the colour or shape of a flower try to choose a camera viewpoint that will give you a dark, uncluttered background, or use selective focusing to blur out background detail that would otherwise confuse the picture.

For shots of insects and small reptiles in glass cases, set the camera on a tripod about two feet from the case and pointing downward at a gentle angle to it; then further minimize the risk of reflection by masking your equipment, using a black card with a hole in it over the lens.

If you want to photograph live insects in what amounts to laboratory conditions, you can keep them still for a short time by cooling them. Using a small box with airholes in it, put the captured insect in the refrigerator for a few minutes. The lethargic creature will then sit still on a twig – but not for long. It will thaw out quickly, especially under warm lights, so it is better to use a cold light source, such as electronic flash. You can also use chloroform or carbon dioxide without harming the insect, if you are careful about the dosage.

Photographing tame birds and domestic animals is fun, and good practice in the skills of taking candid shots. In the wild you will need to use trickery. Birds and small mammals are notoriously bashful, but can sometimes be tempted by bait, such as fresh meat for a fox, or honey or jam for a badger, to come out of their burrows and sit still for a minute. You may be able to get an animal to take its own picture by breaking a light beam: infrared lamps and sensors are available from electronics shops, but some experimenting with the size and strength of the beam for the purpose may be necessary, or you will have insects blundering into the set-up and setting off your equipment prematurely. You will have to rig up your own apparatus for connecting the beam to the DIN or other socket on your motor-drive so that the creature breaking the beam will activate the shutter, flash and motor-drive.

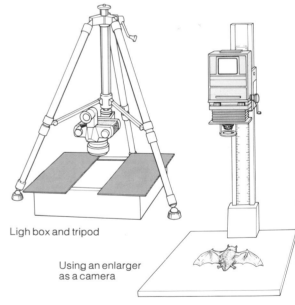

Shots of specimens (right)
Relatively flat objects can be placed on a light box and shot from above using a copy stand or a tripod with the column reversed, as in the drawing at right. Mask off the area of the light box not in use, to reduce flare. Enlargers can also be used for shooting specimens: slides of translucent subjects can be placed in the negative carrier and projected on to film; or you can lay a subject in relief on the enlarger base-board with lamps on either side pointing down at 45°. Test the set-up with an exposure meter, then (in complete darkness) place film in the enlarger carrier and expose as required. This method was used in shooting the bat, below.

Ligh box and tripod

Using an enlarger as a camera

Botanical photography (above)
For a scientific record, first shoot the specimen from a distance to record habitat. For close-ups of flowers, leaves and fruit, use a tripod-mounted camera at the same level as your subject and use flash for fill-in illumination if necessary, directing it downward to imitate sunlight. The least breath of breeze will prevent sharpness, so if you are shooting outdoors, set up a windbreak: white card or canvas will also reflect light, bringing out detail in the shadowed areas.

Ring flash (right)
Close-ups requiring shadow-less detail and maximum visual information are best tackled with a ring flash, since it gives an even non-directional light. The unit (right) consists of a flash head capable of full-, half- or quarter-light output to suit varying film speeds and subject distances, and a power pack able to use either battery or mains. The flash head encircles the lens and can be attached to different lenses, using adapter rings, giving great flexibility. It is used in medicine and dentistry, as well as for shooting such things as parts of flowers or small insects on leaves. (A powerful unit can also be useful in fashion work where, for example, a cut-out effect is wanted.)

Power pack

Ring flash

Using remote control (right)
A remote control system to fire the camera from a distance is useful for photographing animals that are particularly shy. Mount the camera on a tripod and aim the lens where you expect your subject to appear; a pneumatic release, transmitting air pressure from a rubber bulb through a tube to fire the shutter, is effective over distances up to 30 metres. Alternatively use a solenoid-operated cable release. For even greater distances, use a radio transmitter with a receiver on the camera, or a similar system which uses an infrared beam and a sensor (right). A motor-drive is a must with remote control.

Infrared sensor

Infrared trigger

Trip devices (below and right)
Studying the habits of a bird or an animal will reveal its path, back and forth to a nest, for example. You may be able to set up a trip device to get it to photograph itself. Great care must be taken in placing the apparatus so that the creature accepts it; in many cases it may be necessary to construct a blind. Place an infrared lamp on one side of the path and a photo-cell, connected to the camera's motor-drive, on the other. Aim the flash at the light beam.

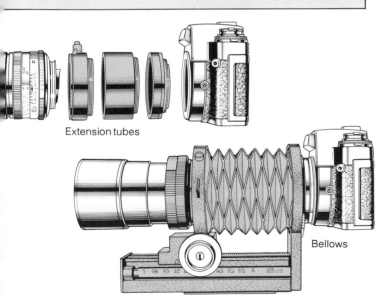

Extension tubes

Bellows

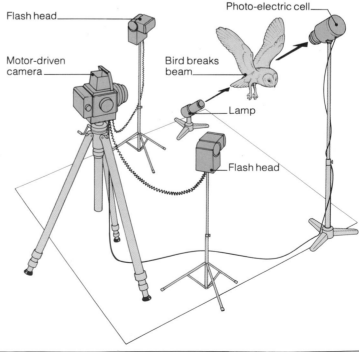

Flash head

Motor-driven camera

Photo-electric cell

Bird breaks beam

Lamp

Flash head

Close-ups (above)
When the camera-to-subject distance becomes too short, focusing with a standard lens becomes impossible. A macro lens, extension tubes or a bellows with macro or standard lens can be used to increase lens-to-film distance. Use exposure factor tables rather than a light meter with bellows or extension tubes, because they decrease the effective f number. Depth of field is restricted in close-up work, so you will need to use small apertures and long exposures.

Wildlife safari

Fortunately for the continued existence of wildlife in tropical countries, the camera has largely replaced the gun – until recently the entire purpose of a safari was to obtain trophies of animals' skins and heads. But the conduct of a group of people on safari, dedicated to the pursuit of big game to record on film, remains more or less the same – you are still in a sense a hunter, and you need stealth, knowledge and great patience to obtain worthwhile shots. Unlike specialists of nature photography, or nature movies, who can afford to wait for weeks for the appearance of a particular species of animal, you will have to photograph whatever you can find – or whatever the game warden in charge of the safari can find, for they are well acquainted with the habits of most animals on a reserve.

Luck, of course, plays a large part in nature photography, but you can also contrive success by aiming for a particular type of shot. For example, potentially fierce game animals, such as rhinos, or the big cats – lions, leopards and tigers – make impressive close-up shots, for which you will need a selection of long-focus lenses. A second type of picture, more difficult to achieve, is that of animals in motion, and it is the sort of shot for which you must be on constant alert: a herd of gazelle in full flight, with a cheetah in pursuit, will give you scant warning. Bear in mind that animals are more likely to

move around in the early morning, or at sunset, when the air is cooler, for in the heat of the day most animals sensibly seek the shade. For this reason it is essential to take fast lenses and fast film. I prefer to use a conventional telephoto lens rather than a mirror lens because of wider apertures (typically f5.6 on a telephoto) which allow for differential focusing so that you can separate an animal from the background. While a mirror lens is lighter and more compact, the aperture will be somewhere around f11, and will need too slow a shutter unless the animal is well lit.

There is a limit to the amount of equipment you can reasonably take on safari, but for a 35mm camera you will need a 100mm macro lens, a 200mm and a 400/500mm or a zoom lens that can take in these focal lengths, plus a lightweight tripod or monopod with any bright parts taped or blackened so that reflections won't give you away. Try to avoid having your camera stand for long periods in bright sunlight – it will absorb a lot of heat which can damage the mechanism and ruin the film. You must also take precautions to shield cameras and lenses from dust, so keep equipment in plastic bags, with some silica gel to absorb moisture. Much of the time you will have to use wide apertures and critical focusing. Your camera will be mounted on a tripod, so practise panning, focusing and zooming all at the same time.

Using a tripod
A long lens on a tripod is ideal for monitoring a clearing or water place where an animal is expected to appear. Used in conjunction with a cable release the tripod will reduce camera shake to a minimum. Choose one that has independently variable legs and a reversible centre column.

Safari techniques
A Jagarundi (left) in poor light called for fast film, wide apertures and critical focusing. The African Kudu (above) was caught in the instant before it fled. Here a wide aperture reduced depth of field and background detail. Monkeys, such as the Macaque (opposite, top left), have a variety of facial expressions, which are well worth waiting for. The other pictures opposite are portraits of a white tiger and of a Bengal tiger taking a bath. A long lens will enable you to get impressive and otherwise dangerous close-up shots of game animals – these needed 400mm and 200mm lenses.

Mountaineering and caving

Caves and mountains present the photographer with scenes of unsurpassed visual drama, but they are dangerous as well as beautiful places, so no one should attempt climbing or caving photography without first gaining the necessary physical skills. For mountaineering photography, manual cameras are more suitable than automatic ones, as automatic cameras are apt to seize up in conditions of extreme cold and damp. An autowinder, however, in spite of the weight and bulk it adds, is a useful piece of equipment, as it cuts down the work to be done with cold fingers. All controls become more difficult to operate as the hands get colder, but it is also difficult to use a camera wearing thick gloves. One way round the problem is to wear gloves or mittens that can be slipped off quickly so that the hands are still reasonably warm when needed to operate the camera. Three lenses – standard, 28mm wide-angle and a zoom in the range 80-200mm – should cover all situations. Lighting will vary greatly, so a selection of filters is necessary. For black and white shots a yellow or orange filter will darken the sky to bring out clouds; for colour, a graduated neutral density filter will do the same. A UV filter helps to overcome haze, and a polarizing filter can cut out harsh reflection from strong overhead light, although it must be used with care as it can also kill the natural sparkle of snow, ice and water. You will probably be breathing heavily so fairly fast film should be used to cut down camera shake. To ensure steadiness special clamps are available to attach the camera to a spike driven into the rock. It is considered good practice – for environmental reasons – to remove such spikes after use.

When caving, camera equipment must be protected from dirt, sand, mud and water. There is also the problem of trying to work in complete darkness. Use a 35mm SLR or amphibious camera, wide-angle lenses, tripod and cable release plus a suitable flash unit. Long or multiple exposures and "painting in" different areas with flash are standard techniques. Because it is difficult to read rangefinder and viewfinder scales in the dark, a tape measure for close-ups and a sports viewfinder for distant shots are useful. ASA 400 film is suitable for both black and white and colour. Keep all your equipment in a foam-lined waterproof metal case.

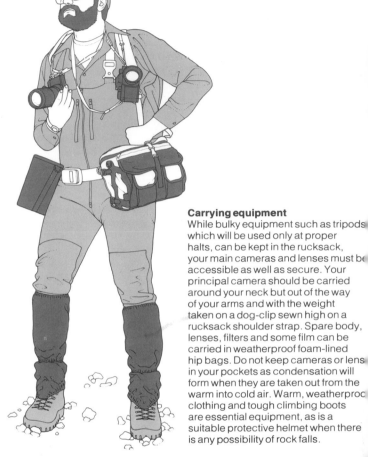

Carrying equipment
While bulky equipment such as tripods, which will be used only at proper halts, can be kept in the rucksack, your main cameras and lenses must be accessible as well as secure. Your principal camera should be carried around your neck but out of the way of your arms and with the weight taken on a dog-clip sewn high on a rucksack shoulder strap. Spare body, lenses, filters and some film can be carried in weatherproof foam-lined hip bags. Do not keep cameras or lens in your pockets as condensation will form when they are taken out from the warm into cold air. Warm, weatherproof clothing and tough climbing boots are essential equipment, as is a suitable protective helmet when there is any possibility of rock falls.

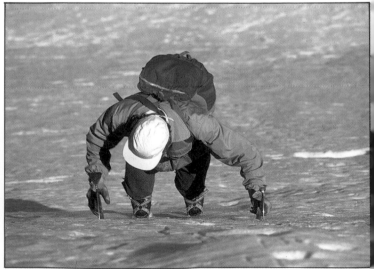

Lighting for caving shots
To illuminate the large area within a cave, left, several flash units were required. Electronic flash is useful but beware of leads and connections shorting out in the damp atmosphere. Flashbulbs are reliable while flash-cubes are good for close-up work.

High-altitude photographs
Tight framing (above) emphasizes the isolation of the climber on a sheer ice wall. But frequently the grandeur of the world's great mountain ranges can be conveyed only by using a high, distant viewpoint (right). A UV filter is useful in such situations.

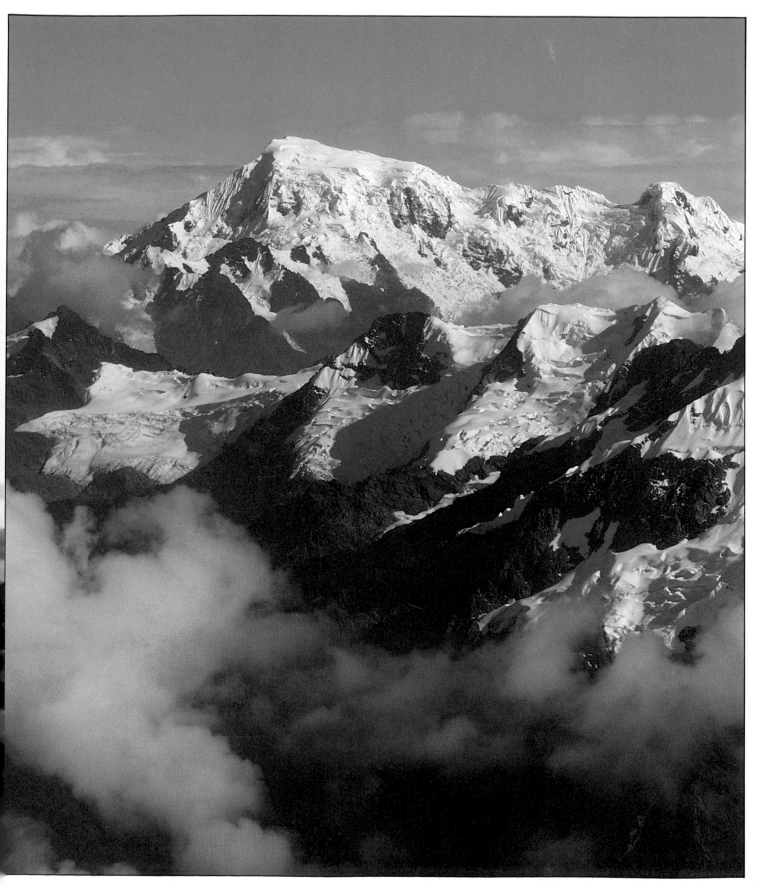

Copying

Whatever your reason for copying an object photographically, the technical problems are the same: you must ensure, first, that the lighting is even and, second, that film, filters and lights are suitably matched so that accurate colour reproduction is obtained. For all copying work it is easiest to work with an SLR camera, as through-the-lens viewing and metering allow precise alignment of the camera and monitoring of lighting. When the highest possible quality is necessary, however, as, for example, in illustrations for lavish art books, there is no substitute for the large-format camera. If much copying is to be done, it is worth creating a permanent set-up, based on a large-format camera running on rails.

Copying pictures

Small pictures can be illuminated with two lights, one either side of the original. Tungsten lamps are most suitable as their light can be adjusted precisely; you must block out all other types of lighting that would affect the colour balance. Filters can be used to remove heat and ultraviolet radiation from lamps. A black velvet sheet forms an ideal background, as it absorbs stray light as well as making the painting stand out. Evenness of illumination can be ensured by holding an incident light meter at the centre of the painting and pointing it at the camera while alternately shading it from the lamp on either side. If possible, paintings should be photographed without their frames so that all the painted area is visible, unless, of course, the frame is also of artistic importance. If your photograph is intended for reproduction, you should include a standard colour reference. Reflections can be eliminated by using polarizing filters over lens and lights. To prevent a reflection of the camera, use a large black card as a screen (right).

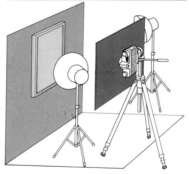

Drawings (below and right)

To photograph drawings, engravings and stamps either use a purpose-built copying stand (A) or lay the original flat and place the camera vertically above using a cross-arm tripod (B). To check alignment, put a mirror flat on the original and adjust the camera until a reflection of the lens is in the centre of the viewfinder. Working with tungsten lamps, angle the lights down at 45° to the original. For engravings and line drawings, use line or lith film and give high-contrast development. For continuous-tone originals, use slow, normal-contrast film.

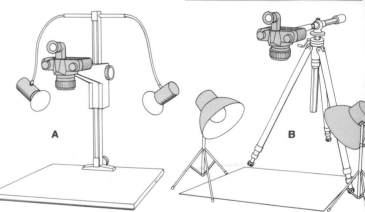

A permanent copying set-up

Printers use a process camera (below) to copy illustrations. The original is held flat against the copyboard by means of a vacuum, and by moving the board and the lens any degree of enlargement or reduction can be obtained. If you are using any other camera, a set of rails on which to move it in front of the copy board is necessary. Place a strip light on either side of the board. Fine-grain film is needed for precision work, and documents can be photographed direct on to special copying paper. With black and white film, filters can be used to improve the original. Stains, for example, can be lightened or eliminated by using a filter of the same colour as the stain. This technique is often of value when working with old documents.

Large paintings (below)

To illuminate a large subject, use four lamps, aiming each at a corner of the painting. They should be about one or two metres away from the painting, and at an angle of about 45° to the surface of the painting. The camera should be placed some distance away in order to avoid flare. Special techniques such as infrared, ultraviolet and X-ray photography can provide material that is of great value to picture restorers or art historians, but such techniques come within the province of scientific photography.

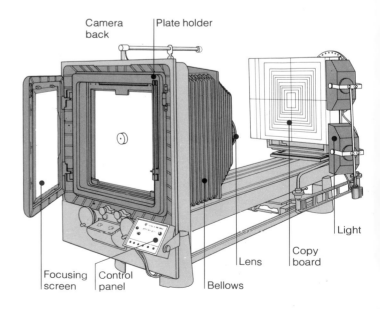

Camera back · Plate holder · Light · Copy board · Lens · Bellows · Control panel · Focusing screen

Stained glass (right)

For true rendition of colour and tone, diffuse lighting is required, so if possible shoot on a day when the sky is slightly overcast. Direct sunlight can cause flare and show up the wire grids that are now often used as protection on the outside of windows. These effects can be overcome by using a wide aperture and fast shutter speed, but a better solution, if practicable, is to hang a white sheet behind the window. It may also be possible to mask round details or small windows to exclude extraneous light. For high positions, a scaffold frame is best, but a simpler alternative is to clamp the camera to a ladder and operate it from the ground with an extra long cable release. In order to determine correct exposure, take readings close to the window of the lightest and darkest areas and average the values. When you are forced to photograph a high window from the ground, a lens hood is essential to exclude light coming from other windows. If your angle of view with a standard lens is too acute, use a long-focus lens from a more distant viewpoint. Fine-grain, medium-speed film is suitable for all shots. Contrast is sometimes a problem with stained glass, and it is worth experimenting with filters to obtain the ideal balance.

Coins (below and right)

Coins can be photographed for record purposes or, by enlarging an original, to facilitate detailed study and examination. Place the coin or medal flat on a contrasting or black background – flock paper is good as it reflects almost no light – and position the camera vertically above using a tripod or copying stand. To bring out the relief of the original, illuminate using a spotlight placed a metre or so away and pointing down at about 30° to the copyboard. Fit a lens hood to eliminate flare or reflections. To bring out surface detail, front or oblique lighting is required. This can be obtained using a ring flash or a glass sheet/snooted-spotlight set-up, below. To construct this, use a clamp to fix the glass at 45°

between camera and subject. Then place the light about a metre away from the glass, as shown in the diagram, so light is reflected down to the original. Most of the light reflected back from the coin will pass through the glass sheet and into the camera lens. It is best to work with an SLR camera, allowing careful monitoring of camera alignment and lighting. By changing the aperture of the snoot or the distance of the lamp from the glass, illumination can be subtly varied. It is a good idea to photograph both sides of a coin or medal (at the same magnification and with identical lighting) and to print the two negatives on the same sheet of paper. In the shot below right, a ruler indicates scale.

Objets d'art (right)

Copying is generally thought of as relating to two-dimensional objects, but *objets d'art* are traditionally a part of the same artistic world as paintings, drawings, coins and so on, requiring some of the same photographic techniques and sharing some of the same problems. The best lighting for objects such as those shown here is soft, directional and without heavy shadows. The easiest way to achieve this is to work with a light tent. Construct a simple wire frame and drape from it plain white diffusing material such as muslin or tracing paper so the subject is enclosed completely: the tent can be suspended from either the ceiling or a horizontal bar supported by two lamp-stands. Cut a small opening in the drape to take your camera lens, and arrange two or three lamps around the outside of the tent to illuminate the interior as desired. You can use flash units, synchronized by slave units, but then extra care must be taken to ensure evenness of lighting. A light tent is also useful for photographing objects with shiny, highly polished surfaces that are likely to reflect light from yourself and your camera and lights. Sheets of matt-white paper can be placed inside the tent to introduce some shadows and subtle reflections.

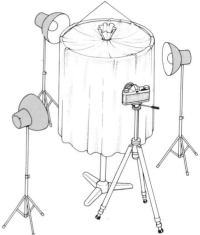

Scientific photography 1

The demands of scientific studies have encouraged the development of various special purpose methods of photography: it is now possible to photograph in complete darkness, at magnifications of x1,000,000 or more, in 3-D and inside the human body. Some of these techniques utilize wavelengths of electromagnetic radiation either shorter or longer than those of visible light, but what they record can be translated into the familiar code of light and colour. This is made possible by exploitation of the television tube, which can turn all types of electromagnetic radiation into images on a fluorescent screen. Computers linked to the television screen can further modify these images to suit the purposes of a specific scientific investigation. The equipment required to produce photographs similar to almost all those shown on this and the following three pages is now available to the amateur. Electron microscopes, laser equipment and sophisticated X-ray machines are, however, extremely expensive, though you may be able to gain access to such instruments at a local college.

The spectrum (below)
Visible light—the familiar red to violet band of the spectrum—makes up only a small part of the entire range of electromagnetic radiation. This radiation travels in wave-like motions, the higher the energy the shorter the wavelength X rays are high energy, radio waves low energy. Normal photographic emulsions on films are sensitive only to the visible light and to some ultraviolet radiation, but X-ray and infrared films are made employing chemical emulsions that are sensitive to electromagnetic radiations beyond the ultraviolet and visible red wavelengths of light respectively. Infrared photography has many applications in science and industry.

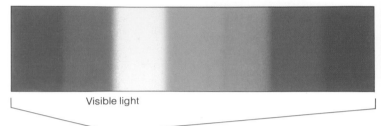

Visible light

Audio	Radio	Microwave	Infrared		Ultraviolet	X-rays	Gamma rays
10^9 10^8 10^7	10^6 10^5 10^4 10^3 10^2 10 1	10^{-1}	10^{-2} 10^{-3} 10^{-4}		10^{-5} 10^{-6}	10^{-7} 10^{-8} 10^{-9}	10^{-10} 10^{-11}

Wavelength in centimetres

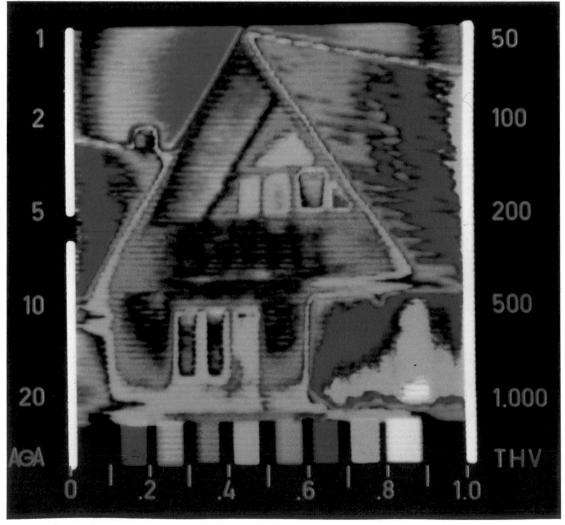

Infrared photography (left)
Infrared is radiation with a wavelength longer than that of visible light. Film sensitive to it enables pictures to be taken in total darkness and through atmospheric haze and can record certa interesting effects. Outdoors, the sun is a strong source of infrared radiation; indoors, tungsten filament lamps and electronic flash both produce it. The film must be used with special infrared transmitting filters. A yellow filter will transmit infrared plus the green and red portions of the visible spectrum—used with infrared Ektachrome transparency film, sky appears deep blu green foliage magenta, people's faces waxen green and red objects yellow. A deep red filter has the effect of making grass and the leaves of deciduo trees appear white and the leaves of coniferous trees dark, while blue skies and clear water look black. Infrared photography is used in forestry surveys the charting of sea currents, detecting silting and pollution of rivers, in forensic studies to detect blood stains and in astronomy to record the heat radiated by stars. Thermography, the recording of infrared emitted naturally by objects as heat, is used in medicine to detect cancerous growths, militarily to locate tanks and aircraft, the engines of which are hotter than surrounding areas, and to test heating and cooling systems in buildings. The heat scan of a house, left, is an electronically falsely coloured thermographic image which the coldest parts of the building are represented by the blue end of the scale along the bottom of the image and the warmest parts by the yellow/white end of the scale. The warmest part of the house is clearly shown to be a room at bottom right; the white patch is a heating source.

X-ray photography (right)
X-rays are electromagnetic radiations of very short wavelength that are able to penetrate solid objects. The lower the density and the weight of any particular substance, the more penetrable it is by X-rays. Thus, a metal object is more dense than the clothes in a suitcase, making possible the detection by airlines of weapons inside baggage. X-ray photography requires a special film emulsion and an X-ray source, usually an evacuated tube in which high-speed electrons bombard a target that then emits the rays. It is used in medicine to detect breaks in bones, impacted teeth and tumours, and in industry to reveal faults in plastics, paper and metals. X-ray crystallography, a technique in which a narrow beam of X-rays is projected through a thin slice of crystal, is used to reveal the atomic structure of chemical compounds. The X-ray photograph, right, is of a live person's head. It was taken by placing an X-ray plate behind and close to the subject and exposing to a short burst of X-rays for a duration of less than a second.

Using polarized light (below and right)
Ordinary light vibrates in all planes at right angles to the direction of travel, but light passing through a polarizing filter is restricted to a single plane. If two such filters are placed with their planes of rotation mutually at right angles, no light is passed. The shot, right, is of a thin section of a crystal of salicin, the base of aspirin, sandwiched between filters arranged in this way—it is visible because salicin rotates the plane of polarization, negating the action of the second filter. In the same way, stresses in a plastic set-square are visible, far right.

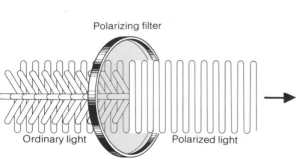

Polarizing filter

Ordinary light

Polarized light

Scientific photography 2

Photomicrography

Photographing through a microscope – photomicrography – is used when magnifications greater than about × 10, the limit of macro lenses, are required. SLR cameras with TTL metering are the most suitable for photomicrography, and can be fitted to the microscope with a special adaptor. To set up a shot, place the microscope slide on the stage, direct the lamp beam on to the subject to illuminate it evenly, focus using the microscope controls, select widest camera aperture for maximum brightness and alter shutter speed to gain correct exposure. Among the best subjects for photomicrography are biological specimens: tiny animals and plants suspended in a droplet of water on a slide can be photographed live using an electronic flash fitted with a low-voltage tungsten lamp as a light source. Below left is a water flea, *Daphnia*, taken through a yellow filter at × 30, and below right is a diatom cluster in water at × 100.

Equipment (above)
Microscopes for photomicrography must be sturdily built to support the camera steadily.

Electron microscopes (below and right)

Objects smaller than the wavelength of visible light cannot be "seen"; the light just goes around them. This is why optical microscopes can magnify only up to about × 2000. An electron microscope can magnify up to × 1,000,000, because it uses a beam of electrons – negatively charged atomic particles – instead of light, focusing with a magnetic "lens". The image is viewed on a fluorescent screen, which is removed to make the exposure on the plate of a camera built in at the base of the microscope. Scanning electron microscopes, or SEMs, which scan electrons reflected from the specimen's surface, produce images with a 3-D appearance, and allow you to view and photograph the subject from different angles and to zoom in on details. SEMs are used mainly to view biological specimens and crystalline structure (it is not possible to examine live creatures). The scanning electron micrograph, right, shows the hopper-like structure of a complex semiconductor at × 400. Below left, an SEM is shown in use, and directly below is a cross-section showing the complex beaming system of a typical electron microscope.

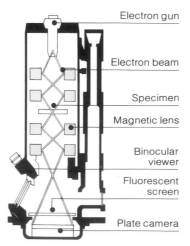

Electron gun

Electron beam

Specimen

Magnetic lens

Binocular viewer

Fluorescent screen

Plate camera

Holography (right and below right)
Holography is a technique for creating 3-D images using laser light focused by lenses and reflected by mirrors. Lasers emit a coherent (parallel-sided) beam of light with a very narrow wavelength range so that it is of an extremely pure colour. To produce a hologram, two such beams from the same source are required. One illuminates the subject, some of the light reflected from it hitting a photographic plate; the other, called the reference beam, shines directly on the plate. The pattern of interference caused by the mingling of scattered light from the object and coherent light from the reference beam produces a complex network of fringes on the plate, and if a laser light is shone through the plate the object

is re-created in such a way that as the observer shifts position the image changes in appearance as it would in reality. The plate (and the image produced from it) is called a hologram, from the Greek for "whole message". In photography, holography is used mainly for high-speed work, the laser being used as a flash to freeze motion. In engineering, for example, double exposure holograms can detect vibrations in machinery by observing minute changes in subject position between exposures. The hologram below right is an archival image of the keys of St Petersburg for the USSR State Records of Art Treasures. The slight haziness is due to reflections from chemicals within the hologram affecting the image.

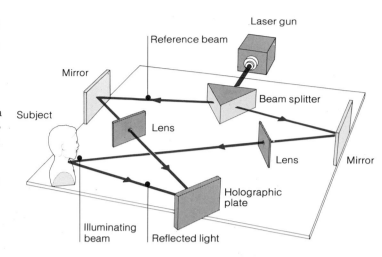

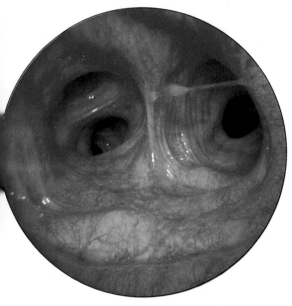

Endoscopy (above and right)
An endoscope is a long, thin, usually rigid tube that carries a miniature lens and lighting system. Various types are employed to examine, for example, the insides of machines and the orifices of the human body, or to give eye-level views of scale models. For photography, a camera can be fitted by means of a special adaptor. Endoscopes with different optics permit viewing and shooting at an angle to the tube's axis as well as straight along it. The shot above shows the division of the left main bronchus into its various branches. The marked reddening of the bronchial lining, with swelling of the blood vessels, is due to chronic bronchitis caused by smoking cigarettes. The picture was taken using an endoscope with a rigid, glass rod optical system. Other endoscopes, using fibre optics, are completely flexible, and can be used to photograph deep inside the various orifices of the body.

Front projection

General principles

Front projection is used to provide background to scenes shot in studios, such as the beach scene, right. In a professional front-projection unit (far right), the projector is set at right angles to the camera and a background is projected on to a screen via a semi-silvered mirror (through which the camera can see) set at 45° in front of the camera lens. With exposure set for the image on the screen, the models are lit separately to match that exposure. If this is done accurately (sometimes with flash), and the models wear non-reflecting clothing, the projected image will not appear on them. Alignment of the camera along the axis of the projection ensures that the models' shadows are hidden.

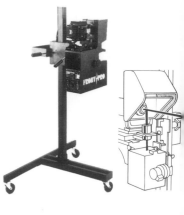

A professional front projection unit incorporates a purpose-built projector and a camera support.

Using a slide projector

An ordinary slide projector used for front projection will throw a shadow of the main subject on to the screen. A way of avoiding this is to project the image squarely on to the screen, photograph it obliquely, and then project the copy transparency from the original camera position. This will correct the distortion and allow you to place a model in front of the background. Match subject lighting to the background and to the situation you are trying to create. Here, the exposure was averaged on the model.

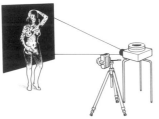

Projecting on to objects

The shot at right was taken simply by front-projecting an abstract pattern from a transparency on to the model, who is standing quite close to a light-absorbing velvet backcloth. An ordinary projector was used to cast the image.

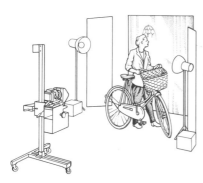

Using a front-projection unit

The image of the church interior used as background in the shot at right was projected by means of a professional front-projection unit. Studio lamps, positioned either side of the projector beam and masked from screen and camera, were used to light the model. Filters are needed on some projection units to compensate for the absorption of magenta light by the projector condenser system. Front-projection units have electronic flash lamps, which make necessary the use of daylight film.

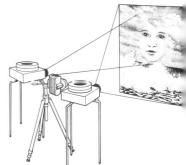

Using two projectors

The large photo, opposite page, is of a screen on to which two images were simultaneously front-projected using ordinary slide projectors. These were placed either side of the camera. In creating such combined images projected elements should be introduced one at a time, and the unwanted parts of each image masked off with a black card placed close to the projector lens. To alter image sizes, move the projectors away from or toward the screen, or equip them with zoom projector lenses.

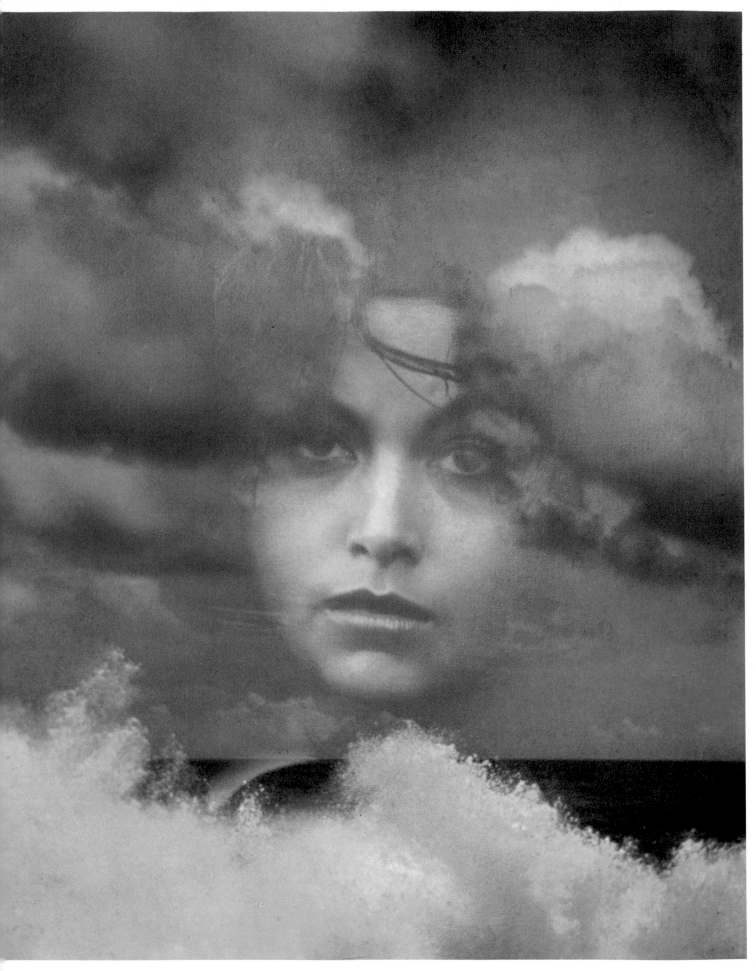

Theatre and film stills

Show business thrives on publicity – pre-production publicity, publicity about opening nights, and publicity about the people involved in it. From ballet to television soap opera, popular interest in the performing arts breeds a symbiotic relationship between the promoters and the Press, each needing the other. Paradoxically, however, it is not always easy for an amateur – or even a professional – to get the pictures he or she wants. Firstly, many film companies have their own publicity sections and do not need the services of anyone from outside. Secondly, both film and theatre companies like to exercise control – if not censorship – over pictures released to the media. And thirdly, many film sets and dress rehearsals are closed to still photographers, either because the stars object to being photographed fluffing their lines or because the photographer's presence is held to be distracting. Most photographs taken on set or stage have to be snatched during rest periods, or at a photo call where press photographers are expected to work shoulder to shoulder like a firing squad: the results are often mediocre.

The best and most professional approach is to build a relationship, however tenuous, with the director or producer. If possible arrange an interview well ahead of rehearsals and don't hesitate to show your portfolio. You must be conversant with the film or play – you can get information from the publicity department – and it is a good idea to sit through a rehearsal, taking notes of the actors' and actresses' dress and movements, and of the most dramatic or characteristic scenes as well as of the best lighting angles.

You can gain experience by starting with local repertory theatres or even school plays. You will find that stage lighting is usually inadequate for photography and has to be simulated with portable electronic flash and bounced lights. Take two or three lights, strobe and photoflood plus reflectors, and make use of existing lighting. Bearing in mind that everything in the theatre is larger than life and twice as natural, you can use quite dramatic lighting effects and encourage actors and actresses to make exaggerated gestures, as in the picture on the right. Players may readily agree to pose for personal publicity shots, especially if you can link them to a magazine interview or the entertainments page of a local newspaper. It is well to find out in advance if the actors expect a fee. This depends very much on the job. The picture at the bottom right of the opposite page was taken for the cover of a cookery book during the shooting of the television series *Upstairs Downstairs*, and a fee was paid. This is perfectly acceptable and puts the session on a strictly professional basis, designed to lead through mutual respect and hard work to excellent results.

Actors and sets

The sets and stylistic approaches of various forms of drama are strongly evident in the selection of photographs on these pages, some of which were shot with existing light. They range from a dance sequence silhouetted against a window, through the truly theatrical poses and costumes of Shakespearean comedy and the artificiality of an atmospheric film set (for *The Return of the Soldier*) to a television set used for the popular series *Upstairs Downstairs*. In all these photographs, a sense of movement and action is an essential ingredient.

Sport 1

High-speed cameras
Cameras such as the lightweight Hulcher (above) can gobble up film at a rate of up to 65 frames per second and provide either several peak-action shots or a detailed analysis of an athlete's posture, movements and technique.

Successful sports photography requires practice, experience and some background knowledge of the sport you are trying to capture. Quick reflexes are needed, whether you are trying to record the speed and power of Grand Prix cars or the vital moment of a judo throw after the contestants have been locked in a motionless embrace for what seems like an eternity.

If you can get close to the action, wide-angle lenses can be effective, giving a dramatic sense of involvement, especially from low or level viewpoints. Whether outdoors or indoors, the possibility of using flash should not be ignored in these situations as a means of freezing movement. In general, however, telephoto or zoom lenses are the most effective for isolating sportsmen from jumbled backgrounds. As fast film, fast shutters and fairly wide apertures are usually necessary, you will need to be able to focus rapidly and accurately. The best angles vary from sport to sport, but frontal or slightly oblique viewpoints make it easier to prefocus and frame the subject. Preplanning is essential, and you will have to be willing to use a good deal of film for one spectacular shot of peak action.

Freezing with flash
The skateboarder's expression, a blend of excitement and alarm, is the main point of interest in a close-up shot taken with flash to allow a fast exposure with sharp detail. The poor light would otherwise have required a shutter speed of about 1/60.

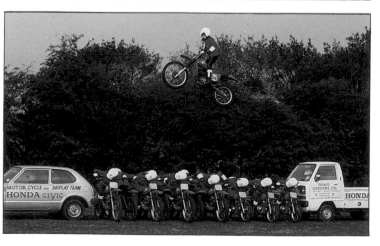

Covering the angles
A decisive moment of action can be captured from several different camera positions by using a number of cameras simultaneously, either triggering them with a long cable release or making use of a photo-electric cell. This is a useful technique if you want to shoot the same event using different types of film or with a variety of filters. The three cameras used to photograph the Imps Motor Cycle Display Team, left, were triggered almost simultaneously.

Sequence photography (left and right) Motor-drive facilities on the modern SLR camera have made it possible for any photographer to pan with a fast-moving event and get sharp pictures in sequences of up to 4 frames per second (faster on a few models). Yet the peak action may still be lost during the split-second transport of the film from one frame to the next. The sequence images of the long-jumper and the flying javelin required a Hulcher dual shutter firing at between 30 and 45 frames per second. Such cameras have been developed to provide unique images well beyond the limits of human vision. The shots here were montaged and rephotographed as single pictures.

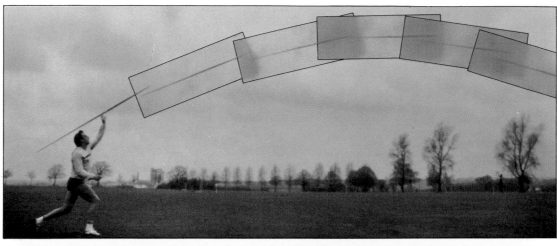

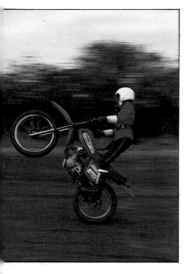

Panning
The key to accurate panning is to begin swinging the body from a firm stance before pressing the shutter – and to follow through. This shot used a shutter speed of 1/60 to heighten the drama with background speed lines, while capturing the spinning wheels.

Using long lenses
Most sports photographers carry either a zoom lens – often with a pistol grip to assist rapid focusing – or a long lens among a collection of at least three cameras to cover every situation. In many, if not most, sporting events it is usually physically impossible to get close to the competitors and a long lens is the only means of composing a tight, dramatic shot – as in this picture of a fire-jump, taken head-on with a 400 mm lens.

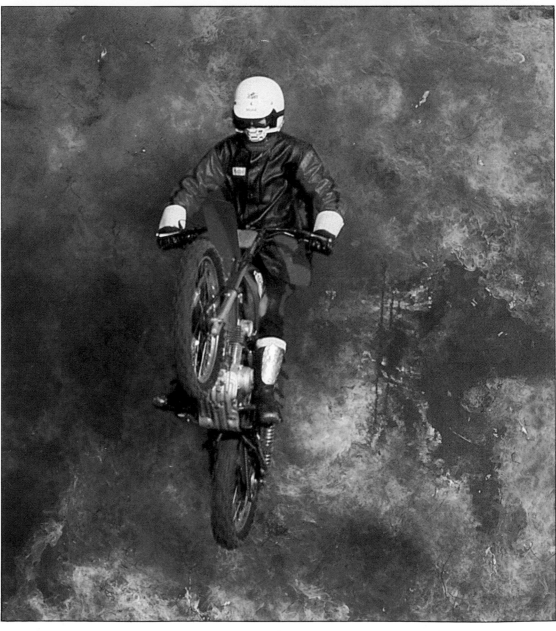

Sport 2

Camera position is all-important in sports photography. Where you place yourself will decide whether or not you grab the most dynamic moment of the action – a sports picture should sum up the entire event. Here, a water skier from the Braintree Ski Club in Essex, England, executes a slalom that sends up a dazzling wall of water as he makes a tight curve. I shot the picture from the towing boat, using a Pentax camera with a 135 mm lens. At 1/1000 the shutter has frozen the peak of the action, but has registered sufficient blur to indicate movement. The shot captures the contrast between the skier's speed and the otherwise placid surface of the lake.

With sports pictures you don't wait for the "lucky break" – even the most sophisticated photographic equipment is useless if you are in the wrong place. Try to plan in advance the best position from which to shoot the action, bearing in mind the future direction of the light and whether spectators may block your view. Have at least two cameras and a selection of lenses, including a zoom and a long-focus.

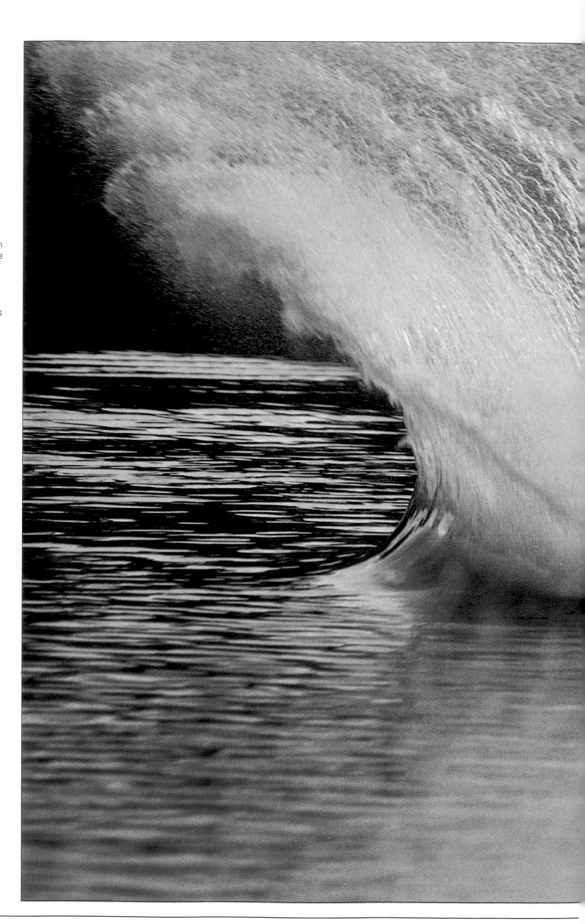

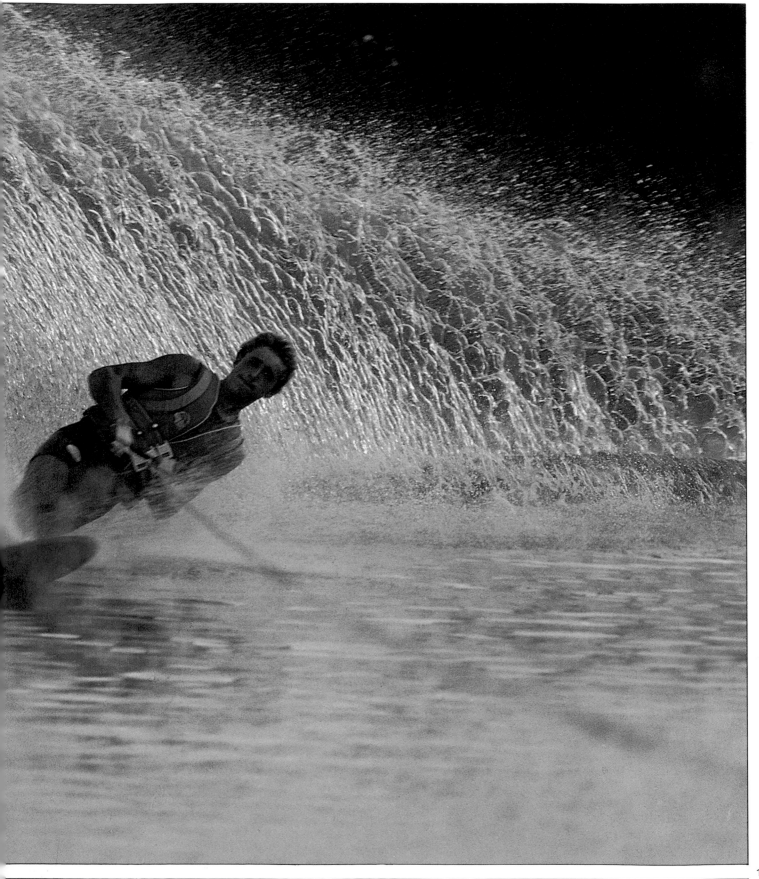

Press photography

Newspapers, news magazines and periodicals are the largest and most regular consumers of pictures. Although the national Press in any country is fiercely competitive, it is not difficult to break into the field of news photography at a more humble level by finding material of interest to your local newspaper. Most small newspapers employ staff photographers, but a picture editor will give serious consideration to any pictures with obvious merit, especially if they are linked to a local event or place. Sporting events, flower shows, amateur dramatics, festivities and anniversaries offer constant opportunities provided your shots are of an acceptable standard and have human interest.

In contrast to these varied if fairly run of the mill subjects, are news shots that will be used because of their immediacy or impact – a motorway pile-up, a robbery, a candid shot of a famous personality you have unexpectedly spotted. If you are lucky enough to capture a unique picture, phone the picture department of one of the major newspapers and you will be given every help in getting your shots to them rapidly. As a newspaper may claim exclusive use, an alternative is to send your pictures to a central picture agency, able to syndicate a picture throughout the world. In either case you will be expected to supply in summary form essential information spelling out the story of the picture – who, what, when, where, why. Relevant details should be written down at the time, with particular care paid to full, correct spellings of any names and with enough data to identify subjects clearly. A typed caption stuck to the back of the print is the best way of presenting this information. Most picture editors prefer 10×8in glossy black and white prints, and transparencies rather than colour prints.

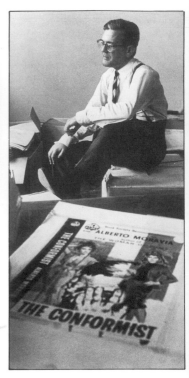

Personalities at work (above right)
The composer Stravinsky is seen from the violin desks in the orchestra, the sheets of music creating an intriguing arrangement of mass and detail. To the right is a shot of a publisher, shown with one of his books, which adds to the reflective air of the portrait. References to the subjects' status or profession are particularly appropriate elements in news or feature photographs, which should aim to tell as much as possible about their work and interests, as well as about their personalities.

News as history (right)
Patrice Lumumba, who led the Belgian Congo – now Zaïre – to independence, is shown during his arrest as a revolutionary. This news photograph, grabbed at an airport, is one of the very few shots taken of Lumumba under arrest – he was later executed. The picture was syndicated, and after 20 years is still being sold world-wide. Although the image is not in itself particularly exciting, its rarity value and exclusivity have guaranteed its continuing use by numerous newspapers and publishers.

Scaling a picture
To scale a picture to match the size of the allotted area, align the picture and area as shown. A diagonal through the corners indicates the limits of equivalent areas and which parts must be cropped accordingly.

Masking
Masking or cropping means you select the most important part of your picture at the expense of the surrounding detail. It is most often done by the picture editor, who knows the style and requirements of his paper. Two L-shaped pieces of cardboard, as shown here, make simple but very effective tools for masking.

Unusual angles and stories
The picture above is one of a series for the travel Press on the delays and frustrations of waiting in airports and railway stations; it avoids the obvious and introduces a welcome note of humour to the situation. There is humour also in the photograph at right, an excellent example of the kind of human interest picture that has wide popular appeal. When the chemist of a small town in Northumberland closed, the local butcher offered to weigh babies.

Prize bull
This shot is very straightforward, but is of a type that can prove lucrative to the photographer, as it can be used by trade magazines as well as by local newspapers. It might sell to a livestock journal or to a manufacturer of animal foodstuffs for advertising purposes.

Cornish shipwreck
Pictures such as this are the staple diet of most newspapers, suitable equally for the national and the provincial Press. Most good news shots are the result of being in the right place at the right time, and from the point of view of the newspaper it is often a case of using the picture that gets there first rather than being able to choose from a selection. The moral is to carry a camera with you whenever it is possible.

Aerial photography

Most professional aerial photographers work with hand-held large-format cameras from low-flying light aircraft. They are able to direct the pilot to alter course to get the composition or light they want and, by opening a window or a hatch, they can avoid having to shoot through glass. But excellent aerial shots can be taken with a 35 mm SLR camera (ideally, one with through-the-lens metering) by shooting from a hang-glider or by using a kite or a balloon to carry the camera aloft. Use medium-speed film, shutter speeds of at least 1/100 second to over-come vibration and, to eliminate haze, use a yellow filter for monochrome shots and a UV filter for colour. The best lighting conditions are those in the early morning or late afternoon.

If you are shooting from an airliner, shoot close to the window and use a wide aperture, to avoid recording scratches on the window. Concentrate on mountain tops or cloud formations: landscape shots from high altitudes are usually disappointing. Use a high-contrast developer to compensate for loss of contrast caused by haze.

Using kites and balloons

A simple and effective method of taking aerial photographs from heights of 500 metres or less, such as the shot of English terraced houses below, is to suspend your camera from a kite or a balloon. Two kites, one below the other on the same cable, give greater manoeuvrability. The first (pilot) kite is launched and then. when it is clear of ground-winds, the second kite. The arrangement is shown at far right. In many commercial kite systems a camera cradle is attached to the cable beneath the second (lower) kite, but it can simply be clamped to the main structure, as shown at right.

Before launching the camera, cock the shutter and set it at a fast speed, adjusting the aperture as for a distant landscape shot. Work with a 28 or 35 mm lens and a motor-drive. To activate the shutter, use a radio-controlled or time-delay device, or rig up your own spring-operated shutter lever to press the button. This can be tripped by using a slow-burning saltpetre fuse to break a stretched rubber band.

In light winds, balloons like those used in meteorology will lift a camera into the air. The cradle is suspended from the main cable and is fitted with a drag parachute to keep it stable and clear of the cable. Before flying kites or balloons, check local regulations about maximum permissible heights – most major cities lie on the flight paths of incoming or outgoing aircraft and civil aviation authorities lay down rigid safety rules.

In the shot above, a 35 mm SLR camera, operated by radio control from the ground, is mounted on a steerable kite with a wingspan of 2 metres.

Pilot kite

Load-carrying kite

Hang-gliding photography

Hang-gliding is an excellent means of obtaining detailed aerial shots, because it is done at relatively low altitude and slow speed. But this method of aerial photography should not be attempted until you are thoroughly experienced at handling the glider. For the necessary freedom of movement, attach the camera to your chest harness or strap it to your helmet. Use a lightweight SLR camera with a wide-angle lens and motor-drive; lead the cable release through the sleeve of your jacket into the palm of your hand. Work with medium-speed film, a fast shutter, and with the lens focused on infinity. The same technique can be used to take aerial shots when parachuting from an aircraft.

Air-to-air photography

Photographing one aircraft in flight from another calls for close collaboration and inter-communication between the pilot of the target aircraft, the photographer and the pilot of the craft from which he is working. The relative speeds of the two aircraft must be monitored continually and contact maintained so that course can be altered to get the best lighting, view-point and background. There are two techniques possible: using a hand-held camera from an open window; or binding the camera to a wing-strut or some other part of the aircraft and using a motor-drive and cable release, or remote control device. In the shot at right, the camera and flashgun were bound to a strut supporting the top wing, close to the cockpit, as shown in the drawing below.

Make sure that you and your camera are securely fastened, and never hold your camera out into the slipstream; use wind deflectors if possible.

Aerial surveys

Photographing large areas of land is carried out from low-flying aircraft using large-format cameras and wide-angle lenses. If the survey is for the purpose of map-making, it is important that camera position and direction are carefully monitored; a fixed camera is usually used, operated by remote control.

For military reconnaissance, forestry surveys and town planning, where size, shape, tone and texture are important but some image distortion is acceptable, smaller format hand-held manually operated cameras such as that shown at right can be used. This type of camera will have quickly interchangeable lenses, a special viewfinder with cross-wires, motor-drive, and a vacuum pump system to ensure film flatness during the fast wind-on operation. Film emulsions sensitive to near-infrared are used to reveal, for example, disease in crops. For greatest coverage of an area a "mosaic" is used; this is a series of overlapping vertical shots taken on parallel tracks, as shown at far right.

Underwater photography 1

There is a unique sense of achievement in capturing on film the beauties and oddities of the underwater world – shoals of brilliantly coloured fish, seaweeds of every shade of green, brown and red gently swaying with the currents, shipwrecks, or the rugged landscape of coral reefs. But whether you are scuba diving in deep water or simply snorkelling close to the shore, a number of special photographic problems are posed. First, salt water is particularly corrosive to camera mechanisms and the pressure at any depth is an added hazard to equipment. Second, the low light intensity and predominantly blue-green hues underwater make accurate exposures and colour balance difficult to achieve. Third, because light rays are diffracted, or bent, as they pass from water into the eye or a camera lens, objects appear larger and nearer than normal. Finally, it takes a good deal of diving practice to operate a camera at any depth smoothly, focusing correctly and avoiding camera shake, especially when following moving fish.

Underwater photography in calm shallows requires no special camera equipment: inexpensive flexible waterproofed housings designed to allow normal adjustment of camera controls can be used with most SLR and Instamatic cameras, and there are now a number of simple water-proofed cameras available. For more ambitious projects, there are purpose-built shallow-water housings – toughened plastic cases that usually allow you to use the camera's viewfinder and to operate focusing, exposure, shutter release and wind-on controls from outside the camera case. More expensive deep-water housings can withstand hydrostatic pressures at depths of 100 metres or more. Anyone intending to do much underwater photography, however, will be best advised to buy from the outset an amphibious camera such as the Nikonos 1V-A. Completely water-tight, rugged and with optics designed specially for use underwater, these cameras can usually be taken down to depths of 50 metres without the need for an extra underwater housing.

Lighting

On a bright day, with a clear sky and calm, clear water – the perfect weather conditions for underwater photography – it is possible to shoot using natural light to depths of about three metres. At greater depths, or with an overcast sky and rough water, the fall-off in light intensity is dramatic and artificial light is essential. Bulb flash units are effective down to about 10 metres, but below this an electronic flash unit must be carried. Amphibious flash equipment coupled directly to the camera is preferable to an above-water lighting unit encased in a housing. Because

Underwater cameras and equipment
An ideal underwater photography outfit is the Nikonos IV-A amphibious camera and electronic flash unit (below and right). The camera body is corrosion-resistant and its synthetic rubber O-ring acts as a gasket and keeps the camera completely waterproof. Used with care the camera is dust-tight, water-tight and pressure-resistant down to 50 metres. A full range of interchangeable lenses, each coated to reduce ghost images and flare and to improve contrast underwater, is available – though they cannot be changed underwater. Exposure is automatic, with through-the-lens metering of the correct shutter speed. This also applies when the camera is used with the specially designed Nikonos flash and sensor unit. Focusing is not automatic but must be set on the lens focusing knob. The distance can then be checked on the lens's distance scale. The viewfinder is designed to allow the use of goggles, safety glasses or a diver's mask.

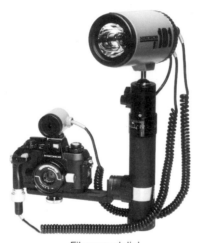

Light meters
Although it is possible to use ordinary hand-held and built-in light meters as long as they are in a housing, a light meter adapted for underwater use is an advantage. The amphibious meter (right) can be bolted on to most cameras and has usefully large controls and figures for working in conditions of poor visibility.

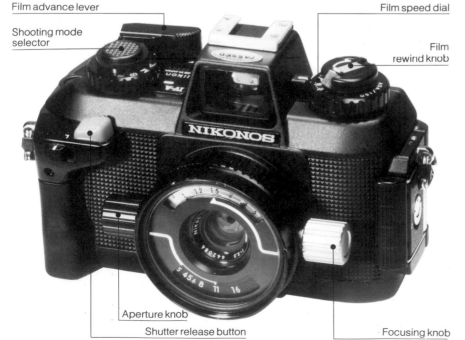

Film advance lever

Shooting mode selector

NIKONOS

Aperture knob

Shutter release button

Film speed dial

Film rewind knob

Focusing knob

Underwater camera housings
Deep-water housings for standard above-water cameras are available for most formats. The Hasselblad housing, shown right, can be used to depths of 250 metres. The simplest form of underwater housing is the Spiratone Aqua-case, above, made of soft vinyl. A rubber glove is set into the housing to allow adjustment of controls. It is adequate to withstand pressures down to at least 10 metres.

flash factors are reduced by varying amounts underwater, the guide number scale must be recalibrated for different conditions by means of trial and error.

Using filters
Water absorbs light selectively – first red, then orange and so on through the spectrum to the shorter wavelengths. At depths below about 10 metres everything appears in shades of greens and blues. To compensate for colour imbalance, in shallow water, a red colour filter should be used, the required filter strength increasing by 12 units for every metre that the light travels underwater. At a depth of one metre and a distance from subject to camera of two metres, a CC40R filter would be appropriate, for instance. At more than five metres beneath the water surface, correction filters are ineffective. With black and white film it is best always to use a yellow filter, to avoid loss of contrast.

Films
In choosing film for underwater work, a balance has to be struck between using a slow film, ideal for contrasty results in the prevailing soft, diffuse light, and using a fast film to compensate for the low light

intensity. For colour work, a 64ASA fine-grain film is best for close-ups and faster – say 200ASA – film when using flash over a distance or when shooting in available light. Transparency film tends to give the best results as colour print film often produces underwater pictures with a blue tinge. For black and white shots, use 125ASA film for close-ups and 400ASA for all other subjects.

Equipment maintenance
Prior to any underwater trip, check the housing for leaks without the camera inside and coat all "O-ring" seals with silicone grease. During a diving session, be sure not to take your equipment deeper than is recommended by the manufacturers. After use, rinse camera housing, lighting equipment and all accessories in warm, fresh water to remove grit, mud and salt. Do not leave your camera in the sun as this will ruin the film and cause the ring seals to expand, leading to leaks. Finally, open out and check housing and camera for any remaining water before storing them away; even the smallest droplet can cause irreversible corrosion. The French Aquamatic underwater camera is designed to be flooded in use, except for the film chamber, but having almost no metal parts it is an unusual exception to all the rules.

Back scatter
When using flash, position your light source away from the camera lens and tilt it at an angle of about 45°. This will help to avoid back scatter – light bouncing and scattering from particles in the water. It will also improve modelling and contrast. Use an electronic flash unit, or blue bulbs and cubes for close-ups to maintain good colour balance.

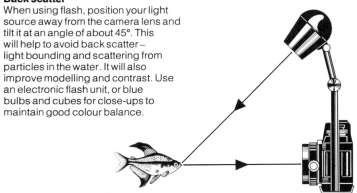

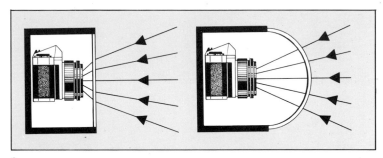

Dome ports
Flat ports as fitted to most soft underwater housings reduce the field of view of your lens because of the refraction, or bending, of light rays at the water/glass interface. As the diagrams above show, this refraction does not occur when a dome port is fitted because the light from every direction passes through it at right angles. The normal field of view is therefore maintained.

Size and distance
Objects underwater look about 25% nearer and 35% bigger. The effect is much the same on the camera lens as the eye so you will need to focus on apparent rather than real distances. SLR or rangefinder cameras allow this, but others, such as the Nikonos IV-A, must be focused by estimating, or by using a focusing rod – a stick with, say, 1 metre marked "75cm". For close-ups use a field frame (right) matching the coverage of your lens.

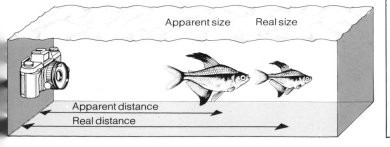

Apparent size Real size

Apparent distance

Real distance

Aquarium photography
Photographing fish in glass aquaria does not require any special equipment. First ensure that the glass of the tank is clean and free from optical distortions and that the water is clear. Position your camera square on to the tank and behind a black card so that it does not cause reflections in the glass, and fit a polarizing filter to your lens to minimize reflections of tiny particles in the water. As a light source use an electronic flash or flashbulb unit – photofloods will heat up the water too much – and place this either above or to one side of the tank. Finally, use a black card background to make the subject stand out and, if possible, use partitions of glass to confine the fish to a small area and help you focus at close range.

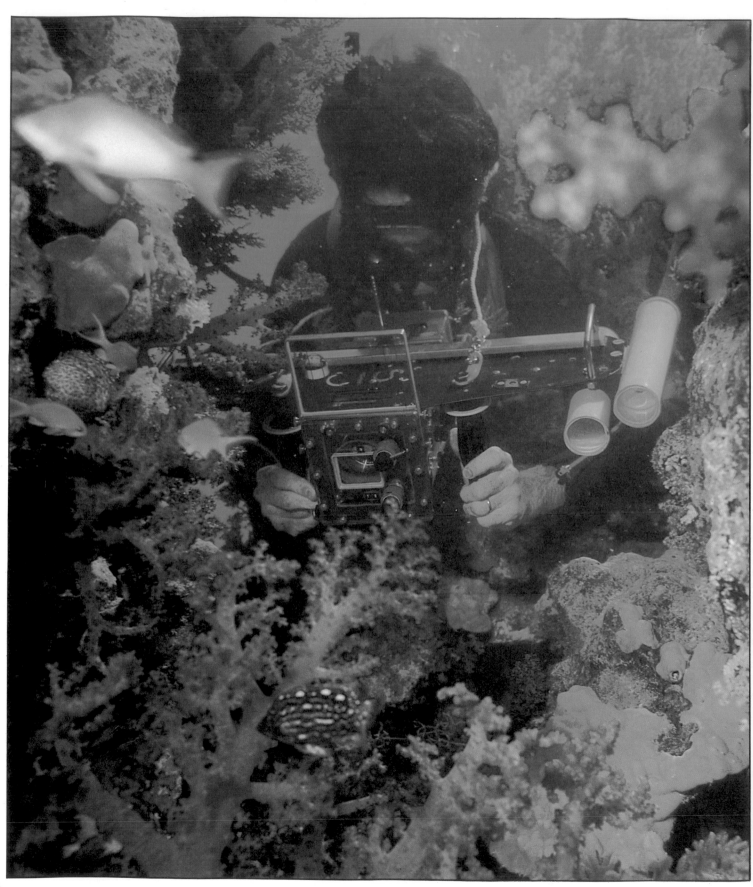

The best locations for underwater photography are rocky areas, particularly those with caves, gullies and arches, coral reefs and rock pools. They are usually rich in both plant and animal life and lend themselves to impressive marine landscape shots. The most colourful fish are found in reef areas, and rock backgrounds also help to give scale. If you want to take shots of individual fish in a shoal, try to drift slowly into the shoal; most fish can swim much faster than you and will dart away if you move suddenly or vigorously. Should a fish that you particularly want to photograph swim away when you move in close, remain stationary and let it come to you; reef fish are territorial and will tend to return repeatedly to a spot to defend it from other fish. Some species are extremely inquisitive and, provided you remain still, will swim right up to your camera. Alternatively, try attracting them with small pieces of raw fish, which you can take with you underwater in a plastic bag.

Corals, sponges, anemones and seaweed are attractive subjects for both distant and close-up shots. Look for shrimps, crabs and other crustacea too; they make refreshingly different pictures from those taken by most novice underwater photographers. Wrecks similarly add interest although they are not easy subjects to photograph effectively. Modern wrecks are often best, as the ship's structure is usually still discernible. As it is difficult to light large areas underwater, wide-angle colour shots will probably suffer from a marked blue bias, with a lack of contrast in black and white shots. To overcome this, in addition to using the appropriate filters, it is helpful to have a colleague who can provide additional light sources. A companion can also help to experiment with backlighting, which can be strikingly effective underwater – and it is worth mentioning that diving is much safer when done in groups of at least two.

Photographs have been experimentally taken at distances of 100 feet underwater, but usually objects even 30 feet away appear hazy and it is best to concentrate on subjects 15 feet away or less. Remember that more sunlight enters the water during the middle of the day and when the surface is calm. Suspended particles in the water limit visibility; avoid disturbed muddy sea-bottoms and silt from rivers. Plankton can present similar visibility problems: this form of green sea life is most prolific in the spring.

The specialist photographer shown at opposite left is using a large-format underwater camera with sports view-finder and an electronic flash unit mounted on a transverse support frame to take close-ups of coral. The shot itself demonstrates two general rules of underwater photography: get in as close as possible, with a wide-angle lens, and try to include a point of reference for scale, or a well-defined background, otherwise the subject may lose its identity, however beautiful it may have seemed in itself. The photographs of the wreck (right above) and of the turtle (right below) include another diver, while the splendid *Pomacanthus imperator* (near right) stands out much the better for the brilliant red patches of seaweed.

How water modifies sunlight
When sunlight strikes a water surface some is reflected or diffused. Those rays that penetrate are both scattered by suspended particles or air bubbles and absorbed. The red end of the spectrum is absorbed first, eventually leaving only scattered blue and green light. (A blue cast is evident in the natural light shot of the diver with a turtle.) At depths greater than about 30 metres there is complete darkness, even in the clearest seas.

Metres

0

10

20

30

Photographing the night sky

Specialized astronomical photography makes it possible to record both transient events such as eclipses and celestial objects too faint to be seen either by the naked eye or through a telescope. But a rangefinder camera with a B setting can be used for good shots of the moon, planets, comets, meteors and stars. Detailed photographs of nearby celestial objects and shots of the sun, galaxies and nebulae are possible with an SLR camera fitted to a telescope.

Photographing the night sky presents two main problems: first, because of the earth's rotation, celestial objects appear to move across the sky, and, second, apart from the moon and nearby planets, all objects are extremely faint and require exposures of several minutes or even hours. If you point your camera at the night sky and expose for more than about 15 seconds without moving the camera the stars will come out as streaks rather than dots on your film. The longer the exposure the longer the streaks. To avoid this you will need an equatorial mounting with electric or clockwork drive (see opposite). With very long exposures you will also need to beware of reciprocity failure. As a general rule take several shots using a different shutter speed and aperture each time. Other problems liable to be encountered in astronomical photography include atmospheric turbulence, airglow and the glare from city lights. Special filters to reduce these factors are available, but it is always best to work from the darkness of the countryside and at the highest possible altitude: a portable telescope such as the Celestron 5 (see opposite) might be worth considering – it also doubles up as a powerful telephoto lens for normal use. Cold, clear nights are best for photographing stars and nebulae; hazy skies (which are less turbulent) for the moon and planets.

To take sharp pictures of brighter objects, such as the sun, moon and nearby planets, use ASA 125 to 400 black and white film. Exposures of only a few seconds should usually be sufficient. For all other celestial objects use film in the range ASA 400 to 800, with exposures of several minutes for star trails, comets and meteors, and of one to two hours for galaxies and nebulae. In general, choose the shortest possible exposure time to minimize guiding errors and problems of atmospheric turbulence. When processing black and white prints, extend the normal development time and print on to hard bromide paper to bring out the most detail. Colour transparency film (ASA 64 to 200) usually gives better results than colour print film. It is now possible to get film with low reciprocity failure, for instance Kodak spectroscopic film, which is ideal for astronomical photography.

Comets (left)
These can be photographed without using an equatorial mount, but for best results use a driven equatorial regulated to the comet's motion. Point your camera in the direction of the comet and expose at full aperture for as long as sky conditions will allow. The shot, left, of Halley's comet, was taken using a 75 cm reflector and a 30-minute exposure.

Stars, meteors and satellites (below)
To capture these on film you need only a fixed camera with a standard 50 mm lens. A passing meteor will produce a long, thin flash bisecting the curved trails of the stars, while a satellite gives a straight trail. The shot of star trails (below) also shows the trail of a bright satellite. It was taken on film uprated to ASA 400 and with an hour-long exposure.

Photographing the sun
Never look at the sun directly or through a camera or a telescope; this could permanently damage your eyes. It is also dangerous to work with smoked glass filters. Instead, fit a piece of aluminized polyester film over the telescope's objective lens; then project the sun's image on to a piece of white card and photograph that. Use exposures of 1/500 second or less to "freeze" the image and to minimize atmospheric turbulence. The shot of a partial eclipse (right) was photographed using a 10 cm refractor telescope. Changes in sunspots become evident if the sun is photographed at various intervals of time.

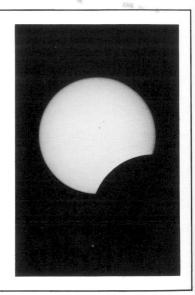

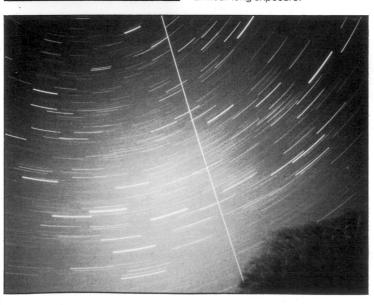

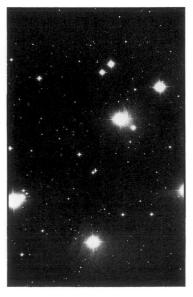

Constellations and star clusters
It is a good idea to concentrate on the well-known constellations and build up a detailed picture of your local region of the night sky, rather than photographing star fields randomly. Newspapers often feature the sky at night. Use an equatorial drive and expose for several minutes to reveal a large number of stars. The shot of the Pleiades star cluster (left) was taken on ASA 400 film using a 40 cm reflector with home-made optics and a 10-minute exposure. The seven brightest stars are visible to the naked eye, but the others only become apparent with a camera (because film can gather light over a period) or a telescope. The haziness and the sparkle of the stars are caused by a cloud of gas in front of the star cluster.

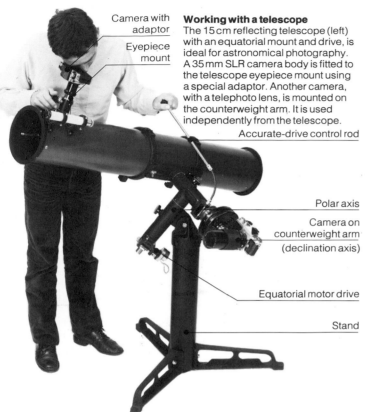

Camera with adaptor

Eyepiece mount

Accurate-drive control rod

Polar axis

Camera on counterweight arm (declination axis)

Equatorial motor drive

Stand

Working with a telescope

The 15 cm reflecting telescope (left) with an equatorial mount and drive, is ideal for astronomical photography. A 35 mm SLR camera body is fitted to the telescope eyepiece mount using a special adaptor. Another camera, with a telephoto lens, is mounted on the counterweight arm. It is used independently from the telescope.

Telescope-camera adaptors

Use an adaptor that allows both prime focus and eyepiece projection. The former is used for star and deep-sky photography. Remove the lens from your camera and use the adaptor to couple the body to the telescope eyepiece mount from which the lens has been removed. For eyepiece projection – used for lunar, solar and planetary shots – the eyepiece lens stays in place. A Celestron 5 portable telescope combined with a 35 mm SLR body with pentaprism viewfinder to facilitate focusing is shown above.

The equatorial mount

To record the stars as fine points and to photograph the planets, nebulae and galaxies you will need to use an equatorial mount and drive. In this the main, or polar, axis is set parallel to the earth's axis – it points towards the celestial pole – and is rotated at the same speed as, but in the opposite direction to, the earth. The earth rotates once every 23hr 56min.

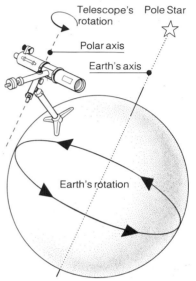

Telescope's rotation

Pole Star

Polar axis

Earth's axis

Earth's rotation

The moon, planets and galaxies

For detailed shots of the moon you will do best with a camera fitted to a telescope with equatorial drive, medium-speed film and exposures of up to 10 seconds. Concentrate on the area nearest the boundary between light and dark side – the low light throws craters and mountains into relief. The sequence above was taken using a 90 cm refractor. For photographs of the planets you should expose between 0·5 and 15 seconds. The shot of Saturn, right, was taken using a 39 cm reflector. Deep-sky shots require a powerful telescope to which fine adjustments of position can be made during the course of the long (up to two hours) exposures. These adjustments are to counteract the slight movement of the subject in the field of view. The shot, far right, of galaxy M81 was taken using the 500 cm telescope at the Mt Palomar Observatory in the United States.

Sandwiching

Many of the most exciting photographs – far more than is generally admitted – are the result of juxtaposing two or more images in a single transparency mount to make a print which is then sometimes combined with a montage and rephotographed. This is true particularly of advertising work where the creative department has produced a complicated visual which the photographer is obliged to realize. The picture of the parachutist, for example, framed in the sun's disc, would have been difficult to obtain without sandwiching two transparencies – the shots were taken with different focal-length lenses.

The parachutist was photographed at an air display on a very dull day, with a 135 mm long-focus lens. This gave a clear result, but the small image of the parachutist had little pictorial interest – ideally, the subject needed a 500 mm lens, and a tripod with a pan-and-tilt head. The sun was photographed at sunset through misty atmosphere with a 200 mm lens, and subsequently enlarged in a transparency duplicating machine. An advantage of sandwiching is that scale alterations can be introduced by enlarging or cropping images while making copy transparencies. Composition can be worked out beforehand, by projecting images on a screen or tracing them on the camera ground glass screen when adjusting the scale of duplication.

The picture of the girl and car in the lake, made for a magazine short story featuring an heiress drowned in a car crash, was composed of two carefully arranged images which, when sandwiched together, produced one image of acceptable density, colour and range of tones. In pre-planned images of this kind, exposure can be calculated in advance. But stock transparencies too dense for sandwiching can still be made acceptably lighter by copying. Sandwiching is a technique that often enables images that alone were rather devoid of atmosphere to be given a more sympathetic setting and a new pictorial dimension, or to be transformed by surreal juxtaposition.

Viewing transparencies
A light box and viewing glass enable a large stock of transparencies to be quickly sorted out for possible use in sandwiching. The effect of combining two images can be gauged simply by taping them together and projecting them. This will indicate any exposure changes needed during duplication.

Planning the image
The first step in creating the image of the drowned heiress was to borrow a car from a wrecker's yard, together with a crane to lower it into the picture location – a shallow lake in a garden. The layout of the final sandwiched image was sketched as a guide to the positions of the car and girl, and the shot (right) was composed with space for the girl at the left of the frame. A polarizing filter cut down reflections. Exposure was calculated at half a stop over the meter reading. Prior to shooting, a rock was thrown into the lake to create surface ripples.

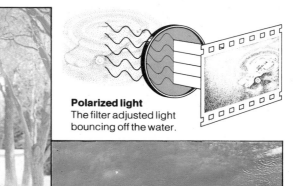

Polarized light
The filter adjusted light bouncing off the water.

Judging exposure
The high-key shot of the girl was overexposed to obtain a transparency thin enough to give a ghost image in the combined print. The correct reading for the scene was f16 but the aperture was opened two stops to f8. Again, the camera position followed the sketch layout.

Simple slide copying set-up
Slides can be copied in a duplicating attachment that may be fitted to the bellows of a range of SLR cameras. The main problem with these copiers is a reduction of colour quality and a tendency towards increased contrast.

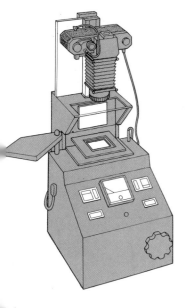

Electronic slide copier
An electronic copier allows more precise exposure and filtration control. The original transparency can be accurately focused on the illuminated panel of the unit, and exposure is by electronic flash.

Models and makeup 1

Beauty photography is a skilled and specialist branch of fashion photography, with its own stringent demands on the photographer's taste, flair and technical abilities. Beauty shots are invariably linked, in some way or other, with the cosmetics industry and great emphasis is placed on makeup. The cover pictures of fashion magazines are usually beauty shots and credit is given by the magazine to the brand of cosmetic, the makeup artist and the photographer.

The style of makeup will depend on several factors – the range of cosmetics that the manufacturer is currently promoting, the mood and look of the moment – which can change almost overnight: a magazine feature relating to daytime styles may be radically different from one relating to evening styles.

With fashion photography, the style will be designed to match the clothes. Though some fashion models are capable of applying their own makeup, the skilful work of a professional makeup artist is essential when clothes are from a leading couturier and the photographs are intended to make a splash in a glossy magazine. While it may be true that a model knows her own face better than the makeup artist, the difference in technique is like the difference between home cooking and *haute cuisine*. Moreover, the makeup artist will have more up-to-date information on the latest trends and techniques.

Because competition among cosmetic houses is fierce, standards in beauty photography are demanding and the work highly specialized. The makeup artist plays an essential role in the end product. Professional makeup can transform with stunning effect a face well-endowed with those qualities sought by photographers: a regular, not too full, oval face is ideal, together with good bone structure, high cheekbones, a straight nose and a shapely jawline. Eyes with generous lid-space under the eyebrows, regular, balanced lips with well-defined shape, and good teeth are also sought.

Makeup artists work on a model's face as an artist works on a canvas, accentuating structural characteristics, delineating eyebrows, enlarging eyes with eyeliner and adding blusher to stress contours. The process can be lengthy, so if you are working with several models, photograph one while the other is being made up and have the models come to your studio well in advance of the shooting schedule. They should be well-rested and have clean hair and perfect nails.

Lighting and camera techniques must complement the style of makeup, the hair and the clothes. As a general rule, use diffused frontal lighting, or daylight bounced off reflectors, for portraits and beauty shots. Frontal light eliminates shadows, and off-centre frontal light will give slight modelling. Harder and more oblique light gives a dramatic effect, useful for theatrical makeup and some pop styles. It will accentuate makeup that contrasts strongly with skin tones – deep red lips and dark eyes against a high-key foundation. Another rule is that the harder the lighting, the softer the makeup must be. Use of a soft-focus lens can be an advantage, though many art editors disapprove of this technique when it is used for beauty shots. For both fashion and beauty work, an autowinder or motor-drive is essential so shots may be taken quickly enough to ensure the right pose or expression is achieved.

The model's hair is set in rollers before the makeup session begins. Moisturizer is dabbed on to her skin and foundation cream is applied to provide a cosmetic base.

Crow's feet and expression lines are painted out with concealer, which is lightly brushed into the foundation above the cheekbones and blended with it.

Heavy powder, followed by loose, translucent powder, is added to set the foundation. The powder serves to flatten highlights and the shiny areas of the face.

The makeup artist, using a fine brush, paints on extra eyelashes to the model's lower lids. They help to balance the upper lashes, especially if these are false.

Black eyeliner, applied with an eyeliner pencil, emphasizes the shape and slant of eyes and makes whites appear whiter. The same lines added to upper lids give finish to false eyelashes.

Blusher is added to contour the face. A large brush is used to define cheekbones. The particular shade of blusher used is keyed to the colour of the lipstick and clothes worn.

Lips have first been outlined with lipstick pencil. Lipstick is now generously applied with a brush. A touch of colourless gloss at the centre of the top lip highlights lip makeup.

The completed work of art. The hair has been combed out and finishing touches attended to by the hairdresser. Earring accessories accentuate the style and shape of the hair and unify the whole.

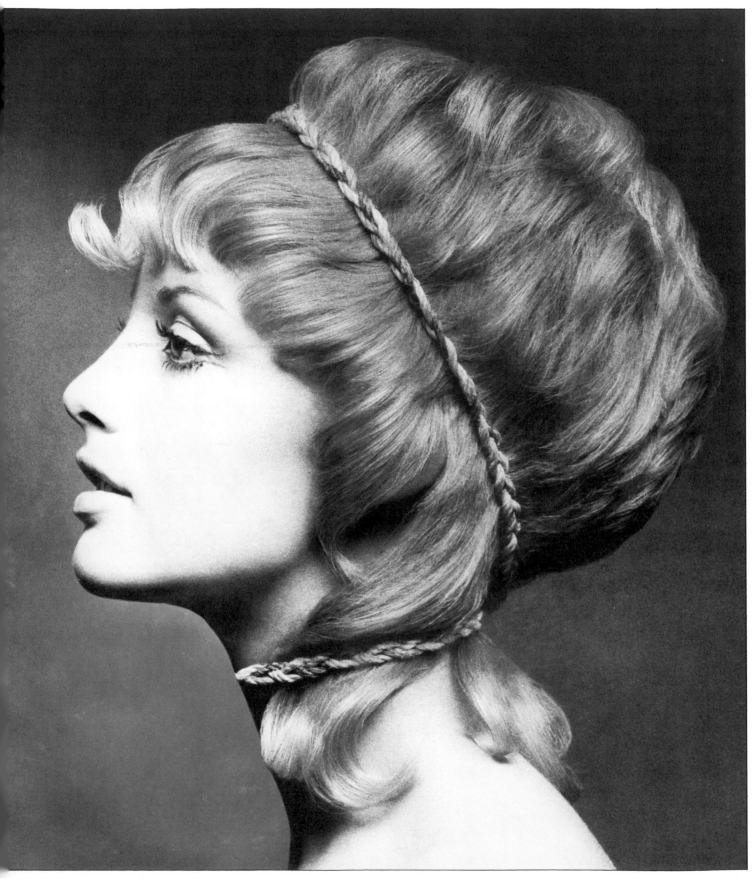

Models and makeup 2

In fashion and beauty photography it is not only the style of the clothes and the quality of the makeup that are important to a magazine editor, but the style and flair evident in the photographs themselves. A fashion editor, in selecting clothes for a feature, may have in mind a particular photographer whose work she admires and whom she knows will create in his studio, or on location, the excitement, colour and movement that the clothes demand. The fashion editor may also suggest a suitable model on the basis of the style she wants to promote and discuss her choice with the photographer.

Apart from the clothes, the model is the single most important element. Between them, the model and the photographer can invest the clothes with a style and elegance that the clothes might not actually possess. A professional model, used to working with photographers, fashion editors, and the art directors of advertising agencies, knows as well as anyone what is needed and she is often the dominant feature in the pictures. This is especially true of a model who, through her looks and skill, has become internationally famous – a status to which thousands aspire and few actually achieve, as beauty in itself is not the key to success as a model.

Advertising models, those who are photographed in domestic settings with foods or appliances, are usually of a type with which the reader can identify, whereas the top fashion model may represent a perfect, unattainable elegance and beauty that appeals only at subliminal levels – the reader responds in fantasy, but the pictures nevertheless sell the clothes, promote the style, and maintain the circulation of the magazine. Just as a photographer needs experience, so a model needs to be trained and then needs experience too. Inexperienced photographers should try to invest in the services of a professional model, for although the fees are high, the result will be well worth the expense – even with simple studio lighting against a bare background, shots of a professional model can be impressive.

You can negotiate with some model agencies, especially for immediate payment, and the agency will help you in your choice – and there are hundreds of models to choose from, especially in big cities. Agencies circulate books, with pictures of the girls and their statistics: models also have a composite card with their latest photographs and relevant details. As these are expensive to produce, a model may be willing to do test shots in exchange for the pictures.

The business of hiring a model through an agency is, of course, conducted on a strictly professional basis and most models are prepared to work hard during a session: even so, an hour can pass quickly and you may find you have only just got into your stride when the session ends.

Punctuality is essential and a part of a model's professionalism. For your part you must pay due regard to her self-respect and need for privacy and provide her with somewhere to change and make up with adequate facilities for washing.

Before starting the session, explain to the model what the particular job entails (though she will probably have been briefed by the agency). Clothes, shoes and accessories are usually provided by the client, or the couturier or fashion designer, but models will always suggest individual touches of their own and many will bring along their own jewellery. If you are shooting on location, you will need to provide facilities for dressing, washing and making up – some photographers arrange accommodation at a hotel, but on remote locations they may hire a van or mini-bus. It is helpful if the model can attend to her own makeup because the expense of taking a makeup artist on location is saved.

If the job entails shooting a wide selection of clothes in different locations with two or three models they must be able to get on together. You should do a test run first, to ensure that they do. When shooting, use each girl in turn so that you are not seen to be favouring one to the exclusion of the others. To get good pictures, you need the full co-operation of the girls to bring out their skills, abilities and personalities, and this requires constant encouragement.

A model's composite card displays recent pictures of her and lists her vital statistics and the name and telephone number of her agency.

A rustic setting (left) can complement a girl's fresh, natural beauty, but will also throw emphasis on her hair and makeup, which needs expert attention to show a professional approach to the subject. This is not the kind of shot that anyone can carry off, needing as it does a trained and experienced model, makeup artist and hair stylist.

Special effects, theatrical and deliberately exaggerated makeup techniques (above) or bizarre body-painting (right) are usually done with experienced girls who are used to it. Such shots are for magazines, record sleeves and calendars, but also provide an interesting folio that shows the creativity of the photographer and the capabilities of the model – not to mention the makeup artist.

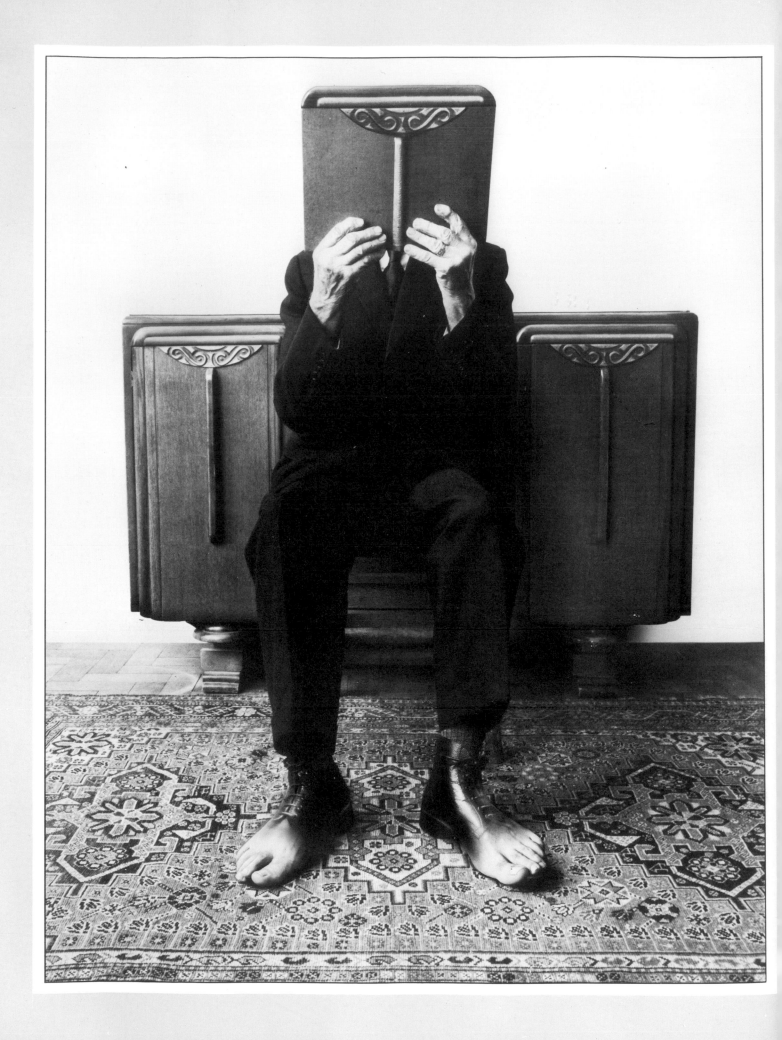

DARKROOM WORKSHOP

The aim of all photography is to make permanent an image
that the photographer sees as much in his mind's eye as in the
viewfinder of his camera. The bulk of this book has dealt with
ways of realizing the vision outside the darkroom; this section
offers ways of achieving it inside the darkroom. It is unusual
in that it emphasizes the use of the copy camera (but alongside,
rather than instead of, the enlarger) and favours colour
transparency material instead of black and white, and colour
negative/positive material. This latter preference recognizes
the popularity of slides in both amateur and professional work
and the ease with which excellent results can be achieved in
making colour prints from transparencies (using positive/
positive materials) rather than from negative film.

The techniques covered are within reach of the advanced
amateur, though some – slit-scan and mandalas, for example –
will present a challenge. The philosophy of approach is outlined
overleaf: the key to it is that there are many routes to a
final image, but only one that will be the simplest, quickest
and most economical. The section also stresses the benefits of
experimentation – once you can handle the basic techniques
outlined here, you ought to be able to go on to others.

Methods of approach

At each stage in the creation of a photographic image, from shooting the subject through processing negatives and transparencies to printing on paper, it is essential to know what end result you want and to take the simplest, quickest and most economical route to that final image. To do that you must first acquire in-depth knowledge of photographic materials – films, papers and chemicals, both in normal and abnormal use – and an appreciation of the relationships between different techniques and procedures. For example, by processing black and white film in a non-standard developer, or by printing a black and white negative on to a particularly hard or soft paper, you can greatly alter image contrast. In colour printing, you can introduce outlandish colours to an image simply by altering the filtration. In more involved manipulative work, a whole host of unusual effects – posterization, highlight and shadow modification, and colour separation, for example – can be produced with masks and positive and negative versions of an original reproduced on line or lith film.

No single technique in the darkroom is very difficult. To achieve what appears to be a complex effect invariably requires only that you carry out a number of straightforward procedures in the correct order. The trick in achieving a hoped-for image is to relate it to a known result and, with a little imagination, to use other familiar techniques to modify that result accordingly. It is important, of course, that before attempting such work you first become experienced at producing normal images.

You must also bear in mind the limitations of your equipment. Unless you have a well-equipped darkroom (see pp 214–215), it may not be possible to achieve some results shown in this section of the book. However, most special effects can be arrived at by more than one route. The routes to an image discussed on the following pages use procedures that are simple with a standard colour enlarger or custom-built copying set-up and highlight the photographic principles employed in producing the final result. Perhaps the most important point is that you should, if time and money allow, experiment with each technique. Work out your own way of producing special effects with what you have, and note each step you take so that you can repeat it. With experience of different techniques, you will be able to go beyond the image manipulations shown here and create your own special effects.

Original colour slide | Contact tone separations on to lith film | Contact negs to pos

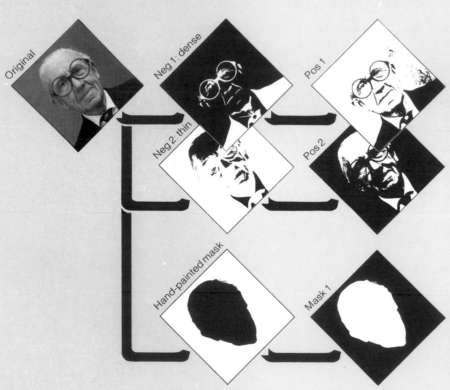

Hand-painted mask on tracing paper | Contact on to lith film

Multiple exposure

First exposure | Second exposure | Third exposure

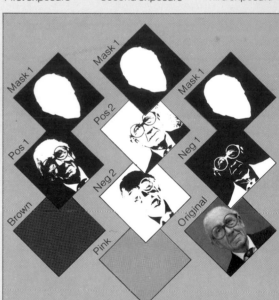

Multiple exposure
The negative of the hand-painted mask (Mask 1, above) was used in all three exposures to keep the background to black. The effect of exposing negative 1 together with the original (righthand strip) was to put into the print the natural colours of the subject's eyes and glasses.

Choosing the route to an image
The portrait, opposite, is part posterization and part real image, derived from a 2¼ × 2¼ in format transparency. The final multiple exposure, requiring accurate registering of original, various masks, and tone separations, could have been made with either a copy camera or an enlarger. The crucial factor in deciding to use the copy camera route was the realization that all the needed masks and separations had to be the same size as the transparency. The copy camera route, above left, involved contacting the original on to high-contrast lith film at two different densities of exposure; hand-painting a mask on a registered piece of tracing paper to isolate the head; contacting tone separations and mask back to positive; laying up all the masks and separations on registered cells; sorting out pairs of masks and tone separations for the final multiple exposure; and making the exposure on to transparency film through the copy camera. The enlarger route would have involved more steps and materials; the final step would have had to be done in complete darkness, making registration extremely difficult; and the final exposure would have been made from a duplicate, not from the original. As with all work of this kind, technique and imagination must be in complete harmony to achieve the best results.

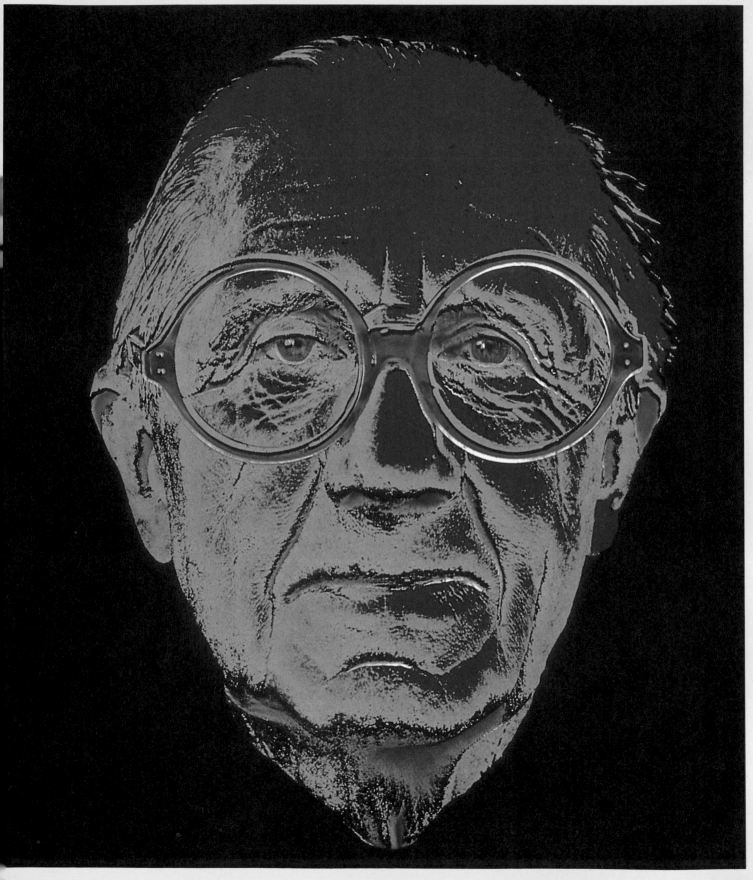

Darkroom layout

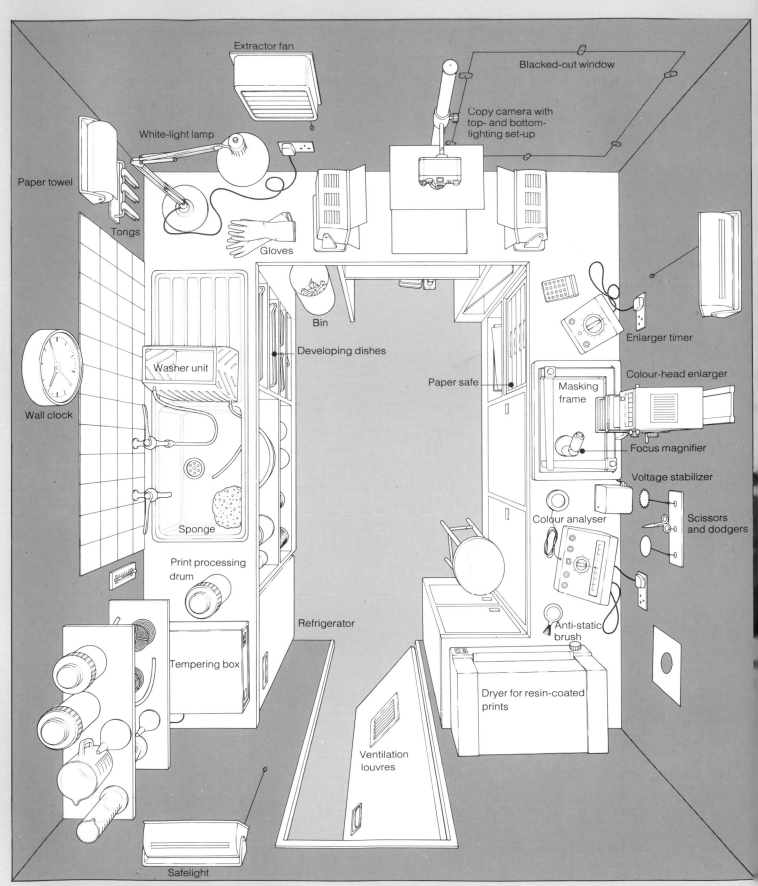

Extractor fan

Blacked-out window

White-light lamp

Copy camera with
top- and bottom-
lighting set-up

Paper towel

Tongs

Gloves

Bin

Developing dishes

Enlarger timer

Wall clock

Washer unit

Paper safe

Masking
frame

Colour-head enlarger

Focus magnifier

Voltage stabilizer

Sponge

Colour analyser

Scissors
and dodgers

Print processing
drum

Refrigerator

Anti-static
brush

Tempering box

Dryer for resin-coated
prints

Ventilation
louvres

Safelight

In the last five years or so, one important addition has been made to the traditional darkroom: the 35 mm single-lens reflex camera has taken up a semi-permanent stance as a process/copying camera. Much of the work discussed in the next sixty pages requires its use in this role. That said, the darkroom remains pretty much as it has always been: a workshop divided into a "wet" area where film and paper stock is processed and a "dry" area dominated by the enlarger. A bathroom can be converted, temporarily, into a darkroom, but is rarely totally satisfactory. A piece of blockboard over the bath provides a working surface large enough to take developing trays, but at the wrong height. Chemical spillage is a constant problem – photographic chemicals create stains that are extremely difficult to remove – and blocking out extraneous light while still providing adequate ventilation calls for light-traps and baffles that tend to turn a temporary conversion into a permanent one. The best aid to efficiency that a photographer can have is a permanent darkroom clearly divided into wet and dry areas, with a separate workshop annexe for print finishing.

A darkroom laid out like that on the opposite page is ideal. The room itself is light-tight, yet well ventilated by means of louvres in the door and an extractor fan mounted on the opposite wall. The lefthand, or wet, side is devoted to chemicals and processing equipment. It has ample storage space, above and below the sink unit, and even a refrigerator for use in controlling temperatures. The righthand, or dry, side is given over to the enlarger and its accessories. Bridging the two sides is a bench carrying a copying unit designed to take a single-lens reflex camera. There are two safelights, one for each area, and the walls are painted white. The light-proofing of a darkroom can be tested by sitting in it for ten minutes

or so or, better, by partially exposing a piece of printing paper under the enlarger and then leaving it emulsion side up for five minutes with an object such as a pair of tongs on top of it. If, when it is developed, an image of the tongs appears, then light is leaking into the room. Cover the floor with a chemically resistant plastic and don't forget to include a chair or a stool – time passes quickly in a darkroom and you may find yourself surprisingly tired at the end of a printing session if you have been standing the whole time.

It is worth noting that there is no need, initially at any rate, to buy a great deal of expensive equipment, such as machine processors for film or prints, or purpose-built copying stands. Provided that you understand what you are doing, and can use the full capabilities of basic equipment, you will be able to achieve results of a professional standard.

Label all chemicals clearly and when they are exhausted make sure that they are disposed of safely and surely. It is helpful to keep different chemicals in distinctly shaped containers so that even when you are working in total darkness they can be readily identified. Label film and print processing tanks, and developing trays, so that they are always used for the same processes. Check electric plugs, sockets and wiring regularly for safety.

Similar principles of tidiness and safety apply in the annexe. Most of the operations carried out here – hand-colouring of prints, airbrushing and montage, for instance – call for daylight, so place the main workbench by a window. Good fluorescent ceiling lighting and a bench lamp for close work are essential. If space in the darkroom is limited, a film drying cabinet, print trimmer, dry mounting equipment and slide copier can be kept in the annexe.

The darkroom (left)
With careful planning, it should be possible to build a properly equipped darkroom, like that shown opposite, in a room measuring about 3 metres × 2 metres. The room is divided into wet and dry areas.

The workshop (right)
Ideally, the workshop should be connected to the darkroom. It is used for all work that can be carried out in daylight. Included in the workshop are: **1**, Light box; **2**, Slide projector; **3**, Hand viewer; **4**, Contact print files; **5**, Slide magazines; **6**, Cabinet with suspension files for storing slides; **7**, Dry mounting press and tacking iron; **8**, Camera case and tripod; **9**, Slide copier; **10**, Print mounting equipment, including ruler and scalpel; **11**, Silkscreen frames and paints; **12**, Designer's board, for retouching and hand-colouring prints; **13**, Paints, dyes, scalpels, brushes and cleaning materials for instant print manipulations, montage, retouching and hand-colouring; **14**, Airbrush and compressor unit; and, **15**, Plan chest for storage.

Routes to images

The photographs on these two pages are examples of the main darkroom image manipulations described in this section of the book. The symbols against each image refer to the standard method of creating that special effect. There is often more than one route to a desired result – for such details, and a fuller explanation of how to produce these effects, use the cross-references given at the foot of each column.

Method of working

		Texture effect	Solarization	Multiple printing	Printing effects	Montage	Print toning
Techniques		B&W	B&W or Colour	B&W or Colour	Colour	B&W or Colour	B&W
	Masking			hand			
	Screen	texture					
	Registration						
Materials	B&W film	tone	tone	tone		tone	tone
	Colour film		neg/pos or pos/pos	neg/pos or pos/pos	pos/pos	neg/pos or pos/pos	
	B&W chemicals	tone	tone	tone		tone	tone & toners, dyes
	Colour chemicals		neg/pos or pos/pos	neg/pos or pos/pos	pos/pos	neg/pos or pos/pos	
Equipment	Enlarger or Copy camera	✓	✓	✓	✓	✓	✓
	Filters				special enlarger		
Page reference		226–227	228–229	230–231	232–233	234–237	240–241

Key

Hand/photo mask — Screen — Peg-bar kit — B&W film — Colour film

B&W chemicals — Colour chemicals — Enlarger — Copy camera — Filters

Slit scan	Contrast masking	Pointillism	Posterization	Dye transfer	Strip-in	Mandala	Neoning
Colour	Colour	Colour	B&W or Colour	Colour	Colour	Colour	Colour
hand	photo	photo	photo	photo	photo	hand	hand or photo
		dot					
line	line	line	line & tone	tone & special film & paper			line
slide	slide	neg/pos or slide	neg/pos or pos/pos	tone & special dyes & chemicals 'sharp-cut'	line & slide	slide	slide
line	line	line	line & tone	line			line
slide	slide	neg/pos or slide	neg/pos or pos /pos		line & slide	slide	slide
	red, blue, green	red, blue, green	red, blue green	red, blue, green			
248–249	250–253	250–253	250–253	253–257	258–261	262–265	262–265

Black and white processing

These two pages present a résumé of black and white film processing and printing techniques. The main steps involved are: negative development; assessment of negatives to determine if compensation for incorrect exposure or development must be made in printing; making a test strip to establish the correct exposure for enlarging; and printing on to paper. It is important that you understand the principles of the various steps, and become proficient in each technique, before attempting advanced darkroom manipulations.

Working with black and white materials is easier than with colour materials. Contact printing and enlarging can be carried out under an ordinary safelight and no involved filtration is required. There is also much greater control of the image, particularly with respect to contrast, which can be increased or decreased when the photograph is being taken, during development of the negative, when the negative is being printed in the enlarger, and when the final print is being developed.

Re-usable Polaroid negatives
Film-based black and white instant picture stock yields negatives which are sufficiently permanent and of sufficiently fine grain for high-quality enlargements. After the normal processing time – usually 30 seconds – peel the paper print from the negative. Then clear the negative in a 12 per cent solution of sodium sulphate, wash it and dry it. A processing kit – a clearing tank, chemicals and measuring cup – can be bought if required.

Measuring cup

Sodium sulphate

Clearing tank

Processing film
Make up the developer and fixer to their normal working strengths and bring the developer to its correct temperature. Keep other solutions to within 3°C of this. Next, in total darkness load the film into the developing tank and pre-wash it in water at the development temperature to help even processing. Then pour the developer into the tank and start the timer. Ten seconds before development is finished start to drain the tank. Continue the process with the stop bath and fixer solutions, then wash and dry the film. You can alter contrast by varying time, temperature and developer strength – though it is prudent to first read the instruction pamphlets issued by the film and developer manufacturers for a detailed guide. There are developers to increase sharpness or impart fine grain.

1 To load film into a plastic tank spiral, remove the top of the film cassette; cut off the shaped leader, taking care to cut between sprocket holes; set the spiral to the width for your film; push the free end of the film into the spiral guides; and feed the entire film into the spiral. Load stainless steel tank spirals from the centre.

2 As soon as you have poured the developer into the tank, replace the cap, tap the tank gently to release any air bubbles on the surface of the emulsion, and agitate the solution by using a rod or by inverting the tank, as shown above. It is usually necessary to agitate for about ten seconds once every minute.

3 After fixing the film, wash it in running water (a few drops of wetting agent in the last rinse will prevent water stains) and then pull it from the spiral by attaching a film clip to its free end. Wipe excess water from the film with squeegee tongs, attach a weighted film clip to one end, and hang it to dry in a warm-air cabinet.

Warm-tone developer

Low-contrast developers
Developers with only metol, para-aminophenol or Phenidone as the active agent produce negatives of low contrast. They work by stopping individual silver grains from forming clumps in the processed emulsion.

Standard developer

Normal-contrast developers
A combination of metol and hydroquinone produces normal contrast – a negative with a full range of tones, from shadows to highlights, fine grain and discernible detail throughout its tonal range.

High-contrast developer

High-contrast developers
Hydroquinone is the main agent in high-contrast developers, producing dense blacks but detailed highlights. It has a long inertia period followed by rapid development. Extreme-contrast developers are made for line and lith film.

Making a test strip and printing

Inspect negatives by placing them on a light box, using fluorescent tubes to give even illumination, and viewing through a focus magnifier or magnifying glass. Pay particular attention to the degree of detail in shadow and highlight areas when determining which developer or grade of paper will best bring out the full tonal range of the negative. To determine the correct exposure, use an electronic printing control unit, a projection print or grey scale, or make a test strip. The strip should be on the grade of paper you intend using for the enlargement and be processed under the identical conditions. Position the strip so that each band of exposure covers a representative range of tones. If your first test is too light, open up one stop; if it is too dark, close down a stop.

1 With the safe filter over the lens, place the test strip in the frame. Expose the strip for 10 secs, then cover a quarter with a piece of card and expose for 10 secs more. Cover one half and expose for 20 secs, then three-quarters and expose for 40 secs. The resulting bands of 10, 20, 40 and 80 secs are easy to assess as they are one stop apart each.

2 Remove the exposed test strip and place it face down in the developer. Start the timer. Turn the print over and gently agitate the solution with tongs. At the end of the correct development time, remove the strip with tongs, allow excess developer to drain from its surface, then drop it face down in the stop bath. Fix and wash the test strip.

3 Carefully examine the processed and dried test strip to determine the most accurate exposure. Set the timer to the chosen exposure, place a sheet of printing paper in the masking frame and switch on. Develop as before. With experience it is possible to test-strip a whole roll of film while making a contact sheet from it.

Photograms

A simple extension of normal black and white (and colour) printing is the making of photograms — patterns or designs created by placing opaque or transparent objects on the printing paper (or in the negative carrier of an enlarger) and exposing to light. Prepare your pattern or design on a sheet of printing paper in the masking frame, working with the red safe filter in position. Rack the enlarger head well up to give a sharp shadow and, ideally, use grade 2 paper. Expose and process the print in the normal way. Make a test strip to find the f-stop and exposure that gives you a rich black background. Experiment with different types of subject. The photogram, below left, was of a transparent model of the human figure. The version below right was made with a cut-out mask (bottom left) to hold the background to white.

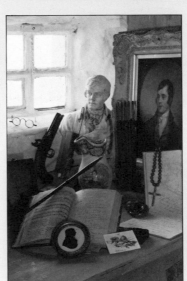

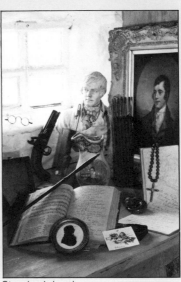

Warm-tone developer

Standard developer

Print developers

Matching print contrast to negative contrast calls for paper of the correct grade and proper exposure and development. Changing the developer is not enough by itself. The three prints above and right were, however, made on normal-grade bromide paper from the same correctly exposed and developed negatives, but using different developers. A slow-acting developer produced the warm tone result; the same result can be obtained by overexposing the print and using a diluted universal developer. The normal print, above right, was developed in a standard fine-grain solution. The high-contrast print called for concentrated universal developer. Warm-tone developers work best with chlorobromide papers; standard and universal developers give good results on all bromide papers.

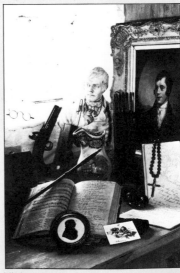

High-contrast developer

Colour printing reviewed

Colour processing and printing are usually presented as exacting, long-winded and difficult procedures. It is true that there is much less latitude in chemical temperatures and processing times than with black and white film; that to make an enlargement from a negative by way of a test strip will probably take an hour or more; and that each processing method often involves as many as ten stages. But it is easy to exaggerate the difficulties involved. Using an ordinary plastic bowl as a water bath, and adding hot or cold water as needed, you can accurately maintain chemicals at the recommended temperatures. By developing negative and reversal films in a light-tight plastic tank, and paper in a processing drum, you can work in normal room lighting. A matrix device or colour analyser will give filtration and exposure readings quickly and accurately. In short, provided that you work cleanly, methodically and with an eye on timer and thermometer, you should not find any technique too complex to tackle, and the expense and trouble involved will soon be outweighed by the advantages.

Colour work is particularly rewarding because you have considerable control over the image. By altering the filtration slightly you can create a warm, sombre atmosphere or one that is cool, dramatic or mysterious. You can also manipulate the image, introducing, say, surreal colours into a normal scene.

Filtration can be either additive or subtractive. Working additively, you can make do with an ordinary black and white enlarger, holding the filter below the lens during exposure. Nowadays, however, most colour materials require subtractive synthesis. For this, it is best to buy an enlarger with a dial-in filter head. Whichever filtration system you use, you will find that printing from negatives (neg/pos work) offers greater control than printing from transparencies (pos/pos work).

Additive colour
This method of colour synthesis uses the primary colours red, blue and green, which together produce white. If three stage lights coloured red, blue and green are centred as shown left, where they add together they produce white and where two overlap the secondary colours magenta, yellow and cyan result. In additive printing successive exposure of the three primary colours are used to synthesize the required colour combinations or to split up a combined image, as in making colour separations.

Subtractive colour
In the subtractive process, colour is controlled or synthesized through the mixing of magenta, cyan and yellow dyes. The principle is shown, left, where three filters have been placed over back-lit opal glass. Each filter eliminates its complementary colour: yellow, for example, eliminates blue. An overlap of yellow and magenta produces red by eliminating cyan. When all three of the filters are equally overlapped, grey (or neutral density) is produced.

Film processing
Most colour negative and colour reversal films can be processed at home. The procedure is almost the same for both, but reversal stock requires an additional step in which the film is fogged. The main steps are development, stop bath, wash, re-exposure and colour development (with reversal film only), bleach, wash, fix, and final wash and rinse. Each type of film needs its own chemicals, the number, timings and working temperatures of which are all film-specific. It is important, therefore, to check that your film and processing kit are compatible.

Colour transparencies, being positive images, are easily assessed for under- and over-exposure. A thin image indicates overexposure and a dense one underexposure. Because colour negatives have an orange mask, and reversed colours and tones, assessment is more difficult. Look in particular for detail in the shadows and highlights. Given that you are sure you have kept within the prescribed latitudes for time and temperature, a thin negative with little detail will indicate underexposure and a dense, dark one overexposure.

1 Make up the processing chemicals, using a measure and mixing jug, and pour them into bottles. Stand the bottles and mixing jug in a bath of water at 38°C (100°F).

2 Warm the developing tank to 38°C. Remove and dry the spiral, and fill the tank with developer. Load the spiral, place it in the tank and start the timer.

3 Tap the tank to remove air bubbles from the film surface. After an initial agitation, and between subsequent agitations, stand the tank in the water bath.

4 After development: (a) with negative film, use a stop bath; (b) with transparency film, wash and reverse the image, either chemically or by exposure to light.

5 Continue processing negative film by bleaching, washing and fixing. Transparency film must be colour-developed before bleach, wash and fix baths.

6 Finally, both types of film must be washed thoroughly under running water for 30 minutes before being removed from the spiral, wiped with tongs and hung to dry.

Subtractive test

The correct filtration and exposure needed to print a colour negative can be determined by using a colour analyser, a test matrix device or by making a test strip. Both the colour analyser and test matrix will give you the two values in one procedure, but with a subtractive test strip you will need to go through between two and four steps. If you are working with an analyser, first calibrate it to your paper and processing procedure by means of a standard negative from which a properly exposed and colour-corrected print has already been made. With the test matrix device, it is the translucent coloured matrix which will give you information about exposure, and the grey scale which will give you information about filtration. You can translate this into the correct enlarger settings from the instructions supplied with the kit. How to get filtration and exposure value for subtractive printing by means of a test strip is described on the right.

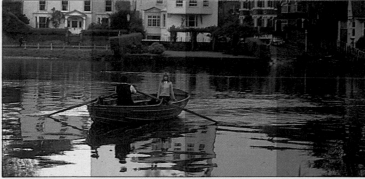

40 seconds 20 seconds 10 seconds 5 seconds

Filtration test

Adjust the filtration to remove any colour cast present in the exposure test, which should be dry before you assess it. To remove a cast, add filters to match the colour: the exposure test above was too yellow, so yellow and a little magenta were added. With added filtration, a change in exposure will be needed. Remove the lowest value filtration to eliminate neutral density and make another exposure test before printing. (The test, right, was made at f11 for 25 seconds.)

Exposure test

Dial in the recommended filtration for your paper, choose an f-stop to suit the lens, and in total darkness place a strip of printing paper in the masking frame. First make an overall exposure of, say, 5 seconds. Then mask one-quarter of the frame during an exposure of 5 seconds, half the frame during a subsequent 10-second exposure, and three-quarters for a final 20-second exposure. In the print, left, filtration of 50Y and 75M was used.

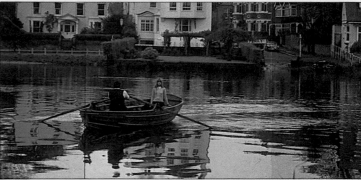

50Y,60M 70Y,75M 85Y,85M 100Y,100M

Additive test

In additive printing, colour balance is produced by varying the exposure of each colour. In the strip below, the first filter (in this case blue) was slid under the enlarger lens and a 10-second exposure made. The enlarger was then switched off and the blue filter replaced with the red. A second exposure of 20 seconds was made, using a black card mask to give exposure bands of 5, 10 and 20 seconds. Finally, the green filter was used to make another three exposure bands of 5, 10 and 20 seconds at right angles to the first.

20 Green 10 Green 5 Green

10 Blue
overall

5 Red

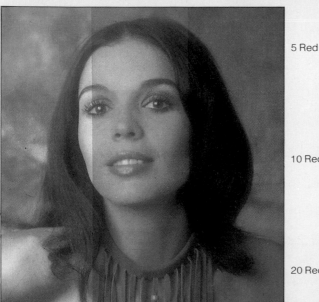

10 Red

20 Red

Correct

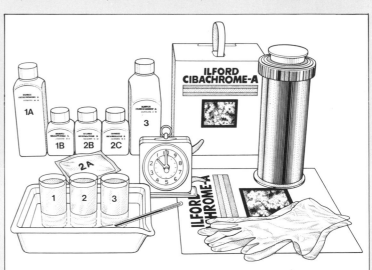

Prints from slides

The simplest way of making colour prints from transparencies is to print directly on to positive/positive paper. There are two types: reversal or dye-coupling (Kodak R-type) and silver-dye or dye destruction (Cibachrome A). There are separate processing chemicals for each type. The advantages of the pos/pos method are that the procedures are speedy and straightforward; good edge effects and sharpness are produced; and colour filtration is easy to assess as you can compare the colours of your final print directly with the original. Reversal papers need chromogenic processing that involves six main stages – first developer, wash, colour developer/reversal bath, wash, bleach/fix and final wash – and takes about 18 minutes. Silver-dye bleach processing involves developer, bleach, fix and wash stages only, and takes about 12 minutes. The Cibachrome A kit and necessary darkroom processing accessories are shown above.

The enlarger and copy camera

The two most important tools in the darkroom for colour manipulations are a good colour enlarger and a copying unit that can be used with either top or bottom lighting. The uses of the enlarger are well established. Those of the copy camera include making high-quality duplicate colour slides, selectively cropping transparencies, making black and white slides from negatives and shooting opaque artwork either as slides or as negatives.

To make a print with the enlarger, place the negative in the carrier shiny side up and set the carrier squarely in the enlarger head. Open the lens to its widest aperture and rack the head up or down until the image is roughly the desired size. Still at maximum aperture (for critical focusing), focus the image on to the masking frame with the aid of the focus magnifier and use the exposure analyser to determine the working aperture, filtration and exposure. (To determine exposure and filtration using a test strip see pp 218–20.) Then dial in the filters, stop down the lens – you should use an aperture of f8 or f11 unless these give an exposure time that is excessively long or short – place the printing paper on the frame and expose.

The copying set-up consists of five main components: the camera, column and carriage, work surface, top-lit light source and bottom-lit source. The set-up illustrated, opposite, is a custom-built unit forming an integral part of the darkroom (see pp 214–215). Cameras most suited to copying work are 35 mm SLRs, Hasselblads and 5×4 in view cameras. A macro lens, extension tubes, polarizing filters and colour conversion filters are essential accessories. A shadow board is used in front of the camera to minimize reflections.

The column and carriage assembly usually comes complete with a baseboard, which should be removed so that the column can be bolted directly to the darkroom workbench. The column should be high enough for shooting large pieces of opaque copy and strong enough to support the weight of the different formats of camera used. It is useful if the carriage can be locked at any desired height and if the arm carrying the camera can be changed or adjusted to centre each camera over the same spot on the work surface.

The enlarger

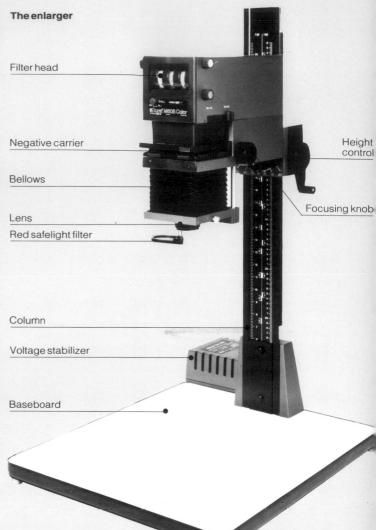

- Filter head
- Negative carrier
- Bellows
- Lens
- Red safelight filter
- Column
- Voltage stabilizer
- Baseboard
- Height control
- Focusing knob

Enlarger accessories

For the accurate measurement of exposure times and colour filtration, work with a colour analyser; this will obviate the need to make a test strip for each print. Also recommended are a timer, focus magnifier and adjustable masking frame.

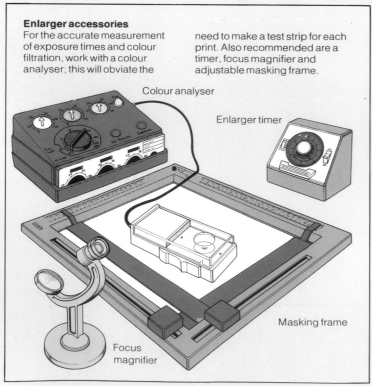

Colour analyser

Enlarger timer

Focus magnifier

Masking frame

Diffuser enlargers
In these, light transmitted through three colour filters is mixed in a scatter box and directed through an opal sheet on to the negative, producing a soft, even effect.

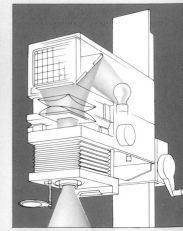

Condenser enlargers
The filtered light is concentrated and directed on to the negative by a condenser lens system. Image contrast is enhanced but film grain is exaggerated.

The work surface itself is a flat, rectangular piece of 6mm-thick opal glass, which permits illumination of transparencies from below. The glass is set perfectly level, inlaid in a window cut in the darkroom workbench. Beneath the work surface is a filter tray made of a sheet of antisun glass.

The top-lit light source comprises a pair of carefully balanced tungsten lights fitted with barn doors and polarizing filters. The polarizers are set on the same axis and the polarizing filter on the camera lens is rotated to produce the darkest black or the minimum reflection, at the same time increasing colour saturation. Polarizers are not essential for all work.

Depending on the budget available, the bottom-lit light source is a flash, tungsten lamp or tungsten unit with dichroic filtration. If you are using a flash head, work with a synchronized lead to both the camera and a switch that can be used to fire the flash independently of the camera shutter: the switch is used to make multiple exposures with the camera on its B setting. Use a 100W household lamp as a modelling light. With flash, small amounts of colour correction will be necessary. The tungsten source will need more filtration when used with duplicating film stocks. The dichroic light source is primarily used by studios whose main job is copying transparencies. It is, however, the ideal light source for slide copying and special colour manipulation techniques.

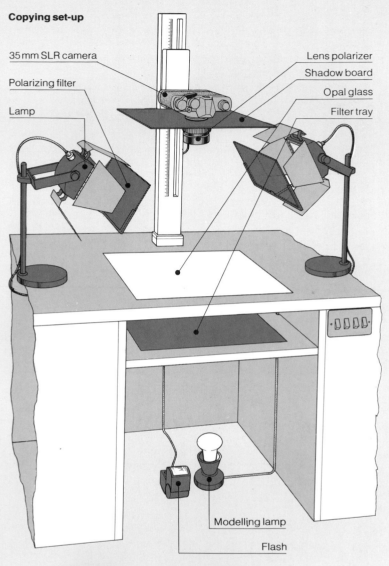

Copying set-up

- 35 mm SLR camera
- Polarizing filter
- Lamp
- Lens polarizer
- Shadow board
- Opal glass
- Filter tray
- Modelling lamp
- Flash

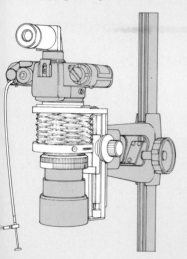

The copying camera
A 35 mm SLR camera, with bellows, macro and 28mm lenses, is ideal. Useful accessories are a right-angle viewfinder for ease of observation and a viewing screen with a grid to enable quick framing. The camera should have a wind-on system that ensures the spacing between frames is constant, and the facility for making double exposures. It is important to know exactly how much of the picture is cropped off by the viewfinder. One way of doing this is to focus on a ruler and read off the units, then open the shutter and the camera back and, using tracing paper, read off the units between frame edges. This gives the area ratio between viewfinder and lens.

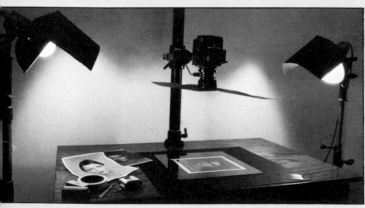

Top-lit copying (above)
Shoot opaque artwork using top-lighting. Lay the piece of artwork on a sheet of black card placed over the glass of the work surface. Polarizers on the lights will help prevent unwanted reflections, but have the disadvantage of reducing the light intensity.

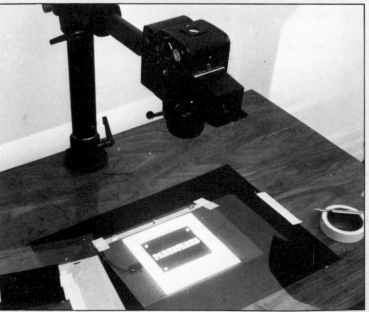

Bottom-lit copying (right)
Photograph artwork on clear acetate sheet using bottom lighting. Here a graphic logo has been placed on a peg-bar taped to the opal glass. The light source was a 3,200K quartz-iodine bulb. The area around the artwork should be masked to black in order to prevent flare.

Copying transparencies

The best copies of colour transparencies are made using a bottom-lit copying set-up and an SLR camera fitted with extension tubes and a macro lens (see previous page). The original is placed on opal glass, with filters between the glass and the light source (see below), and shot on Kodak 5071 tungsten film. The next best results are produced by purpose-built slide copiers. The third, and least attractive, choice is to make the copy with an SLR fitted with two sets of bellows, one between the camera body and the lens and the second between the lens and the carrier that holds the original to be copied. Using this set-up, the transparency can be copied in daylight by aiming at a slightly overcast sky and measuring exposure through the camera's meter. An alternative is to back-light the original with a photoflood and shoot on tungsten film.

Unless a slide copier is used, determining correct exposure is largely a matter of experiment. The exposure which is seemingly correct will probably provide a copy that is too contrasty – try overexposing by a stop and reducing development. Use a medium aperture for good definition. Films specially made for transparency copying include Kodak 5071 tungsten film. This has very fine grain and low contrast, and is available in

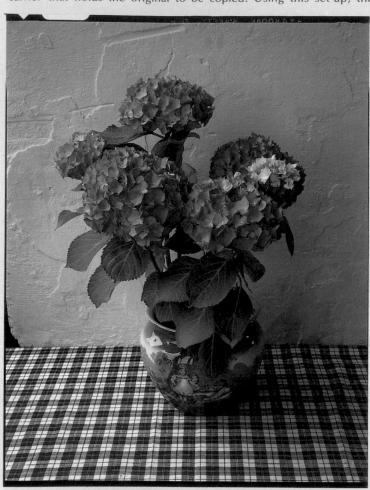

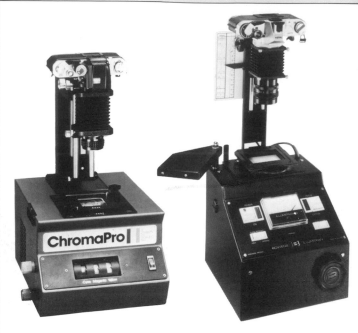

Slide Copiers
The copier above left has a tungsten light source and a built-in dichroic filter head; that on the right has a flash unit – with a tungsten modelling light – and built-in contrast control that fogs the film slightly during exposure. With both systems exposure is determined by a photo-electric cell placed over the transparency. The camera is a single-lens reflex fitted with extension bellows and an enlarger lens. The ChromaPro 1 has the advantage that Kodak 5071 tungsten film, specially designed for copying, can be used. Kodak 5071 has fine grain, high definition and wide exposure latitude but demands accurate filtration for best results.

Original

With extension tube

With bellows

With reversing ring

Enlargements or reductions
The transparency at the top of the page was reduced to 35 mm format using a macro lens. Then, by adding an extension tube, it was possible to copy a portion of the original at 1:1 magnification (above). Using the macro lens and bellows, a further enlargement was made of the same flower representing a 15 mm-wide section of the 5×4 in original (above). Finally, a 4 mm-wide section of the original was enlarged by using a 28 mm wide-angle lens, reversing ring and bellows. An enlargement such as this last cannot be achieved on most slide copiers and requires a special set-up.

224

35 mm format, but only in 100-metre lengths. Kodak do not give a film speed rating, but it is normally used as ASA 3 or ASA 6 and processed in E6 chemicals. The film is sensitive to ultraviolet (UV) and infrared (IR); when working with gelatin filters include a Kodak 2B or 2E UV filter and a heat-absorbing filter in the pack. The Kodak 304 IR filter is expensive, but it should be used if copying is being done from mixed film stocks – if it is omitted, filter strengths of 60Y and 60C may be needed. Also useful is a glass such as "antisun green", which acts as a partial IR cut-out and considerably reduces the filter pack.

If you are working with ordinary film stocks and a flashlight source, use Ektachrome Professional (EPR) ASA 64 daylight film rated at ASA 15 or ASA 30. Overexpose to reduce contrast and develop accordingly in E6. With tungsten sources, use EPY ASA 50 (tungsten) or EPR ASA 64 (daylight converted to tungsten), again rated lower and processed accordingly. The altered processing will give copies an overall blue hue, but this can be corrected by using magenta and yellow filters. Ordinary films give less good results, but are useful in the $2\frac{1}{4} \times 2\frac{1}{4}$ in format, in which there is no special transparency duplicating film.

Colour corrections

A filtration guide can be obtained by taking three or four transparencies of average density and copying them at several different exposures and with a number of different filtrations. Compare them with the originals to determine the best combination. The filters used should be the complementaries of the colour casts to be corrected. Most corrections can be made with quite weak filters (+5 or +10). The four images below are copies of the original (right) taken using magenta and green filters of the strengths indicated.

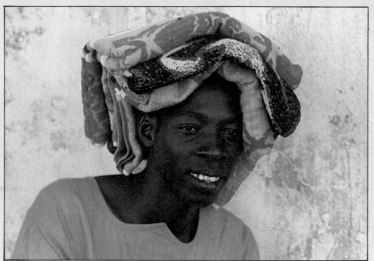

Prints from slides
The best way of making black and white prints from slides is to copy the slide on standard black and white camera film. You will need to experiment with both the film stock and development to get results that are acceptable to you – judging whether tones have been reproduced well is a matter of personal taste.

+20M

+10M

+10G

+20G

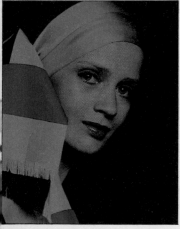

Underexposed original

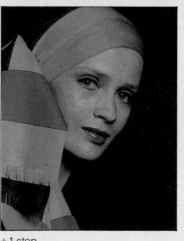

+1 stop

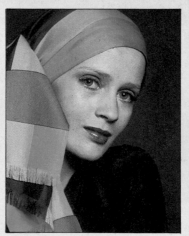

+ 2 stops

+ 3 stops

Exposure corrections

Occasionally, you may have to make a copy from a particular light or dark original or one that has, say, a small bright object against a dark background, each of which can give spurious exposure meter readings. (For example, with the averaging meters used in most slide copiers, the last shot would need an exposure less than the indicated reading.)

In such cases make several bracketed exposures. The sequence above shows a dark original and three copies made by varying the exposure by a stop each time. By using the correct film stock – in this case Kodak 5071 special slide copying film – and experimenting with colour filtration and exposure, it is possible greatly to improve on the original.

Print manipulation

The darkroom techniques described below and on the following 18 pages are all possible without recourse to working in register. They include a mixture of manipulative techniques that progress from corrective procedures, such as the deliberate mishandling of chemicals and processing lore, to working towards distinct end results. The techniques break down into three main categories. First, manipulation of processing or of illumination during exposure under the enlarger or copy camera. Solarization, reticulation, vignetting and burning-in are included in this set of techniques. Second, mechanical manipulation of the print during exposure. This includes sandwiching negatives and the use of textured and half-tone screens, as well as camera, artwork or baseboard movements for perspective correction or distortion. Third, corrective or creative work with chemicals, such as toners and bleaches, or with dyes and paints in techniques such as retouching, airbrushing and hand-colouring prints. The pictures on these two pages are the results of applying methods in the first two categories to black and white images. Retouching is dealt with on pages 238–239, hand-colouring on pages 240–241.

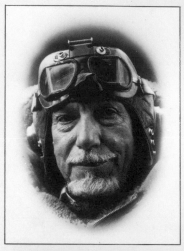

Vignetting (left)
To make a white vignette, mask the picture surround during exposure with a sheet of cardboard with a hole in the centre, held a few inches above the printing paper. For a black surround, vignette as before, then turn off the enlarger, remove the negative, hold a dodger over the image, and turn on the enlarger for a further 15 seconds or so to fog the surround.

Tone elimination (below)
The original negative was contacted on to lith film and the positive was cleaned up and spotted with opaque dye where necessary, and then contacted back on to lith film. This was then printed on grade 5 paper.

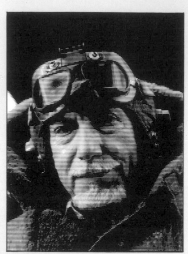

Half-tone screens (left)
Used with lith film, half-tone screens reduce continuous-tone images to thousands of dots or lines. From a normal viewing distance, these give the illusion of the original tones. Glass half-tone screens should be placed between the enlarger lens and the film in the masking frame. Contact half-tone screens, which usually carry a pattern of vignetted dots, should be sandwiched with the lith film. The image was created using a line conversion half-tone screen. Screens can be made by shooting a regular black and white pattern on high contrast film and then enlarging this, slightly out of focus, on to ordinary sheet film.

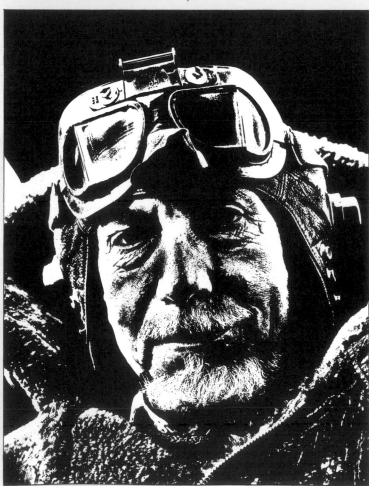

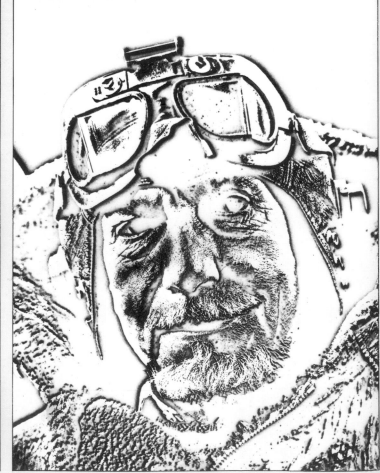

Solarization

The form of solarization known as the Sabattier effect involves re-exposing the image to light partway through its development. The underdeveloped areas of the image are fogged and are thus reversed. The final image consists of both negative and positive parts. To solarize a black and white negative, contact print the original on to line film, develop this for half the normal time, and then fog the film by placing the developer tray under the enlarger and switching on for the same period as the original exposure. Complete development and print on to bromide paper. To solarize a black and white print (left), expose on to high contrast paper, re-expose to white light for a second or two halfway through development, complete without agitation, and fix normally.

Exposing through glass (right)
By placing a sheet of diffusing glass just below or above your enlarger lens during an exposure, you can soften an image to a considerable degree. Similarly, positioning a sheet of textured glass in contact with either the negative or the printing paper will superimpose the pattern of the glass on the final image. The pseudo-reticulation result (right) and the two images far right were each achieved by printing the negative through glass with the pattern face down in contact with the printing paper.

Reversal of tones (opposite)
The same effect as solarization – reversal of some image tones – can be produced without having to fog the image. To produce this image the original negative was contacted on to lith film. The positive result was developed and contacted back on to lith. The lith positive and lith negative were then taped together with tracing paper in between them and the sandwich was printed on grade 1 bromide paper. The tracing paper flared the edge lines.

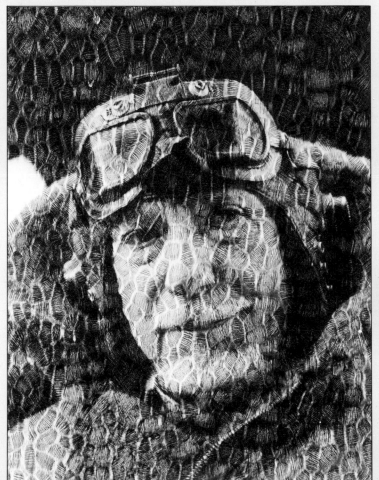

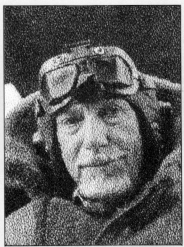

Solarization

True solarization is the reversal of the image on film by exposure in the camera of hundreds of times the necessary amount. Both positive and negative image areas are visible on the film and in the final print. It is an effect difficult to achieve nowadays because films are made specifically to counteract extreme overexposure.

The term solarization is most commonly applied to the Sabattier effect, which also produces both a negative and positive image on the same film, but is the result of re-exposing the film halfway through development. A further distinction is that the Sabattier effect produces a fine line or rim of low density between the fogged and already developed areas of the image. This is the Mackie line. It is more evident on solarized negatives than on prints.

Techniques for solarizing black and white negatives and prints are outlined on the previous page. To solarize a colour negative, first make a black and white solarized film image on lith stock. Print the solarized positive on to colour negative film, adjusting the filtration as desired. Colour prints can be made from the negative in the normal way. You can make a solarized colour print directly from a black and white negative by printing it through a colour filter on to colour paper and re-exposing the paper partway through development. Print through primary colour filters to produce red, blue and green colour effects.

Various alternative versions of solarization can be achieved using solarized lith positives, or negatives, as intermediate stages. Try contacting the original colour negative or positive on to lith film and solarize this contact during development. If the original was a transparency, make an in-register double exposure on to reversal paper, filtering the transparency in the ordinary way and the solarized negative with a strong colour cast. With a negative, contact the solarized lith film back to positive and sandwich this in register with the original negative. Print as normal. There are numerous other combinations along similar lines.

For solarized results from a colour transparency, print the original on to colour paper to obtain a paper negative, re-expose the image for a few seconds halfway through the development, and then continue processing as normal. By juggling the image and fogging exposure times, and colour filtration, you can control the end result. In fact, with all solarizations the amount of reversal in your final image can be altered by reducing or increasing the re-exposure time or the amount of development after re-exposure, or by delaying or bringing forward the moment during development when you make the re-exposure. For example, to enhance the reversal effect, extend the re-exposure or make it earlier in the development process. All the solarized prints on these two pages were made from the same transparency using different re-exposure times and filtrations. The final prints were all 12.5 × 17.5 cm. The larger the print size, the finer the Mackie line will be in relation to the image.

Making the negative colour print

To produce a solarized image of a colour transparency, first make a negative colour print from it. Place the original in the enlarger negative carrier, size and focus the image, and make a test strip using different filtrations and exposure times. Look for a result where deep shadows in the original have printed as white and where dark greys have become light greys. This gives the filtration value and primary exposure time. Using these settings, make the negative print and start to process it. For the original, right, a primary exposure of 24 seconds at f11 was needed. The print is shown below.

Solarizing the negative print

The prints above and opposite were made by re-exposing a negative colour print of the original to filtered light halfway through development. The light source was an anglepoise lamp with a 15 watt bulb filtered by coloured lighting gels. The light was bounced from the white ceiling above the developer tray so that it was diffuse. The low wattage of the bulb permitted long fogging exposures and thus considerable control of the final image. For the top image, re-exposure was for 10 seconds through a purple filter; for the image above left, 15 seconds through an amber filter; above right, 15 seconds through a dark green filter; and, opposite, 15 seconds through a purple filter. The images show something of the variety of mood that solarization can convey.

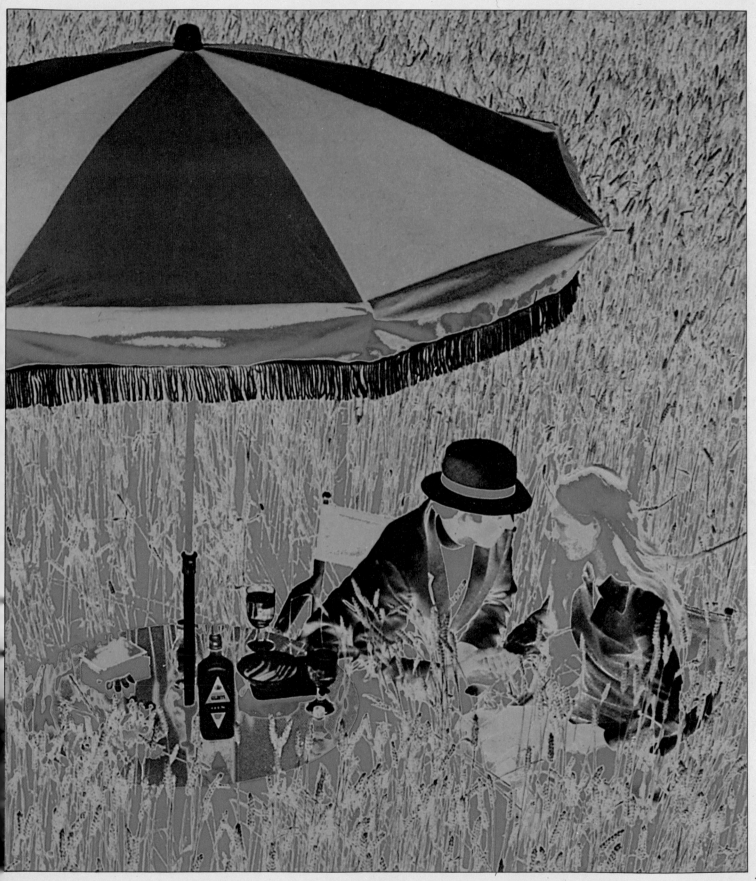

Multiple printing

Sandwiching two negatives together in an enlarger's negative carrier is the simplest way of producing a multiple print. The image from one will print in the shadow (clear) areas of the other. As coinciding highlights or shadows will produce little effect, try to combine strong images on one negative with blander areas – for example, expanses of sky or water – on the other. Normal and slightly overexposed negatives often work well together. Experiment by sandwiching not only different negatives, but also positives and negatives of the same image. Try also the effect of sandwiching two colour transparencies and printing on to reversal colour ("pos/pos") paper, or of combining a colour negative with a black and white one.

You can get similar results by double printing – exposing two negatives one after the other on to the same piece of paper – but the great advantage is that you can print the second image at any desired size and position simply by moving the enlarger head or the masking frame. You can also, by altering the exposures, modify the image densities, and there is scope for vignetting, printing-in and dodging. You can create images composed of as many elements as you wish to use together – true multiple printing.

A double exposure print can be made using only one enlarger by changing the negatives in the carrier, but a more flexible method is to use two enlargers, moving the masking frame from one to the other between exposures. Whichever method you use, and particularly when you are creating more advanced multiple prints, it is important first to plan the final image on paper. Project each negative in turn on to a sheet of white paper and trace the outline. Then use the tracing as a hinged overlay, either on the baseboard or on the print, so that you can size and focus each negative correctly. Make a test print for each negative. When printing, shade each image using masks and dodgers cut to the appropriate shapes from a sheet of black card. The shapes can simply be devised from the tracing.

Creating a frieze
To produce the image below, the same negative was printed five times on to a long strip of paper. The first exposure was made on the left, the rest of the paper being masked with a black card. The paper was fed through the masking frame, the exposed portion covered to prevent its being fogged, the negative was reversed in the carrier, and the second exposure was made. This sequence was repeated three more times to complete the frieze.

Using a single negative
A triple exposure of the same negative on to a single sheet of paper produced the top image. A black card with a rectangular cut-out was used as a mask and the masking frame was moved twice. In the double exposure on the right, the image was first printed the correct way up, but with the beach area masked off. The negative was then turned through 180° and the masking frame moved to print in the girl and the sea.

Using two negatives

The two images below were merged together to produce the final print, right. First, the negative of the cottage was projected on to a sheet of card in the masking frame and the main outline traced in pencil. The negative was changed and the image of the sheaves traced on to the card. The correct exposure for each negative was determined with test strips. Then the first image was printed, the bottom half being masked by the card cut to act as a dodger. The printing paper was placed in a paper safe, the second image set up, the paper returned to the masking frame, and the second image printed using the other half of the card as a mask.

Printing effects

The colour printing techniques discussed below, which are extensions of those described on the previous two pages, are relatively simple to apply in the darkroom, but are capable of yielding striking results. The first technique is colour combination printing from two negatives on to negative/positive paper or from two transparencies on to positive/positive stock. The procedure is no different from printing two black and white negatives on to the same piece of paper, printing them one after the other and using black card masks, but much more attention must be paid to matching the density and contrast of each element of the images. The most accurate way of doing this is to determine exposure and filtration by making test strips of each original. With a copy camera, this technique can be used to combine transparency images on duplicating film, as shown below.

The second technique involves attaching filters to the lens of the enlarger. It is possible, of course, to shoot a scene with, say, a starburst filter, a soft focus filter and a colour graduated filter and then combine the transparencies to produce a particular effect, but in practice it is difficult to produce the precise effect wanted this way – a good deal of speculation is involved about what effect each filter will have. It is in fact better to take a straight shot of the scene and then use similar filters on the enlarger lens. A range of filters now available (see right) enables creative enhancing of the image in a manner previously possible only in the camera. They have been designed for positive/positive printing. They can be used with both black and white and colour negatives, but it is important to remember that the colours and densities of the effects will then be reversed.

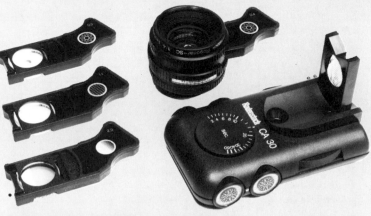

Rodenstock enlarger filter kit
The kit offers a choice between two enlarger lenses, a colour analyser and "creative modules". Each module has a filter in a holder which can be inserted in a slot on the side of the lens. There are also blank holders in which other image control elements – polarizing glass, grids or texture screens – can be placed. Modules are grouped in fives: four holders with filters and one blank in each "creative print set". Soft focus, graduated colour, colour ring, contrast variation and special effects sets are available. The last includes two elements that spread the image directionally and two that create ghost images of bright spots in the picture. The colour analyser bears a light guide that fits the lens slot; it is used to determine correct filter values and exposure.

Combining transparency images
The picture on the opposite page was made by double exposing two colour transparencies shot on identical film in similar light on to 35mm slide duplicating film. Using a copy camera and bottom-lighting, the first transparency, of the statue of Christ set on a hill against a hazy sky, was placed on a work table, the bottom half of the image masked with black card, and the first exposure made. The second transparency, of the clouds, was put in place of the first, the top half masked, and the second exposure made. The exposures and filtration had previously been determined by test shots. The difficulty of establishing where the images merge illustrates the accurate match of tones and densities.

Using enlarger lens filters
The spectrum effect on the right was produced by printing the straight image through a prism placed just in front of the enlarger lens. A Rodenstock graduated red filter was used to modify the straight image of the beach scene below left so that the true colours were altered in the horizontal plane, as shown below right. (By rotating the filter 90° the graduation effect would have been in the vertical plane.) The graduated filter "creative print set" includes nine interchangeable module filters giving different proportions of red, yellow, green and blue effects plus a half-neutral density filter, used when printing positive/positive to reduce the effective exposure of brilliant highlights.

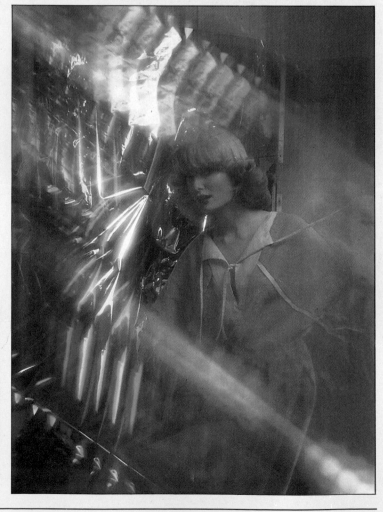

Original

Two-colour filter effect

Black and white montage

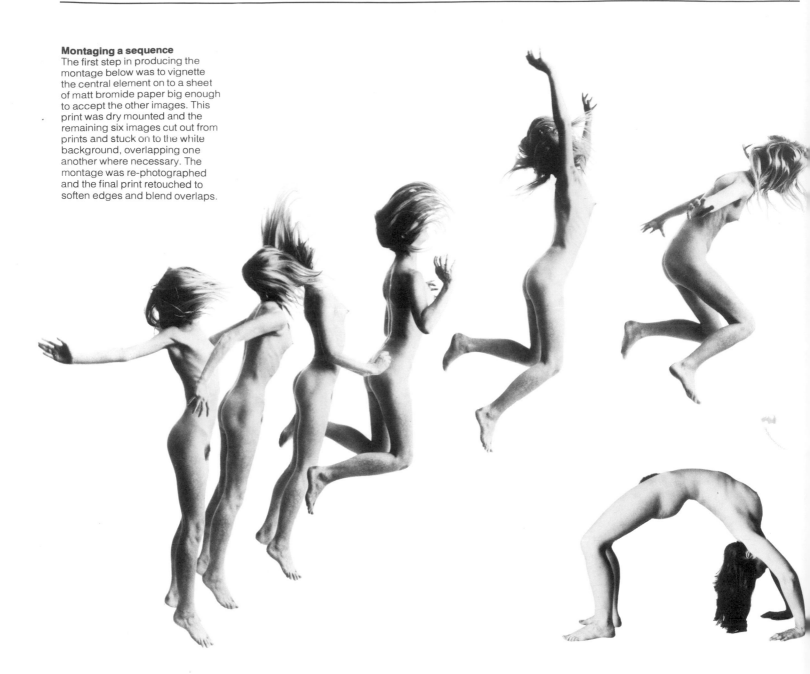

Photomontage is the art of combining portions of different prints into one image. The elements can be joined, overlapped or blended together to create symmetrical patterns, panoramas, friezes or surreal images. Scale and perspective can be distorted, "straight" prints dissected and rearranged, or several identical prints from a negative laid out to give a kaleidoscopic effect: there is complete freedom of choice.

A few points apply to all photomontage. First, the prints to be used in a composition should be of similar contrast, density and colour and be on the same grade paper – ideally, singleweight stock – to make the joins as inconspicuous as possible. Second, it is important that the prints are cut cleanly and smoothly – work with sharp scissors, a new razor blade or a scalpel. Rubber solution is the best adhesive: it will not stain the prints and any excess can be easily removed.

The first step in creating a montage is to make a sketch of the final image and to correctly size and position each element. Then dry mount the main background print on to a sheet of stout card larger than your final image. If you are aiming at a cut-out appearance, use scissors to remove unwanted areas of each print, first cutting away the bulk of the waste, then working accurately along the outline. Mount each element using double-sided tape. To produce a montage with invisible joins, cut out the elements with a razor blade or scalpel, either holding the blade tilted at an angle and moving the print past it, to produce an oblique edge, or score round the image, turn the print over and pull away the unwanted backing. The edges of each element should then be rubbed with sandpaper until they are wafer thin. (If, when the elements are mounted, the edges are still visible, they can be retouched with water-colour or dye to match the neighbouring tones.) The back of each piece of print is then smeared with adhesive and the piece is positioned carefully on the main image. Apply pressure from the centre and when the adhesive is dry, remove any excess. The montage can be trimmed and framed or re-photographed to produce a master negative. There will be no sign of joins on prints made from the negative.

Producing a montage
Basic equipment for montage work includes scissors, scalpel, glue and a retouching kit. To produce the montage near right, the park background image was enlarged and traced on to paper and the cat image positioned and sized accordingly, below. From each negative a print was made on single weight matt paper. The park print was dry mounted and the cat's head cut from the second print by scoring the outline with a scalpel, making scissor cuts up to the score line, bending the paper back until it split along the line, and then pulling away unwanted sections of the print. Its edges were then tapered.

Creating a mirror effect
The image above right was created by the careful blending, through retouching, of eight separate prints of the same girl. The central element, for example, is a montage of three prints – left profile, frontal, and right profile. The profiles were used in their complete form as the extreme left- and righthand elements of the montage.

Using "stick-on" technique
Prints of a girl shot against a black background were cut to shape and stuck on to a print of a brick wall, right. The montage was then re-photographed and printed. The cut edges are barely visible.

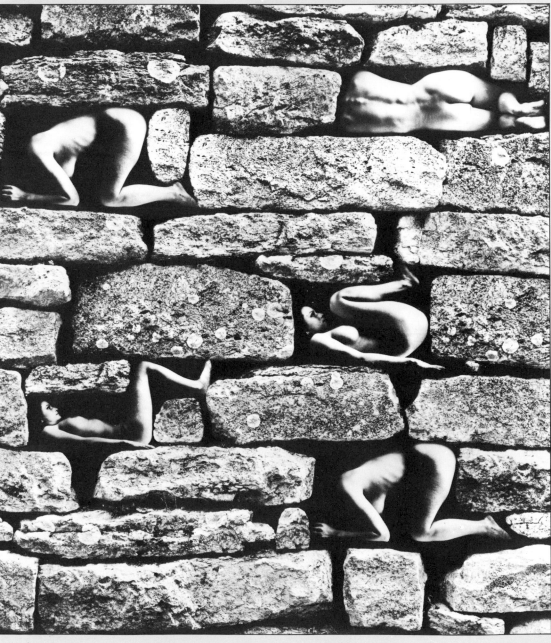

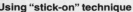

Colour montage

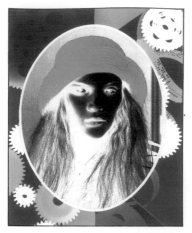

Two portions of a manipulated colour photogram butted together were overlaid by a negative print of a transparency to produce the photomontage of the girl, left. In the example below, two prints of a rooftop panorama, seen through a net curtain, were positioned either side of the image of the girl by the window. Two halves of separate slides were used to create the image at bottom. The camera was centred on the partition between the similar rooms. For the first shot the girl stood in the lefthand room, facing the wall. She then stood in the righthand room with her back to the wall and an identical exposure was made. After processing, the two transparencies were cut in half and the edges butted together. The large montage opposite was made from three colour prints. The print of the hotel entrance and horse was used as the foreground image, the drive print was inserted behind, and finally the farmhouse was positioned in the distance, linked to these strange half-images.

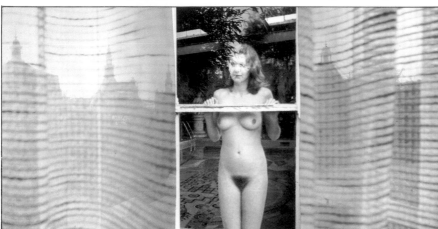

Retouching

Retouching negatives and prints using special dyes or watercolour paints is intended primarily to remove or hide scratches and spots, work up tones, renovate pictures, or disguise joins in montage work and combination printing. Airbrushing – the application of opaque spirit- or water-based colour pigments to a print with a fine spray gun – is used to colour prints, mask out backgrounds, or add shadows or highlights.

Dark areas of black and white negatives are reduced or removed with graphite powder or abrasive reducer applied to the surface with cotton wool or a felt stump, or by scraping with a sharp retouching knife. Alternatively, soak the negative in water, treat with a wetting agent, and apply Farmer's reducer with a fine sable brush. Wash the negative thoroughly afterwards. To soften outlines or fill in tiny transparent areas, spot with grey dye or watercolour pigment, or rub with a pencil: you will first need to treat the negative with matt varnish, or the pencil will not take. To blot out parts of a negative completely, paint them with black dye or opaque retouching medium. To lighten areas in the final print, paint the corresponding negative areas with dilute black or red retouching dye or use special retouching foils. These are printed in register with the negative, allowing precise control of the tones of the print.

You can hope to correct only small blemishes in colour negatives, because retouching involves all three layers. Use special yellow, cyan and magenta coloured pencils, checking the effect of each by viewing the negative through a filter of the complementary colour.

Use water-soluble paints or retouching dyes to spot or lighten areas of black and white or colour prints. Dyes are preferable since they penetrate the emulsion and do not mar the surface, even on glossy prints. Work from the darkest to the lightest tones, progressively diluting the dye. Tiny dark spots on a black and white print can be gently scratched off with a knife and larger areas bleached white or lightened with Farmer's reducer. Retouch transparencies with transparent watercolour paints: work on a light box and check the effect of each brush stroke.

Prints to be airbrushed must first be dry mounted. Then cover the picture area with self-adhesive masking film, taking care not to trap any air bubbles. Using a sharp scalpel, cut round the outline of the main subject and peel off the mask to expose the area you wish to spray. Start with a broad spray and build up the colour gradually.

Retouching a multiple print
Two images were printed on to the same piece of paper, opposite, by vignetting. To create a space on the main print into which the image of the man's face could be vignetted, a mask slightly smaller than the image was cut from black card, above, and held about 10 cm above the masking frame during exposure of the street scene. The rest of the card acted as a mask for printing in the second image. The area where the two separate images overlapped was first airbrushed over with dyes and then retouched using watercolours applied with a fine spotting brush. A sheet of tracing paper was used to protect the print surface from handling marks – this is essential as any finger marks will show up clearly on retouched work.

New prints from old
A damaged print, top left, was restored by retouching and airbrushing. Its two halves were mounted on card and then re-photographed. An unglazed print was dry mounted and scratches and blemishes were spotted in with a fine brush and water-soluble paints. The crack was filled in and the border restored by spraying with an airbrush, above right. The result was re-shot and the background of the final print cleaned up with bleach, above left, giving an almost blemish-free result.

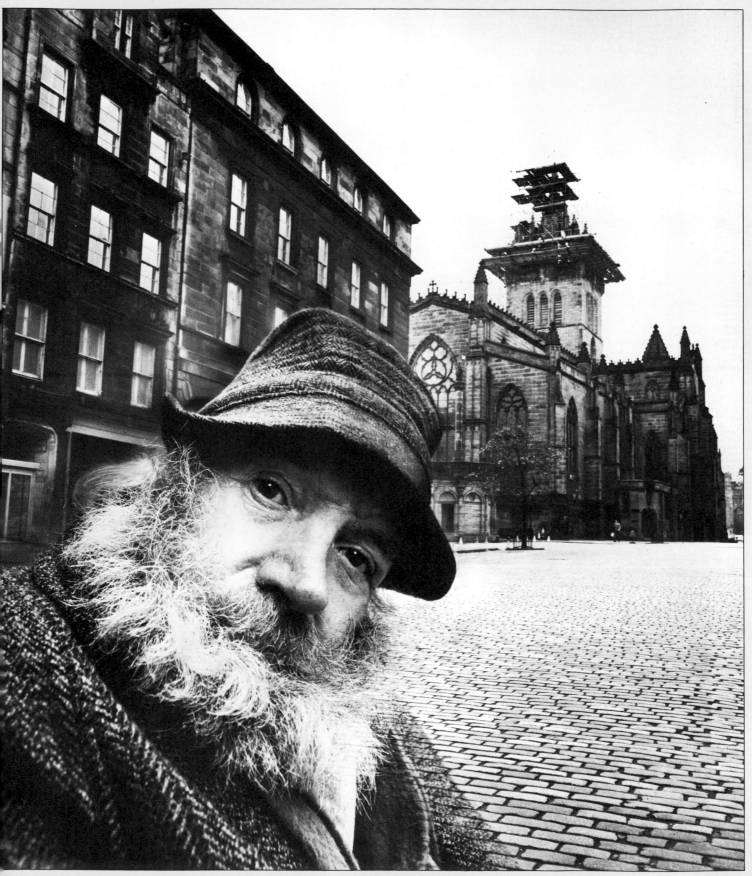

Hand-colouring

Black and white prints can be hand-coloured with transparent oil colours, felt pens, water-based pigments or dyes, pastel chalks, crayons or pencils. If brown tones are needed in the final print, sepia-tone it first. Experiment with selective bleaching and sepia toning: apply bleach and toner locally with a brush or cotton wool pad, or mask area with clear, semi-adhesive film or rubber solution and soak the whole print in bleach and toner. You can then hand-colour parts of the image, creating an image part black and white, part sepia and part second colour. Water-based colours should be applied to a damp print. With dyes, gradually build up the depth of colour: as they are transparent, they will not obscure detail in the original. Hand-colouring with oils should be carried out on a dry-mounted print that has been cleaned with turpentine. Mix and thin the colours with turpentine, then work them into the surface of the print. Pencils or pastel chalks should also be used on dry prints – the colours can be fixed with steam or liquid spray varnish. It is possible to hand-colour black and white film – negative or positive – with water-based inks or dyes. The negatives can then be printed on neg/pos paper. Use colours complementary to those required in the final image, working on a light box and viewing the film through appropriate filters. Make several prints, altering the filtration each time.

Colour toners

Four main types of toner are available. One-bath toners gradually replace the silver of the print, turning it into a new chemical compound of a different colour. Two-bath toners first bleach the silver image and

Materials and equipment

Hand-colouring, toning and airbrushing call for a variety of dyes; water- and spirit-based pigments; an airbrush and compressed air bottle; clear, self-adhesive masking film and rubber solution; a magnifying glass; scissors, a scalpel; sable brushes and cotton wool pads and buds for applying dyes, paints or chemical reducers and toners; bleach solution; a palette; small pieces of blotting paper and sponge to remove excess water and dyes; and double-sided tape for mounting prints.

Overall toning

Overall toning

The print on the left was made by bleaching a black and white print and then redarkening it in a blue toner. Most blue toners are iron-based: since they tend to have an intensifying effect, making the original more contrasty, work on soft, light prints.

Selective toning

To tone selective areas of a print, cover the surrounding image zones with rubber solution or semi-adhesive masking film, both of which can be peeled away when the print is dry, and soak the whole print in toner. The eggs in the print at bottom left were toned by masking the entire print and then cutting the mask away over the eggs. The print was bleached until the black tones of the eggs faded to straw colour, then toned for 3 minutes in sulphide sepia toner.

Multiple toning and dyeing

The image on the right was produced from a black and white original by toning or dyeing the print a different colour as each area of masking film was removed. The film covering the bottle was removed first and the print blue-toned. Then the film covering the wall was peeled away, a fresh piece of film was used to mask the bottle, and the print was toned sepia. Finally, the foreground was uncovered, the wall area remasked, and the print toned green with a colour coupler.

Local toning

Multiple toning and dyeing

then redarken it. With colour-coupler toners, the black silver image is bleached out and then redeveloped in a solution that fixes the coupler on the image. A silver image is also produced: this can be retained or bleached out to leave just the dye colour. Lastly, using special dye/toning kits, the image is first toned and then dyed, some dyes affecting the dark areas leaving the white print base unaffected, others affecting light areas only. Most toners are intended for use with resin-coated papers, but they can also be used on black and white negatives and positives. Make sure prints are fully fixed and washed, and soak dry prints in water before treating with toner. If you are using colour couplers, you can create multi-toned images by preparing several small quantities of the colour developer, mixing each with a different coupler, and then applying them to the appropriate areas – perhaps one colour for highlights and one for shadows – with a cotton wool pad or bud or a fine sable brush.

Airbrushing

Airbrushing, the technique of applying opaque colour to a print with a fine spray gun, can be used to make colour prints, eliminate back-grounds, or add shadows or highlights. It can also be used to retouch badly damaged prints (see pages 238–239). Work on dry-mounted prints, covering areas of the image to be retained with clear, self-adhesive masking film. If you wish to airbrush large areas of the print, bleach it before working on it. For the best results, rephotograph the finished print.

Hand-colouring

Water-based inks were used to colour the print on the right. Areas of the print already coloured, or about to be, were protected with masking fluid.

The ink was applied to broad areas with a cotton wool pad and to details with a fine brush. Each segment was allowed to dry before the next was tackled.

Airbrushing

Airbrushing consists of three steps. First, dry-mount the print and cover the picture area with clear, self-adhesive masking film, taking care not to trap air bubbles. Then, using a sharp scalpel, cut around the outline of the main subject and peel off the masking film. Starting with a broad spray, build up the colour. To create a soft edge, constantly move a card mask cut to the appropriate shape over the print surface while airbrushing around it. Airbrushing was used to create the rainbow in the print far right. A thin sliver of mask was cut away and, with the airbrush about 4 cm above the print, red pigment was sprayed on in a band. The next sliver of mask was removed and orange sprayed on while a card mask was used to shield the red band. This sequence was repeated for the additional colours.

Lay mask

Cut mask

Spraying

Liquid emulsions

1. The first stage towards the large illusionistic photograph on the page opposite was to choose a suitably light-coloured van and align it with the caravan so that its exact position could be marked, with the wheels used as reference points. The camera tripod position was also marked and the van was then moved away from the site.

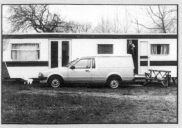

Nowadays photographic images can be made on almost any firm surface. Ready-mixed or home-made silver halide emulsion can be sprayed on to receive an enlarged or contact printed image which is then developed and fixed in the normal way. Signwriters find liquid emulsion, or "liquid light", useful for transferring complex designs to large display areas. The sequence below shows creative use of the medium by the Marshall McLaren studio.

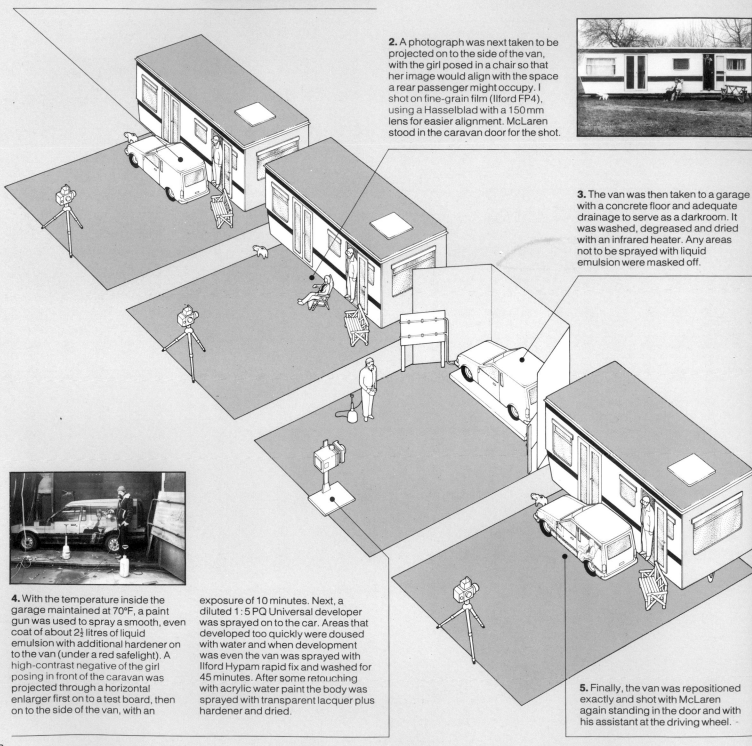

2. A photograph was next taken to be projected on to the side of the van, with the girl posed in a chair so that her image would align with the space a rear passenger might occupy. I shot on fine-grain film (Ilford FP4), using a Hasselblad with a 150 mm lens for easier alignment. McLaren stood in the caravan door for the shot.

3. The van was then taken to a garage with a concrete floor and adequate drainage to serve as a darkroom. It was washed, degreased and dried with an infrared heater. Any areas not to be sprayed with liquid emulsion were masked off.

4. With the temperature inside the garage maintained at 70°F, a paint gun was used to spray a smooth, even coat of about 2½ litres of liquid emulsion with additional hardener on to the van (under a red safelight). A high-contrast negative of the girl posing in front of the caravan was projected through a horizontal enlarger first on to a test board, then on to the side of the van, with an exposure of 10 minutes. Next, a diluted 1:5 PQ Universal developer was sprayed on to the car. Areas that developed too quickly were doused with water and when development was even the van was sprayed with Ilford Hypam rapid fix and washed for 45 minutes. After some retouching with acrylic water paint the body was sprayed with transparent lacquer plus hardener and dried.

5. Finally, the van was repositioned exactly and shot with McLaren again standing in the door and with his assistant at the driving wheel.

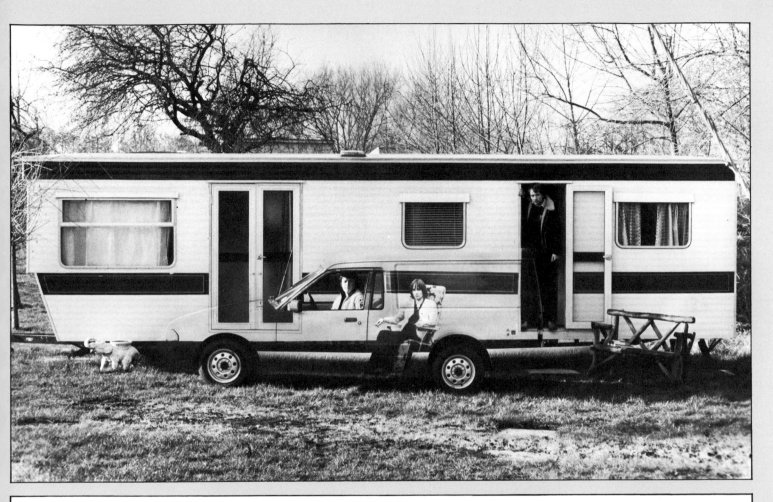

Photographic images can be imposed permanently on a great variety of objects, including such domestic articles as plates, cups, mugs, lampshades or furniture. The technique is used in commercial photography to decorate props for still-lifes and other subjects where the client is looking for an unusual approach to a familiar theme – in food photography for example. Liquid emulsion used straight from the bottle or tube retains brush-marks, which create a texture on art paper and other smooth surfaces. Warmed up so that it flows evenly, the emulsion can be sprayed, as on the louvred door far right, or poured on to the selected surface and spread to provide a uniform coating. The plate (right) was first warmed, then coated with a subbing solution (provided with the emulsion) and the emulsion was then poured on and rolled around. Before the final exposure, make a test strip with emulsion-coated paper, and watch for halation from shiny surfaces. Process as you would black and white photographic paper. Use a coat of subbing for non-porous surfaces, polyurethane for plastics.

Polaroids

The "point, shoot and view" immediacy of instant-picture materials is exploited most by commercial photographers. In studio work, there is no better way of testing the lighting prior to shooting on conventional, darkroom-processed film than to take an instant-print test shot. (For most studio-type view cameras special instant-picture film backs are available.) Other situations that exploit the speed and ease of processing possessed by these materials include medical and scientific photography and business or scientific conferences, where overhead high-quality slides of images produced by computer graphics are ready to project within minutes of production: Polaroid Colorgraph film 25 × 20cm has been developed for this purpose. But this form of photography also lends itself to creative work. For example, you can quickly produce friezes or mosaics, such as the image on the left. By virtue of the processing mechanism of instant prints you can manipulate the emulsion simply and without recourse to other chemicals, often with extremely interesting results.

Instant-picture materials are of two types. "Peel-apart" film comprises a negative and positive adhering face to face. Once exposed, you pull the film out of the camera and after the recommended processing time – usually 30 seconds – you separate the positive from the film negative. (The negative can be cleared and re-used in the normal manner.) 'Integral' prints contain the processing chemicals sealed between a backing material and a transparent plastic overlay. As you pull the exposed film through rollers in the camera, pressure releases the processing chemicals. You can manipulate peel-apart films – for example the popular ASA 125 black and white instant-print films and Polacolor film – before, during and after processing. Integral prints – high-speed black and white films, Polaroid SX-70 and Kodak PR films – can be manipulated only during and after processing, not before.

Polaroid negative and positive film

Certain Polaroid black and white and colour films will produce a fully developed, re-usable negative and a positive print in less than a minute. The separately packaged negative is loaded into the film holder, the holder is inserted into the camera, and the film exposed. Then the positive is inserted into the holder to align with the negative. The holder is placed in the slot of the film processor, where rollers break the chemical pod and spread the chemicals.

Film holder

Automatic processor

Processing tray

Manipulating integral SX-70 film
During the processing stage of SX-70 integral colour prints the image can be altered by pressing on the front. Try working the print between your fingers to move the dyes around in the emulsion or place the print on a table and rub the surface with the end of a pencil or paint brush, as shown below. The print at left was made this way. With processed prints you can colour the plastic fronts with gouache, felt-tip pens or crayons, or slit the prints open and work on them on the inside. Separate the plastic front and the backing sheet, then gently wipe away the opaque white layer that underlies the image and tint the picture using dyes, inks or coloured gouache. You can also scrape away the image partially and apply gouche or wax crayon colours to selected areas.

Manipulating peel-apart film
To work on a sheet of black and white peel-apart film, pull the end-cap off the film pack (in darkness), remove the film packet, and peel away the negative. Try scribbling over the negative. Then re-assemble the film packet and return it to the pack. During processing, experiment by lightly scoring the negative or striking it with something blunt. With colour peel-apart film, soak the print in boiling water and then cut off the margins. You can then work on the emulsion or transfer it to a piece of acetate, as shown right.

Working in register

Register is the recording, on film or paper stock, of two or more images in a precise, pre-determined relationship to each other. The photographs in this book, for example, were printed from four separate printing plates, each of which had to be accurately registered in relation to the other three to ensure that the illustrations were crisp and clear. The darkroom techiques described in the following eighteen pages all depend on accurate register.

One of the most important techniques to master is the making of multiple exposures in register using either an enlarger or a copy camera. The simplest example of a multiple exposure made with an enlarger is the test strip, where register between successive steps in the exposure sequence is controlled by the sharp edge of the masking card and the fact that the strip is kept firmly in position by the masking frame: a basic requirement of working in register is that the film or paper remains in or is returned to precisely the same place for each exposure. The technique of securing the masking frame to the baseboard, and of ensuring that each successive sheet of paper is placed in the same position within the masking frame, firmly against the stops, is used when a set of matching prints are required. Its main use as a registration method for special effects work is in the making of multiple prints from tracings (see pp 230–231).

The technique can be taken a stage further with a register system in the negative carrier of the enlarger, and some 5 × 4 in enlargers have such a system built-in. The carrier has pins which accept punched film and is itself located in an accurate mount in the enlarger housing. Originals and their overlays or masks are pre-punched and successive exposures made in the normal way. The film or paper on the baseboard can be secured to it by means of a peg-bar.

Using hinged overlays
Overlays on tape hinges (above) are an alternative to a peg-bar system. They can be either additions or changes to an opaque image, mounted on board if the artwork is to be top-lit, or, if it is to be bottom-lit, they can be parts of a composite image on acetate sheets, hinged to an acetate base or to a board with a hole cut in it. A disadvantage of the hinge system is that the number of overlays is limited to four unless both overlays and hinges are cut in a complex way. However, it is possible to dispense with the hinges and work entirely with registration ("crop") marks on the base piece of artwork or on the mount: these marks must be kept out of the field of view. This works well with large overlays.

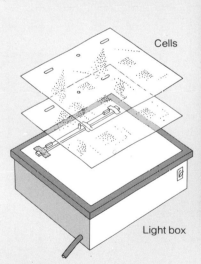

Cells

Light box

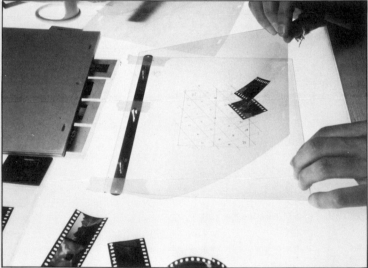

Shooting the artwork
The registered cells are taken from the light box to the copy camera set-up, in the correct order. The first cell, bearing the grid, is lined up in the camera viewfinder and the peg-bar taped to the work surface (below). The camera is adjusted so that the subject fills the frame, and focused on the grid. Then the first cell is removed and the artwork cells placed on the peg-bar in sequence. For each exposure a mask (see below) must be used so that the multiple image is built up gradually.

Acme peg-bar system
Borrowed from the animation trade, this system consists of a peg-bar (below), punch and pack of pre-punched clear acetate sheets or cells. The original is usually prepared on a light box. The peg-bar is taped to the glass and the first cell placed on it (above left). This cell often bears a grid that is used as a position guide. A second cell is placed in position and the primary piece of artwork – for example, a transparency – is taped to it (above right). On a third cell the second piece of artwork is registered exactly with the first – and so on.

Using a mask
When shooting a composite of 35 mm transparencies, built up on the grid (1, left), in which each cell bears one transparency, move the mask (2) one space across the grid for each exposure.

1

2

The Kodak register system

This kit uses the same principles as the Acme system, but applies them differently. It consists of a peg-bar, punch and printing frame, the last designed to make contacts in register. The peg-bar is built into the glass-faced printing frame, which has a hinged tensioning back to ensure that the original and the unexposed film or paper are kept flat and in close contact, below. The original negative or transparency is printed on to film that has been previously punched. A floating peg-bar is used, taped to the baseboard of the enlarger. The film (or "first stage") is then placed in the printing frame in contact with unexposed film or paper, punched for the peg-bar, and a print made, usually by employing the enlarger as a light source. (Kodak peg-bars are available in two sizes, the smaller of which is useful for small acetate sheets and can be used as in the Acme system.)

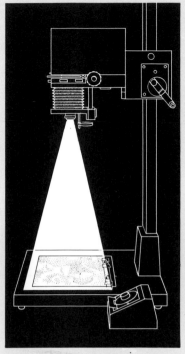

Preparing the first stage
Mount a punched acetate grid sheet on the enlarger peg-bar. Size and focus the enlarger, then tape down the peg-bar. Punch the unexposed film or paper, mount it on the peg-bar, and expose (above).

Kodak punch

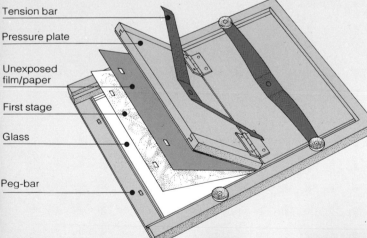

Tension bar
Pressure plate
Unexposed film/paper
First stage
Glass
Peg-bar

Making the contact print

The first stage is placed on the peg-bar in the printing frame and the unexposed stock is placed on top, emulsion side to the glass (above). The frame back is locked shut and the frame, glass uppermost, is placed on the enlarger baseboard; the first exposure is then made (right). Without moving the enlarger head, the process can be repeated many times to create a multiple image.

The copy camera can be used in two ways to make multiple exposures: the shutter can be opened and the lighting system used to make the exposures, or, when it is possible, the shutter can be re-cocked without moving the film. Both methods require the artwork to be registered accurately on the copying work table. If flash is used as the primary light source, the procedure is simple: the first piece of artwork is placed in position, the shutter set to B and opened, and the flash fired. The sequence is repeated with successive pieces of artwork as many times as required until it is complete, and then the shutter is closed. Tungsten lights pose more of a problem because exposures must be accurate: it is simplest to link them to a timer. If they must be switched on and off manually, use long exposures, which can be timed with a reasonable degree of precision.

Only a few SLR cameras have a multiple exposure button, which allows the shutter to be cocked without advancing the film. Without this facility it is still possible to make multi-exposures, but the method calls for practice and patience. The re-wind button is pressed to release the film and the shutter is cocked normally. The method relies on the balance of tension between the cassette and the take-up spool – it is possible to get perfect register if you are using a camera the ways of which you thoroughly understand.

Several $2\frac{1}{2}$ in format cameras are ideal for making precise multiple exposures because the magazine can be removed while the shutter is cocked. Hasselblad bellows are also useful, as the lens and shutter are operated separately from the rest of the camera. Also ideal are 5×4 in cameras, since the shutter is on the lens board and independent of the film holder. Accurate multiple exposure is one of the features of rostrum and other specialist copying cameras.

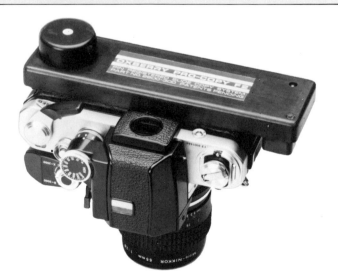

Pin-registered cameras

In most rostrum cameras, film sprocket holes are pushed on to two pins in the camera gate before exposure – each successive frame is thus in exactly the same position in respect to the holes, and multiple exposures are in precise register. Some 35 mm SLR cameras have been modified for pin-registration, for example, the Nikon camera above. Registered slide mounts (right) bear pegs that maintain the relationship between sprockets and frame area.

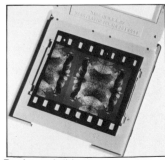

Registered slide mount

Slit-scan techniques

Slit-scan is a photographic technique that distorts images. It can be applied in two ways. In the first, use is made of the autofocus capability of an enlarger or copy camera; in the second, a moving object is scanned through a slit that travels in a horizontal plane between lens and subject (or the printing paper or film is moved).

An enlarger or copy camera equipped with autofocus will keep its lens in focus as the image size is increased or decreased by moving the body of the instrument up or down its column. With an enlarger, the effect of movement up the column is to increase the size of the projected image with the result that anything originally near the edge of the masking frame moves outside it. With a copy camera, the effect is the reverse, because the camera is not projecting an image but receiving one.

The effect of scanning a moving subject through a travelling slit is to produce a distortion best exemplified by the images of racing cars with oval wheels taken by J. H. Lartigue with an early focal plane shutter.

The two main types of slit-scan can be achieved with an ordinary enlarger fitted with a zoom lens, which is kept in focus as the enlarger is racked up or down; and with a slit cut in black card which is moved across the projected image while the printing paper is also moved. Try combining both these techniques to get effective image distortion.

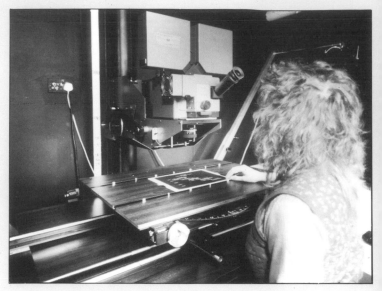

Creating a slit-scan image

The zoom effect embodied in each of the inset photographs opposite was created by using the first of the slit-scan techniques described above. A punched cell was used to make a hand-cut mask that established the position of the insets and this was then contacted to negative on a 12.5×10cm sheet of lith film (Mask 2). Outlines to match the mask rectangles were drawn in black on a second cell and this was also contacted to negative (Artwork to be scanned). The negatives were laid up on cells. A fresh cell was placed beneath the mask negative and the five inset transparencies were aligned behind the windows and taped down. Then, using a rostrum camera, three exposures involving these elements were made on to 35mm colour slide duplicating film: (1) the ganged-up transparencies sandwiched with Mask 2 – this produced the image bottom right; (2) Mask 2 alone; and (3) the outline negative. During the last exposure (to a red light source) the camera was racked up and down its column and the autofocus mechanism used to create the slit-scan effect: the rectangles of the original gave rise to tunnel-like images (Scanned artwork). In preparation for the final image, the transparency of Mask 2 was twice contacted to positive on lith film. A triple exposure was then made: (1) for the transparency of the five images set in Mask 2; (2) for the desert scene 35mm transparency sandwiched with one of the Mask 2 lith positives; and (3) for the zoomed negative sandwiched with the other Mask 2 lith positive.

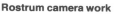

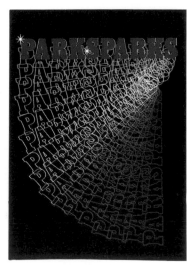

Rostrum camera work

The rostrum camera (top) is a precision copy camera. Its special features include electronic autofocus; a 30m film reel; a pin-registration system; a picture frame counter; and controls to move the film back and forth along its entire length. To create the image at left, three pieces of artwork were prepared: solid lettering of "Parksparks", an overlay with the lettering in outline; and an overlay with the two stars. A multiple exposure was made, each with a different light source, while the negative of the outline lettering was moved about a fixed point.

249

Separations and masking

The image manipulations shown on the next two pages were obtained by using colour or tone separations and printing additively. Tone separations, made by shooting an original at several different exposures on line or lith film, each record a specific density range within the image. Generally only three are produced – a low-density negative, a mid-tone negative and a high-density negative. Contact positives of these, used in conjunction with tone separation negatives and the original, create a variety of special effects. Contrast masking, the manipulation of the tonal range of a colour image, uses a very under- or overexposed tone separation. Posterization, the technique of converting a continuous tone original to an image consisting of flat tones or colours, involves printing tone separations in register on to a single sheet of paper or film. Examples of both a contrast masked image and a posterized image are shown overleaf.

Colour separations are produced by shooting the original on ordinary panchromatic black and white film through red, blue and green filters. They are used in dye transfer and photo-silkscreen work, a full-colour image being re-assembled on the same principle as additive printing. They can also be used for posterizations and for producing a pointillist effect – the rendering of a picture in dots.

Making tone separations

Tape a peg-bar to the enlarger baseboard to permit registration and then expose the original negative or transparency on to three 12.5 × 10 cm punched sheets of lith film, exposing one sheet normally, underexposing the second by 1½ stops and overexposing the third by 1½ stops. Each separation will record, in black, only a portion of the image: on the first separation this will be the shadows and mid-tones; on the second the shadows only; and on the third only the highlights. Process the separations in lith developer, dry them, and contact them back at a constant exposure on to punched lith film.

With the accuracy obtainable by working in register on a copy camera, tone separations can be made straight on to 35mm film. Having made lith positives by the process outlined above, tape one of them to the centre of a pre-punched cell on a peg-bar taped to a light box. Place a new cell on top, register the corresponding negative on the positive, and tape it in position. Replace the second cell with a new one, then register and tape down the next lith negative or positive. Repeat until all six separations are laid up in register. Number the cells Pos 1, Neg 1, Pos 2, Neg 2 and so on. A full set of tone separation negatives and positives is shown below. Some of these were used to produce the posterized image shown overleaf. Such a set of separations can be combined in any way you wish to produce a desired effect.

Colour separations

A colour transparency or negative can be split into its three component colours with the use of tricolour filters. Make an exposure through the red filter, then through the blue and finally through the green: if you are working with Kodak filters use 47 blue, 58 green and 25 red. Each filter has a factor that should be used to adjust your exposure. The simplest way of making colour separations is to use a copy camera. Load the camera with ordinary black and white film. Calculate an exposure for a correct negative or positive, then apply the filter factor for each separation. Process the film in the usual way. Take the utmost care not to move the camera or the original between exposures, for the separations will be of use only if they can be registered precisely. From negative originals you will, of course, get colour separation positives. Contact these back to negatives. If you are using a transparency original, contact the separation negatives back to positives. Lay up the six separations on cells as detailed left. To create a variety of special effects in the use of colour separations, produce line or lith separations. For low-contrast colour separations, use a film such as gravure positive. For contrasty results, use lith film and process in tone developer. (Colour separations can be made under the enlarger on to panchromatic film stock.)

Dense neg / Pos 1 / Medium neg / Pos 2 / Thin neg / Pos 3

Red neg / Red pos / Blue neg / Blue pos / Green neg / Green pos

Contrast masking

Duplicate transparencies or pos/pos prints are often very contrasty, even with correctly exposed, normal-density originals. This can be overcome by contrast masking – shooting or enlarging your original in contact with an underexposed panchromatic black and white negative that records just the subject highlights. The technique can be used not only for corrective purposes, but also to manipulate colour images. For example, you can make very dense contrast masks on lith film – developed in tone or lith developer – which when contacted with a transparency will alter those areas of the image with the same tonal value. To do this, tape the original on to a register-punched cell and make the contrast negative with the enlarger or copy camera. Contact it back to positive and lay both negative and positive on cells, in register with the transparency. You can then alter the image using just one mask or, alternatively, by using both, one after the other, splitting the transparency image into distinct parts that can be double exposed back together. With this method it is possible to give highlights one exposure and filtration and the rest of the image quite different treatment.

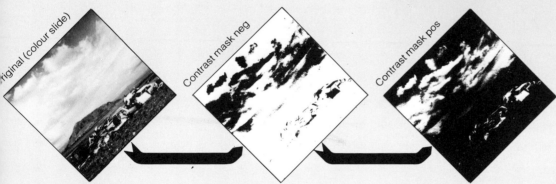

Original (colour slide)

Contrast mask neg

Contrast mask pos

Posterization

The first step in posterizing a black and white negative or positive is to make registered tone separations. With a colour original, make tone or colour separations according to the end result desired. The six separations can subsequently be shot in any combination and with any filtration you wish. Shoot on to transparency film using the copying set-up with bottom lighting, or contact-print the separations on to register-punched black and white or colour neg/pos paper. Work with a peg-bar taped to the copying surface or enlarger baseboard. To make a black and white posterized image, as shown below, shoot separations one after the other, giving each negative or positive only enough exposure to produce a mid-grey tone. You can create a simple colour posterization by exposing a single lith positive or negative separation on to colour film or paper with a coloured light source. The result will be a posterized black image on a plain coloured background. For multi-coloured images, experiment with mixtures of negatives and positives, using a different coloured light for each exposure. The correct exposure can be determined by means of a test strip, though with experience you should be able to guess the correct setting from just a light meter reading.

Pointillism

A colour original can be converted into a pointillist image either by using a coloured dot screen in contact with a negative or transparency and printing normally or by using a black and white dot screen in contact with paper or film and printing additively. Use negative screens with negative originals, printing on to neg/pos paper, and positive screens with transparencies, printing on to slide duplicating film or pos/pos paper. A black and white screen can be made by contacting or enlarging a sheet of self-adhesive graphic dot film on to lith stock or by making a photogram on black and white film of fine beads, sugar crystals or cake decorations. From these you can create a coloured dot screen by hand-painting the dots with transparent colour inks and then copying the result on to colour negative or transparency film.

Either an enlarger or a copy camera can be used to make the image. Using an enlarger, sandwich a coloured dot screen with the original in the negative carrier, project on to film or paper, and process normally. With a black and white screen, size and focus the original on the masking frame, place the screen in contact with paper or film, and give three additive exposures. Move the screen slightly between each exposure. Take care not to move the original, or the paper or film, until you have completed the triple exposure.

With a copy camera, tape the original to the work surface, place a coloured dot screen over the lens, and make a single exposure. If you wish to use a black and white screen, lay it on top of the original and expose using red, green and blue light sources. The dot edges can be softened by placing a sheet of glass between screen and paper or screen and original.

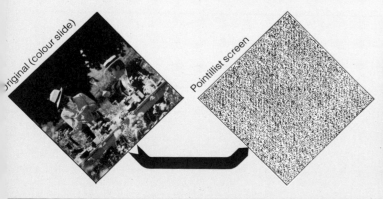

Original (colour slide)

Pointillist screen

Colour separations

Contrast masking, pointillism and posterization

The large image opposite is the result of a double exposure using a copy camera and bottom lighting. The first exposure was for the original colour transparency sandwiched with an underexposed contrast mask, the second for the transparency sandwiched with the positive of the mask. By using different colour light sources for each exposure, the division between highlights and the rest of the image was enhanced. The pointillist effect above was produced with a black and white positive dot screen. The original was placed in the negative carrier of the enlarger and the image sized and focused. With the screen placed in contact with a sheet of positive/positive paper, printing was done additively. The image of the house below is an example of posterization, so called because it produces the bold flat areas of colour appropriate for posters. From the original transparency a set of three tone separations of varying density was contact printed on to high-contrast lith film. The negative separations were then contacted back to positive. The first exposure for the final image used a positive of the densest tone separation sandwiched with the thinnest negative, the second exposure the converse separations and a green light source.

Dye transfer 1

Dye transfer is a method of making colour prints by applying dyes from three separate gelatin printing matrices. It produces a greater fidelity of colour and offers a higher degree of colour control than any other printing technique, and the colours of the dyes used are more brilliant than those obtainable by ordinary photographic methods. The process consists of three main steps. First, using a matched set of red, green and blue separation filters a set of three separation negatives is produced from the transparency original. As with all the steps involved in dye transfer, this requires careful registration of the film elements. Secondly, the separations are enlarged on to matrix film, which is developed to produce a relief image in gelatin. The thickness of the processed gelatin is proportional to the amount of light it received from the separation; that is, it is thickest in the shadow areas of the image. Finally, the three matrices are dyed up in their respective printing colours – cyan, magenta and yellow – and brought into contact, in turn, with a sheet of specially prepared paper. The transfer paper absorbs the dyes out of the matrices to produce the colour print.

The dye transfer technique permits great flexibility: commercially it is used to manipulate prints from transparencies, as shown overleaf. It can also be used to create a colour image from a black and white original by hand-dyeing the single matrix and to make matrices directly from a colour negative by printing on to special panchromatic matrix film under the enlarger. For this you must make use of the correct Kodak red, blue and green filters.

Materials and equipment
In addition to the chemicals, filters and enlarger you will need the following: matrix film, separation film, film for colour correction and highlight masking; dye transfer paper; processing dishes, graduated measure, flat squeegee, roller squeegee; register punch; printing board with peg-bar.

Masks and separation
Photographic masks are needed when making colour separations from a transparency in order to optimize tonal quality and to compress the excessive contrast range of the original to within the limitations of the matrix material. The masking process will also compensate for colour imperfections in the transfer dyes. First make a highlight mask (above right); without this the final print will show little tonal separation in the highlights. Sandwich the mask in register with your original and make a contrast reduction/colour correction mask: its strength usually has to be about 30 per cent. The separation negatives ideally need densities ranging between 1.0 and 1.4, with a minimum of 0.4. Sandwiching the transparency with the contrast reduction/colour correction mask, make the three separations on to register-punched panchromatic film. Include a grey scale with each negative: its density and contrast should match in each of the three negatives.

Green filter

Red filter

Blue filter

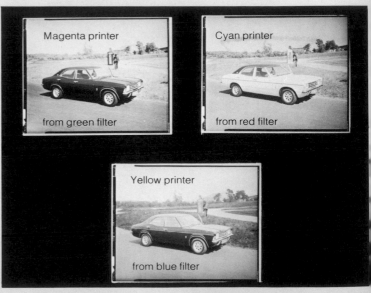
Magenta printer
from green filter

Cyan printer
from red filter

Yellow printer
from blue filter

Producing the matrices
Under a red safety light, register-punch three sheets of matrix film. Place the red separation in the enlarger. Size and focus the image and make a test strip on matrix film. Expose through the base of the film. Process the matrix in the two-solution tanning developer and non-hardening fixer, wash away all untanned gelatin with a flow of water at 49°C, and then flood with water at 20°C. Assess the test strip by dyeing the matrix and rolling it out on a previously prepared sheet of transfer paper. When printing the set, mark each matrix with its printing colour.

Dyeing the matrices

Begin the dyeing and transfer sequence by conditioning as many sheets of transfer paper as you wish to print. If all the solutions are kept clean, and the gelatin relief images not damaged, it should be possible to make about 50 prints from one set of matrices. Rinse the sheets in warm running

water for 30 seconds, then soak in conditioner for at least half an hour. Meanwhile, make up the cyan, magenta and yellow dye baths. (If the matrices are dry, soak them gelatin side up in water at 38°C for 3 minutes.) Drain each matrix and transfer it to its dye bath – the red separation to the cyan bath, the green to the magenta and the blue to the yellow. Agitate the dishes frequently for at least 5 minutes. Remove a sheet of transfer paper from the conditioning bath and, with its gelatin side up, position it on the rolling board, butted up against the register pins. Wipe off excess liquid with a squeegee and sponge around the paper with 1 per cent acetic acid. Drain the first matrix and remove surplus dye by agitating it in a bath of 1 per cent acetic acid for 1 minute and in a further bath for 30 seconds. (The first acid rinse should be discarded each time. The second rinse can be used until it becomes discoloured.)

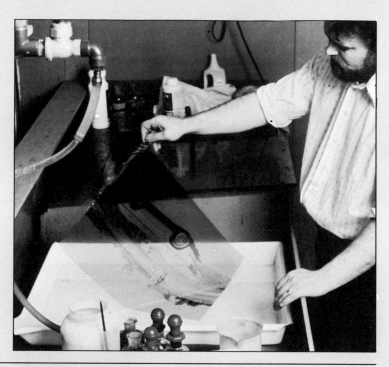

Transferring dye to the paper

Lift the dye matrix from the second rinse bath, drain it, and, with the emulsion side face down, position the punched end of the matrix on the printing board register pins. While holding the matrix taut, roll it gently down in contact with the transfer paper. Leave it in position for 5 minutes so that the dye can transfer to the paper. Remove the matrix by pulling it up at one corner and stripping it slowly from the paper. Repeat the sequence using the other two matrices. Dry the completed print on a glazer or flat-bed dryer. After rolling out, wash each matrix for 3 minutes in running water at 38°C to clear it of dye, drain it carefully, and hang it up ready for re-use.

Localized colour balancing

To reduce cyan dye in selected areas of a completed print, apply a 0.5 per cent solution of potassium permanganate with a brush or cotton wool swab (left). Remove any brown stains with a 15 per cent solution of sodium bisulphite, then swab with 1 per cent acetic acid. To reduce magenta, apply concentrated wetting agent and to reduce yellow use a 5 per cent solution of sodium hypochlorite, afterwards washing the print in 1 per cent acetic acid. To strengthen colours, apply dye to the cleared matrices (right), pass through the acid rinse baths, and then print down a second time.

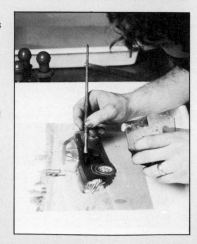

Dye transfer 2

Changing the image
Dye transfer was used to make the three prints on this page. The red car was the straight print. To produce the two manipulated prints, a fresh set of matrices was made from the original separation negatives sandwiched with a mask of the car body. Prints from these matrices produced the normal background image common to all three results. The matrices were then re-exposed to the red-filter separation negative sandwiched with a reverse mask of the car body. The now modified matrices, when rolled, produced prints with a white car showing full modelling. Finally, using the blue-filter separation negative sandwiched with the reverse mask of the car body, a single matrix was made which, for the second print, was dyed blue and transferred to the print. To introduce colour stripes to the car body to produce the third print, this matrix was repeatedly selectively masked, dyed in the appropriate colours, and rolled out.

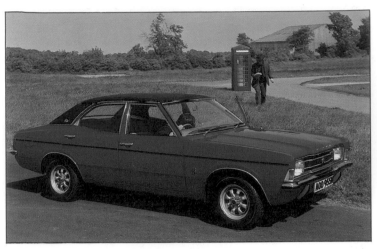

Adding detail
Dye transfer prints provide an ideal basis for retouching, as the paper and dyes can be matched to the consistency of the air-brushing dyes. The straight image of the man on the sofa above was retouched (right) on a dye transfer print from the original transparency. The shaded area on the wall was introduced to give the impression that a picture had once hung there. Applying additional dye to a print is also a way of increasing contrast, a second transfer being made from the appropriate matrix. However, as it is rarely desirable to make a second transfer at full strength, the matrix is dyed for between 10 and 30 seconds, not for five minutes.

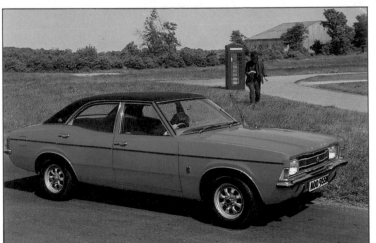

Strip-ins 1

A print combining several images from different originals can be made either by photomontage or by the technique of stripping-in. In photomontage the various images are printed on to separate sheets of paper and then cut out and assembled together with adhesive. Stripping-in involves cutting out the images photographically by using combinations of positive and negative masks and assembling them by a multiple exposure. It is particularly effective in combining several transparency images and can be done under the enlarger or in the copy camera.

The necessary masks can be made directly from the originals by contact printing or by shooting at 1:1 magnification on the copy camera – for example, you can use positive or negative lith separations. Or they can be made by hand, either painted on to film or cut from special masking film. As in photomontage, the first steps in creating a stripped-in image are to size each element by making a tracing of the final picture, and to establish the correct exposures and filtrations by means of test strips. The special techniques involved use exactly the same principles as those demonstrated earlier in this section: for example, working in register, contact printing and shooting originals sandwiched with positive or negative masks.

Stripping-in can be done with black and white or colour originals. If you are starting from 35 mm transparencies, and have to make involved masks, it is sometimes best to produce enlarged duplicates. But first consider the extra cost and number of steps involved.

Using a hand-cut mask
The apple-and-pear picture (below left) was made under the enlarger from two transparencies, the image of the apple being stripped into that of the pear by means of a hand-cut mask. The image of the apple was projected at final size on to a punched 25×20 cm sheet of masking film held on a peg-bar taped to the enlarger baseboard and its outline drawn on. It was then cut from the film with a scalpel to produce a precise mask. The mask was contacted to negative and then back to positive on lith film (Neg 1 and Pos 1 below). A double exposure was then made on slide duplicating film, of the apple plus positive mask and of the pear with the negative mask.

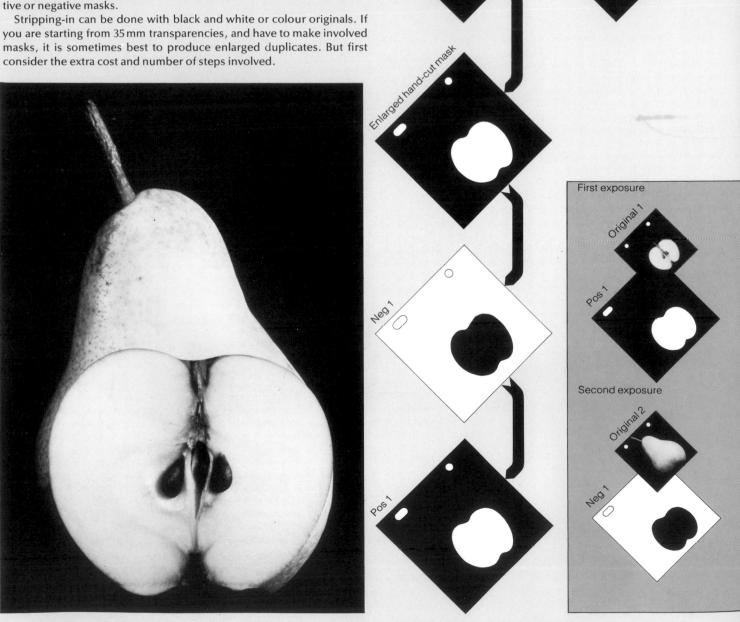

Original 1

Original 2

Enlarged hand-cut mask

Neg 1

Pos 1

First exposure

Original 1

Pos 1

Second exposure

Original 2

Neg 1

Working with graphics

The two elements stripped together to form the travel image overleaf were derived from 35 mm transparencies. The graphic element, the figures 123, was on a black and white bromide print. It was decided that it would be easier to reduce it to fit the 35 mm format (the actual size of which is 36×24 mm) than to enlarge the transparencies. The 123 image was therefore reduced, on to lith film, to a width of 22 mm, using a copy camera. The print was kept flat on the worktable by covering it with a sheet of glass and was top lit. The lith negative that resulted was contacted back to positive and the pair laid up in register on punched cells. The two transparencies were also laid up on cells in positions that matched the desired cropping. A double exposure was made on the copy camera, the first involving the beach transparency – the background element – and the 123 lith positive, the second the sailboat image to be stripped in and the 123 lith negative. The original artwork and the masks used are shown on the right above black and white versions of the original transparencies.

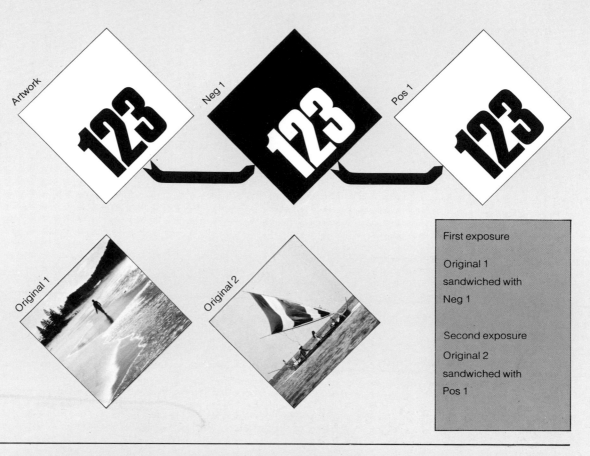

First exposure

Original 1
sandwiched with
Neg 1

Second exposure
Original 2
sandwiched with
Pos 1

Masks as picture elements

The stripped-in photograph of artist Richard Hamilton (overleaf) came from a 6×6 cm transparency. The transparency was taped to the glass work-surface of a light box and a sheet of tracing paper laid on top and taped down. Then the first part of a two-part pencil drawing was made, to identify those areas of the transparency that were to be retained. The second tracing identified the drawn parts of the final image. The two tracings were contacted on to lith film under the enlarger: to record the thin pencil image it was necessary to underexpose the lith film. Then the negatives were contacted back to positives on lith film. The negative of the first tracing, the two lith positives and the original transparency were then laid up in register on punched cells. (The second negative was not used in the final exposure.) To assemble the elements, a double exposure was required. Shooting was done with the copy camera on to slide duplicating film, using bottom lighting and registering the punched cells on a peg-bar taped to the glass. The first exposure was for the two tracing lith positives, the second for the original transparency sandwiched with the lith negative of the first tracing. The tracings and film derivations involved in the process are shown below.

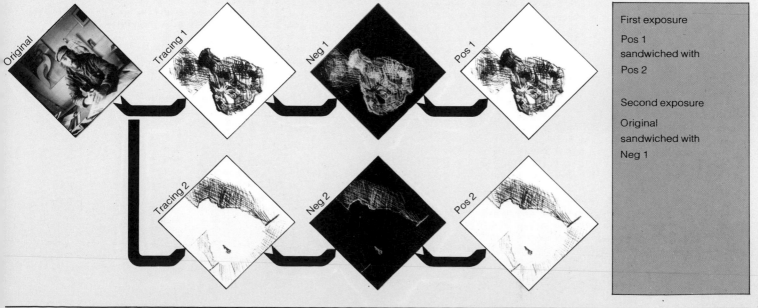

First exposure
Pos 1
sandwiched with
Pos 2

Second exposure
Original
sandwiched with
Neg 1

Strip-ins 2

Moods and images
The travel poster on the left is
an example of the kind of bold
direct image frequently found in
advertisements, where a company's
logo or the brand-name of a
proprietary product will often
form part of the design. When
creating a strip-in, it is usually
best to work with uncomplicated
images and to try to previsualize
the end product to determine the
best route and materials to use.
The photograph of the artist
Richard Hamilton on the right,
however, shows that subtle and
personal effects can be created
using strip-in techniques, and
that they are not limited to
commercial applications. The
procedures necessary to create
the striking images shown here
are discussed and illustrated
on the two previous pages.

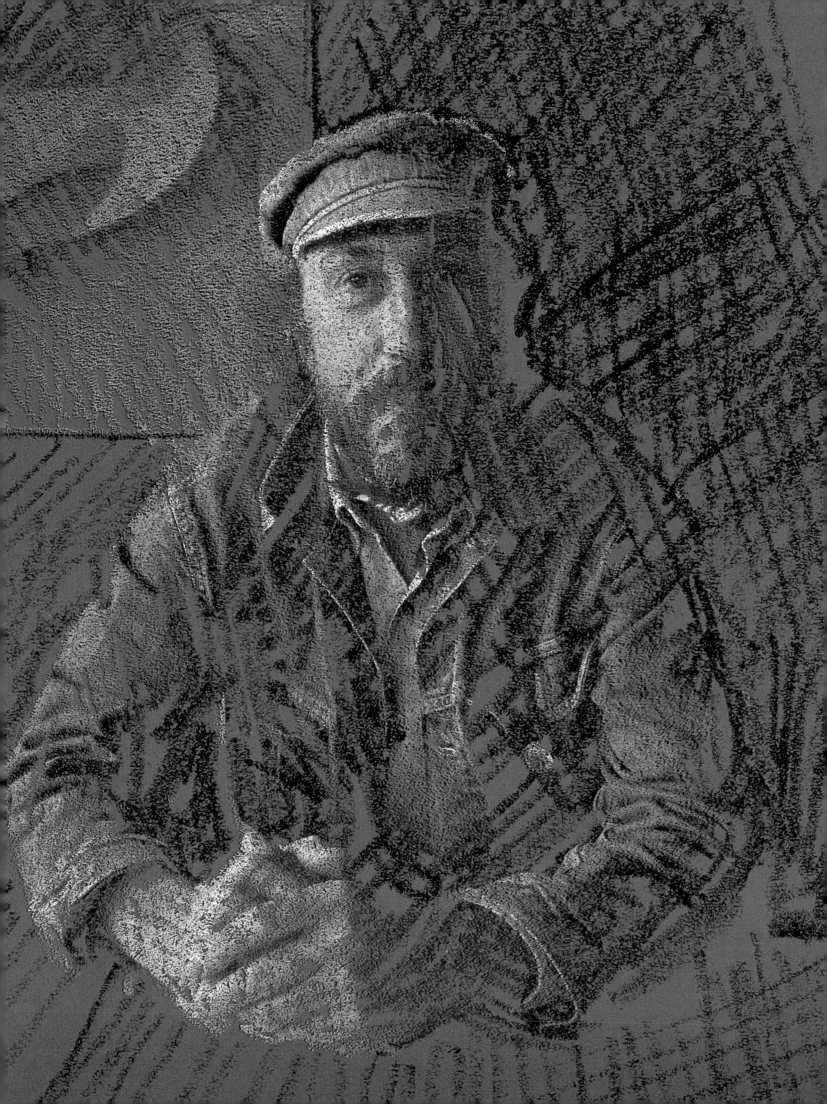

Mandalas and neons 1

A mandala is an image made up of many identical elements arranged in a regular, repeating pattern. Mandalas can be produced photographically using photo-montage techniques (see pp 234–237), multiple printing (pp 230–231) or by making a multiple exposure in a copy camera from duplicates of the original. This last method lends itself well to using a peg-bar registration system, which in turn permits the creation of mandalas with an almost limitless number of elements merged together accurately and precisely. The image shown below and over page was made in this manner. You can create a mandala using the register method from black and white or colour negatives or transparencies.

These can be of any size, but to keep down the cost of materials and the size of the copy-camera light table necessary, it is probably best to make the duplicates required on 35mm stock.

Neoning is the technique of producing an image with flare around the outlines to simulate neon lighting. It is widely used to produce attractive titling for cinematography work, record sleeves and advertisements, but it works well with any form of graphics. The effect is produced by sandwiching a sheet of float glass and opal film between a negative and positive of the image and shooting the combination in a copy camera using bottom lighting.

Mandalas
The first step in producing the mandala bottom right was to make duplicates of the original transparency (right). A grid for the final image was drawn on a punched cell, which was placed on its peg-bar on a light box. Using the grid as a guide, the duplicates were laid up on separate cells (below). The peg-bar was then transferred to the copy camera work surface and the grid on the first cell was used to size and focus the camera for the multiple exposure. A shadow box with a horizontal glass shelf about 7 cm above the base was placed over the work surface (far right). A second peg-bar was taped to the glass shelf and on a punched cell a grid for the masks was drawn. This grid was similar to the first, but smaller by an amount calculated by projecting one grid on to the other from the camera position (far right). Using the smaller grid, masks were cut for each of the duplicates and were laid up on punched cells. Because the masks were well separated from the duplicates during the multiple exposure, each element in the final image appeared with soft edges. The mandala was, in this instance, based on a shot of a crankshaft from a Ford engine, but the intriguing image seems more organic than mechanical.

Colour original

18 colour duplicates

Mask

Duplicate on cell

Shadow box

Bottom lighting

Making the duplicates
Duplicates were made on Kodak 5071 copying film with the copy camera set for 1:1 magnification. The original was bottom-lit. Exposure and filtration were determined by making a preliminary test.

Making the multiple exposure
The cell bearing the first duplicate was placed on the lower peg-bar and that bearing the corresponding mask on the upper peg-bar. The first exposure was made, the pair of cells removed and, without winding on, successive pairs placed in position and exposed.

1	2	3	4	5	6
7	8	9	10	11	12
13	14	15	16	17	18

Laying up on cells
Using the grid cell on the light box, the 18 duplicates were in turn taped, emulsion side down, on to separate cells in the order and orientations shown on the left. The grid was drawn to such a size that each final image picture frame was some 30 per cent smaller than the 35mm duplicate: each mask was cut to match this smaller size. This was done so that the multiple exposure would show good image continuity where the elements joined. The result, on the right, can be compared with the original transparency above.

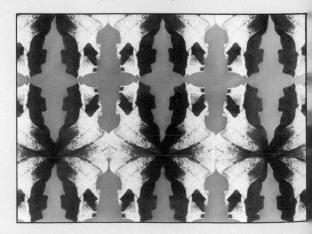

Producing a neoned image

The image of the bird far right was created from the black and white film positive below by neoning. The principle of the technique is illustrated right. Light from the bottom-lit glass work surface strikes the negative. Only where the negative is clear (the final image area) can light pass through. This light is transmitted by the float glass, but then diffused by the opal film. The positive acts as a mask, so that the diffused light flares outwards only at the edges of the subject in the final image.

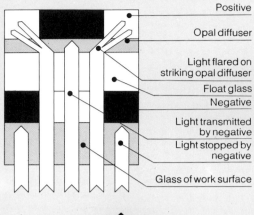

Positive
Opal diffuser
Light flared on striking opal diffuser
Float glass
Negative
Light transmitted by negative
Light stopped by negative
Glass of work surface

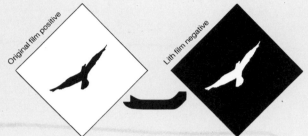

Original film positive

Lith film negative

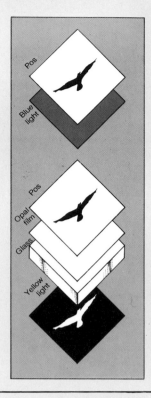

Pos
Blue light

Pos
Opal film
Glass
Yellow light

Exposing for neoning

The neoned image below required a double exposure. Using the copy camera, bottom lighting, and 35mm transparency film, the first exposure was of the original film positive and used a blue light source. The second exposure, of the combined film positive, float glass, opal film and film negative – a contact print of the original on lith film – was made with a yellow light source.

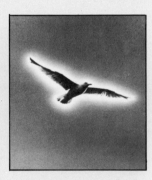

A neoned image from artwork

The artwork made to produce the partly neoned illustration bottom right consisted of two line tracings and three masks. The first tracing was of Venus's face, the second of her hair. The masks were for the three colour areas of the final image: one for the background blue; one for the dark brown hair and one for the skin. All were prepared on punched cells in register. The separate elements

were shot on 35mm lith film using a registered copy camera – the five originals and their film derivations are shown below – then placed in registered slide mounts. The multiple exposure (details far right) was made on 35mm colour transparency film in the copy camera, with bottom lighting. A slide mount guide frame (right), taped to the work surface, was used to position the slide correctly.

Multiple exposure

Exposure 1
Mask neg 1,
Blue light source

Exposure 2
Mask neg 2,
Dark brown light source

Exposure 3
Mask neg 3,
Light brown light source

Exposure 4
Mask neg 1, Opal film,
Float glass, White light source

Exposure 5
Neg 1, Neg 2,
White light source

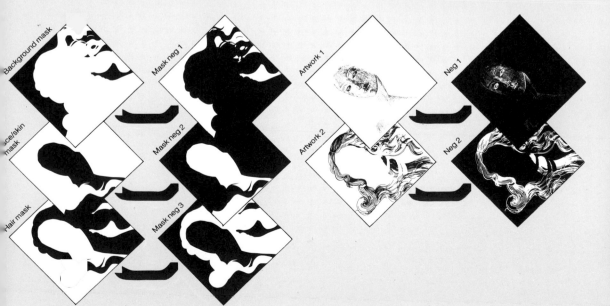

Background mask

Face/skin mask

Hair mask

Mask neg 1

Mask neg 2

Mask neg 3

Artwork 1

Artwork 2

Neg 1

Neg 2

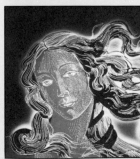

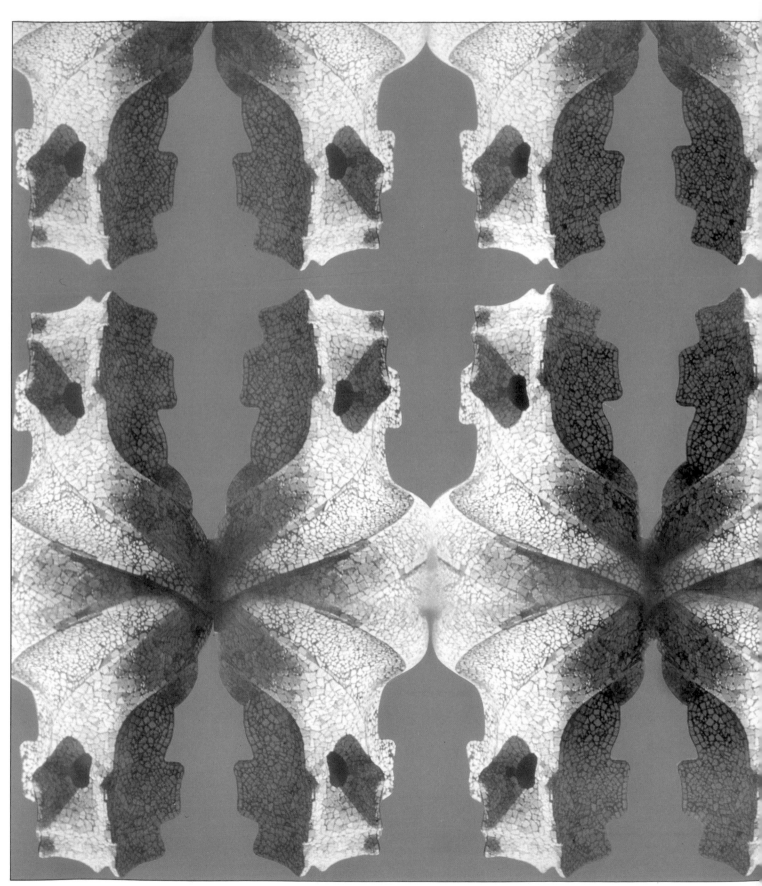

Creating the images

The mandala (left) was shot on 35mm transparency film. Exposure and filtration for the multiple exposure were determined previously by taking some trial shots and assessing the processed results. The neoned image of the bird (top) was made from a black and white film positive. The blue of the background and the yellow of the neoned outline were introduced during the multiple exposure by the appropriate masking of the coloured light sources. Black and white artwork is particularly suited to the neoning technique. To produce the image of Venus (above), the hair was neoned in a multiple exposure that involved the use of two line tracings and three masks. The strong, flat areas contrast with the wispy delicacy of Botticelli's famous original.

Audio-visual and computers 1

Audio-visual is a means of communicating with an audience through still pictures linked with, and synchronized to, a soundtrack. In its simplest form it is a single-projector slide show with a commentary or background music played through an ordinary cassette recorder. In its most advanced form it is a multi-projector presentation linked with a multi-channel soundtrack played through a large public-address system. The pictures can be projected on to a small, free-standing folding screen set up in the living room – even on the side of a building. They can be back- or front-projected transparencies or specially created graphics. Control can be manual or by means of a prerecorded pulse on a tape that activates the slide-change mechanism at the appropriate part of the recording that you have selected.

Planning a show
First, define the purpose of your show. Secondly, consider the space available, the size of your audience, the limitations of your existing equipment and your budget. Lastly, decide whether your show needs to be portable. If it does, this will set a limit on the equipment you can use for projection and soundtrack playback.

Having established the size and scope of your show, make a draft storyboard and script. From this you should see if the format you have chosen suits the concept. If it does not, make compromises at this stage rather than trimming and editing later. On a large sheet of paper draw a number of boxes to the same proportions as your final screen format. Within each box sketch out the separate stages of the story. Use the completed storyboard as the base for the rest of the production: to select the soundtrack, write the script and to establish how each photographic or graphic element must relate to neighbouring images.

Equipment
You can create quite stunning shows with only two Kodak Carousel projectors linked by a variable dissolve remote control unit. A dissolve system causes one projector lamp to fade out as the other grows to full brightness, thereby ensuring that instead of the normal blank screen between pictures there is always an image on the screen. Most control units also incorporate an interval timer that changes slides at pre-set

intervals – ideal for automatic slide shows – and a programer system that enables you accurately to synchronize the pictures and soundtrack. Essential for synchronization is the twin- or four-track tape recorder. On one track you record your accompanying sound – if you are using a twin-track recorder this can be in mono only – and on the other track pulses to activate the projectors. Sound can be from a record or tape. Also needed are speaker, amplifier and, of course, a screen. For front-projection use a white matt-surface screen, such as a board covered with cartridge paper, or a specially beaded reflective surface screen, for back-projection, a translucent tracing paper or special plastic screen.

Programing
In the production of audio-visual shows, programing is, in its broadest sense, the design process that links the visuals to the soundtrack. In its narrowest sense, and in the sense that will be dealt with here, it is the last stage of the production when the information to enable pictures to be

Audio-visual consoles
A back-projection console (right) is ideal for a small presentation. In most models the magazine can hold up to 80 slides, enough for a 10-minute show. To program a show, load the magazine, insert it in the console, plug in the control unit and audio input, and switch both console tape channels to "record". (Using the control unit, you will produce a machine code which, in playback, will activate the projector slide-change mechanism.) To replay, return tape and magazine to the start and switch on, with the recorder set on "playback".

Two-projector units
Custom-built for creating semi-professional shows are two-projector "showtape" systems such as the Electrosonic ES 3669 unit at left. This consists of two carousel projectors, a projector stand, an audio cassette recorder linked to a continuously variable dissolve unit, a hand controller, microphone, and a carrying case with a loudspeaker built into its lid. The audio and control tracks can be recorded and replayed independently. Also available are a lightweight case for the projectors and a pushbutton hand controller which permits simple dissolve. Though this type of presentation unit is only a "first generation" audio-visual system, it functions well for quite sophisticated shows. Beware of producing shows for five or six projectors: apart from the cost of the equipment, there is also the problem of transporting it. These two-projector units are light and compact enough to be carried on a plane as hand luggage.

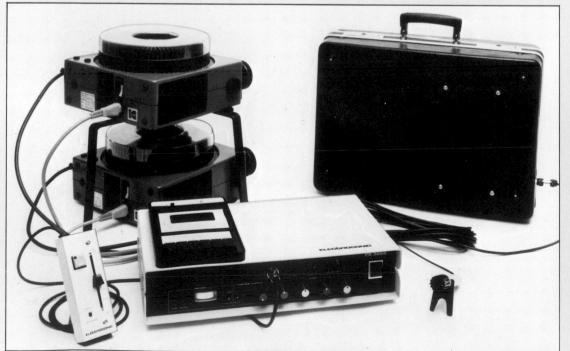

projected in synchronization with the soundtrack is put in a machine code form on to the audio control track. The code can be carried on the tape in two forms: in its complete form, modulating continuously during the show, or in an abbreviated form as a series of single pulses each of which triggers a chain of events from a memory held in a computer.

The first form of programing requires that you operate a projector controller in time with the soundtrack to record the machine code on to the tape. The simplest type of controller, comprising a hand-set with a slider, generates a continuous tone that is modulated by moving the slider up or down a scale. To record the machine code, you go through your show, moving the slider to the top of the scale to activate projector 1 and to the bottom of the scale to activate projector 2. The slider system allows you to alter the speed of dissolve and, if desired, to superimpose the two projector images to a varying degree. Each time you want to present your show you simply set your slide magazines and tape at "zero", switch on your projectors and tape recorder, and set the controller to "playback": the machine code does the rest. The only drawbacks with programing in this manner are that tape editing is difficult and manual dexterity and numerous rehearsals are essential. If you make a mistake during recording, you must re-record the whole presentation from the beginning.

Computer-based programing systems are of several types. In one, you first record a time track on the tape. Writing each of your cue points in terms of minutes and seconds, you then enter the dissolve unit commands: in replay mode the computer reads the clock and at any time that has been entered into the memory, it performs the appropriate commands. The computer records the completed program on your master tape. It is not required for further replays. In a second computer system, you link together short series of cues to form chains that are initiated in sequence from various start points along the tape. You then record these start points as single pulses on the master tape. On replay of the tape, the single pulses activate the computer memory.

Producing the final slides

For multi-screen presentations, in which several images must butt-join with one another, or overlap by a precise amount, all artwork and transparencies must be prepared from a grid that accurately represents the screen format. The screen format below uses three banks of projectors: the images of the outer banks butt-join exactly, the image of the middle bank centres on the butt-join. If you are producing your show slides on 35mm stock which, mounted, has an image size of 34.7×23mm, the grid must be in proportion to the height (23mm) and to double the width (69.4mm). Draw the grid on a punched cell at as large a size as is convenient. Divide up the rectangle to fit your three projector screen areas, then add diagonals, centre points and corner register marks, as shown below. Make a series of reductions of the grid as line film positives. This is best done on a high-quality process camera, in which lens distortions are minimal. For simplicity, use one size reduction for all artwork and three to four different size reductions for the photographic work. You will need a reduction measuring 34.7×23mm to make final slides from existing transparencies. Tape the line film positives on to cells that are punched to fit a registration peg-bar. Working on the grid, produce artwork for each frame sequence on identical cells. To achieve precise registration, commercial houses use a rostrum camera, but a copy camera set-up will give satisfactory registration. Centre and size the camera to fit the left-hand projector screen area of the grid. Make a slide of the grid – this is the "lining-up" image for registering the left-hand projector on the screen – then replace the grid cell with the artwork cells, shooting them one at a time. When that is done, align the camera with the central projector screen area of the grid and repeat the operation. Do the same for the right-hand projector screen area images. Use the identical technique to make final slides of the photographic material. To maintain registration, mount each transparency in a special plastic register mount. To produce a completely seamless panorama of the three projected images, sandwich each transparency with the appropriate soft-edge film mask, as shown below. Although you can obtain soft-edge masks ready-made, it is best to make your own to suit the brightness of the projected images, the screen format and the size of the originals. To shoot soft-edge masks you use a positive release stock which has a clear film support. The artwork itself consists of a finely graded airbrushed shadow, shot out of focus.

Projector-1 slide

Projector-2 slide

Projector-3 slide

1 a b c d 2 a b c d 3 a b.c d

Audio-visual and computers 2

Multi-screen presentations
Large, permanent audio-visual shows use giant screens and numerous banks of projectors. The projectors can be programed to work together to produce a single huge picture or independently to form a chequer board, mosaic or random pattern of separate images. To produce a single picture, projectors must be arranged like the three-projector seamless panorama shown on the previous page. The multi-screen presentation set-up shown below employs a screen 15×2.5 metres and seven banks of projectors in an arrangement of five such panorama formats.

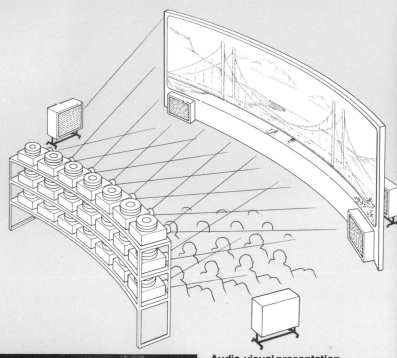

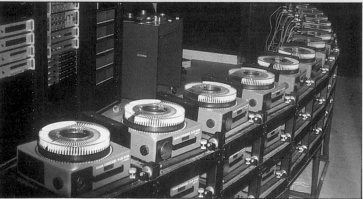

Audio-visual presentation
Audio-visual presentations are widely used in advertising and sales. The collection of images opposite is from a presentation highlighting features of a new computer system. It involved 12 Carousel projectors arranged in three banks of four to form three overlapping image areas on the screen. The soundtrack was made up of a commentary, music and a machine code that programed the projectors. Fifteen different language commentaries were available.

Computer graphics
The most recent advance in audio-visual and movie animation work is the generation of full-colour visuals by computers which, linked to rostrum camera equipment, can be used to create, manipulate, store, transmit and record artwork in digital form and to turn the information into transparencies. The heart of the system is an artist's console (below right) with a colour TV screen, alphanumeric keyboard, graphics tablet with pen for control and manipulation of artwork, and a diskette storage unit. The system can handle techniques such as airbrushing, laying flat tints and overlays, and photographing finished artwork. The image below left was produced in five minutes. Such techniques open up infinite scope for rapid experimentation and creative improvisation.

Quick reference table

Black and white film

Key: S=sheet; R=roll; P=plate; Pk=pack; m=medium; f=fine

Type	ASA	Available as	Grain	Uses	Examples
Slow	12–50	S,R	m–f	General photography; photomicrography; big enlargements	Kodak Panatomic-X, Ilford Pan F, Agfapan 25, Efke-Adox KB 17
Medium	50–200	S,R	m–f	General photography, especially studio work; colour separations	Kodak Plus X, Ilford FP4, Agfapan 100, Efke-Adox KB 21
Fast	200–800	S,R	m	Poor light; artificial light; news and reportage	Kodak Tri-X, Ilford HP4, HP5, Agfapan 400
Ultra-fast	800–1600	R	m	Poor light	Kodak Royal-X Pan 4141
Lith	8–40	S,R	f	Line and screen negatives	Kodalith Ortho 2556 type 3, LPD 7 and LPD 4 (reversal)
Infrared	4–100	S,R,P	m–f	Poor light; scientific photography; special effects	Kodak Infrared
Reversal	32–100	R	m	Slide film	Agfa Dia-direct
Copying	8–20	S,R	f	Copying printed matter, drawings	Kodak Technical Pan SO 115

Black and white instant pictures

Type	ASA	Available as	Grain	Uses	Examples
Print and neg.	50–75	Pk	f	General photography	Polaroid 105, 55
Fine-grain print	200–400	Pk	f	General photography; copying	Polaroid 42, 51, 52
High-speed print	400–3000	Pk	m	Poor light	Polaroid 37, 47, 57, 87

Black and white paper

Key: S=single; M=medium (resin-coated stock); D=double; G=glossy; L=lustre; M=matt

Type	Grades	Weight	Surface	Uses	Examples
Chloride	0–5	S,D	G,L	Contact printing	Kodak Azo
Bromide	0–5	S,M,D	G,L,M	General enlarging	Kodabromide, Ilfobrom
Chlorobromide	2–4	S,M,D	G,L,M	General enlarging, contact printing; warm tone results	Kodabrome 11 RC Paper F
Document	5 only	S	M	Copying documents by contact printing	Kodagraph Transtar, TC5
Direct reversal	5 only	S	M	Printing from transparencies	Kodak Positive Direct Kodaprove

Pushing black and white film development
Effect: increase in ASA, increase in grain size, increase in contrast
Example uses Ilford chemicals and HP5 35mm film

Meter setting	Developer	% increase in time	time at 20°C
400 ASA (standard)	ID-11	—	7½ min
500 ASA (standard)	Microphen	—	6 min
800 ASA (−1 stop)	Microphen	+40%	8½ min
800 ASA (−1 stop)	ID-11	+100%	14 min
1600 ASA (−2 stops)	Microphen	+83%	11 min
3200 ASA (−3 stops)	Microphen	+183%	16 min

Cutting black and white film development time
Effect: decrease in ASA, decrease in contrast
Example uses Ilford chemicals and PAN F film

Meter setting	Developer	% increase in time	time at 20°C
50 ASA (standard)	ID-11	—	6 min
32 ASA (+½ stop)	Perceptol	+50%	16 min
25 ASA (+1 stop)	Perceptol	normal time	11 min
12 ASA (+2 stop)	Perceptol ½ strength	normal time	11 min

Black and white developers – Examples of types

Developer	Make	Purpose
Perceptol	Ilford	For extra fine-grain negatives; for large enlargements. Loses 1 stop in film speed
ID-11	Ilford	Standard black and white film developer
Microphen	Ilford	Fine-grain developer for push processing; use for high-speed films when pushed
Hyfin	Ilford	High-acutance developer to increase sharpness of negatives
Microdol-X	Kodak	Extra fine-grain developer for large enlargements. Use at full strength for fine grain, dilute 1:3 for enhanced acutance
D-76	Kodak	General purpose fine-grain developer
D-8	Kodak	Maximum contrast developer for line films and general purpose developer for sheet films, including process materials
Kodalith	Kodak	Two-part concentrated liquid developer for Kodalith materials.

Colour film

Key: S=sheet; R=roll; Pk=pack; m=medium; f=fine

Type	ASA	Available as	Grain	Uses	Examples
Negative, normal speed	25–100	S,R	f	General photography	Kodacolor 11 (C-41), Agfa CNS2 (Agfa N), Fujicolor F-11 (C-41), Sakuracolor 11 (C-41)
Negative, high speed	100–400	R	m	General photography; poor light	Kodacolor 400 (C-41), Agfacolor 400 (C-41), Fujicolor 400 (C-41), Sakuracolor 400 (C-41)
Reversal, normal speed	25–100	S,R	f	General photography	Kodachrome 25 (no user processing), Ektachrome 64 (E-6), Agfachrome 50 (Agfa 41) Fujichrome R100 (E-6)
Reversal, high speed	100–400	R	m	General photography; poor light	Kodak Ektachrome 200 (E-6), 400 (E-6), GAF Colour slide 200 (E-6)
Infrared	16–100	R	m	Poor light; scientific photography; special effects	Kodak Ektachrome IR
Duplicating	4	S,R	m–f	Copying transparencies	Kodak Ektachrome 5071 (E-6), 6121 (E-6), Agfa Duplichrome (Afga 41)
Slide film	—	S,R	f	Making transparencies from colour negatives or internegatives	Kodak Vericolor 5072 (C-41), 4111 (C-41)
Internegative	—	S,R	f	Copying transparencies for printing	Kodak Vericolor 6011 (C-41), 4112 (C-41)

Colour instant pictures

Type	ASA	Available as	Grain	Uses	Examples
Normal speed	75	Pk	m–f	General photography	Kodak PR-10, Polacolor type 58, Polaroid SX-70 Land film

Colour paper

Key: G=glossy; L=lustre

Type	Surface	Uses	Examples
Neg/pos	G,L	Enlarging	Kodak Ektacolour 78RC, Agfacolor type 4, 5
Pos/pos, reversal	G,L	Prints from slides	Kodak Ektachrome 14RC, Agfachrome PE
Pos/pos, silver dye bleach	G,L	Prints from slides	Ilford Cibachrome A

DICTIONARY
OF TERMS

Technical terms likely to be encountered in advanced photography are defined and explained on the following pages. Photographic glossaries are sometimes abbreviated to the point of obscurity. This dictionary tries to explain terms clearly and, where possible, to make the information useful by relating it to actual photographic situations. As the aim is practical utility, terms that are little-used, archaic or purely scientific are usually left out. The entries, arranged in alphabetical sequence, nevertheless provide a comprehensive guide and reliable source of quick reference. Often, they complement and supplement material in the main body of the book – and some are kept fairly short if the subject has been fully treated already. Others explain basic terms that may not be discussed elsewhere. The index at the back of the book will direct readers to references in the other sections. Within the dictionary entries, words given in SMALL CAPITALS refer readers to useful information in another entry; words in **bold** type indicate that the topic is treated at that point rather than in a separate entry in the main alphabetical sequence.

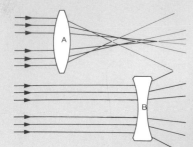

Aberration is reduced by combining converging (A) and diverging (B) lenses

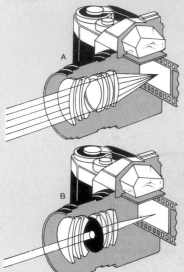

Aberration is greatest at wide apertures (A) and diminishes at small apertures (B)

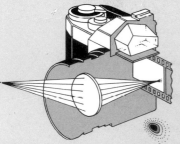

The unsymmetrical light patches called coma are formed by oblique rays

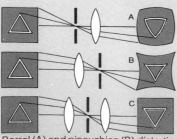

Barrel (A) and pincushion (B) distortion can be minimized by a compound lens (C) with the aperture between elements

A

Aberration

Inherent optical defect in a lens causing unsharp or distorted images. No lens is perfect, and the correction of aberrations is one of the most important elements of lens design. It is achieved principally by combining single lenses in such a way that the aberrations in one lens are corrected by opposing aberrations in another. While it is relatively easy to correct any particular aberration in this way, it is much harder to achieve an overall balance, as compensation for one error can increase another. To this extent all lens design is an exercise in compromise. There are two main types of aberration: **spherical**, or focus distorting; and **chromatic**, or colour distorting. Both are caused by the fact that light rays passing through a simple lens do not focus upon a common point. Rays passing through the outer part of a lens are subject to greater refraction than those passing through the central zone and thus in the case of a convex lens come to focus nearer the lens. Similarly, the different wavelengths of the colours of the spectrum which make up white light are subject to different degrees of refraction so that blue light rays passing through a lens reach a point of focus nearer to the lens than the green and red rays. Lenses corrected by the use of different types of glass to bring two colours to a common focus are known as **achromatic**; most modern lenses are of this type. Those corrected for blue, green and red wavelengths are called **apochromatic**; they are very expensive to produce and used mainly in technical work. The effects of both spherical and chromatic aberration are minimized by using a small aperture, since then the light passes through only the central part of the lens where curvature and hence differences in refraction are at their least. Both types of distortion affect images formed by light passing through the lens from any angle, including along the lens's axis, but there are five other principal types of aberration that are caused only by off-axis images, and are thus most pronounced with wide-angle lenses. These are: (1) **Lateral chromatic aberration**, which causes images to vary in size according to their colour. The more oblique the image, the greater the distortion caused by the spreading of the different colour wavelengths. This aberration cannot be corrected by stopping down, which affects depth of field rather than magnification. (2) **Coma**, an exaggerated form of spherical aberration in which an off-axis point is imaged as a series of tiny overlapping circles forming a tailed shape like a comet – hence the name. (3) **Astigmatism**, produced when a lens is unable to simultaneously focus lines at right angles to

each other near the edge of the field, giving a compromise image with blurred edges. (4) **Curvature of field**, which is the failure of a lens to convey an overall sharp image in a flat plane – the film. Images of distant objects are formed closer to the lens than those of near objects, and when a flat surface parallel to the focal plane is imaged, the top, bottom and edges of that surface are further away from the lens than the central part. In a lens uncorrected for field curvature, it might not be possible to focus the edges and centre of the surface at the same time. (5) **Distortion**, which occurs when off-axis rays of light passing through parts of the lens other than the centre are spread so that the magnification of the image varies across the focal plane. Thus shape, not sharpness, is affected. Where the edges of the image bow outwards, the effect is known as **barrel distortion**; where they bow inwards, the term **pincushion distortion** is used. Coma, astigmatism and field curvature are all reduced by stopping down, but not distortion, which varies with the position of the aperture relative to the lens. The best modern lenses are of such high quality that their user will seldom be concerned with aberration problems, although zoom lenses rarely match the performance of their fixed-focal equivalents. Orthodox lenses can cope with most situations, and more specialist lenses take care of others. Lenses for aerial photography, for example, are made to give optimum flatness of field and sharp definition over the entire picture area when focused at infinity and operating at high shutter speeds (because of the motion of the aircraft) and consequently wide aperture. They are also chromatically corrected to compensate for the yellow, orange or red filters normally used with them. As well as providing problems to be overcome by the technician, aberration can also be exploited creatively. Soft focus lenses, deliberately under-compensated for spherical aberration, are, for example, favourite tools of the portrait photographer.

Abrasion marks

Scratches and abrasions on processed photographic emulsion. They can be caused in a number of ways, most usually during loading or processing. Abrasion marks are difficult to remove, but less severe examples can be erased by rubbing the mark with cotton wool and methylated spirit, or can be prevented from appearing on an enlarged print by using diffuse illumination when enlarging.

Absorption

Taking up of light energy by matter and its transformation into heat. Light-waves are either absorbed or reflected by the surfaces upon which they fall, colour being the result of selective absorption. Black absorbs most of the spectrum, whereas white surfaces re-

flect all the colours, combining to give white light; similarly, a red surface absorbs blue and green light, reflecting red. Absorption can be calculated by measuring the absorbed part of a light-wave against its known length. Plotting such figures on a graph produces an "absorption curve", which is used in determining certain characteristics of colour materials and filters.

Accelerator see DEVELOPER

Acceptance angle

The "angle of view" of an exposure meter. Too wide an acceptance angle can give a false reading, especially when taking a light reading in close-up. Meter designs use systems that limit the acceptance angle in order to increase effectiveness and standardize sensitivity.

Achromatic lens see ABERRATION

Actinic

Term used to describe the power of light to produce chemical or physical changes in materials exposed to it, for example photographic emulsions. The actinic quality of lightwaves is stronger at the blue-violet end of the spectrum.

Acutance

Scientific measurement of image sharpness. It is determined by testing how rapidly tones change from light to dark on a contact-printed image of a knife edge; the more rapid the transition, the sharper the image. Acutance, together with RESOLVING POWER, plays an important part in subjective assessments of a photograph's clarity of definition.

Additive synthesis

Means of producing a colour image by mixing blue, green and red coloured lights in proportion to those reflected by the original subject. This synthesis was first demonstrated in 1861 by the Scottish scientist James Clerk Maxwell. He made three positive black and white transparencies of a tartan ribbon taken through separate primary filters, then projected them through primary filters on to a white screen, so producing the world's first colour photograph. When the additive primaries are combined in pairs, they give the primaries used in the SUBTRACTIVE SYNTHESIS: blue/green make cyan; blue/red make magenta; red/green make yellow. A form of additive synthesis was used in early colour photography procedures such as Autochrome and is used today in colour television, but since the 1920s colour photography has been based essentially on the subtractive synthesis.

Aerial perspective

Phenomenon created by haze in the atmosphere, causing distant parts of a landscape to appear blue and softened. It is produced by the scattering of short (blue) lightwaves that refract

and reflect droplets of moisture or dust particles in the air. The effects of aerial perspective can be very attractive visually and help to convey a sense of depth, but where clarity is essential, UV and skylight filters can penetrate the haze.

Air bells
Bubbles of air which form on the surface of films or papers during development. They appear if the processing chemicals are not agitated sufficiently, and leave spots on the emulsion. A wetting agent in the developer helps to prevent air bells from forming by reducing surface tension, and they can be removed by lightly brushing the film with a finger during processing.

Airbrush
Instrument that uses compressed air to spray paint in a very fine mist. In appearance it is rather like a large fountain pen and is held in a similiar manner, with the forefinger controlling the supply of air. The airbrush can be used for colouring photographs, retouching positives and negatives, hiding the joins in montaged photographs, adding pictorial effects such as clouds in a landscape, and removing defects or unwanted backgrounds. The techniques of successful airbrushing are not easy to master, but they make possible effects that are difficult and often impossible to obtain with even the finest brush.

Albada finder
Type of direct-vision viewfinder in which the area of the subject that will be recorded on the film is indicated by white framing lines. The viewfinder's angle of view is greater than that of the lens, so part of the subject is seen outside the frame. The framing lines are painted on the inner surface of the rear window of the finder and reflected in the curved half-silvered mirror which forms the front window.

Anamorphic lens
Lens that uses prisms or cylindrical elements to produce an image with a wider angle of view in the horizontal direction than the vertical, or vice versa. The image thus looks stretched or squashed, and can be restored to its normal aspect by printing or projection through a similar lens. Anamorphic lenses are particularly associated with motion pictures, as they can compress a wide-angle view on to a standard frame of film, which gives a wide-screen effect (such as Cinemascope) when projected. In photography they are used mainly for trick effects.

Anastigmatic lens
Lens corrected for the ABERRATION of astigmatism.

Angle of view
The angle over which a lens accepts light or "sees". On a 35mm camera a

standard 50mm lens has an angle of view of about 45°, roughly equivalent to normal human vision. (By "normal human vision" is meant the angle over which our eyes see a clearly focused image; overall angle of human vision is about 150°–170°, but what we see at the periphery of our vision is indistinct. Our angle of vision seems to be more than that of a standard lens because in practice our eyes are continually moving, and our brains processing the information into an overall picture; to stare fixedly ahead like the "eye" of a camera is completely unnatural.) A 28mm lens has an angle of view of about 73° and a 135mm lens one of about 20°. Angle of view can be expressed more scientifically as the angle subtended by the diagonal of the film or focal plane at the rear NODAL POINT of the lens. Thus the larger the negative format, the greater the angle of view for any particular focal length. On a large-format camera, for example, a 50mm lens will give a wide-angle view, not a standard one, and on a camera using 120 roll-film, a standard lens has a focal length of about 80mm. Similarly, a standard lens for a camera taking 110 film has a focal length of about 24mm.

Ångstrom unit
Unit by which wavelengths of light are measured. One unit, abbreviated Å, measures one ten-millionth of a millimetre (10^{-8} cm).

Anhydrous
Term which indicates that a substance is free from water, used in photography particularly to distinguish a chemical in powder form from the same substance when hydrated.

Animation
A series of progressive pictures – drawings or photographs – designed to convey movement and action. The pictures may be produced on film and projected, as in movie cartoons, or bound together in sequence as a "flick book".

Anti-halation backing
Coating of dye or pigment on the back of negative materials that absorbs the light that passes through the emulsion. Without this backing, light could reflect back through the emulsion, causing "halos" around the highlights.

Aperture
Opening at the front of a camera which admits light. It is usually circular, and except in very simple cameras is variable in size, so regulating the amount of light that passes through the lens to the film. The term **effective aperture** is used to indicate the diameter of the beam of light that passes through the outer lens component along its axis to the aperture. Except in the unusual circumstances of the aperture being in front of the lens, the effective aperture

is slightly larger than the real aperture, as the light is refracted as it enters the lens and thus the beam is narrowed. The effective aperture, however, increases or decreases proportionally as the real aperture is varied, usually by means of an iris diaphragm. **Relative aperture** is the ratio of the focal length of the lens to the effective aperture. Thus, if the lens has a focal length of 50mm and the effective aperture is 25mm, the relative aperture is 50/25 = 2. This is commonly expressed as an f number, in this case f2; the larger the f number the smaller the aperture. The usual sequence marked on the lens barrel is 2, 2.8, 4, 5.6, 8, 11, 16, 22, each "stop" marking (approximately) a halving of the amount of light which the aperture admits. Some lenses go outside this range, and a lens with a large maximum relative aperture is referred to as "fast" because the amount of light it can transmit to the film makes shorter exposure possible – a very useful feature in dim lighting conditions and/or when high shutter speeds are required, as, for example, in indoor sports photography. The current state of lens design and manufacture determines the standards by which a lens is considered fast for its focal length. Today a standard 50mm lens with a wider maximum aperture than f2 or a 28mm or 135mm lens with a wider maximum aperture than f2.8 could be described as such. The greater the "speed" of a lens, the more difficult (and thus more expensive) it is to manufacture.

Aperture preference see AUTOMATIC EXPOSURE

Apochromatic lens see ABERRATION

Arc lamp
Lamp using as its source of illumination incandescent particles produced when an electric current passes across a gap (arc) in a circuit. Various types of arc lamp are used in photography and projection, and the nature of the light depends on the material (usually a gas such as hydrogen) between the electrodes. The most common type is the carbon arc, in which the electrodes are carbon and the material between them usually air.

Artificial light
Term used to describe any light source used in photography other than that from natural sources (usually the sun). Generally it refers to light specially set up by the photographer such as flash or floodlights. There is a difference in the sensitivity of photographic emulsions to daylight and artificial light, and films may be rated for either type.

ASA
Abbreviation for American Standards Association, used to designate one of the most commonly used rating systems for FILM SPEED.

Airbrush: the cable supplying the air is wrapped around the wrist

Albada finder

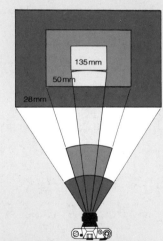
Angle of view: angles of three popular lenses for 35mm cameras

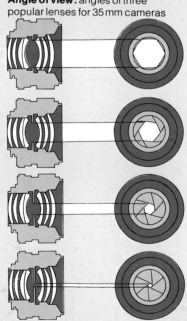
Aperture shown fully open at f2 (top) and closing down to f22 (bottom)

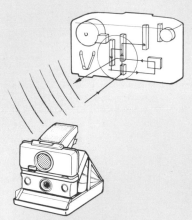

Automatic focusing: the sonar system is used in Polaroid cameras. A transducer emits an ultrasonic wave, and from the time it takes to bounce back, the subject distance is established.

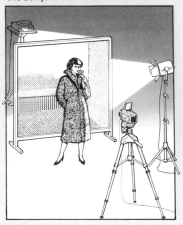

Back projection

Barn doors

Bas relief

Aspheric lens
Lens where the surface curvature does not form part of a sphere, designed to eliminate spherical ABERRATION. One aspheric lens may replace two or more spherical elements, and thus simplify lens design.

Astigmatism see ABERRATION

Automatic diaphragm see EXPOSURE METER

Automatic exposure
System that automatically sets correct exposure by linking a camera's exposure meter with the shutter or aperture diaphragm or both. There are three main types: **aperture priority** (the most popular), when the photographer sets the aperture and the camera selects the appropriate speed; **shutter priority**, when the photographer chooses the speed and the camera sets the correct aperture; and **programmed**, when the camera sets both aperture and shutter speed. Multi-mode cameras can be set to aperture or shutter priority, and, in some models, programmed. Aperture priority is advantageous when it is important to control depth of field; shutter priority comes into its own particularly in action photography; and programmed exposure can be useful when the photographer has to react quickly to get a "grab" shot.

Automatic focusing
Camera system that automatically brings the lens into sharp focus on the subject. The most common method of automatic focusing works on the same principle as the rangefinder, using two mirrors within the camera to compare two views of the same scene. One mirror is fixed; the other moves, reflecting a changing view as it turns. Both reflect the scene to an electronic comparator, and when it senses that the contrast of light and shade in the two views agrees, the movement of the non-fixed mirror, which governs the movement of the lens, is stopped. All this happens so quickly that to the photographer it seems instantaneous. Another system uses a form of echo-sounding; when the shutter release is pressed, a beam of ultrasonic waves is emitted from the auto-focusing unit and bounces from the subject back to the camera, where a receiver calculates the distance of the subject from the time that the sound waves have taken to get there and back. The receiver in turn operates a motor drive on the lens. A variant on this system uses a beam of infrared light (invisible to the human eye) rather than sound waves. Automatic focusing has obvious potential in photo-journalism and candid photography, but selective focusing is limited on all systems and none is foolproof. The co-incident image system does not work in dim light, where there is insufficient contrast, and can be "fooled" by repeating patterns. The

systems using bounced sound and light waves work in dim conditions (indeed they will work in total darkness), but can be fooled when shooting through windows, the camera focusing on the glass rather than what is seen through it. Automatic focusing systems are now fairly common on cameras without interchangeable lenses, but their development for SLRs is still at an early stage. Such systems are also found on cine cameras and slide projectors.

Autowinder see MOTOR-DRIVE

Available light
General term used to describe existing light, without the introduction of any supplementary light by the photographer. Usually it refers to low illumination levels, for example indoors or at night.

B

Back focus
The distance between the back surface of a lens and the focal plane when the lens is focused on infinity. In a simple one-element lens, this will be virtually equivalent to the focal length, and as a general rule back focus will vary proportionately with focal length. Many compound lenses, however, are designed so that the back focus is greater or lesser than the norm; a wide-angle lens for an SLR, for example, has a back focus much greater than the focal length to allow the mirror to operate freely, and a telephoto lens has a much shorter back focus than its equivalent focal length to minimize its size.

Back lighting
Lighting, natural or artificial, from behind the subject of a photograph. Because contrast tends to be high, judgement of exposure can be difficult in back-lit scenes. An average exposure meter reading over the whole scene will often produce over- or underexposure, so it is advisable to take also a separate reading for the part of the subject for which normal exposure is required. As well as causing problems, back lighting can also be used creatively, to give, for example, pure silhouetted shapes or a halo effect around a sitter's head in portraiture.

Back projection
Projecting an image or picture on the back of a translucent screen to provide a suitable background for a subject placed in front of it. The technique is particularly useful in commercial photography, where a model or car, for example, can be shot against an exotic scene, thus saving the expense of going on location. Considerable skill is needed to match the foreground subject with the background so that there are no inconsistencies, particularly in

lighting. Back projection is also used to show films and slides in situations where the projector cannot be situated in front of the screen.

Bag bellows
Short sleeve that can be used in place of concertina-type bellows on some large-format cameras. Concertina-type bellows are unable to compress totally, and bag bellows enable the lens to be brought closer to the focal plane to focus the image from short focal length (wide-angle) lenses.

Barn doors
Hinged flaps mounted on the front of spotlights to control the direction of light and width of the beam.

Barrel distortion see ABERRATION

Baryta coating
Smooth, chemically inert base of barium sulphate in gelatin, used as the foundation layer for the emulsion on most types of photographic printing paper.

Base
The main support for the photographic emulsion, either glass, cellulose triacetate, polyester or paper.

Bas-relief
Darkroom technique where a negative image and its positive counterpart, both on sheet film, are sandwiched slightly off-register in an enlarger or contact frame, producing in the developed print an image appearing as though side-lit and in low-relief.

Batch numbers
Set of numbers printed on the packs of photographic papers and film to indicate a specific batch of emulsion coating. The numbers are important because of the slight variations in contrast and speed that may occur from batch to batch. With colour printing paper, filtration recommendations are also included, and these should be observed when progressing to a fresh batch, which may need a modified filter pack.

Beam splitter
Prism or prism and mirror system designed to split a beam of light into two or more separate beams. It is used in projectors to produce a stereoscopic image where the beam is split by a 90° prism, each separate image being then conveyed through additional prisms, so placed that they superimpose the images in register on the screen. An image-separating attachment can be used on the lens of a camera to produce side-by-side images on the film for stereo projection. Beam splitters are also used in cine equipment, TV cameras, and to split the laser beam in holography.

Black body
Theoretically perfect source of radiant

energy, used as a standard in measuring COLOUR TEMPERATURE or the spectral composition of light. Units of light, relating to the radiant energy of a light source, were originally measured by the luminous intensity of a candle (candle power or CANDELA) made according to standard specification. This method was superseded by the use of a black, hollow metal sphere that in theory reflected no light and that, when heated through red to orange, and finally to white (the melting point of platinum) emitted light purely as radiant energy and thus gave a perfect, standard source of measurable luminance.

Bleaching
Chemical process that converts the black metallic silver which forms a photographic image into an almost colourless compound such as a silver halide, which can then be dissolved, reduced or dyed. Bleaching is a preliminary stage in toning or intensification processes and is also used in most colour chemical developments.

Bleach out process
Technique of producing a line drawing based on a photographic image. The outlines of a photograph are drawn over with pencil or waterproof ink, then the silver image is bleached away, leaving the outline behind. For best results, the subject represented should have clear outlines and the print should be fairly pale.

Blocking out
Painting out unwanted areas, most usually the background, of a negative or print.

Bloomed lens
Alternative term for COATED LENS

Blur
Unsharp or ill-defined image caused by a moving subject, camera shake, unclear focusing or lens aberration. Blur is often unintentional and undesirable, but can be used to creative effect. In particular, it is one of the photographer's principal means of creating a sense of movement. There are two main ways in which blur is used in this way: by choosing a shutter speed too slow to "freeze" a moving subject, in which case it will appear blurred; or by "panning" with a moving subject so that it is sharply focused while the background is blurred. Depending on the shutter speed chosen and hence the degree of blur, effects can be gained ranging from vivid action reportage, through various degrees of self-expression, to pure abstraction. Suitably long exposures of water in movement can produce particularly striking blurred effects. Blurring also occurs in those areas of a photograph outside the depth of field zone, and this can be put to use in DIFFERENTIAL FOCUSING.

Boom light
Studio light attached to a long horizontal pole, counterbalanced at the other end. It is used when a light on a conventional stand would intrude into the picture area, as, for example, when top lighting a portrait.

Bounced flash
Technique of softening the light from a flash source by directing it on to a ceiling, wall, board or similar reflective surface before it reaches the subject. The light is diffused at the reflecting surface, and there is a decrease in light power because of absorption there and because of the greater distance between light source and subject. Bounced flash is particularly used in portraiture, where direct flash is often harsh and unflattering and can cause RED-EYE. If the reflecting surface is coloured, this will affect the light, so white surfaces should be used unless special colour effects are desired.

Bracketing
Technique of ensuring optimum exposure by taking several identical pictures of the same subject at slightly different exposure settings. Bracketing is used in tricky, non-average lighting situations (back-lit scenes, snowscapes, sunsets), particularly when the EXPOSURE LATITUDE of the film is small.

Bright field
Method of illumination used in photomicrography that lights the specimen from below, causing it to be seen against a light background. It is particularly used with transparent or translucent specimens. See also DARK FIELD.

Brometching
High contrast positive print resembling etching or line drawing; also the name of the technique used to produce it. A normal bromide print is placed in an acid bath to burn out the highlights and remove any grey tones. The print is then fixed and washed.

Bromide paper
One of the most common types of photographic paper used for black and white prints, giving a completely neutral image colour. It derives its name from the silver bromide with which it is coated.

Bromoil process
Technique of applying oil-based colour pigments to a bleached, black and white bromide print made on a special bromoil paper. The gelatin emulsion can also be stripped off the backing paper and the image transferred by pressure to another base. Prints made by bromoil transfer have a distinctive delicate quality, but the bromoil process is very little used today as suitable materials are difficult to obtain.

Bubble chamber photography
Photographic technique used in nuc-

lear physics to record the performance and behaviour of ionizing particles (protons and electrons). The bubble chamber contains super-heated hydrogen through which the high-energy particles are fired at speeds approaching that of light. The particles boil as they pass through the heated hydrogen, releasing a trail of bubbles. These are photographed by synchronized electronic flash linked to two or three cameras in sequence.

Bulk loader
Device for handling 35 mm film that has been bought in bulk as a single length to be loaded into empty cassettes or special bulk film magazines that can replace the normal camera back. The loaders hold up to about 30 m (100 ft) of film, and any number of frames, to a maximum of about 36, can be loaded into the cassette. Bulk magazines usually hold 250 exposures.

Burning in or printing in
Technique used in printing photographs when a small area of the print requires more exposure than the rest. After normal exposure a card with a hole in it is held over the print, so that only the area below the hole (for example, a highlight which is too dense on the negative) receives further exposure. The hands may be used instead of a card, and, as with DODGING, card or hands are kept constantly moving to prevent harsh tonal transitions.

C

Cable release
Thin cable encased in a flexible rubber or metal tube, used to fire the shutter without touching the camera. This helps to avoid camera shake when the camera is mounted on a tripod for a long exposure, or when it is fitted with a heavy long focal length lens. One end of the cable screws into a socket in the camera, often within the shutter release button; the other end has a plunger which when depressed fires the shutter. Some models have locking collars that hold the shutter open for long exposures, and some special equipment may have provision for several cable releases to operate at the same time, as for example when using bellows for close-up work. There is also a pneumatic type of release, operated by an air bulb, and fitted with a long cable, for remote control work, including self-portraiture. An air release is less liable to wear through friction, but will perish with age.

Callier effect
Scattering of light in a condenser-type enlarger, causing an increase in contrast compared with the image formed from the same negative by a diffuser enlarger. When light rays from a condenser pass through a negative held in

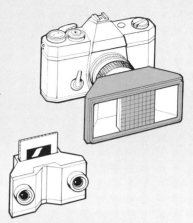

Beam-splitter: at top is a stereo adapter shown fitted to an SLR; below it is a stereo viewer used for viewing transparencies

Bounced flash requires an exposure adjustment for the added distance

Bright field: the angle of the mirror can be used to vary the lighting

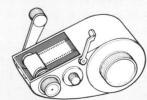

Bulk loader

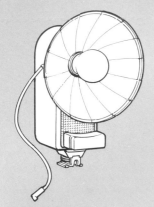

Capacitor flash gun

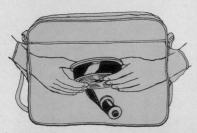

Changing bag

Chemical fog

Circles of confusion

the carrier, they are selectively absorbed or scattered by the dense, highlight areas, while passing unimpeded through the clear parts – the shadow areas. The effect is to give strong highlights and dense shadows. With a diffuser enlarger, the light reaching the negative has already been scattered by the diffuser itself, so no more scattering takes place. The Callier effect is named after the Belgian physicist André Callier, who first investigated it in 1909.

Camera movements
Mechanical systems most common on large-format cameras that allow the relative positions of the lens and film to be adjusted. The movements can create greater depth of field in specific planes, and can correct or distort image shapes as required, for example correcting converging verticals in architectural subjects. On SLR cameras similar but more restricted movements, generally limited to rising, falling and lateral movement, can be obtained by using a SHIFT LENS.

Camera shake
Accidental movement of the camera during exposure, resulting in overall blurring of the photographic image. The main causes are pressing the shutter release too vigorously and handholding the camera while shooting at slow shutter speeds. Using a tripod and cable release will generally overcome the problem, but not, for example, when photographing near a source of vibration, such as heavy machinery on a factory floor. The slowest speed at which it is safe to hand-hold a camera varies with numerous factors, such as the weight of the camera, the smoothness of the shutter release mechanism and the skill and confidence of the photographer (the photographs on pp. 92–93, for example, were taken at 1/30). Non-reflex cameras are slightly less susceptible to shake than SLRs because they do not have a mirror mechanism – a source of vibration. The use of long and heavy lenses will increase the effects of camera shake at slow shutter speeds, as will photographing in a moving vehicle by land, sea or air. Camera shake probably ruins more photographs than any other basic error, but it can also be used creatively, particularly in colour photography, where it can "spread" the image.

Canada balsam
Fluid resin from a species of North American fir tree, used in lens manufacture to cement elements of optical glass together. It possesses a refractive index almost identical to that of glass and thus forms an invisible adhesive. Some manufacturers object to Canada balsam on the grounds that it yellows with age, but it takes at least 30 years before starting to discolour, and even then its effect will generally be negligible in black and white photography.

Candela
Unit of measurement used to indicate the strength of a light source. One candela (formerly known as one candle power) is defined as 1/60 of the luminous intensity of one square centimetre of a BLACK BODY at the solidification temperature of platinum (1,769°C).

Candle metre
Unit of measurement of illumination. It is defined as the illumination per square metre of a surface one metre from a point light source of one candela.

Capacitor flashgun
Flashgun incorporating a condenser (capacitor) that builds up a charge of electricity to fire a flash bulb.

Carbon tetrachloride
Solvent that may be used for cleaning the surface of negatives. It must be used in a well ventilated atmosphere as its fumes are toxic.

Catadioptric lens see MIRROR LENS

Caustic potash
Alkaline chemical used in developers to accelerate development.

Changing bag
Bag made of opaque material and having elasticated sleeves that allows light-sensitive materials to be handled outside the darkroom. Bags for carrying cameras and equipment sometimes have a changing bag incorporated into them.

Characteristic curve
Graph of the image density produced by a photographic emulsion against the logarithm of the exposure. A black and white film has one curve, a colour film three – one for each layer of emulsion. The graphs give information about emulsion speeds, fog level, contrast and tone reproduction. A steep curve indicates a high-contrast material.

Chemical fog
Overall deposit of metallic silver on a negative, caused by overactive or incorrect developing solution or by certain reducing agents.

Chlorobromide papers
Printing papers coated with a compound of silver bromide and silver chloride, used to produce warm tones in the image, when processed by normal development.

Chromatic aberration see ABERRATION

Chrome alum (Chromium potassium sulphate)
Chemical that acts as a hardening ingredient in some fixing baths.

Chromogenic development
Term used to describe the simultaneous production of a colour image with a silver halide image, by means of a dye coupler in the emulsion, or in the developing solution.

Chromogenic film
Recently introduced black and white material that has been hailed as one of the most important innovations in emulsion technology of the 20th century. It forms a silver halide image in the usual way, but during processing the silver grains couple with image-forming dyes; the silver is then removed by bleaching, leaving a negative that is free of silver and consequently almost grainless. In practice, this means that a chromogenic film with a speed of ASA 400 can produce the sharpness of detail associated with conventional film rated at ASA 125. A drawback of chromogenic film is that its processing requires different chemistry and higher temperatures than conventional black and white film, but this is not likely to prove a handicap to those already working with colour materials, and many commercial processors handle chromogenic film. Ilford XP1 was the first chromogenic film to be launched, in 1980, followed by Agfapan Vario-XL.

Circle of confusion
Disc of light in the image produced by a lens when a point on the subject is not perfectly brought into focus. In fact, no lens can resolve a point as a point, but from normal viewing distance the human eye accepts a circle as a point if its diameter is less than about 1/100 in (0.25 mm), and an image or parts of an image made up of circles of confusion smaller than this will appear sharp.

Cleaning or **clearing bath**
Any bath used in the processing of negatives or prints to remove stains or neutralize chemicals left by previous parts of the processing.

Coated lens
Lens in which the glass-to-air surfaces have been treated with an anti-reflection coating, such as magnesium fluoride, which reduces flare and increases light transmission. Most modern lenses are multi-coated.

Cold cathode enlarger
Type of non-condenser enlarger using as its light source a special fluorescent tube with a low working temperature. It provides even, diffuse illumination and produces less contrasty prints than condenser enlargers (see CALLIER EFFECT). The uniformity of their illumination makes cold cathode enlargers very suitable for large-format work.

Colour analyser
Darkroom device that measures the colour balance of a projected image and determines the correct exposure and filtration for making colour enlargements. Colour analysers are fairly expensive pieces of equipment, but

they save the time and paper that would be used in trial exposures.

Colour correcting or light balancing filters
Comparatively weak colour filters used to correct for small differences between the colour temperature of the illumination used for a particular exposure and that for which the film was manufactured. The name is also sometimes rather loosely used to describe the cyan, magenta and yellow filters that are used in an enlarger to balance the colour of prints made from colour negatives.

Colour couplers see DYE COUPLERS

Colour developers
Highly active and concentrated chromogenic chemicals that develop both the silver image and the subtractive colour dyes in tripack films. Where couplers are incorporated in the developers, the latent silver image is first developed; then the film is processed so that each colour layer is independently developed for the production of dye images. The principal developing agents in negative and reversal films are salts of diethyl-paraphenylene diamine, potassium bromide and sodium carbonate.

Colour separation overlay unit
Electronic device used with video equipment to enable an image from one source to be superimposed on a background from another source. It works on the same principle as the travelling matte used for movie special effects and can be used to create special effects in still photography by photographing the image formed on the television-type screen of the unit. Colour separation overlay units are often known as Chromakey units—the trade name of a well-known make.

Colour synthesis
The formation of colours by mixing lights, dyes or pigments of other colours. Colour photography depends on either the ADDITIVE SYNTHESIS or the SUBTRACTIVE SYNTHESIS.

Colour temperature
Measurement of a light source's energy distribution over the spectrum and hence its colour quality. Colour temperature is usually expressed in Kelvins (K), which are equivalent to degrees Centigrade + 273°, absolute zero being −273° (0K). When a light source is said to have a particular colour temperature (say 5,000K), it means that a BLACK BODY would have to be heated to that temperature to emit radiation of the colour of the light source. A black body when heated to certain temperature will begin to glow red, and as temperature increases it will become orange, and so on. Thus, light at the red end of the spectrum has a low colour temperature, and colour temperature becomes

progressively higher as light moves to the blue end of the spectrum. Colour temperature, then, has no necessary connection with actual temperature, and does not relate to the notion that red is a "warm" colour and blue a "cool" one. In colour photography, a colour reversal film must be matched or "balanced" to the overall colour and luminance of the light to which it will be exposed. Most forms of artificial light have a colour temperature in the range of 2,000K to 6,000K; the colour temperature of blue sky with bright sunshine is about 6,000K, and of overcast sky about 10,000K. See also MIRED.

Coma see ABERRATION

Combination printing
General term for techniques in which more than one negative is printed on to a single sheet of paper.

Complementary colours
Any two colours that, when mixed, will produce an achromatic colour, white, grey or black. The complementary colour pairs used in most colour film and printing processes are red-cyan, green-magenta and blue-yellow.

Condenser
Lens, usually of simple construction, used in an enlarger or slide projector to concentrate light from the lamp source and focus it on the negative or slide.

Constant density ratio
Law stating that the relative silver halide densities on an exposed negative are decided by the exposure, not by development, as development affects only contrast.

Contre jour
Alternative term for BACKLIGHTING (French for "against the light").

Cosine law
Law relating to the variation in illumination between the centre and the edges of an image formed by a lens. At the edges of the image the light-waves fall more obliquely on the negative and brightness is correspondingly decreased. The law states that the illumination varies as the fourth power of the cosine of the angle formed between the lens axis and an imaginary line drawn between the rear NODAL POINT and the image point in question.

Covering power
The maximum area of the focal plane over which a lens is capable of producing an image of acceptable illumination and definition. Illumination falls off progressively from the centre of the image in accordance with the COSINE LAW, and definition, because of ABERRATIONS, suddenly decreases at a certain point, earlier at wide apertures than small apertures. The covering power of a lens is normally only slightly greater than the negative size for which it is

intended. In the case of a lens intended for use on a camera with CAMERA MOVEMENTS, however, covering power must be considerably greater in order to accommodate the differences in alignment between the lens and the film plane that the movements produce. Similarly, a SHIFT LENS must have greater covering power than an ordinary lens of the same focal length.

Cross front
Movable lens panel on some types of large-format cameras that allows the lens to move horizontally across the camera. This is one of the principal CAMERA MOVEMENTS.

Curvature of field see ABERRATION

Cut film
Another name for SHEET FILM.

Cyan
Blue-green colour, one of the three primaries used in the SUBTRACTIVE SYNTHESIS.

D

Dark field
Method of illumination used in photomicrography which lights the specimen from above, causing it to be seen against a dark background. See also BRIGHT FIELD.

Dark slide
Light-tight holder in which sheet film is loaded for exposure in the camera. Holders are often designed to take two sheets of film back to back; these are called double dark slides.

Data back
Device that can replace a normal back on an SLR to enable figures recording information to be optically imprinted on to the corner of the negative. Usually there are three dials that can be turned to a combination of numbers to record, most typically, the date (day, month, year) on which the photograph was taken. A more sophisticated kind of unit enables the photographer to write an annotation with a special pencil on to a small panel on the back, from where it is transferred, appropriately reduced in scale, to the negative. The latter type, in particular, is regarded by many as a gimmick rather than as a useful tool.

Daylight film
Colour reversal film balanced to give accurate colour rendering in average daylight, that is to say when the colour temperature of the light source is around 6,500K. Daylight film is also suitable for use with electronic flash and blue flash bulbs.

Dedicated flash see FLASH

Colour analyser

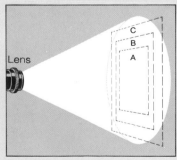
Contre jour

Cosine law: illumination at B and C (edge of field) is Cos⁴θ less than at A

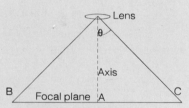
Covering power: format C is not covered

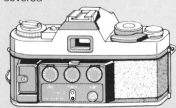
Data back

Differential focusing

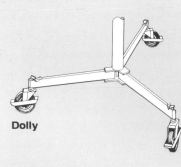

Dodging

Dolly

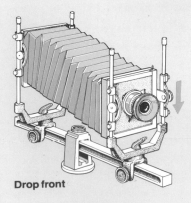

Drop front

Definition

The sharpness of detail and general clarity of a photograph. Definition depends on several factors – accurate focusing, the quality and resolving power of the lens and the speed of the emulsion.

Density

The light-absorbing power of a photographic image, which varies in proportion to the deposits of metallic silver in an emulsion following exposure and development – in general terms, the opaqueness of a negative or the blackness of a print. Density can be measured by a special instrument called a densitometer; a logarithmic scale is used in measurement, 1.0 representing 100% absorption, and 0.3 representing 50% absorption. A graph of densitometer measurements plotted against a logarithm of exposures produces a CHARACTERISTIC CURVE.

Depth of field

Zone of acceptable sharpness extending in front of and behind the point on the subject which is exactly focused by the lens. Depth of field varies with (1) the distance of the point focused from the lens (the shorter the distance, the more shallow the depth of field); (2) the size of the aperture (the smaller the aperture, the greater the depth of field); (3) the focal length of the lens (the greater the focal length, the shallower the depth of field). The zone of sharpness behind the point focused is greater than that in front of the point. Depth of field can be calculated in various ways, and most lenses have a depth of field scale inscribed on them. Many modern SLRs using open-aperture exposure metering also have a **depth of field preview** button that closes the lens diaphragm to the f number selected and enables the depth of field to be assessed on the viewing screen. The drawback of this method is that the screen darkens progressively as the diaphragm is closed. SLRs using stop-down metering automatically give depth of field preview, as metering can be done only at the selected aperture and not at full aperture. Control of depth of field is one of the most useful weapons in the photographer's armoury, as the overall sharpness required in, say, an interior shot of a building might be quite inappropriate for a soft romantic portrait. Perhaps the most obvious and useful way of using restricted depth of field is the blurring out of unwanted backgrounds and foregrounds. When photographing animals through bars in a zoo, for example, at a suitable combination of aperture and distance, the bars can be made to disappear from the image so the subject is seen unimpeded.

Depth of focus

Very narrow zone on the image side of the lens within which slight variations in the position of the film will make no appreciable difference to the focusing of the image. As with depth of field, depth of focus increases as the aperture is reduced, but the effects of subject distance and focal length are opposite to those for depth of field; depth of focus increases the nearer the point focused is to the lens and the longer the focal length. Depth of focus also differs from depth of field in extending an equal distance on either side of the plane of optimum focus, and in that it is a concern of the camera designer and manufacturer rather than the camera user, dictating the degree of accuracy with which the film needs to be positioned.

Desensitizers

Chemical dyes that reduce the sensitivity of a film emulsion to light, allowing development by inspection under a brighter light than usual. For example, a bright green safelight can be used to inspect fast panchromatic films. Desensitizers do not affect the latent image, but some types can affect the action of the developer. Typical dyes are the pinacryptols, employed as a forebath to treat the film prior to development.

Developer

Solution containing a number of chemicals that convert the latent image in an exposed photographic material to a visible image. In addition to the developing agent that reduces the exposed halides to black metallic silver, the solution may also contain an **accelerator**, usually an alkali such as sodium carbonate, sodium hydroxide or borax, which helps to speed up the action; a **preservative**, such as potassium metabisulphite, which helps to avoid stains and extend the life of the developer; and a **restrainer**, usually potassium bromide, which acts as an overall controller of chemical action, and also helps to reduce fog.

Developer improvers

Chemicals with anti-fog properties that can be added to conventional developers, or may already be included in the ingredients of a developer.

Diaphragm

Part of the camera that determines the size of the aperture. In its original most elementary form, it was simply a plate with a hole (the aperture). Adjustable diaphragms formerly consisted of metal plates containing a series of holes of varying sizes that could be slid or rotated into position in the lens barrel, but the most common form today is the iris diaphragm. This is a system of overlapping metal blades forming a roughly circular opening that is continuously variable in size, adjustment being made by means of a ring on the lens barrel. The diaphragm can be placed in front of or behind the lens, but in compound lenses it is almost always placed between components.

In a **diaphragm shutter**, the leaves can close completely in the centre, blocking out all light; diaphragm and shutter are thus combined in one mechanism. This kind of shutter obviously precludes TTL metering and viewing.

Diapositive

Term that describes positive pictures on a transparent support, viewed by transmitted rather than reflected light. Colour transparencies and lantern slides are diapositives.

Dichroic fog

Processing fault characterized by a stain of reddish and greenish colours on the negative – hence the name "dichroic" (literally "two-coloured"). It is caused by the use of a contaminated or exhausted fixer whose acidity is insufficient to halt the development entirely. A fine deposit of silver is formed, appearing reddish by transmitted light and greenish by reflected light. The stain is difficult to remove, but in less severe cases can be treated with FARMER'S REDUCER.

Differential focusing

Technique of exploiting shallow DEPTH OF FIELD to make one part of a photographic image appear sharp while others are unsharp. It is a very useful device for blurring unwanted elements or emphasizing the main subject, and can help to create a sense of depth or suggest atmosphere. **Selective focusing** is another commonly used term for the same technique.

Diffraction

Phenomenon occurring when light passes close to the edge of an opaque body or through a narrow aperture. The light is slightly deflected, setting up interference patterns that may sometimes be seen by the naked eye as fuzziness. The effect is occasionally noticeable in photography, as when, for example, a very small lens aperture is used.

Diffusion

Scattering of light when it is reflected from an uneven surface (diffuse reflection) or when it is transmitted through a translucent but not transparent medium. A reflecting surface does not have to be obviously rough, as even tiny irregularities (as in a layer of seemingly perfectly smooth paint) will scatter the light. The term diffuser, however, usually refers to a medium through which the light is transmitted (smoke or tracing paper, for example), rather than to a reflecting surface. Diffusion has the effect of softening light, eliminating glare and harsh shadows, and can therefore be a phenomenon of great value to the photographer. It is extensively used, for example, in portrait photography (SEE BOUNCED FLASH and SOFT FOCUS). When coloured surfaces and media act as diffusers, some of the light is also absorbed.

DIN
Abbreviation for Deutsche Industrie Norm, used to designate one of the most commonly used rating systems for FILM SPEED.

Diopter
Unit of measurement of the strength of a lens, defined as the reciprocal of the focal length expressed in metres. It is used in photography to express the strength of a supplementary close-up lens.

Direct-vision finder
Any camera viewfinder (with or without optics) through which the subject is seen directly, rather than by reflection from a mirror. The advantages of a direct-vision finder over a reflex viewing system are that the subject can be viewed at the moment of exposure and that it is easier to see the subject clearly in dim lighting conditions. Disadvantages are PARALLAX ERROR and the fact that it is not possible to see the effects of, for example, filters or differential focusing before taking the photograph.

Dispersion
The splitting of lightwaves into visible component colours of the spectrum when light passes through a refractive medium such as glass. The degree of dispersion depends on the angle of incidence of the light and the refractive index of the medium.

Distortion
Alteration of normal shape or proportions within a photographic image, whether intentional, for expressive purposes, or accidental. Distortion can be produced by a variety of ways of altering the transmission or registration of the image, for example by using a lens very close to the subject or tilting the baseboard of the enlarger during exposure of the negative. ANAMORPHIC lenses produce one of the most spectacular types of distortion. Unintentional distortion is caused mainly by lens ABERRATION.

Dodging
Technique used in printing photographs when one area of the print requires less exposure than the rest. A piece of black matt card mounted on a wire handle is held over the selected area to prevent it from receiving the full exposure. The "dodger" (sometimes also called a "paddle") is kept in constant movement to avoid abrupt changes in tone. The same technique using a hand instead of a piece of card is sometimes called **shading**, although many photographers make no distinction between the terms and use them interchangeably. See also BURNING IN.

Dolly
Mobile support on wheels, used in the studio with large-format cameras and with lights.

Dosimeter
Device that can be fitted to an autowinder or motor-drive to set it to make a predetermined number of exposures in any one sequence. It is often used in conjunction with an INTERVALOMETER.

Double exposure
Recording of two images, either identical but off-register with each other, or of quite separate subjects, on the same frame of film. It is one of the most common methods of achieving trick effects. Most modern cameras have some sort of locking device to prevent making accidental double exposures. On older cameras it was often possible for this to happen if the photographer forgot to wind on the film after making an exposure.

Double extension
Characteristic feature of technical or similar cameras, permitting the lens to be moved up to two focal lengths from the film. This makes possible an image the same size as the subject.

Drift-by technique
Processing technique used to allow for the cooling of a chemical bath (normally the developer) during the time it is in contact with the emulsion. Before use, the solution is warmed to a point slightly above the required temperature, so that while it is being used it cools to a temperature slightly below, but still within, the margin of safety.

Drop front
Lens panel on some types of large-format cameras that allows the lens to be moved below the normal axis. It is one of the principal CAMERA MOVEMENTS.

Drying marks
Blemishes on the film resulting from uneven drying. They are virtually impossible to remove if on the emulsion side of the material.

Dry mounting
Method of mounting prints on to card backing, using a special heat-sensitive adhesive tissue that is placed between the print and card and bonds them when they are placed in a hot press. It is the most effective method of mounting, as it produces a wrinkle-free and permanent result, and does not introduce any potentially harmful chemicals to the print, as do many glues.

Dye couplers
Chemicals used in colour film emulsions or in the processing developers that "couple" with exposed silver halides to release dyes that form the colour image. The chemicals used in today's tripack film to form subtractive dyes are commonly phenol for cyan dye development; pyrazolones for magenta; and acetoacetanilides for yellow. Couplers are complex structures, designed to form a molecular

"ball and chain" to prevent them from wandering through the tripack layers.

Dye destruction process
Method of forming colour images by selectively eliminating dye by chemical means. It makes use of a tripack material that already contains the final dye in the emulsions before exposure. After exposure, a bleaching agent is used to destroy the dyes in proportion to the development of the silver halide image. Using this process it is possible to produce positive prints from colour transparencies without reversal.

Dye sensitizing
The process of rendering a silver halide emulsion sensitive to colours of light other than the blue to which the halides have an inherent response. The German chemist Herman Vogel first carried out successful experiments in this field in the 1870s and 1880s, and his work led to the orthochromatic and panchromatic materials used today.

Dye transfer process
Complex but versatile method of producing colour prints involving the making of three separate negatives, one for each primary colour, and the subsequent registration of a positive dye image from each.

E

Eberhard effect
Development phenomenon whereby very small areas of the image have a greater developed density than larger areas that have received the same degree of exposure. The Eberhard effect, named after the German physicist Gustav Eberhard, who first described it in 1926, is caused by the same kind of exhaustion and displacement of developing solution that brings about EDGE EFFECTS; when an area is sufficiently small (less than about 1 mm across) the distance from side to side is so slight that in effect the whole of the area reacts as an edge, and has no centre that remains unaffected.

Edge effects
Development phenomena characterized by increased contrast at the boundaries of areas with markedly different densities. The effects are produced when developer becomes rapidly exhausted in heavily exposed areas, and fresher developer from the adjacent area moves across to replace it. Thus the edge of the heavily exposed area receives more development than the average for that area (the displaced fresh developer penetrating only slightly into the area), and the edge of the adjacent, lightly exposed area receives less development than the average for that area, some of its development potential having been lost to the edge of the heavily exposed area. The

Dry mounting: 1 A sheet of special tissue is secured to the back of the print with a tacking iron.

2 The print is trimmed to required size, and print and tissue are now of equal size and perfectly in register.

3 The print is placed on the mount, each corner is lifted in turn, and the tissue tacked down to the mount with the hot electric iron.

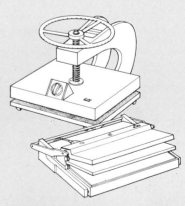
4 The surface of the print is covered with clean cartridge-paper to protect the print surface, and the sandwich is placed in a dry mounting press. The tissue is melted and bonds the print permanently to the mount.

Expiry date

Exposure meter: above left, reflected light reading; above right, incident light reading

Exposure metering (through-the-lens) top, spot reading
centre, averaged reading
bottom, centre-weighted reading

resulting increased sharpness is an effect that is sometimes sought after, and can be emphasized by using a developer that exhausts rapidly and by avoiding agitation.

Effective aperture see APERTURE.

Effective f number
Value used instead of the normal f number in close-up photography when the increased lens – image distance makes extra exposure necessary. The effective f number is calculated by dividing lens – image distance by effective aperture (see APERTURE). The terms effective f number and effective aperture are often confused.

Ektaflex
Kodak trade name for a recently-introduced colour printmaking system, radically simpler than the conventional procedure. It uses a special printmaker and chemical solution (activator), and instead of a single sheet of printing material, it uses two, both the size of the final print. The first, plastic-based, is exposed under the enlarger (there are two different types of material – one for working from negatives, one for working from transparencies), then soaked in the activator and sandwiched with the second, paper-based, sheet in the printmaker. After about eight minutes, the two sheets are peeled apart, revealing the finished paper print (either 7×5in or 10×8in). Much of the process can be carried out in daylight, and there is no need for washing and drying or for careful temperature control. These advantages of speed and simplicity are to some extent offset by the fact that the Ektaflex system is more expensive per print than conventional colour printing methods.

Electronic flash
Artificial lighting in the form of a repeatable, very bright, short duration flash produced by a high-voltage electrical discharge between two electrodes in a gas-filled tube. The electrical discharge is activated when a circuit is closed by the camera's shutter synchronization mechanism. Flash units are powered by dry-cell batteries, rechargeable cells or mains power.

Electron photomicrography
Production of photographs using an electron microscope, which is capable of higher magnification than conventional optical microscopes. In an electron microscope a high-velocity electron beam is emitted by a tungsten filament lamp, and the beam is conveyed through the specimen and on to a fluorescent screen by a number of magnetic coils, which bring the electrons to focus much as a lens focuses light. The image produced by the electrons can be registered directly on to film. The film is mounted behind the screen, which is lifted when an exposure is to be made.

Emulsion
General term for the light-sensitive layer of films and printing papers. The conventional photographic emulsion is made up of ultra-fine grains of silver halide suspended in gelatin. In colour film, the sandwich, or tripack, of gelatin layers contains, in addition to the silver halides, molecules of dyes, or colour couplers. Formerly, many other materials were used in the emulsion, some producing very distinctive effects. Platinum paper, for example, produced extraordinarily deep, velvety blacks, and the distinguished English photographer Frederick Evans was so devoted to it that he gave up photography when it became unobtainable during World War I. Some photographers (for example Irving Penn) make their own emulsions for specific purposes, especially printing papers, sometimes even using gold or platinum, and there has recently been a major revival of interest in old printing techniques using special papers.

Endoscopic photography
Technique of using an endoscope to photograph in small, confined areas inaccessible to a normal camera. An endoscope is an instrument consisting of a long tube containing optical and lighting equipment that relays the view seen from an aperture at one end of the tube to an aperture at the other, to which a camera can be attached by means of a special adapter. It was originally developed for use in medicine, and this is perhaps still the major field in which endoscopic photography is used (enabling photographs to be taken inside the human body), but it is also employed in industry (photographing details of machinery, for example), and in other specialist areas such as photographing scale models. See also FIBRE OPTICS.

Enlarger
Apparatus that makes enlarged positive prints by projecting and focusing a negative image on to sensitized paper. There are two main types of enlarger available – those that use a condenser system and those that use a diffuser system (see CALLIER EFFECT and COLD CATHODE ENLARGER).

Enprint
Commercially produced fixed-ratio enlargement – usually 4½×3½in from a 35mm negative.

Existing light
Alternative term (used chiefly in the USA) for AVAILABLE LIGHT.

Expiry date
Date marked on film packs to indicate the useful life of the emulsion. The date may be anything from 18 months after the time of manufacture for colour films to more than three years for black and white films. In practice, a film may stay usable well beyond the given

date, especially if refrigerated, but the manufacturer's recommendations should generally be followed. As films age, the fog level rises, speed falls and colour balance changes.

Exposure
Total amount of light reaching the light-sensitive material during the formation of the LATENT IMAGE. The exposure is dependent on the brightness of the subject and the amount of light that is allowed to reach the light-sensitive material, the latter factor being controlled by aperture size and shutter speed.

Exposure factor
Amount of increase in exposure required when using accessories such as bellows, extension tubes and filters, which extend the lens-to-film distance or reduce the intensity of the light reaching the film. It is usually expressed as a multiplication factor, and such factors are often marked on the rim of filters. A filter with an exposure factor (or filter factor, as it is often called in this case) of x2, for example, would require a doubling in exposure time or an increase in aperture size by one f number.

Exposure latitude
Tolerance of a film emulsion to record satisfactorily if exposure is not exactly correct. Black and white films generally have more latitude than colour films, fast black and white films the most latitude of all.

Exposure meter
Instrument for measuring the intensity of light so as to determine the shutter and aperture settings necessary to obtain correct exposure. Exposure meters may be built into the camera or be completely separate units. Separate meters may be able to measure the light falling on the subject (incident reading) as well as the light reflected by it (reflected reading); built-in meters measure only reflected light. Both types of meter may be capable of measuring light from a particular part of the subject (spot metering) as well as taking an overall reading. Built-in meters are often "weighted" to a particular part of the image – most usually centre-weighted. The basic principle involved in exposure meters is that of light energizing a photosensitive cell to produce a current that actuates a pointer or light emitting diodes (LEDs) indicating the light reading. LEDs are overtaking needles in popularity as they are easier to see in dim lighting and are more reliable, having no moving mechanical parts. Four main types of cell are used in exposure meters. (1) Selenium (Se): this type needs no battery power as it generates an electric current when exposed to light, but it is unsuitable for use inside a camera as it needs to be quite large to be sufficiently responsive in very dim conditions.

(2) Cadmium sulphide (CdS): this, like the two following types of cell, is small enough to be easily accommodated in a camera, and like them is in circuit with a battery, the resistance of the cell changing in proportion to the intensity of the light. A cadmium sulphide cell has good responsiveness in dim light, but a disadvantage is that it has a "memory", which means it retains a reading for a few seconds, particularly with very bright scenes. This time lag can cause incorrect exposure in changeable lighting conditions, and CdS also has a tendency to underexpose red subjects as it is oversensitive to red light. (3) Silicon (silicon photo diode – SPD): this is also especially sensitive to red light and is often fitted during manufacture with a blue filter, when the cells are called silicon blue. The cells are fast-reacting and have virtually no memory, but their reliability can suffer in temperature extremes.(4) Gallium arsenide phosphide (GaAsP or GPD); this is the newest type of meter cell. It is fast-reacting and reliable, but so far has been used in relatively few cameras. Built-in meters for SLR cameras are now almost without exception of the through-the-lens (TTL) type, which means that the reading is taken after the light has passed through the lens. TTL metering thus has the very great advantage of taking into account filters or any other lens attachments that modify the light reaching the film. Most modern SLRs also incorporate an **automatic diaphragm** system. This means that whatever aperture has been chosen for an exposure is acknowledged by the meter, but the aperture actually remains wide open until the shutter release is pressed. The viewing screen therefore retains maximum brightness until the moment of exposure. In many modern cameras the exposure meter is linked with the shutter and/or aperture diaphragm to give AUTOMATIC EXPOSURE.

Exposure value
Numerical expression used to give a single value to the combined effect of aperture and shutter speed on exposure. An exposure of 1/60 at f2, for example, is equivalent to one of 1/30 at f2.8 (twice the time at an aperture half the size), so they have the same exposure value. Exposure values are expressed on a logarithmic scale; the higher the exposure value, the smaller the amount of light admitted to the film.

Extension rings or tubes
Accessories used in close-up photography, consisting of metal tubes that can be fitted between the lens and the camera body, thus increasing the distance between the lens and the film. They are usually sold in sets of three, and can be used in combination with one another, making possible a variety of different extension lengths, and thus forming a serviceable, though less flexible, alternative to **extension**

bellows, which are continuously variable, but more cumbersome, ideally needing to be securely mounted. Extension rings may be automatic or non-automatic; the former, which carry the necessary mechanical linkage, allow open-aperture metering in the same way as an automatic diaphragm. Olympus have recently introduced a telescopic auto tube, which combines something of the portability of extension tubes with the flexibility of bellows.

F

Farmer's reducer
Solution of potassium ferricyanide and sodium thiosulphate, used to bleach negatives and prints. It is named after the English photographer E. H. Farmer, who invented it in 1863.

Fibre optics
Optical system that employs hair-thin glass fibres to form "light-guides". Fibres are coated with a material of a low refractive index that effectively traps light to contain it within the length of the fibre; light entering at one end is thus transmitted along the fibre to emerge at the other end. The fibres, or rods containing bundles of fibres, will transmit light even when they are bent or severely distorted, and can therefore be used in the form of an ENDOSCOPE to illuminate places difficult of access, either for inspection or to transmit images for photography.

Field
The extent of the view or scene that a lens is capable of conveying as an acceptably sharp image. It can be expressed as the angle that the diameter of the maximum image circle of acceptable quality subtends at the lens. See also COVERING POWER.

Field camera see LARGE-FORMAT CAMERA

Filament lamp
Type of incandescent lamp in which the light source is supplied by running an electric current through a filament. Filament lamps are a convenient source of electric light for both photography and domestic purposes. In photography, TUNGSTEN FILAMENT lamps are the most commonly used.

Fill-in lighting
Additional lighting used to supplement the principal light source and lighten shadows. In portrait photography, for example, a single light source, such as available light streaming through a window, might cast very heavy shadows on one side of the sitter's face, and to achieve a better balance of contrast, an additional light, or the main light source "bounced" off a reflector, would illuminate or fill in the shadow area.

Film
Sensitized material in the form of an EMULSION coating a flexible base, usually cellulose acetate or plastic. The base is merely a support for the emulsion: a film usually also has additional layers, the function of which is to protect the emulsion. Black and white films have one layer of emulsion; tripack colour films, as the name suggests, have three layers in a sandwich. Colour negative film is used to produce prints, the colours of the subject being recorded in complementaries that are subsequently reversed again in the printing process to give the correct colours; colour reversal film produces a direct positive (usually in the form of transparencies mounted as slides) by effectively "reversing" the negative image during processing. Films are manufactured in various types and sizes. Large-format cameras are usually loaded with single sheets of film, which come in sizes up to a normal maximum of 10×8in (25.4×20.3cm); other types of camera use film that comes in continuous strips of up to 72 or more frames. There are three main methods of packaging film of this kind. (1) Cartridges: plastic containers that simply drop into the camera without any need for film threading. The film is wound from one side and stored in the other after exposure. Cartridges are made only in the smallest formats – 110 (13×17mm) and 126 (28×28mm) – and are used mainly in inexpensive viewfinder cameras. (The numbers used to designate film sizes – 110, 126, 135 and so on – are arbitrary, and have no relationship to one another.) (2) Cassettes: metal or plastic containers with a slit in the side that is lined with a velvet-like material to form a light-trap. A tongue of film protruding from the cassette is threaded on to a take-up spool in the camera, and when finished the film must be rewound into the cassette. Cassettes are used for 35mm film (36×24mm), and the widest variety of film types are manufactured in this form because of the popularity of the cameras (including most SLRs) in which this size of film is used. 35mm film can also be bought in bulk for loading into re-usable cassettes or special bulk film backs usually taking 250 exposures. (3) Roll-film: film wound on to spools and protected by a lightproof backing paper. It is used in medium-format cameras and is obtainable in a number of frame sizes, usually 2¼in (6cm) wide; 6×4.5cm, 6×6cm, 6×7cm and 6×9cm are the most popular formats. Roll-film is also available without backing paper, this thinner form allowing more frames per roll.

Film plane index
Symbol found on the top plate of many cameras indicating the plane that the film occupies within the body. It is used as a reference mark from which to measure distance when exact accuracy is necessary in close-up work.

Extension rings

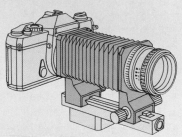

Extension bellows

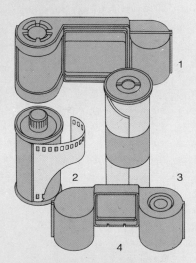

Film: (1) 126 cartridge (2) 35 mm cassette (3) roll-film (4) 110 cartridge

Film plane index

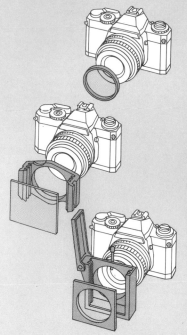

Filters

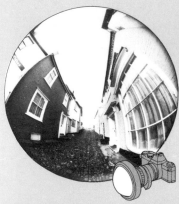

Fisheye lens

Flare

Film speed

Degree of sensitivity, or "speed", of an emulsion expressed numerically for the purpose of exposure calculation. In the past, numerous systems, both proprietary and national, have been used, among them H&D (Hurter and Driffield), Scheiner, Weston, BSI (British Standards Institution), DIN (Deutsche Industrie Norm), GOST (Gosudarstvenny Obshchesoyuzny Standart) and ASA (American Standards Association). GOST still has some currency in the USSR and Eastern Europe, but otherwise only ASA and DIN are now used, the former being an arithmetical system, the latter a logarithmic one. A film with a speed of ASA 200, for example, is twice as fast as one rated ASA 100; on the DIN system the equivalent figures are 24° and 21°, each increase of 3 indicating that the sensitivity of the emulsion has doubled. By recent international agreement, these two systems have now been incorporated in a new rating system known as ISO (International Standards Organization). Thus ASA 100 (21° DIN) now becomes ISO 100/21°.

Filter

Sheet of glass, gelatin or acetate used to absorb or transmit a specific part of the light passing through it to alter tone or colour, or to manipulate the light to change or distort the image. Certain types of filter are employed in printing, but a much greater variety is used in front of the camera in both black and white and colour photography. In black and white photography a familiar example is the use of a yellow filter to darken the tone of the sky. Black and white film is particularly sensitive to blue lightwaves, and this means that in normal circumstances the sky areas of a negative are often overexposed and thus appear too pale on the resulting print. A yellow filter passes green and red light but absorbs light transmitted from the blue sky to give greater contrast between sky and clouds on the print. An orange filter will darken the sky still further. Filters used in such a way are called contrast filters, although, somewhat confusingly, the term correction filters is also sometimes applied to them. The latter term is best reserved for the colour conversion or correction filters (CC filters) used in colour photography to correct for small differences between the colour of the illumination used for a particular exposure and that for which the film was manufactured, as when an amber filter enables tungsten film to be used in daylight. There are also colour filters used to actively change the colours of a subject; some do this so subtly that the fact that a filter has been used may not be apparent, and at the other extreme there are ones that completely transform the character of a scene. Strong colour filters can produce startling results, but if they are not used with discretion the effects can be merely garish. A variety of special purpose and special effects filters is also available for colour and black and white photography. Of the former, the three most popular and useful are probably **ultraviolet** (UV) filters, **neutral density** filters and **polarizing** filters. A UV filter absorbs ultraviolet radiation and helps to penetrate haze. As these filters have no effect on exposure they can be used to protect the lens from rain, dust and so on. (**Skylight** filters are very similar to UV filters, but they also absorb a small amount of blue light and thus have some of the effect of the contrast filters described above.) Neutral density filters are uniformly grey and reduce the brightness of an image without affecting either contrast or colour balance. They can be used to reduce depth of field (the reduction in the light reaching the film necessitating a larger aperture for a given shutter speed) and to enable fast films to be used in strong light beyond the camera's exposure controls. Polarizing filters cut down reflections from certain shiny surfaces. Special effects filters are of many different types. The most popular are probably starburst filters, which break point sources of light into dramatic star shapes, and multi-image filters, which produce repeated, overlapping images of the subject. Strictly speaking, these are not filters but optical lens attachments (just as polarizing "filters" are more correctly called "screens"); however, the usage of the word "filter" to cover all attachments of this type is securely established. As with strong colour filters, special effects filters can produce extremely exciting results, but ones that through uninventive repetition can easily degenerate into photographic clichés. Filters are attached to the camera in either of two ways. Circular "mounted" filters have metal rims that screw on to the lens, making different sizes of filter necessary for lenses of different diameter (the lens's "filter size", expressed in millimetres). Square filters are slotted into a holder that can be fitted to lenses of various diameters by means of an adapter, so use of the filters is not confined to lenses of one particular size.

Filter factor see EXPOSURE FACTOR

Filter pack

Assembly of filters used in an enlarger when making colour prints. Normally a filter pack consists of any two of the three subtractive primaries (yellow, magenta, cyan) in the appropriate strengths.

Fisheye lens

Extreme wide-angle lens with an angle of view up to 180° or even beyond. Such lenses produce highly distorted circular images, cropped in all but the widest angle fisheyes to a square or rectangle by the film format. The area in the centre of the subject is greatly enlarged, especially when the subject is close to the camera, with the remainder of the image bowing outwards towards the edges, producing an effect similar to that seen in a distorting convex mirror. Some less extreme fisheye lenses are linear corrected, producing a stretched image while faithfully recording any straight lines in the original subject. No focusing is necessary with fisheye lenses as they have enormous depth of field. Fisheye attachments for standard lenses are cheaper than genuine fisheye lenses, but the quality of the results they produce is poorer and they usually demand a restricted aperture. A related device is the bird's eye attachment, a clear tube that fits on the lens and by means of a spherical mirror in the tube creates a fisheye-type image looking behind the camera and in which the camera itself is seen.

Fixer

Chemical bath needed to permanently establish the photographic image after it has been developed. The fixer stabilizes the emulsion by converting the undeveloped silver halides into water-soluble compounds, which can then be dissolved out. Fixing agents belong to two main chemical groups: the thiosulphate group and the cyanide group. The latter are extremely rapid but highly poisonous and are thought to affect the permanence of the silver image. Sodium thiosulphate (hypo), first used by Fox Talbot in 1841, still remains the most popular and the cheapest fixer.

Flare

Light reflected within the lens barrel or between the elements of the lens, giving rise to irregular marks on the negative and/or an overall degradation of the quality of the image. Flare, which usually occurs when the camera is pointed towards a light source, is to some extent overcome by using COATED LENSES and having the interior surfaces of the camera treated with matt black paint and anti-reflection material. See also GHOST IMAGE.

Flash

Artificial light source giving a powerful and very brief illumination, either by passing an electric discharge through a tube filled with an inert gas (electronic flash) or through an expendable flash bulb. Apart from packs of flashcubes such as Magicubes and Flashbars used on inexpensive and instant picture cameras, flash bulbs are now practically obsolete. Compact electronic flash units are built into many types of camera, but they have the disadvantage of a slow recycling period – a delay of more than ten seconds between shots is necessary for the power to build up. Flashguns are lightweight units that can be mounted on the camera's hot shoe, and the majority are now "computerized", that is, they automatically adjust the intensity of the light to the aperture

setting. The computer measures the strength of the light reflected from the subject and shuts off when a predetermined level has been reached – all, of course, in a tiny fraction of a second. Some computer flash units include a **thyristor** control (a solid state electronic switch), which conserves unspent energy and enables faster and more economical recycling. Many electronic flashguns have a tilt-twist head so that the flash can be bounced from a wall or ceiling (see BOUNCED FLASH), and some can be fitted with supplementary diffuser panels, filters and a means of spreading the beam of light for use with wide-angle lenses. **Dedicated** flashguns are made for one specific model or range of cameras to enable light output, aperture and shutter speed to be synchronized perfectly. **Ring flash** units are circular and fit around the lens. Ring flash casts no shadows, but produces an image that is soft and lacking contrast. It is used particularly in close-up work in medical or scientific photography and also in portraiture. In addition to the contact for flash on the hot shoe, many cameras have a socket to take an electrical lead so that flash can be used off-camera, enabling more varied lighting set-ups to be created. Flash is also used in the studio as an alternative to TUNGSTEN lighting. A disadvantage of flash is that it is not possible to study the lighting effects of a set-up before the picture is taken, but it also has many advantages over tungsten lighting. Flash lamps are much cooler than tungsten lighting, and so are suitable for fragile subjects such as flowers or food and for portraits; they have a much longer life; their colour temperature is close to that of daylight, and so they can be used with daylight film; they provide very bright light, and so can be used with small apertures to provide great depth of field; and the brief duration of the flash they produce can be used to "freeze" movement. In studio flash work, supplementary flash units can be triggered by a photoelectric device called a **slave unit**. This senses light from the main flash source and fires the secondary unit to which it is attached.

Flashing
Printing technique in which the printing paper is given an auxiliary "fogging" exposure by light that has not passed through the negative. The extra exposure may be spread equally over the whole print, producing a soft overall effect; it may be used for vignetting so that the image merges into a black border; or it may be directed to a particular area by means of a torch to cause local darkening.

Floodlight
General term for an unfocused artificial light source that provides a constant and continuous output of light, suitable for studio photography or similar work. A floodlight usually consists of one or more 275–500 W tungsten filament lamps mounted in a reflector.

Fluorescence
Emission of radiation in the form of light from certain substances that have acquired energy from a bombarding source of radiation, usually ultraviolet light. Substances that absorb light usually convert it into kinetic energy or heat, but fluorescent substances, which include many minerals, convert the short wavelengths of (invisible) UV light into longer wavelengths of (visible) fluorescent light. The fluorescence usually ceases when the source of energy is removed, but in some cases it continues – radiation of this kind is called phosphorescence. Fluorescent lamps consist of a tube internally coated with a fluorescing substance such as phosphor and containing mercury vapour, which produces UV radiation during an electric discharge. Fluorescent dyes are incorporated in the base of some printing papers to make white areas on the print appear more brilliant, especially when seen by daylight, which is rich in UV radiation. The phenomenon of fluorescence is also made use of in specialized branches of photography to create contrast that is not apparent in ordinary light. It is, for example, possible to detect falsifications to documents because of the different degrees of fluorescence of inks that might appear identical under normal lighting conditions. In such photography, a UV filter has to be used to prevent invisible radiation from reaching the film and thereby obscuring the effect caused by the fluorescent light.

F number see APERTURE

Focal length
Distance between the rear NODAL POINT of a lens and the point at which rays of light parallel to the optical axis are brought to focus when the lens is focused at infinity. The longer the focal length, the narrower the angle of view of a lens.

Focal plane
Plane on which the image of a subject is brought to focus by a lens. In practical terms, the focal plane is the film itself.

Focal plane shutter see SHUTTER

Focal point
Point at which rays of light from a given object point meet after transmission through a lens.

Focusing
Adjusting the lens to film distance in order to form a sharp image of the subject on the film. On all but very simple cameras (which have a fixed lens operating at an aperture small enough to ensure that everything beyond a distance of a few feet is in focus) there is some means of changing the lens to film distance. On large-format cameras this is usually accomplished by moving the front (lens) panel relative to the back (film) panel to which it is joined by bellows (the back panel usually remains stationary as it determines magnification or image size); in smaller cameras the lens is usually adjusted with a screwing action. In large-format and reflex cameras the photographer can see on the FOCUSING SCREEN an exact image of what will be recorded on the film and can thus assess focus visually. In non-reflex cameras in which the image is not seen through the lens, focusing is done either by estimating the distance (basic cameras sometimes give a limited choice of settings related to symbols such as a head and a range of mountains for the shortest and longest distances) or in more sophisticated models by a **rangefinder** device. This works by comparing images of the subject reflected by two mirrors (or prisms) within the camera that move relative to one another as the lens is adjusted. When the images co-incide (either two images overlapping perfectly or two halves of a split image joining) the subject shown is sharply focused. A split image device is also incorporated as a focusing aid in the focusing screen of many SLR cameras, which often have as an alternative or additional aid a system of microprisms that shimmer when the image is out of focus and become clear when it is sharp. Often the microprisms are arranged in a ring or collar around the split image device. See also AUTOMATIC FOCUSING and DIFFERENTIAL FOCUSING.

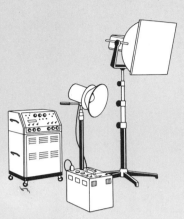

Flash: studio flash

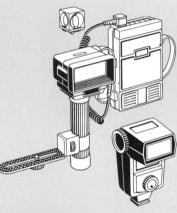

Flash: portable flash

Focusing cloth
Small sheet of opaque cloth used to aid focusing with a large-format camera. It is draped over the photographer's head and shoulders, cutting out external light from the viewing screen to enable as bright an image as possible to be formed on it.

Focusing hood
Folding hood incorporated in waist-level reflex cameras as an aid to focusing. It surrounds the viewing screen, shielding it from light so that a clear, bright image can be seen. The hood often incorporates a magnifying glass that can be folded out for precise focusing of the central area. Some large-format cameras can take hoods that invert the image to appear upright.

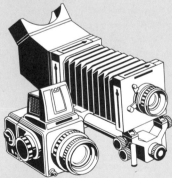

Focusing hoods

Focusing screen
Screen of glass or plastic mounted in a camera to allow viewing and focusing of the image that the lens forms. GROUND GLASS focusing screens are used principally in large-format cameras. SLR cameras usually have a FRESNEL LENS incorporated in their focusing screens, together with one or more focusing aids, typically in

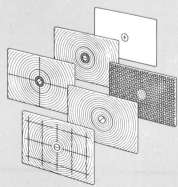

Focusing screens

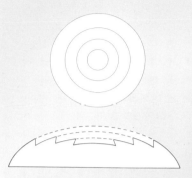

Fresnel lens

Glazing machines

Grey scale

the form of a microprism collar and/or a split image rangefinder device. Some SLR cameras have interchangeable focusing screens suited to specialist subjects or the photographer's individual preferences. A screen with a grid of fine horizontal and vertical lines, for example, is a useful aid in architectural photography for ensuring correct alignment of the upright and transverse elements of buildings.

Fog
Veil of silver in a negative or print that is not part of the photographic image. Fogging is often accidental and can be caused in a variety of ways: optically, by stray light entering the camera or film cassette and exposing all or part of the film; chemically, by faulty processing solutions such as an overactive developer or a weak fixer containing heavy deposits of silver salts (see DICHROIC FOG). It can even be caused by vapours in the darkroom. Intentional fogging is a stage in the processing of colour reversal film. In those areas where unexposed and unwanted silver halides remain on the developed image, they must first be re-exposed and developed before being bleached away.

Fog level
Density of fog produced when an unexposed film is developed. For a film to register an image properly, the minimum density produced by exposure must be above fog level.

Forced development
Development that is extended beyond the normal level to attempt to increase the density of an underexposed negative. It is used particularly when a film has been uprated. The price paid for the increased density is greater graininess and the risk of a high fog level.

Fresnel lens
Lens consisting of a plane surface on one side and a series of concentric stepped rings, each a section of a convex surface, on the other. This construction, in which the stepped rings collectively refract the light to the same extent as would a single more bulbous convex surface, produces a very flat lens of light weight. Because a Fresnel lens has a series of refracting surfaces rather than a single one, it provides even illumination and sharpness all over, with no fall-off at the edges. The rings, however, are visible, and Fresnel lenses are mainly used in spotlights and focusing screens.

G

Gamma
Measure of the gradient of the straight line section of the CHARACTERISTIC CURVE, expressing the contrast of a given photographic material under specified conditions of development. On a characteristic curve graph the vertical axis represents density (D) and the horizontal axis represents the log of the exposure (E): gamma (γ) =D/log E.

Gamma rays
Rays emitted by radioactive bodies – similar to X-rays but of shorter wavelength and possessing greater powers of penetration. Gamma rays are used in industry to reveal and record on film the internal structure of materials in much the same way as X-rays are used in medicine to "see" inside the human body.

Gelatin
Substance used as the binding agent for the grains of silver halide in photographic emulsions. Gelatin, which is also used to make filters, is an animal protein, for which completely satisfactory synthetic alternatives have not been devised. The properties that make it especially suitable for use in emulsions are transparency, flexibility, permeability by the solutions used in processing, the ease with which it can be converted from liquid to solid, and its protective bonding action towards silver halide grains.

Ghost image
Image of a light source or bright highlight formed on the negative by unwanted reflections from the internal surfaces of the front and back elements of a compound lens. A ghost image, then, is a particular kind of FLARE, consisting of an identifiable image such as a window, and can be largely overcome by using COATED LENSES.

Ghost photograph
One of the commonest types of trick photograph, produced by double exposure. Two exposures of the same scene are made on a single sheet or frame of film, identical except that in the second a figure is introduced. In the resulting print the figure appears as a transparent ghostly presence.

Glazing
Process by which glossy prints can be given a shiny finish by being dried in contact with a hot drum or metal sheet of chromium or steel plate.

Glossy paper
Printing paper with a smooth and shiny surface. Glossy paper produces sharp prints with deep blacks, bright highlights and clear detail, and is therefore much used for technical photographs and those intended for reproduction. A drawback of glossy paper is that it tends to show up blemishes much more clearly than textured or matt surfaces, where the greater scattering of light (see DIFFUSION) makes faults less noticeable. For the same reason it is more difficult to retouch glossy prints.

Goldberg wedge
Wedge-shaped layer of tinted gelatin sandwiched between glass, used in sensitometry. The density of the gelatin increases in measurable degrees from the thin to the thick end of the wedge, and negative densities can be compared with these known values.

GOST
Abbreviation for Gosudarstvenny Obshchesoyuzny Standart (Soviet Government All Union Standard), used to designate a rating system for FILM SPEED used in the USSR and some Eastern European countries. GOST is a mathematical system similar to ASA.

Gradation
Term used to describe the range of contrast or tonal variation in a photographic image. An image that has many different intermediate tones between the darkest and lightest parts is described as having a soft gradation; when there are few variations between light and dark, the image is said to have a hard gradation. Gradation depends initially on the speed of the film, slow film producing hard gradation and fast film soft gradation, but it is also affected by development. Concentrated and extended development leads to hard gradation, dilute and shortened development to soft gradation.

Grade
Term used to describe the degree of contrast of black and white printing papers. They are usually available in a variety of different grades.

Grain
Granular texture appearing to some degree in all processed photographic materials. In black and white photographs, the grains are minute particles of black metallic silver that constitute the image. In colour photographs, the silver has been removed chemically, but tiny blotches of dye retain the appearance of graininess. The faster the film, the coarser the texture of the grain. Grain may be undesirable in photographs that aim to convey maximum sharpness and detail, but it can also produce arresting pictorial effects that are appropriate for the subject, conveying intimacy, for example. in candid shots. The term **granularity** is applied to the objective measurement of grain, the term **graininess** to its subjective assessment.

Grey card
Card of a standard reflectance, used to obtain average reflected light exposure readings.

Grey scale
Series of grey tones arranged (on a print or transparency) in a regular order of increasing or decreasing depth of tone, used as a standard against which measurements can be made in sensitometry.

Ground glass
Translucent glass with a granular textured surface on one side on which images can be formed. It is used primarily in focusing screens.

Guide number
Indication of the power of a flash unit, enabling the correct aperture to be selected at a given distance between flash and subject. The number divided by the distance gives the f stop to be used. A film speed is specified with the guide number, and a new guide number is needed for different speeds.

Halation
Phenomenon characterized by a halo-like band around the developed image of a bright light source. It is caused by the internal reflection of light from the support of the emulsion – the paper of the print, or the base layer of a film. While technically it may be considered a fault (negative materials usually have an ANTI-HALATION backing to prevent it), the phenomenon can create interesting effects of light, and in some pictures may be considered an advantage.

Half-frame
Film format measuring 24×18mm, half the size of the standard 35mm frame.

Half-plate
Term used to describe a negative or (now more commonly) a print measuring $4\frac{1}{4}\times6\frac{1}{2}$in.

Halogens
Group of chemical elements, among which chlorine, bromine and iodine are included. These elements are important in photography because their compounds with silver (silver halides) form the light-sensitive substances in all photographic materials.

Hardener
Chemical used to strengthen the gelatin of an emulsion against physical damage caused, for example, by scratches on the surface and high temperatures in processing and drying. Hardeners can be incorporated in the fix, or as a special hardening bath after processing.

Heat filter
Device that absorbs heat radiation from a beam of light without affecting its degree of illumination to an appreciable degree. Heat filters are used mainly in projectors and in some enlargers.

High-contrast developers
Developers based on hydroquinone and alkali that yield very high contrast results, especially with lith films, halftone, document and line images.

High-key see KEY

Highlights
Bright parts of the subject that appear as the densest areas on the negative and as the lightest areas in prints or transparencies.

High-speed processing
Method of rapid developing and fixing of photographic materials when conventional processing techniques are too slow. Picture editors of newspapers and agencies, for example, often need prints very quickly, and darkroom technicians use a variety of means to provide almost instantaneous (yet good quality) negatives and prints. Some make up their own solution of such developers as Ilford's liquid Autophen (a Phenidone developer used in machine processors), ID 11 or Microphen, warmed to just below the point where chemical fog might be a hazard. Negatives can be developed in 20 seconds, fixed in two minutes with a rapid fixer, and dried in two minutes, the entire process taking less than five minutes. Monobath developers, which also incorporate a fixing agent, can develop and fix a film in three minutes while still in the cassette. Prints from these, though, may lack contrast, and there is a slight chemical fog, so the process has yet to be refined for commercial application.

Holography
Technique whereby information is recorded on a photographic plate as an interference pattern that, when viewed under the appropriate conditions, yields a three-dimensional image. Holography bears little relation to conventional photography except in its use of a light-sensitive film.

Hot shoe
Fitting on top of a camera that incorporates a live contact for firing a flashgun, thus eliminating the need for a separate socket. It makes contact between the flashgun and the shutter circuit to provide flash synchronization.

Hue
The title of a colour, the property that distinguishes blue, for example, from red. Hue is determined by wavelength; red has a longer wavelength than blue.

Hyperfocal distance
The shortest distance at which a lens can be focused to give a depth of field extending to infinity. Depth of field, of course, extends in front of the focused point as well as behind it and when the lens is focused on the hyperfocal distance, depth of field will in fact extend from half that distance to infinity.

Hypersensitizing
Term used to describe any method of increasing the speed, or sensitivity, of a photographic emulsion after manufacturing and before exposure in the camera; treatment after exposure is known as LATENSIFICATION.

Hypo
Colloquial name for sodium thiosulphate, which until recently was used universally as a fixing agent. The term was thus once generally used as a synonym for FIXER.

Hypo eliminator
Solution for removing traces of hypo from negatives or prints so as to reduce washing time. It is used particularly in HIGH-SPEED PROCESSING.

I

Image
Optical representation of an object or subject formed by rays of light reflected or refracted from it. An image formed on a physical surface (such as a focusing screen) is called a **real image**. When such an image is formed on a plane in space rather than on a surface, it is called an **aerial image**. An image which cannot be formed on a screen is called a **virtual image**. Such an image (for example, that which we see in a mirror) is seen in a position through which rays of light appear to have passed, but have not. The invisible image formed on the emulsion during exposure is called the LATENT IMAGE.

Image fall-off
Deterioration of definition and/or brightness towards the edges of an image formed by a lens. See ABERRATION, COSINE LAW and COVERING POWER.

Image intensifier
Electronic device that is placed between the lens and camera body to increase image brightness. Essentially, the device consists of an evacuated glass envelope with a semi-transparent photo-cathode at one end and a television type luminescent screen at the other. The photo-cathode receives the image and emits a pattern of electrons proportional to the brightness of the image, which the screen then converts back into visible light. Image intensifiers, which typically provide a gain in intensity of about ×50 ($5\frac{1}{2}$ stops), can be used only for black and white photography.

Image plane
Alternative term for FOCAL PLANE.

Incident light
Light that falls on a subject or surface as distinct from light that is reflected from it. Many hand-held exposure meters are able to measure the incident light in addition to the reflected light.

Indicator
Chemical or chemicals that when added to a processing bath indicate certain features about its condition, particularly the pH factor (degree of acidity or alkalinity), which shows the effectiveness of the solution.

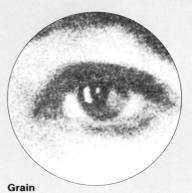
Grain

Half-frames (enlarged)

High-key

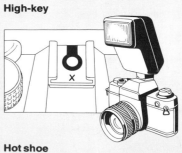
Hot shoe

DICTIONARY

Infrared photography

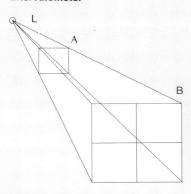

Intervalometer

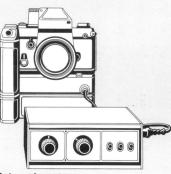

Inverse square law:
light intensity at B is one
quarter of light intensity at A,
which is half the distance
from the light source, L

Infinity
Theoretically, a point which is immeasurably distant; in practice, a point at such a distance from the camera that moving beyond it makes no difference to the sharpness of the image focused by the lens. The infinity setting, marked on the camera by the symbol ∞, places the lens as close as possible to the film plane, giving a sharp image of distant objects.

Infrared
Radiation with a wavelength longer than that of visible red light. Infrared radiation may be felt as heat, and can be recorded on suitable types of photographic film. Special dyes within its emulsion make infrared black and white film sensitive to these long wavelengths. Surfaces that emit infrared radiation appear as white on the finished print, other surfaces appearing as black. Deciduous foliage, for example, reflects infrared, creating the ghostly effect of white trees against a black sky. Infrared colour film is a tripack reversal film sensitized to green and red, but with the blue-sensitized layer replaced by one that is infrared sensitive. Infrared colour film produces an image that is predominantly magenta-coloured, but this can be altered by the use of filters. A green filter, for example, will change reds to orange, skin tones to yellow, and white to green. As well as producing such interesting effects, infrared photography has many specialist applications in various technical and scientific fields, from plant pathology to the investigation of documents.

Integral tripack
Composite photographic emulsion used in virtually all colour films and papers, in the form of a multi-layer "sandwich" of subtractive colour dyes coupled to silver halides. The layers are blue-sensitive for the yellow dye image; green-sensitive for the magenta dye; red-sensitive for the cyan dye. In addition to these three main layers, the emulsion contains other layers, such as a yellow filter to prevent blue light penetrating the red and green layers and an ANTI-HALATION layer. Including the film base, some instant colour print film packs have as many as ten layers.

Intensification
Technique of increasing the image density of a thin black and white negative, either with a chemical or dye intensifier, or by optical means. The chemical process is the one most widely employed, the negative being treated by immersion in chemical baths containing chromium, mercury or silver compounds that increase the size of the silver halide grains. This will, of course, intensify only areas where halides exist, thus increasing the image contrast. Silver areas of the image can also be treated with dye toners, increasing the opacity of the negative

and thus partially stopping the light-waves passing from the enlarger to the print. Optical treatment by IRRADIATION consists of photographing the negative by a raking side light. The silver grains scatter the light within the emulsion, thus producing a denser image.

Interference
Alteration of the wavelength of light resulting from the meeting of two wavefronts, as when light reflected from the back of a thin film meets light reaching the front.

Intermittency effect
Phenomenon observed when an emulsion is given a series of very brief exposures, resulting in an image of weak density and loss of contrast owing to RECIPROCITY LAW FAILURE. The density of the image produced is lower than that produced by a single exposure of duration equal to the total of the short series of exposures.

Internegative film
Special type of film designed to produce copy negatives. It has a built-in mask against loss of saturation and against an increase in contrast inherent in the copying technique. Colour internegative film is often used to produce an intermediate negative from a colour transparency from which colour prints are required.

Intervalometer
Device that can be fitted to an autowinder or motor-drive to provide a predetermined delay between exposures in any one sequence. The delay may be variable from as little as a second up to several days. It is often used in conjunction with a DOSIMETER.

Inverse square law
Mathematical formula used in calculating the increase or decrease in light intensity falling on a surface as the distance between the surface and a point source of light changes. This change of intensity is calculated by inversely squaring the change of distance. At twice the distance the light has one-quarter the intensity. If the distance is reduced three times the intensity is increased nine times. The law applies only to light radiating from a single point source, and is used to calculate the guide number (flash factor) of flash bulbs and electronic flash.

Inverted telephoto
Short focal length lens with a comparatively long BACK FOCUS. Many WIDE-ANGLE lenses for 35mm cameras are of this construction.

Iris diaphragm see DIAPHRAGM

Irradiation
Scattering of light within the emulsion, caused by multiple reflections from the minute silver halide crystals. It increases the effects of HALATION, and is

more prevalent in thick emulsions than in thin ones. Effects of irradiation can be partially controlled by using a high-acutance surface developer that speeds up the development of low-density areas adjacent to the areas of high-density irradiation.

IR setting
Mark sometimes found on the focusing ring of a camera lens indicating the shift in focus needed for infrared photography. Infrared radiation is refracted less than visible light, and the infrared image is therefore focused slightly behind the visible image.

ISO speed see FILM SPEED

 J

Joule
Unit of energy equal to one watt-second. In photography, the joule is sometimes used to indicate the output from an electronic flash.

 K

Kelvin scale see COLOUR TEMPERATURE

Key
Term describing the prevailing tone of a photograph. "High-key" refers to a predominantly light image; "low-key" refers to a predominantly dark one.

Key light
The main source of light in any lighting set-up, determining the overall character of the illumination.

Kostinsky effect
Development phenomenon whereby small areas in the image situated very close together shift relative to one another. It is caused by the same kind of exhaustion and displacement of developing solution that brings about EDGE EFFECTS. In the case of dense areas on a clear ground, the developer exhausts more rapidly between the areas than elsewhere, so that the edges of the areas are underdeveloped and in effect recede. In the case of light areas on a dense ground, the opposite effect takes place and the areas move nearer to each other.

L

Lamphouse
Part of an enlarger or projector containing the lamp or light source. Since the lamp gives off considerable heat, the lamphouse is usually ventilated (and in the case of a projector cooled) by an electric fan. The lamphouse may also contain a heat filter, condenser, reflector and negative carrier.

Lantern slide
Rather archaic term for a projection slide or transparency. It dates from the time when projectors were called magic lanterns.

Large-format camera
General term applied to cameras using large sheet film negatives, now usually 5×4in and above, although smaller formats such as $3\frac{1}{4}×4\frac{1}{4}$in (quarter-plate) are also still used. Large-format cameras come in many shapes and sizes, but they all share certain characteristics. They focus by means of extensible bellows running between front and rear panels. The front panel holds the lens, the rear panel a ground glass screen, which is replaced by a DARK SLIDE containing film when the exposure is to be made. Interchangeable lenses usually have integral diaphragms and shutter mechanisms. Images on the focusing screen are inverted, but some cameras take a focusing hood with an angled mirror that corrects the image to appear the right way up. The various names applied to different types of large-format camera tend to be used with a confusing degree of interchangeability and lack of precision. The clearest distinction that can be made is between **monorail** and **baseboard** cameras. Monorail cameras have a sturdy tube or rail on which the bellows and panels slide, with a locking mechanism to clamp them firm. They provide the greatest possible control over the image, having a complete range of camera movements and the capacity for variable extension by the addition of extra bellows and rail elements – there is no camera "body" as such. In baseboard cameras, the lens panel and bellows move on twin rails on a baseboard that folds up against the rear panel when the camera is not in use, making the unit comparatively compact and portable. Baseboard cameras have more restricted movements than monorail cameras, sometimes limited to rising and falling front. The terms **field camera** and **view camera** are used for large-format cameras designed to be portable enough for regular work in the field, and they are thus more-or-less synonymous with baseboard camera. The term **studio camera** now tends to be restricted to the very large and solid type of apparatus hardly ever met with outside the establishments of professional portrait photographers. **Technical camera** is a term used virtually synonymously with large-format camera, and the term **plate camera** is still often encountered used in the same fashion, although all modern large-format cameras, of course, take sheet film rather than glass plates.

Laser
Acronym for Light Amplification by Stimulated Emission of Radiation, describing a device for producing an intense beam of coherent light of a single

very pure colour. Lasers are used in the production of holograms and in various fields of scientific photography. A technique has also been recently developed for making colour prints from transparencies by using lasers to produce from a 35mm transparency a set of electronic signals that can be processed to produce a print. Blue, green and red lasers pass through the transparency and generate electronic signals according to the proportions and densities of the colours in the image; the signals are processed in a computer and used to drive three more lasers that make an exposure on high-resolution, fine-grain film that can be processed in the normal way. This laser process, which is available commercially, produces prints of a quality comparable with those obtained by the dye transfer process but is quicker and also cheaper per print. It is also possible to use the process to produce a variety of special effects by distorting the colour values of the image.

Latensification
Intensification of the latent image, a process similar to HYPERSENSITIZING but differing in that it is carried out after exposure and before development of the negative. Latensification may be carried out with a chemical solution or a chemical vapour and also by exposure to light. In effect it is a method of boosting the emulsion speed of negatives that have suffered from RECIPROCITY LAW FAILURE through very long exposure to weak light or very short exposure to insufficient light. Exposing the latent image to additional light at low intensities increases image density only in areas where the image already exists, and although some overall fog is also formed, this is more than compensated for by the gain in image intensity that the process produces.

Latent image
Invisible image recorded on photographic emulsion as a result of exposure to light. The latent image is converted into a visible image by the action of a developer. The manner by which the physical formation of the latent image takes place is still not clearly established, but it may be that atoms of silver coagulate or concentrate through the influence of actinic light to form nuclei of silver specks. The increase in growth of these specks depends on the relative intensity of the light and it appears that a foundation of receptive nuclei is necessary to establish growth and image formation. Weak light fails to create a sufficiently stable foundation upon which to build a strong image, resulting in RECIPROCITY LAW FAILURE, often encountered when very short exposures are used.

Lateral chromatic aberration see ABERRATION

Latitude see EXPOSURE LATITUDE

LCD (Liquid crystal display)
Electronic numerical indicator that displays shutter speeds and apertures in the viewfinder of certain SLR cameras, relating directly to the camera's exposure control. LCD systems, which are also used in other photographic apparatus such as hand-held exposure meters, have the advantage over LEDs of using less battery power but the disadvantages of being less easily visible in dim lighting conditions and suffering in temperature extremes. At high temperatures (above about 60°C) the display turns black, clearing as it cools down, and at low temperatures (below about −10°C) the liquid crystals become more viscose, causing the reaction time of the display to slow down. Among the cameras that use LCDs, which are a fairly recent innovation, are the Nikon F3 and the Ricoh XR7; in the Nikon, the information is presented as digital figures; in the Ricoh by a needle moving over a scale.

Leaf shutter
An alternative term for between-the-lens SHUTTER.

LED (Light emitting diode)
Solid state electrical component used as a glowing coloured indicator inside a camera viewfinder or other photographic apparatus to provide a visual signal or warning indicator for various controls. The most common use of LEDs is to provide exposure information in viewfinders. This is done most simply by a light glowing when exposure is correct, and in its most sophisticated form by a display of digital figures indicating aperture, shutter speed and other factors such as whether flash is being used. The Canon A-1 and Mamiya ZE-X are cameras using such digital displays.

Lens
Device of glass or other transparent material used to form images by bending and focusing rays of light. Light travels more slowly through the solid material of the lens than through air, so that rays of light, other than those travelling along the lens's axis, are bent, or refracted, both on entering the lens and on leaving it. As well as bending light, a lens also disperses it, the blue component, for example, emerging at a different angle to the red. The refractive and dispersive power of a lens depends on the composition of the glass and on the lens's shape, and lenses are grouped into two main types according to shape – converging and diverging. A converging, or positive, lens bends light rays to meet at a point on the axis of the lens; a diverging, or negative, lens bends light rays to spread away from the axis. Converging lenses are thicker at the centre than at the edges, and thus essentially convex; diverging lenses are thicker at the edges than the centre, and so essentially concave. One of the surfaces

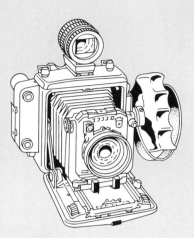

Large-format camera: baseboard type

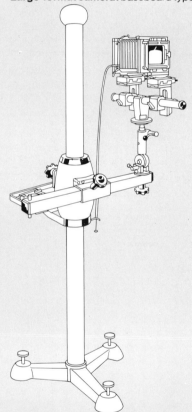

Large-format camera: monorail type mounted on a studio stand

LEDs

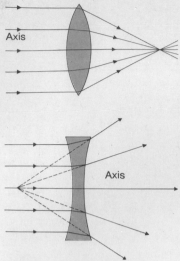

Lens: the refraction of light by a converging (positive) lens, above, and a diverging (negative) lens, below

Lens shapes: above converging, below diverging (1) biconvex (2) plano-convex (3) concavo-convex (4) biconcave (5) plano-concave (6) convexo-concave

Wide

Long

Standard

Lens hoods

may also be flat, and according to the arrangement of convex, concave or flat surfaces, lenses may be classified into six different kinds – biconvex, plano-convex, concavo-convex, biconcave, plano-concave and convexo-concave. Most lenses are biconvex, and the word "lens" in fact derives from the Latin for lentil (*lens*) because of the similarity in shape. The OPTICAL GLASS used in lenses is of two main types: flint glass possesses a high refractive index and high degree of dispersion; crown glass combines a high refractive index with low dispersion. A single lens cannot produce an image that is acceptably accurate for normal photographic purposes, and the principal aim of the lens designer is to combine separate pieces of glass (elements) into a compound lens that reduces ABERRATIONS to a minimum. A standard lens for a 35mm camera usually has about six elements; a zoom lens may have well over a dozen elements. The calculations necessary to determine suitable curvatures for the glass surfaces involve the tracing of the paths of thousands of imaginary rays of light through various elements. Today this is done by computer, but originally involved extraordinarily painstaking computations by hand. The Hungarian mathematician Josef Petzval, who in 1840 designed the celebrated lens named after him (the first lens to be designed in the modern sense rather than created by a process of mechanical trial and error), is said to have obtained the services of a company of military engineers to assist him with his calculations. Grinding and polishing of lenses must also be carried out with extreme accuracy to ensure optimum optical performance. Assessing the quality of a lens involves the consideration of many different factors, which goes some way to explain why evaluations of the same lens in different photographic journals may vary considerably. The factors taken into consideration usually include resolving power, degree of contrast and balance of aberrations. A lens giving good contrast may produce an image that to the subjective human eye looks sharper than one produced by a lens with higher resolving power but giving weaker contrast.

Lens hood
Simple lens accessory, usually made of thin metal or rubber, used to shield the lens from light coming from areas outside the field of view. Such light is one of the sources of FLARE. Lens hoods are designed specifically for each focal length of lens, giving an angle of view slightly larger than the lens's. Obviously, a hood made for a long focal length lens would cut off the field of view of a wide-angle or standard lens, and as a general rule the shorter the focal length, the shallower the depth of the hood. Rectangular hoods are more efficient than round ones.

Lens mount
Mechanism on an interchangeable lens for fitting it to the camera body, most common with lenses for 35mm single-lens reflex cameras. There are two main kinds of lens mount – screw thread and bayonet: the former, as the name suggests, screws into the camera body; the latter locks the lens into position by slotting a flange (bayonet) into a groove and giving the lens a short twist. Bayonet lenses have now virtually eclipsed screw lenses as they are quicker to use and can more easily accommodate the sophisticated linkages necessary to convey information between body and lens in modern battery-powered automatic cameras. An advantage of the screw mount, however, is that whereas bayonet mounts (with one exception mentioned below) usually fit only one manufacturer's range of cameras, screw mounts are more standardized. For this reason the 42mm diameter screw thread for 35mm cameras is sometimes called the "universal screw mount"; it is also known as Pentax screw and Praktica screw, after the names of two of the famous manufacturers most closely associated with it. Pentax also introduced the bayonet mount (known as the Pentax "K" mount) that has become most popular, being used by Chinon, Cosina, Ricoh and a number of other camera manufacturers. Many independent manufacturers make lenses obtainable with a choice of mounts, and adapters are also available to enable various lenses to be fitted to cameras other than those for which their mounts are matched.

Lenticular system
System of small lenses of equal size and shape combined for the purpose of gathering and concentrating light or for breaking up an image that can later be recombined by a matching lenticular screen. The system is similar to that found in the compound eye of a fly. Lenticular lenses and screens have various uses in photography. In some exposure meters – the Weston Master, for example – a lenticular lens covers the photoelectric cell to gather light-waves and determine the angle of acceptance. Lenticular screens are employed, for example, to produce stereoscopic images and for projection purposes.

Light
Visible electromagnetic radiation, the natural agent that arouses the sense of sight. The visible part of the electromagnetic spectrum, from red to violet, encompasses wavelengths between 4,000 and 7,000Å (400–700nm), the colour of the light being determined by the length of the wave. Blue light, for example, has a shorter wavelength than red. The waves at the blue-violet end of the spectrum are the more highly actinic, that is they more strongly affect the photographic emul-

sion. Infrared and ultraviolet waves, invisible to the human eye, can be recorded on specially sensitized films.

Light units
Values used to measure light according to its intensity, colour or quality. Wavelengths are measured in Ångstroms (Å) or nanometres (nm), the former being one ten-millionth of a millimetre, the latter a millionth of a millimetre (ten Ångstroms). These units enable colours to be identified and defined scientifically. Blue-green light, for example, has a wavelength of 5,000Å (500nm). Light can also be measured according to its COLOUR TEMPERATURE in Kelvins (K) or on the MIRED scale. The intensity of light can be measured at its source; as it falls upon a subject (incident light); or as it is reflected from a subject. Light emission was originally measured by candle power related to the intensity of a specified wax candle burned under controlled conditions. This was replaced by the CANDELA, defined in terms of the radiating power of a black body at a specified temperature. Incident light is measured in lumens, one lumen being the luminous flux or light flow measured on one square metre of a subject's surface placed a metre away from a point source of one candela. The light of one candela reflected from one square metre is known as a foot lambert or nit. Many other terms are used in the scientific study of light, but they are rarely encountered in practical photography.

Line film
Type of film similar to lith film but producing even sharper edges when greatly enlarged. Line film is slightly more expensive than lith film, but it has the advantage of possessing greater exposure latitude. It is used principally in the graphics industry for copying work where maximum clarity of definition is necessary.

Lith film
Ultra-high-contrast film used to eliminate grey half-tones and produce an image of pure black and white areas. The film has a very thin coat of emulsion, producing extreme contrast, sharpness and speed, and is designed to be processed with a special lith developer based on formaldehyde-hydroquinone. Lith films are used in graphic design to convert half-tone drawings, or photographs, into line, and in the reproduction of printed matter to produce both line and screen negatives and positives.

Local control
In printing, giving specific parts of the print more or less exposure than the rest. See BURNING IN and DODGING.

Long-focus lens
Lens with a focal length greater than that of the standard lens for a given

format. As a standard lens has a focal length approximately equal to the diagonal of the film format it covers, a long-focus lens may also be defined as one with a focal length greater than this diagonal. Long-focus lenses have a narrow field of view and make distant objects appear closer; the longer the focal length, the greater the magnification and narrower the angle of view. In order to decrease their length, many long-focus lenses have a TELEPHOTO construction.

Long Tom
Colloquial term for a large, high-powered long-focus lens.

M

Mackie line
Line appearing around a highlight on a silver halide emulsion. It is produced by the lateral diffusion of exhausted developer that causes EDGE EFFECTS. The increased density at the edge of a high-density area and the reduced density at the edge of a low-density area give the effect of a lighter line around the dense image area. The Mackie line is not usually obvious except in extreme circumstances, and is particularly associated with the Sabattier effect.

Macro lens
Term used to describe any close-focusing lens, although strictly speaking it should be confined to ones capable of giving 1:1 (life-size) or larger magnifications. Macro lenses can also be used for normal photography at ordinary subject distances.

Macrophotography
The production of giant photographs, for example as posters or mural decoration. Although this is the strict definition of the term, it is more commonly used to refer to close-up photography, for which the correct term is photomacrography. The usage is so widespread, however, that it would be pedantic to attempt to discontinue it.

Magazine
Interchangeable, preloading film carrier that locks on to the back of a roll-film or 35mm cassette camera, allowing for quick change of film type or format or quick renewal of film during shooting – often invaluable aids for professional work. Bulk film magazines can hold up to 250 exposures.

Magenta
One of the three colours in the SUB-TRACTIVE SYNTHESIS, also known as minus-green. Magenta, the complementary colour to green, is formed by the combination of red and blue lightwaves, the addition of green making white light. Subtracting green from white light gives magenta, hence the term "minus-green".

Masking
Term used to describe various ways in which light is prevented from reaching selected areas of an image for various purposes. Some enlargers, for example, have masking devices built into their carrier – metal strips that can be adjusted so that only the exact part of the negative or transparency that you wish to print will be projected. More complex types of masking occur in SANDWICHING.

Masking frame
Frame placed beneath the enlarger lens (usually on the enlarger base-board) to establish print size, determine proportions of the picture and keep the printing paper flat. It may also be adjustable to provide white borders around the print.

Matrix
Gelatin relief image used to transfer colour to paper in certain printing processes such as the dye transfer process. The gelatin has a raised or embossed surface, similar to that used in letter-press printing.

Matte
Opaque strip or plate used in MASKING during exposure or printing.

Medium-format camera
Term applied to cameras taking roll-film and producing a negative or transparency between approximately 6×4.5cm and 6×9cm. Medium-format cameras therefore come in size between MINIATURE and LARGE-FORMAT cameras. There are three main kinds of medium-format camera: (1) the single-lens reflex, of which there are types used at both waist and eye level; (2) the twin-lens reflex; (3) non-reflex models, the most popular type of which is rather like an enlarged 35mm rangefinder camera except that its lens panel is fitted to extensible bellows.

Mercury vapour lamp
Light source sometimes used in studio photography, giving a bluish light produced by passing an electric current through a tube filled with mercury vapour.

Metol
Developing agent, available under various brand names. It is a white crystalline powder, and can cause allergic reaction.

Microflash
Flash of light of extremely short duration. Microflashes are obtained by using light sources such as a pulsed laser beam, and are operated in conjunction with special shutters such as a Kerr cell (see SHUTTER).

Micrograph
A photograph taken through a microscope. It is a shortened form of the more correct term, photomicrograph.

Microphotography
Technique used to copy documents and similar materials on to very small format film so that a large amount of information may be stored compactly. Special cameras are used for microfilming. The most common type is somewhat similar in appearance to an enlarger, the camera unit being attached to an upright column on which it can be moved up and down to give various reductions, while the document is placed flat on a baseboard in the same position as an enlarging easel. Lights are built-in on arms on each side of the central column. Exposure is usually automatic, with a variable speed shutter, and a typical lens has a focal length of 28mm and an aperture of f4.5. Film, which must have a very fine grain and high resolving power, comes in long rolls of various widths, usually of 16mm or 35mm format. The processed film is stored either in rolls or on small sheets of film called **microfiche**, both types being read on special viewers that project the image on to a screen, enlarging it to approximately original size. Large table viewers are now common features in libraries, and portable viewers, folding to the size of a small attaché case, are also available. It is also possible to project microfiche images on to a large-scale screen, so they can be used to illustrate lectures or demonstrations. Fiche come in various sizes; a typical one is the size of a postcard (approximately 4×6in) and contains 60 frames. An advantage of fiche over microfilm in rolls is that the material is easier to handle, and being possible to scan the film with the naked eye to locate particular images. While rolls of microfilm are highly suitable for recording rare books or other printed material, fiche are better for subjects where there is more variation in the individual images, such as, for example, photographs of works of art. The art collections of major museums such as the Victoria and Albert Museum and the Wallace Collection in London have been recorded on microfiche in this way by specialist companies such as Mindata, the microfiche format being so compact that more that 10,000 eye-legible images can be stored in an easily accessible form in a simple 12×10in binder. Microfiche (frequently computer generated) are also extensively used in trade and industry, recording, for example, customer lists and banking transactions.

Microprism
A small prism. A series of microprisms is used moulded into the standard focusing screens of most 35mm SLRs to assist focusing, the image appearing to shimmer when out of focus. The microprisms are usually arranged in a central ring or "collar". Some photographers consider them more a hindrance than a help, and prefer the viewing screens of their cameras to be as uncluttered as possible.

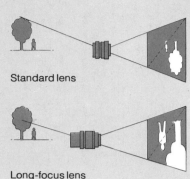

Standard lens

Long-focus lens

Long-focus lens: it has a narrower angle of view than a standard lens

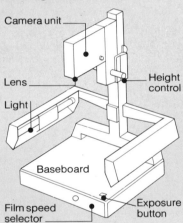

Masking frame

Camera unit

Lens

Height control

Light

Baseboard

Film speed selector

Exposure button

Microfilming camera

Microfiche: section of a 60-frame microfiche reproduced actual size

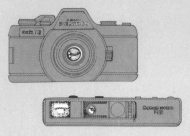

Miniature cameras

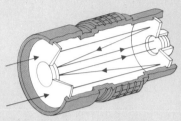

Mirror lens

Moiré

Monopod

Motor-drive

Miniature camera

Term applied to cameras with a film format of 35mm or less. It dates from the time when almost all serious photography was carried out on larger-format cameras, and since 35mm is now the most common format for both professional and amateur use, the term is falling into disuse.

Mired

Acronym for Micro-Reciprocal Degree, a unit of COLOUR TEMPERATURE used to calibrate colour correction filters. The mired value of a light source is found by dividing one million by the source's colour temperature in Kelvins. A filter's ability to change the colour quality of a light source, expressed as a plus or minus number of micro-reciprocal degrees, is called its **mired shift value**. Filters are assigned fixed mired shift values by which they will modify the mired value of the light source. Yellowish filters have positive mired shift values, which means that they raise the mired value of the light source and lower its colour temperature. Bluish filters have negative values, lowering the mired value of the light source and raising the colour temperature. A decamired is ten mireds – a colour shift of a magnitude that can just be detected by the human eye.

Mirror lens

Lens of long focal length that uses mirrors within its construction to make it more physically compact than a lens of the same focal length of normal construction. The path of light is "folded" by the mirrors, making the lens much shorter than its counterpart, and because mirrors replace some of the glass elements, it is also much lighter. Mirror lenses also reduce aberrations, because when light is reflected from a mirror it is not refracted as it is when passing through a lens. Against these obvious advantages must be set the drawback that mirror lenses have a fixed aperture – typically f8 for a 500mm lens. Under very bright conditions this problem can be overcome to some extent by using neutral density filters to reduce the amount of light entering the lens, but this will not change the depth of field, as would altering the physical aperture. The construction of mirror lenses produces a distinctive – and often very attractive – effect with out-of-focus highlights, the patches of light being ring shaped rather than continuous discs as are the ones created by lenses of normal construction. The effect is caused by the blank spot resulting from the positioning of the front mirror in the centre of the front element of the lens. The term **catadioptric** lens is often used interchangeably with mirror lens, but strictly speaking a catadioptric lens is only one type of mirror lens. A catadioptric lens uses mirrors and lenses; the other type, called a **catoptric** lens, uses only mirrors.

Mirror lock

Facility found on some advanced 35mm SLR cameras for holding the reflex mirror in the "up" position. The mirror lock is used in three different situations. First, some extreme wide-angle lenses extend so far into the camera body as to obstruct the movement of the mirror in its normal position, so it must be locked up when the lens is used. Secondly, the mirror lock can be used during extreme precision work to minimize vibration during the exposure. Finally, the mirror lock can be used when a motor-drive is fitted to the camera, so that the time taken by the mirror to rise and return to its original position does not prevent the motor-drive from operating at its highest rate of frames per second. When the mirror is locked up it is obviously impossible to view the image through the normal viewfinder, but in this situation an accessory viewfinder can be fitted to the camera's hot shoe.

Moiré

The effect produced when identical patterns are superimposed slightly out of register, producing a shimmering quality. Interesting moiré effects can be produced in SANDWICHING.

Monobath

Combination of developer and fixer in a single solution for the rapid one-stage processing of black and white film. The process takes only three to four minutes, and so is useful when speed is of the essence or for convenience on location. With the latest type, a 35mm film can be processed in the cassette and in daylight, the film being simply dropped into a container of the solution; a disadvantage is loss of contrast due to slight fogging.

Monopod

A one-legged camera support, usually collapsible. Although obviously less stable than a tripod, a monopod is a useful piece of equipment in certain circumstances, particularly where space is cramped. When photographing from a crowd, for example, the monopod can be braced against the photographer's body or can be used to lift the camera above obstructions, the shutter being operated with a long cable release.

Montage

Composite picture made from several different photographic images cut out and mounted on a single piece of paper or other support. Montage is used in making panoramas and mosaic pictures (as in aerial surveys, for example), and is one of the most common techniques used in trick photography. The image produced is frequently re-photographed so that the joins between separate parts of the picture are inconspicuous. The term montage is sometimes extended to cover pictures made by combination printing.

Mirror lock
Facility found on some advanced

Mosaic

Type of montage consisting of an assembly of separate photographs making a continuous image. Mosaics are used, for example, in aerial reconnaissance, cartography and to make panoramic views.

Motor-drive

Battery-operated device for automatically advancing film in the camera and retensioning the shutter after an exposure has been made. The terms **autowinder** and motor-drive tend not to be used with great precision. Strictly, an autowinder is capable only of winding on the film a single frame at a time and not of rapid sequences, but in practice the term is generally used for units that can wind continuously at a rate of up to two frames per second (fps); for winders capable of higher speeds than this, the term motor-drive is used. **Power-winder** is a somewhat vaguely used term, but generally it is construed as a synonym for autowinder. Almost all 35mm SLRs now accept an autowinder and/or motor-drive unit, and some medium-format SLRs accept autowinders. Cameras with built-in autowinders are made in both these formats. Autowinders are also made for the Pentax 110 format SLR and for the Leica M4-2 rangefinder. Almost all autowinders and motor-drives attach to the bottom of the camera, but they are rarely interchangeable between cameras, even on models made by the same manufacturer. Motor-drives, which come into their own in fast-action sports photography, are much more expensive than autowinders, and the cameras to which they can be fitted must be more robustly built (more "professional") than ones that accept only an autowinder because of the strain that the repeated vibration of its internal parts imposes on the camera. Most motor-drives have a maximum speed of 5fps, but Nikon make one capable of 6fps with the camera's mirror locked up. Faster speeds are available with special high-speed cameras such as the Nikon F2H, which is capable of 9fps. As a motor-driven camera operating at 5fps will run through a 36-exposure film in less that ten seconds, motor-drives are often used in conjunction with bulk film backs holding enough film for 250 or more exposures. Recently, 35mm cassettes containing 72 exposures on a very thin base have been introduced, mainly for use with motor-drives. Other pieces of equipment used with autowinders or motor-drives are the **dosimeter** and the **intervalometer**.

MQ/PQ developers

Popular developing agents based on a combination of metol and hydroquinone, or Phenidone and hydroquinone. The developers are all-purpose, producing good, strong blacks and warm tones on film negatives and on bromide papers.

MTF (Modulation transfer function) Method of evaluating the sharpness of lenses by plotting on a graph the ratio of subject/image contrast against the image resolution. To the experienced eye, the graph contains more information about lens quality than a conventional set of resolution figures.

Multigrade paper
Ilford trade name for a type of variable contrast paper, used to print negatives of varying degrees of contrast by means of changing filters in the enlarger. This variation is made possible by Multigrade's special emulsion, which has a mixture of two types of silver halide, one sensitive to blue light, the other to green light. Exposing the blue-sensitive part produces a high-contrast image; exposing the green-sensitive part produces a low-contrast image. Yellow filters are used to absorb blue light and transmit green, magenta filters to absorb green and transmit blue. An enlarger with a colour-mixing head can be used to print on Multigrade paper, but greater control is possible with special Multigrade filters, which come in a set of seven varying densities – two yellow and five magenta. It is, of course, also possible to print on Multigrade using no filter at all, so eight degrees of contrast are obtainable. Multigrade paper is of particular advantage to photographers who do not do a great deal of printing, because if several grades of paper were kept, the little-used ones would tend to go stale. It is also useful for printing difficult negatives, as by skilful local control and changing of filters it is possible to have part of the image effectively on soft paper and part of it effectively on contrasty paper.

Multi-mode camera
SLR camera offering three or more "modes" (systems of exposure control) – manual, aperture priority, shutter priority and "programmed" being the most common (see AUTOMATIC EXPOSURE). Multi-mode cameras require extremely sophisticated electronics, and are a recent innovation, the first – the Minolta XD7 – being introduced in 1977. The Canon A1, introduced in 1978, offers the most modes of any camera to date – the four mentioned above plus automatic flash and stop-down aperture priority (useful for photomacrography), in which the exposure meter reading is taken not at maximum aperture but at the selected aperture. Multi-mode cameras are relatively expensive, but because of their versatility already are very popular.

Munsell system
System of classifying and specifying colours published by the American scientist Albert Munsell in 1915 in his book *Atlas of the Munsell Color System*. Three factors are involved in Munsell's classification system: hue (the dominant wavelength of a colour – that is, the quality distinguishing, say, blueness from redness); value (lightness or darkness); and chroma (strength or purity – that is, the freedom from desaturation through admixture with white or from degradation through mixture with black). Theoretically, any colour can be specified by giving references for each of these factors. In practice, the system is employed mainly by paint chemists, who use the published colour samples as reference points.

N

Nanometre (nm)
One thousand millionth of a metre, a unit for measuring the wavelength of electromagnetic radiation. It is now replacing Ångstrom units in photographic contexts; one nanometre is equal to ten Ångstrom units.

Negative
Photographic image in which light tones are recorded as dark and dark tones as light. Lightwaves transmitted from the subject cause the silver halides in the emulsion to change through various tones of grey to black on subsequent development. The more intense the light the stronger the effect it has on the halides, and thus the darker they turn; areas from which little or no light is reflected leave clear areas on the emulsion – a reversal of the original scene. In colour negatives, every colour in the original subject is represented by its complementary. A **positive** image, corresponding in tonal values to the original subject, is made from a negative by passing light through it to a second light-sensitive material, usually printing paper.

Negative carrier
Frame for holding negatives or transparencies in an enlarger, positioned between the light source and the lens. Large- and medium-format flexible-base films may need sandwiching between cover glasses to keep the film flat, but smaller formats can be held in a glassless frame.

Negative lens see LENS

Neutral density filter see FILTER

Newton's rings
Narrow, multicoloured, concentric bands that appear when two transparent surfaces are sandwiched together with imperfect contact. The pattern is caused by INTERFERENCE, when the minute gap between the two surfaces is the same measurement as the wavelength of reflected light. The phenomenon sometimes occurs when negatives are not completely dry and are sandwiched between glass or plastic plates in a negative carrier. Some glass plates are very finely etched in order to prevent the appearance of Newton's rings.

Nodal point
Two points, front and rear, on the optical axis of a compound lens, used as references from which to make basic measurements such as focal length. Light entering a lens at a specific angle usually leaves at a different angle. However, there are two points on the axis such that a ray of light directed towards one appears to leave through the other in a parallel direction. These are the nodal points.

Nonsubstantive films
Colour reversal films that do not have colour-forming couplers incorporated in their emulsion, these being instead in the processing solutions. Kodachrome tripacks are of this type.

Notches
Indentations cut in the edges of sheet film to indicate the emulsion side – if the notch is cut from the top left of the film when held vertically, the emulsion (matt side) is facing away from you. Notches of various shapes indicate different types of emulsion.

O

Opacity
Light-stopping attribute of a material. The greater the opacity, as opposed to transparency, of a substance, the more light it will stop. In photography, opacity is expressed as a ratio of the amount of light falling on the surface of the material to the amount transmitted by it. A substance transmitting half the light falling on it has an opacity of 2, one transmitting a third of the light falling on it an opacity of 3, and so on.

Opal glass
White translucent glass, used mainly as a light diffuser in enlargers and as the viewing surface of light boxes.

Open-aperture metering
System of exposure metering, now almost universal on SLR cameras, in which the lens remains at its widest aperture until immediately prior to the moment of exposure, although by mechanical or electrical coupling the meter acknowledges whatever aperture has been set and reads accordingly. The advantage of this system over the older method of **stop-down metering** is that the viewing screen retains maximum brightness whatever aperture has been set, the diaphragm automatically closing to this aperture when the shutter release is pressed. In stop-down metering, the diaphragm has to be physically adjusted to the required aperture to obtain a correct reading. Although this means that the viewing screen progressively darkens as the aperture decreases in size, a compensating advantage is that it shows an approximation of the available depth of field.

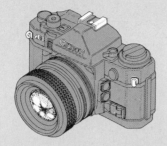

Multi-mode camera

Negative carriers

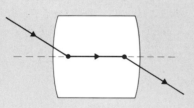

Nodal point

Notch

Open flash

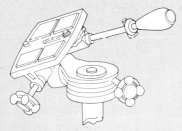

Optical axis

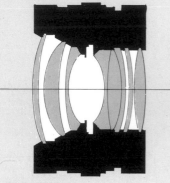

Pan-and-tilt head

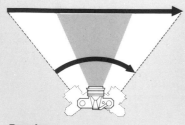

Panning

Open flash

Technique of firing flash manually after the camera shutter has been opened, instead of synchronizing the flash automatically. A particular form of open flash – known as "painting with light" – is a technique often used when making long exposures in large dim interiors, the photographer firing off several flashes from different positions while the shutter is open.

Optical axis

Imaginary line through the centre of an optical system (for example a compound lens) at right angles to the image plane. Light passing through the lens along the optical axis is not refracted and is thus free of distortion.

Optical flat

High-quality element of optical glass with the two main surfaces polished to make them as flat and parallel as possible. Optical flats are used for filters when very great accuracy of performance is required.

Optical glass

Glass of high quality and purity specially produced for the manufacture of lenses and other optical equipment. Optical glass must have precisely defined standards of dispersion and refraction, and therefore must be physically and chemically as uniform as possible, free from bubbles and other deformities. It must also transmit the maximum amount of light and not selectively absorb light of different wavelengths. Durability – resistance to water vapour, atmospheric gases and so on – is also a desirable quality, but it is not always possible to combine this with the necessary optical properties. There are two main types of optical glass: flint glass, containing lead oxide, which has a high refractive index and high degree of dispersion; and crown glass, made with barium oxide, which combines a high refractive index with low dispersion. See also LENS.

Optical wedge

Device used in SENSITOMETRY, consisting of a wedge-shaped strip of material ranging from clear at one end to opaque at the other, either in regular steps (step wedge) or in a continuous transition (continuous wedge).

Orthochromatic

Term applied to black and white photographic emulsions sensitive to the blue and green regions of the spectrum but not to red or orange light. In the 19th century, all emulsions were either orthochromatic or "ordinary" – that is, sensitive only to the blue region of the spectrum; the first panchromatic plates were introduced in the early years of the 20th century, stimulated by the work of chemists such as the Austrian Benno Homolka, who discovered the important red-sensitizing dye pinacyanol in 1904.

Ostwald system

System of colour classification invented by the German chemist Wilhelm Ostwald and published by him during World War I. Ostwald's system is somewhat similar to Munsell's, and arranges colours according to the amount of white, black and saturated colour they contain.

Overdevelopment

Over-long contact of emulsion with the developer, or use of a developing solution that is too powerful or too warm for the particular film. Overdevelopment, which results in very dense highlights and marked contrast, can be corrected to a certain extent by immersing the film in a reducing bath. For deliberate overdevelopment see PUSHING.

Overexposure

Excessive exposure of a photographic material to light. Overexposed negatives (colour or black and white) generally lack contrast and highlight detail; overexposed transparencies are "thin" with burnt-out highlights. Acceptable prints can often be made from black and white negatives by using a hard grade of paper or by treating the negative with a reducing agent; acceptable colour prints may call for prolonged exposures and further adjustments to the filter pack. It is not possible totally to negate the effects of gross overexposure of transparencies.

P

Pan-and-tilt head

Type of tripod head employing independent locking mechanisms to allow movement in two planes at right angles to each other. Thus the camera can be locked in one plane while remaining free to move in the other. Movement in the horizontal plane is called pan, movement in the vertical plane tilt.

Panchromatic

Term used to describe black and white photographic emulsions that are sensitive to all the visible colours (although not necessarily uniformly so). Panchromatic films owe their wide-spectrum sensitivity to various sensitizing dyes. See also ORTHOCHROMATIC.

Panning

The action of swinging the camera to follow a moving subject. Most often it is used to produce a sharp image of the subject against a blurred background, thus conveying a sense of movement. The celebrated French photographer Jacques-Henri Lartigue was one of the first to use the panning technique – with a hand-held plate camera.

Panoramic camera

Camera in which the lens (or the whole camera unit) travels in an arc during exposure to make a record on a long strip of film that receives successive parts of a wide view. The lens in a panoramic camera usually has a fairly narrow angle of view, and so "sees" parts of the view successively; film is wound around a curved drum and exposed through a moving slit. Panoramic cameras may be capable of covering a complete circle of 360°, but their main use is for large group portraits. The group is usually arranged in a concave curve, which, if matched properly to the curve of the film in the camera, becomes a straight line in the picture; if there is a building behind the group, it will appear to have a convex facade.

Parallax

Apparent displacement of an object brought about by a change in viewpoint. In photography, the term **parallax error** is used to refer to the discrepancy between the image of a subject as viewed and as recorded on cameras in which the viewing lens is separate from the "taking" lens and thus has a slightly different viewpoint (for example 35mm non-reflex cameras and twin-lens reflex cameras). With these cameras, parallax difference is generally apparent at subject distances closer than about six feet, when some form of compensation becomes necessary (the distance varies with the focal length of the lens being used). Non-reflex cameras often have lines in the viewfinder showing the allowance that has to be made, and some TLRs have a built-in compensation device in the form of a bar or blind (linked to the focusing controls) that moves across the focusing screen, showing the part of the image that will be cut off at various subject distances. Another method of overcoming parallax error with TLRs is, when the shot has been set up, to raise the camera by the distance between the two lenses. This can be done by simply measuring the distance and raising the tripod by this amount, or more accurately by using a special Mamiya accessory called a Paramender – a raising device that fits between the camera and the tripod. For precision close-ups, however, it is essential to use either a single-lens reflex or large-format camera as they are parallax-free, the image on the viewing screen being exactly the same as that which will be recorded on the film.

Pentaprism

Five-sided prism used as part of the viewing system of eye-level SLR cameras to provide a laterally correct, upright image in the viewfinder. In practice many pentaprisms have more than five sides – usually eight – the additional facets being due to unnecessary parts of the prism having been cut off to reduce bulk.

Permanence

Ability of a photographic image to resist fading through exposure to light or

other deterioration caused by atmospheric chemicals. Permanence is determined initially by the effectiveness of the processing, and in colour photographs by the stability of the dyes in the emulsion layers. Development and fixing must be followed by thorough washing to remove, as far as possible, all traces of those residual silver compounds that could affect the image's appearance. Hypo, for example, if left in the image can decompose into silver sulphide, causing a bleached or sepia-coloured appearance, and most other fixing agents can react in a similar way. If prints are to be mounted, dry mounting is the best method with regard to permanence, because it does not introduce any potentially harmful chemicals to the back of the print, as do many glues. When processed and stored carefully (in dry, well ventilated conditions, preferably in metal rather than wooden cabinets), black and white photographic materials will generally stay in good condition indefinitely. In the case of archive material such as microfilm of precious documents, however, more stringent environmental management is necessary, including control of temperature and relative humidity, and filtering of the air to cleanse it of acid gases. Colour images are less permanent than black and white ones, and are especially susceptible to direct sunlight, as can often be seen in the fading of colour prints displayed as advertisments in estate agents' windows or outside cinemas. To obtain maximum life expectancy, colour images should be stored in refrigerated conditions or as separation negatives. For archival storage, it is possible that colour videotapes will take over from actual dye images.

Perspective
Means by which the illusion of a three-dimensional object or space is created on a two-dimensional surface. The main elements of perspective in photography are diminution of size and convergence of lines with distance (linear perspective); the overlapping of forms; and the modifying effect of distance on colour known as AERIAL PERSPECTIVE. Depth can also be suggested by DIFFERENTIAL FOCUSING. Choice of viewpoint is obviously a crucial factor in determining the perspective effect of a photograph, and choice of lens is also important, long-focus lenses appearing to "compress" depth and wide-angle lenses having the opposite effect. Perspective effects can also to some extent be controlled (or intentionally distorted) by adjusting the relative positions of the lens and film. These CAMERA MOVEMENTS are normally possible only on large-format cameras, but on medium-format and 35mm cameras a limited range is made available by the use of a SHIFT LENS (sometimes known as a perspective control lens), which is used mainly in architectural photography.

Phenidone
Popular developing agent, produced by Ilford. Phenidone, which is more active than metol, is claimed not to cause many of the skin problems sometimes associated with processing chemicals.

Photo-cathode
Device consisting of a light-sensitive layer of such metallic substances as antimony or sodium on a glass or quartz base, which discharges electrons when exposed to a certain level of light. The electrons in the layer absorb photons and acquire their energy, which is discharged as a steady stream towards, for example, a photographic emulsion. Photo-cathodes are used in IMAGE INTENSIFIERS and in television cameras.

Photo-electric cell
Light-sensitive cell used in the circuit of an EXPOSURE METER.

Photoflood lamp
Type of filament lamp designed to be overrun to produce a more intense light than that from conventional tungsten lamps of the same wattage. Photofloods work at a temperature near the melting point of the filament, and have a colour temperature of about 3,400 K.

Photogram
Photographic image produced without a camera or lens by arranging objects on the surface of photographic film or paper, or so that they cast a shadow directly on to the material as it is being exposed. This was one of the earliest photographic techniques, used by Thomas Wedgwood and Fox Talbot, who made negative images of natural objects by direct contact on a photographic base (subjects such as plants can be kept flat with a sheet of glass). In its purest form, a photogram will have a solid black background with the shapes of the object in white, but by varying such factors as the strength, direction and character of the light source, different (often unpredictable) effects can be obtained. Indeed, the scope for imaginative experimentation and abstract composition with this essentially simple technique is very considerable – the American artist Man Ray produced some particularly outstanding work in this field (he called his photograms "rayographs"). It is also possible to produce colour photograms, using coloured paper and filters.

Photogrammetry
Branch of science concerned with using photographs to make accurate measurements. The use of aerial photographs in land surveying and map making is an example of photogrammetry, and photogrammetric techniques can also be used, for example, to measure the dimensions of buildings.

Photomacrography
The production of photographic images at a scale of reproduction on the film of 1:1 (life-size) or larger. A more commonly used term for close-up work is MACROPHOTOGRAPHY, although this can also be used to refer to the production of giant photographs.

Photometer
Instrument for measuring or comparing light intensity. An exposure meter is a kind of photometer, but generally the latter term is used for instruments that are employed, for example, to determine the levels of illumination in office buildings rather than for photographic purposes.

Photomicrography
Technique of taking photographs through a microscope. SLR cameras are most suitable for use with microscopes because of their through-the-lens viewing and metering, the camera body being fitted to the microscope by means of a special adapter. Optical microscopes can magnify up to about ×2,000, but electron microscopes, which use a beam of electrons (negatively charged atomic particles) rather than light, can magnify up to ×1,000,000 or more. Electron microscopes usually have a special camera built in at the base of the equipment. A photograph taken through a microscope is correctly called a photomicrograph, sometimes abbreviated to micrograph. The term microphotography, which refers to the copying of documents and similar materials on to a very small format film, is often confused with photomicrography. See also BRIGHT FIELD and DARK FIELD.

pH value
Indication of the degree of acidity or alkalinity of a solution, strictly defined as the logarithm of the concentration of hydrogen ions in grams per litre. The scale of pH values, on which water is neutral at pH7, is as follows:

0–2	Strongly acid
3–4	Acid
5–6	Slightly acid
7	Neutral
8–9	Slightly alkaline
10–11	Alkaline
12–14	Strongly alkaline.

In photography, pH values are important mainly in connection with developing agents, which generally work most efficiently in an alkaline solution.

Physiogram
Photographic image of the pattern traced out by a light source attached to a moving object. As well as being used in photographic experiments, physiograms are useful in industry for examining the operation of machinery, and for time and motion studies. Simple physiograms are produced by attaching a light source, such as a pencil torch, to a pendulum suspended from the ceiling or a frame. In a darkened

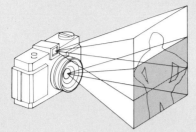

Parallax

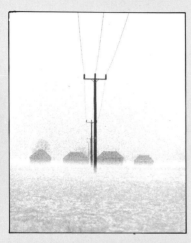

Perspective

Photogram

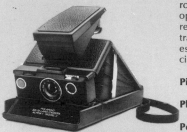

Polaroid: above, SX-70 camera; below, creative effects with SX-70 film

Projector: daylight type

Projector: autofocus type

Projector: 2¼×2¼ in format

room, with the camera's shutter kept open for a time exposure, the light will record its movement as patterned tracks of light. Tests will be needed to establish the correct exposure, especially if filters are used in colour work.

Pincushion distortion see ABERRATION

Plate camera see LARGE-FORMAT CAMERA

Point-source lamp
Arc lamp used in enlargers and projectors. An arc current, conducted by mercury vapour between two tungsten filaments or beads, heats the tungsten, which becomes incandescent and emits a powerful concentrated light.

Polarized light
Light whose vibrations are confined to a single plane. Waves of light are usually unpolarized, having electrical and magnetic vibrations in every plane, but polarized light follows a simple and regular vibration pattern, a phenomenon that has various consequences and applications in optics and photography. Light (or part of it) may become polarized in several ways – for example, when it is reflected at certain angles from flat, polished, non-metallic surfaces such as glass, water or wooden furniture; when it is scattered by tiny particles of gas or dust in the atmosphere; and when it passes through certain translucent crystals. Man-made polarizing filters, in effect screens made up of many tiny polarizing crystals, can be used for various purposes in photography, notably darkening blue skies and eliminating unwanted reflections from non-metallic surfaces. When eliminating reflections, the polarizing filter is, in fact, blocking the light that has already been polarized and passing the non-polarized part. The filter is able to do this because it has a specific plane of polarization, and thus by rotating the filter the proportion of light inhibited can be varied. Further variation is possible with two polarizing filters, and if they are placed with their planes of polarization at right angles to each other, no light at all is passed (this phenomenon was first noticed by the 17th-century Dutch scientist Christiaan Huygens, who discovered that if the crystals of certain translucent minerals were placed with their long axes at right angles, they stopped the passage of light). Two polarizing filters can thus be used as a kind of variable neutral density filter, and the two types of filter are, in fact, very similar in appearance. Polarizing filters used in pairs can be particularly useful in photomicrography; certain crystals, for example, may be indistinguishable in ordinary light, but differ in their ability to polarize light and therefore show up clearly when the filters are suitably rotated. As well as being scientifically useful, this procedure can produce colour images of startling beauty.

Polaroid camera
Camera that produces more-or-less instantaneous pictures by using a "sandwich" of film, processing chemicals and printing paper. After exposure the sandwich is ejected from the camera through rollers that rupture pods containing the chemicals. Development usually takes about 10 seconds to a minute. Although Polaroid cameras are most closely associated with family snapshots, Polaroid film has also become an invaluable aid to studio photography, as it enables lighting and exposure to be accurately monitored before a shot is made on ordinary film. Polaroid backs are available for almost all large- and medium-format cameras and also can be fitted to some 35mm SLRs. In addition, Polaroid markets a "professional" camera, the 600SE, a "press" type with interchangeable lenses, producing 4¼×3¼in prints with an image area of about 3¾×3in. There are several types of Polaroid film, colour and black and white, and with one exception they produce only a print and not a negative, so additional prints can usually be made only by copying the original print to make a conventional negative. The exception is Type 665, a black and white film that produces a print and recoverable negative at the same time. Another Polaroid film, SX-70, can be used for creative effects, and a book has been published on the subject. Rubbing a print with an object such as the end of a pen while it is developing, for example, will produce streaky lines and blurring. In addition to Polaroid, Kodak and Fuji now also produce instant-picture cameras and film; their products and Polaroid's are not compatible.

Positive see NEGATIVE

Positive lens see LENS

Posterization
Technique of drastically simplifying the tones of an image by making several negatives from an original, with different degrees of density and contrast, and then sandwiching them together and printing them in register. The technique is so called because it makes it possible to produce, by using the high-contrast properties of lith film, the bold, striking effects associated with the style of posters during the 1930s in which shapes were filled in with solid, unshaded colours. Many different combinations are possible in posterization, and there is considerable scope for experimentation.

Power-winder see MOTOR-DRIVE

Preservative see DEVELOPER

Primary colours
In the ADDITIVE SYNTHESIS of colour, blue, green and red. Lights of these colours can be mixed together to give white light or light of any other colour.

Process camera
Special type of large-format camera used for extremely high-quality copying work, usually to make images for photomechanical reproduction or for scientific work. There are various different types of process cameras, some arranged horizontally, others vertically. The most specialized may be very large (capable of making negatives over 4 feet square), with motor-driven movements enabling settings to be made with extreme accuracy. In the largest types, the end holding the film may be built in to a darkroom.

Process film
Slow, fine-grained film of good resolving power, used mainly for copying work.

Process lens
Highly corrected lens used for copying illustrations for subsequent photomechanical reproduction. As fast exposures are not needed in copying work, process lenses have fairly small maximum apertures (generally about f8 or f11), which gives the lens designer greater scope for achieving the high degree of correction needed. As well as being more accurately corrected than conventional camera lenses for the various types of spherical ABERRATIONS, process lenses are apochromatic (that is, corrected for three colours instead of the usual two), and consequently they are very expensive to manufacture.

Projector
Apparatus for throwing an image from a transparency on to a screen. Typically, the system employs a projector lamp (usually a tungsten filament type), a condenser, cooling fan, film carrier and lens. In addition, the projector may have a magazine for rapid loading and changing, and a means of remote control or preprogrammable operation. Many modern projectors also have an autofocusing device that detects any flexing of the slide caused by heating and adjusts the focus to compensate for it. The latest designs eliminate even the need for initial focusing by hand, a system similar to that used on certain AUTOMATIC FOCUSING cameras keeping the projected image at optimum sharpness by advancing or retracting the projector lens. Most projectors are for transparencies in 2×2in mounts (they are usually 35mm slides, but medium-format "superslides" – 1⅝×1⅝in – also use this size mount). Models are also made for the 110, 126 and 2¼×2¼ formats, and some 35mm projectors are capable of accepting slides of smaller formats. Projectors are usually intended to be used in a darkened room, but there are some small, portable models with built-in screens that can be used in daylight.

Programmed exposure see AUTOMATIC EXPOSURE

Pushing
Prolonging the development of film beyond the normal duration in order to compensate for underexposure or to increase contrast. Pushing a film is often used after **uprating** (rating of a film at a higher speed index than that at which it was designed to be used), which in practical terms means underexposing to cope with low light conditions. An ASA 400 film uprated to ASA 800 represents one stop underexposure and is usually compensated for by increasing or "pushing" the development time. It is a useful technique in, for example, photo-reportage or sports photography, when it may be necessary to work with weak available light.

Q

Quarter-plate
Term used to describe a negative or (now more commonly) a print measuring $3\frac{1}{4} \times 4\frac{1}{4}$ in.

Quartz-iodine lamp
Incandescent lamp with a quartz envelope containing a tungsten filament and a trace of iodine. The iodine vaporizes as the lamp gets hot and prevents the deposits of burning tungsten from collecting on the envelope. Instead, the tungsten-iodine vapour is deposited on the filament, thus recycling the tungsten. The process prolongs the life of the lamp, increasing its working efficiency and brightness. This type of lamp has now been largely replaced by the tungsten halogen lamp, in which bromine takes the place of iodine, and types of silica envelopes other than quartz are used.

R

Rack and pinion
Mechanism for focusing used on many large-format cameras. The focusing wheel is fixed to a pinion wheel that engages in a toothed rack along the baseboard of the camera. When the focusing wheel is turned, the lens panel slides along the baseboard.

Rangefinder see FOCUSING

Reciprocity law
Principle according to which the density of the image formed when an emulsion is developed is directly proportional to the duration of the exposure and the intensity of the light. However, with extremely short or long exposures and with unusual light intensities the principle ceases to be valid and unpredictable results occur – this is known as **reciprocity law failure**. In colour photography it may cause colour casts, which to some extent can be compensated for with filters when the characteristics of the film are known.

Red-eye
Effect seen in colour photographs when the flash is too close to the camera lens, and nearly level with the sitter's eyes. The unnatural, glowing red of the eyes is due to internal reflections from the vascular membrane behind the retina, which is rich in blood vessels. In black and white photography the phenomenon produces unusually light pupils. Red-eye can be avoided by making sure the subject is not looking directly at the camera or by using off-camera or bounced flash.

Reducer
Chemical agent used to remove silver from a negative or print, thereby reducing its density. Confusion often arises between the terms "reducer" and "reducing agent"; the latter refers to a chemical agent used to convert the exposed silver halides in an emulsion to metallic silver, and is therefore a synonym for developer.

Reflector
Any surface capable of reflecting light, but in photography generally understood to mean sheets of white, grey or silvered card employed to reflect light into shadow areas. Lamp reflectors are generally dish-shaped mirrors, the lamp recessed into the concave interior, which points towards the subject. Studio electronic flash equipment is often combined with an umbrella reflector, usually silvered, mounted on a stand.

Reflex camera
Generic name for types of camera employing a mirror in the viewing system to reflect the image on to a screen. There are two main types. The **single-lens reflex (SLR)** camera reflects the image to the screen by means of a hinged mirror that flips out of the light path when the film is being exposed. Viewing and taking functions are thus combined in one lens, and if the viewing system also employs a pentaprism, the viewfinder shows exactly the same image as that which will be recorded on the film. The **twin-lens reflex (TLR)** has separate viewing and taking lenses of identical focal length. The upper (viewing) lens hås a mirror behind it that reflects light to the focusing screen. At close subject distances, the difference of viewpoint between the two lenses causes PARALLAX ERROR. TLRs are now made only for medium-format film; SLRs are most popular in the 35mm format, but there are several high-quality medium-format SLRs and Minolta and Pentax produce 110 format SLRs.

Refraction
The bending of lightwaves as they travel from one medium to another of different optical density. Three factors affect the degree of bending: the wavelength of the light; the composition of the second medium; and the angle at which the light enters it. The angle that the arriving wave makes with a line at right angles to the surface of the second medium is known as the angle of incidence; the angle that the light travelling through the medium makes with this line is known as the angle of refraction. Rays of light perpendicular to the interface between the two media are not subject to refraction. The amount of bending a medium produces is described numerically as its **refractive index**. Different colours of light (because they have different wavelengths) are refracted to different degrees, a phenomenon called DISPERSION. See also ABERRATION, LENS and OPTICAL GLASS.

Rehalogenization
The process of converting deposits of black metallic silver into silver halides. The process may be used to bleach prints in preparation for toning.

Relative aperture see APERTURE

Replenishment
The regeneration of processing solutions by the addition of those chemicals that have become weakened or used up.

Resin-coated (RC) paper
Photographic printing paper coated with synthetic resin to prevent the paper base absorbing liquids during processing. RC papers can be processed more quickly than conventional papers as they require less washing and dry more quickly. In addition, RC papers do not require glazing. Against these obvious advantages of speed and convenience must be set the disadvantages that RC paper is easily scratched (especially when wet) and difficult to retouch successfully; some critics also suggest that the blacks it produces are somewhat lacking in depth compared to those obtained using conventional bromide paper.

Resolving power
Ability of an optical system to distinguish between elements that are very close together. The resolving power of a lens (expressed in lines per millimetre) is measured by using a special test chart consisting of a complex pattern made up of lines of varying thickness. An emulsion can also be said to have a resolving power, and if this is less than that of the lens used with it, some sharpness will be lost. Factors other than resolving power also affect sharpness (see LENS).

Restrainer see DEVELOPER

Reticulation
Fine, irregular pattern appearing on the surface of an emulsion that has been subjected to a sudden and severe change in temperature or in the relative acidity/alkalinity of the processing solutions. The phenomenon is caused

Reducer: used to highlight the eye

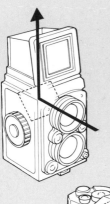

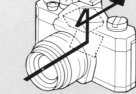

Reflex camera: above, twin-lens reflex; below, single-lens reflex

Refraction: A = angle of incidence B = angle of refraction

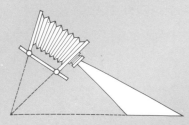

Scheimpflug principle

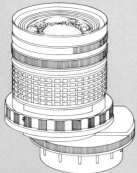

Shift lens: it allows the subject to be apparently displaced without tilting the camera

by the swelling and cracking of the gelatin emulsion and cannot be rectified once it has occurred. Reticulation may, however, give interesting effects to the final print when it is enlarged, and can be used as a means of experimenting with negatives that might otherwise be discarded.

Retouching
Handwork (on negatives, prints or transparencies) using a brush, AIR-BRUSH, pencil or knife, together with specially prepared spotting and retouching fluids, to remove or disguise flaws or otherwise improve or alter the image. Retouching is usually carried out on prints rather than on negatives or transparencies because of the larger image area and the fact that mistakes can be more easily rectified. Medium- and large-format negatives are big enough to be retouched successfully, but the job requires considerable skill and experience.

Reversing ring
Device for attaching a lens to the camera body (or extension bellows) back to front. This helps to maintain good definition in close-up work.

Rim lighting
Lighting arrangement, principally used in portraiture, in which the light comes from behind or above the subject, creating a bright rim of light around the contours.

Ring flash see FLASH

Rising front
Movable lens panel on some types of large-format cameras that allows the lens to be moved vertically in a plane parallel to the film. It is the most commonly used CAMERA MOVEMENT, and is associated particularly with architectural photography: raising the lens panel enables the top of tall buildings to be included in the picture without distorting the vertical lines. On 35mm and medium-format cameras, a SHIFT LENS performs a similar function.

Roll-film see FILM

S

Sabattier effect
The partial reversal of the tones of a photographic image, resulting from a secondary exposure to light during development. Sometimes known as pseudo-solarization, it can be used to give interesting printing effects. The secondary exposure reverses the shadow areas of the negative, but only partially, because these dense areas have already become desensitized by chemical action during development; the resulting image is a mixture between a negative and a positive. See SOLARIZATION.

Safelight
Special darkroom lamp whose light is of a colour (such as red or orange) to which sensitized materials will not respond. Not all materials can be handled under a safelight, and some require a particular type designed specially for them. Some safelights have provision for change of filter colour, the filters being made of gelatin or glass sheet. No safelight is entirely safe, however, since filters cannot block all critical wavelengths completely. Fogging will occur if the work is too close to the light, three feet away being judged the minimum safe distance. A lamp of a higher wattage than usual (25W is the normal maximum) can be used if the safelight is bounced off the darkroom ceiling, but tests for fog should be made before printing begins.

Sandwiching
The projection or printing of two or more negatives or slides together to produce a composite image. Pictures of considerable complexity and visual impact can be produced by the sandwiching technique, which is widely employed in, for example, advertising and magazine editorial pictures.

Saturated colour
Pure colour free from any admixture of grey. A saturated colour reflects light of only one or two of the three PRIMARY COLOURS; the addition of a third colour would desaturate it towards white, grey or black.

Saturated solution
Solution in such a condition that no more soluble substance can be dissolved in it at a given temperature.

Scheimpflug principle
Principle stating that for a large-format camera maximum depth of field over the subject plane is obtained when the subject plane, lens plane and image plane are so inclined that if extrapolated they would meet at a common point. It is chiefly used to work out the optimum camera position to achieve overall sharpness when a subject is disposed in a plane inclined to the camera axis, but can also be used when the baseboard is tilted in enlarging, if the enlarger's negative plane can also be inclined.

Schlieren photography
Branch of scientific photography employing an optical system sensitive to, and capable of recording, small local differences in the refractive index of transparent media. As hot air has a different refractive index from cold air, Schlieren photography can record air movement that is invisible to the eye, and can be used to study, for example, airflow in windtunnels or the transfer of heat energy from living organisms to the atmosphere. Schlieren photography was first demonstrated in Germany in the 1860s, and "Schlieren" is

German for streaks or striations. As with many other branches of scientific photography, Schlieren photography can produce very striking and beautiful images.

Scratch-proofing
Technique for hardening a photographic emulsion to protect it from abrasions. Hardeners such as potassium or chrome alum can be contained in the fixing bath, but more durable and scratch-resistant finishes can be obtained using a solution of tannic acid and formalin.

Screen
Flat surface for receiving a projected photographic image. Screens are usually made of a matt white or glass beaded material such as fabric or plastic, and designed to be portable, although a white wall can of course serve as a screen.

Secondary colours
Colours resulting from mixing together any two of the primary colours, red, green or blue. The principle secondary colours used in colour film and printing processes are cyan (blue-green), magenta (red-blue) and yellow (red-green). The purity of these colours depends on their being produced by mixed coloured lights, and not pigments; red and green paints when mixed will not produce yellow, but grey, owing to the absorption of specific wavelengths of light by the pigment itself.

Sensitized material
Any support or base, such as paper, glass plates or film, bearing a coating of light-sensitive photographic EMULSION.

Sensitometry
Branch of science devoted to measuring the response of photographic materials to radiant energy and thereby establishing numerical values for the relationship between exposure and density. The most commonly used of these numerical values are FILM SPEEDS.

Separation negative
Negative or, more usually, transparency made from a coloured image rephotographed through one of several coloured filters so as to record only one colour component of the original. For photomechanical printing, a set of three separation negatives recording the blue, green and red components are commonly obtained, together with a black and white negative recording the tones of the image. These are used to make four printing plates in cyan, magenta, yellow and black. In theory, full colour printing could be done with only three plates, but without a black plate a printed picture would lack punch: a solid black area would look like very dark brown. In books illustrated with colour pictures, the black plate usually carries also the textual

matter. Very high quality colour printing, as used, for example, in producing facsimiles of medieval manuscripts, may require the use of more than four plates to achieve maximum fidelity to the original.

Shading see DODGING

Sheet film
Individual pieces of film for use in large-format cameras. Sheet film, also known as cut film or flat film, is available in various sizes up to a normal maximum of 10×8in and is stored in DARK SLIDES.

Shellac
Natural resin used for varnishing negatives and as an adhesive for DRY MOUNTING. It has now been generally superseded by synthetic resins.

Shift lens
Lens for a 35mm or medium-format camera that can be moved off its axis to provide an equivalent for some of the CAMERA MOVEMENTS of large-format cameras. Also known as perspective control lenses, shift lenses can move both laterally and vertically (depending on the design, it may or may not be possible to use lateral and vertical movement at the same time) and are used chiefly in architectural photography to enable, for example, the top of a tall building to be included in the picture without tipping the camera backwards and thereby causing the vertical lines to converge. (The name shift lens is therefore somewhat paradoxical as "shift" is the term used for lateral movement produced by a cross front on large-format cameras, whereas the camera movement used most in architectural photography is the rising front.) A shift lens made by Canon also incorporates a mechanism for moving it so that it is not parallel to the film plane, giving it a limited degree of the large-format camera's swing front and tilt movement. The focal length of shift lenses for 35mm cameras is either 28 or 35mm and maximum aperture ranges from f2.8 to f4. Although they share certain optical and mechanical characteristics (the diaphragm, for example, has to be operated manually so OPEN-APERTURE METERING is not possible), the shift lenses marketed by different manufacturers are surprisingly different in appearance and construction for instruments designed to perform the same task. For example, Pentax's 28mm f3.5 shift lens, which has built-in filters, is constructed of 12 elements in 11 groups; it is almost twice as long and three times as heavy as the Schneider PA Curtagon 35mm f4 shift lens, which is constructed of 7 elements in 3 groups.

Shutter
Mechanical device used to expose film to light for an exact period of time. There are two main types: **between-**the-lens shutters (sometimes called leaf shutters) and **focal plane shutters**. A between-the-lens shutter is built into the lens barrel, close to the diaphragm, and consists of thin metal blades or leaves that spring open when the camera is fired and close again when the time for which it has been set has elapsed. A focal plane shutter is built into the camera body, slightly in front of the focal plane, and consists of a system of cloth or metal blinds that travel across the image area either vertically or horizontally when the camera is fired, forming a slit that, according to its width and speed of travel, determines the length of the exposure. Both types of shutter have advantages and disadvantages. Focal plane shutters seal off the film between exposures while permitting light to pass through the lens, so they are used particularly in single-lens reflex cameras. The sealing-off of the film means that lenses can be changed at any time. Between-the-lens shutters are more expensive (and every lens has to have its own shutter), but they are quiet, smooth-working and more mechanically reliable than focal plane shutters. The fact that the between-the-lens shutter exposes the whole film frame at once gives it certain advantages over the focal plane shutter when using flash and when photographing fast movement. Between-the-lens shutters can be sychronized with flash at any speed, but focal plane shutters can be synchronized at only one fairly slow speed (usually 1/60 or 1/125) because the shutter has to be fully open to make sure the blinds do not cut off part of the image at the edges of the frame. When photographing fast motion, the position of the subject will have changed slightly by the time the shutter has completed its traverse of the film plane, and depending on the direction of movement of the subject and the shutter, various kinds of distortion can result. Between-the-lens shutters generally have a maximum of 1/500, focal plane shutters of 1/1000 or 1/2000. Faster speeds are obtainable with special shutters, and those used in scientific work, such as the **Kerr cell**, may be capable of exposures of less than one millionth of a second. In the Kerr cell, two polarizing filters are placed on opposite sides of a glass tank containing nitrobenzine. A beam of light passes through the first filter, then through the tank, but is stopped by the second filter, set in a different plane of polarization. When an electric current is passed through the nitrobenzine, it has the effect of rotating the plane of polarization, allowing the light beam to pass through the second filter and on to the emulsion. The speed of the Kerr cell shutter thus depends on the duration of the current, which is discharged as a pulse from a condenser or capacitor. Using a high-frequency oscillating electric field, a Kerr cell shutter can be opened and shut millions of times a second.

Shutter priority see AUTOMATIC EXPOSURE

Silver halide
Chemical compound of silver with a HALOGEN (for example, silver iodide, silver bromide or silver chloride). Silver bromide is the principal light-sensitive constituent of modern photographic EMULSION, though other silver halides are also used. The latent image produced on these compounds by the action of light is converted to metallic silver by developers.

Skylight filter see FILTER

Slave unit see FLASH

Snoot
Conical lamp attachment used to control the beam of a studio light.

Soft focus
Deliberately diffused or blurred definition of an image. Soft focus effects, used most typically in portraiture to create a dreamy, romantic image and to hide blemishes, can be achieved on the camera or during enlarging. Special lenses or filters can be used to soften the image by diffusing the light or giving a controlled degree of spherical aberration (Minolta make an 85mm lens in which the degree of aberration and thus of softness can be continuously varied to a certain point). Similar effects can be obtained by smearing the lens (or a filter attached to it) with petroleum jelly or by covering it with gauze or similar material. During printing, a diffusing screen is the usual means of softening the image, but the soft focus effects for which the celebrated firm of society photographers called Lenare was famous were often created during enlarging with a variety of special lenses. All these means can create subtle and beautiful effects, but unless they are used skilfully and sensitively can easily produce photographic clichés.

Solarization
Strictly, the complete or partial reversal of the tones of an image as a result to extreme overexposure. The term is often used, however, to refer to the SABATTIER EFFECT, which produces results similar in appearance.

Spectrum
Term used to refer either to the whole range of electromagnetic radiation or to the part of it that is detected by the human eye as light (the visible spectrum). All electromagnetic radiation is pure energy, but the various types of radiation have different wavelengths; at one end of the spectrum, radio waves have relatively long wavelengths, and at the other end, gamma rays have extremely short (intense) wavelengths and can be dangerous. Each part of the spectrum can be resolved, received or detected by

Snoot

Soft focus

Solarization

Spotlight: used for dramatic effect

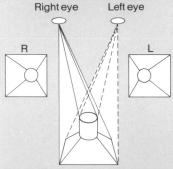

Stereoscopic photography: R shows right eye's view, L left eye's view

Stroboscopic flash

Subminiature camera

apparatus such as wireless equipment and geiger counters, and each has its industrial and scientific uses. The band of the spectrum visible to the human eye is very narrow (though some animals, such as certain species of snakes, can see infrared as well, and some insects, notably bees, can see ultraviolet). It can be resolved into its constituent colours by a prism, which breaks It Into bands of red, orange, yellow, green, blue, indigo and violet. Some other wavelengths, notably infrared, ultraviolet, X-rays and gamma rays, can be recorded by special photosensitive materials.

Specular reflection
Reflection of light from a relatively smooth surface, when every ray is reflected at the same angle. Irregular surfaces produce diffuse reflection (see DIFFUSION), which has the effect of softening light.

Speed
Term used in photography to refer to (1) the degree of sensitivity to light of a film emulsion (see FILM SPEED) or (2) the maximum aperture of a lens (see APERTURE).

Spherical aberration see ABERRATION

Spotlight
Lamp unit designed to emit a concentrated beam of light. Spotlights have clear lamps and polished reflectors (usually a hemispherical concave mirror), and are often fitted with a FRESNEL LENS, which by its design is lightweight and heat-resistant, and throws a beam of evenly directed light. Many spotlights are also fitted with grooved guides to hold barn doors, filters and snoots that help to direct, shape, colour or diffuse the light beam.

Spot meter see EXPOSURE METER

Spotting
Retouching a print or negative to remove spots and blemishes.

Sprocket holes
Regular, rectangular perforations along the edge of 35mm and other small-format films that engage the teeth of the camera's wind-on mechanism.

Stabilization
Chemical process of making superfluous silver halides stable in prints. It is used instead of fixing and washing when speed is more important than permanence.

Standard lens
Lens of focal length approximately equal to the diagonal of the negative format for which it is intended, giving an ANGLE OF VIEW close to that of normal human vision. In the case of 35mm cameras, the standard lens usually has a focal length in the range 45–55mm,

slightly greater than the actual diagonal of a full-frame negative (about 43mm). A standard lens for a 110 format camera has a focal length of about 24mm, for a medium-format camera about 80mm, and for a 5×4in camera about 200mm.

Stereo photography
Production of photographic images that give an appearance of depth approximating to that apprehended by normal human (binocular) vision. Practical stereoscopy was invented in the 1830s by the English scientist Sir Charles Wheatstone, and had a great vogue in the late 19th century. The principle involved is to produce two images taken from slightly different viewpoints through a pair of matched lenses; when the two resulting transparencies are seen through an appropriate viewer – the left-hand image by the left eye, the right-hand image by the right eye – an effect of binocular vision is produced. Projection of stereo images can be carried out by means of a beam splitter. Stereo photography has never entirely died out, but it has declined greatly in popularity since its Victorian heyday. However, a new system of stereo photography, aimed mainly at the popular market, has recently been devised, its great novelty being that it produces its 3D effect on a single print that is viewed unaided. The camera used for this system has four lenses. Each produces a normal negative of the subject, and the negatives are developed conventionally. The innovation comes in the printing: the images are precisely integrated on to a new plastic printing material, the surface of which is in effect made up of thousands of micro lenses. The human eye re-forms the images seen through these lenses into one 3D image.

Stop bath
Weak acidic solution used in processing as an intermediate bath between the developer and fixer. The stop bath serves to halt the development completely, and at the same time to neutralize the alkaline developer, thereby preventing it lowering the acidity of the fixer. Some stop baths have indicator dyes that show when the bath is exhausted and needs replenishment.

Stop-down metering see OPEN-APERTURE METERING

Stopping down
Colloquial term for reducing the aperture of the lens.

Stress marks
Marks visible on a developed photographic image, caused by friction or pressure before processing.

Strobe light
Abbreviation for STROBOSCOPIC FLASH lamp. The term is also often used (particularly in the USA) as a colloquial term for any electronic flash unit.

Stroboscopic flash
Series of very brief flashes in rapid sequence, used to produce multiple exposure images recording progressive stages of movement. Stroboscopic flash units, which may be capable of firing thousands of times per second, are used mainly in scientific photography, but have also been used to create beautiful and revealing images of , for example, a golfer's swing.

Studio camera see LARGE-FORMAT CAMERA

Subminiature camera
General term for cameras taking very small format film, usually of 16mm width or less. The Minox EC, which measures only about 18×30×80mm (96mm when it is open ready to shoot) and weighs about two ounces, is the smallest camera currently available. It has a 15mm f5.6 fixed-focus lens giving depth of field from three feet to infinity, and takes cartridges of black and white, colour negative or colour transparency film in 8×11mm format. Exposure is automatically controlled, with a stepless range of shutter speeds from 1/500 to 8 seconds.

Subtractive synthesis
Means of producing a colour image by blocking (subtracting) appropriate amounts of unwanted coloured light from white light. Modern photographic processes generally use dyes or filters of three colours known as the **subtractive primaries** – cyan, magenta and yellow. Cyan passes blue and green but absorbs red, and is thus sometimes termed "minus red"; magenta passes red and blue but absorbs green (hence "minus green"); yellow passes red and green but absorbs blue (hence "minus blue"). In conjunction, the three subtractive primaries are theoretically capable of producing any other colour, and if all are used together in equal amounts they will block all light and produce black. The basis of the subtractive synthesis was first systematically expounded by the French scientist Louis Ducos de Hauron in his book *Colours in Photography*, published in 1869, and the subtractive synthesis was gradually seen to offer more practical methods of successful colour photography than the ADDITIVE SYNTHESIS, which had been first demonstrated in 1861.

Supplementary lens
Simple positive lens used an an accessory for close-ups. The supplementary lens fits over the standard lens and produces a slightly magnified image.

Swing back/front
Facility found on some large-format cameras allowing the back (front) panel to be swivelled around its vertical axis. This CAMERA MOVEMENT can be used to control or distort shape or to alter the plane of focus and depth of field.

T

Tacking iron
Electrically heated device used in DRY MOUNTING to attach the bonding tissue to the print and then the print to the mount prior to permanent bonding in a press.

Technical camera see LARGE-FORMAT CAMERA

Teleconverter
Device that fits between a lens and camera body to increase the effective focal length of the lens and produce a magnified image. Teleconverters come in various "strengths", typically ×2 or ×3, and reduce the effective f number of the lens proportionally. Thus a 50mm lens set at f2 used with a ×2 converter has the effect of a 100mm lens set at f4 (a decrease of 2 stops), and the same lens used with a ×3 converter has the effect of a 150mm lens set at f5·6 (a decrease of 3 stops). Some teleconverters link with a camera's automatic diaphragm, in which case the camera's exposure meter compensates for the light loss; with non-automatic systems the necessary adjustment must be calculated and made manually. The image quality that teleconverters provide varies greatly, and is always less good than that which could be gained from a single prime lens of the equivalent focal length. Best results generally come from converters designed solely for use with specific lenses (Vivitar, for example, make "Matched Multipliers" for individual lenses in their range); the performance of a converter not designed for a specific lens depends to some extent on how its optical system happens to mesh with the residual aberrations of any particular lens with which it is used. Teleconverters are generally used with lenses of focal lengths from about 50mm to 300mm; outside this range results are less likely to be of an acceptable standard.

Telephoto lens
Type of LONG-FOCUS LENS having an optical construction that results in it being physically shorter than its focal length. Two groups of elements, often separated by an appreciable distance, are involved – a front converging system and a rear diverging system. The rear group has the effect of lessening the convergence caused by the first group; the cone of light that reaches the image plane thus appears to converge from a point in front of the front group, producing the same effect as a lens positioned farther from the film. As most long-focus lenses are now of telephoto construction, the two terms are often incorrectly used as synonyms.

Thermography
Technique of forming images by re-cording infrared radiation emitted as heat. An infrared scanner produces an image on a device similar to a television screen, different degrees of heat creating varying colours that can be recorded on conventional colour film. The shapes of the subject are usually represented on film more or less as they appear to the eye, but the colours produced are non-naturalistic, creating sometimes bizarre and beautiful effects. Thermography has various scientific applications: it can, for example, be used to record heat loss from houses, or, for medical purposes, to detect unusually hot or cold areas in the human body.

Threshold exposure
Exposure just sufficient to produce visible density above FOG LEVEL when a sensitized material is developed.

Tilt back/front
Facility found on some large-format cameras allowing the back (front) panel to pivot around its horizontal axis. This CAMERA MOVEMENT can be used to control or distort shape and perspective or to alter focus and depth of field.

Toner
Chemical used to impart a degree of colour to a black and white print or positive transparency. There are four principal types of toner, each requiring a different process for treating the print: (1) sulphide and selenium toners, which give a brownish or sepia tint to a previously bleached print by converting the (bleached) silver image to silver sulphide; (2) metallic toners, which use metal salts such as gold chloride or lead chromate to convert the silver image into metallic compounds of various colours; (3) dye toners, which deposit dye on top of the silver to colour the image; (4) colour developers, which give a dye image at the same time as the silver image.

Tone separation
Technique of producing a print with a limited range of distinct tonal values from a normal continuous tone negative. The technique involves making several copy negatives of different densities on lith film and printing them in register; in its most developed form it is known as POSTERIZATION.

Transparency
A photograph viewed by transmitted, rather than by reflected, light. When it is mounted in a rigid frame, a transparency is called a slide.

Tripod
Camera support with three (often collapsible) legs hinged together at one end to a head to which the camera is attached. Tripods are made in many sizes, from large studio models that are virtually items of furniture to miniature devices, intended mainly for table-top use, that will fit into a coat pocket. Tripods designed to be used with 35mm or medium-format cameras are most typically made of aluminium to combine durability with lightness. The feet are usually made of rubber or nylon and may be fitted with spikes for securing them firmly during outdoor use. The head to which the camera screws is generally of one of two main types: ball-and-socket and PAN-AND-TILT. In a ball-and-socket head the camera attaches to a plate mounted on a ball that can turn freely in a socket until it is locked in place, allowing the camera to be tilted or angled as desired. A pan-and-tilt head allows the same degree of movement, but it is more versatile in that it can be locked in one plane while being free to move in another at right angles to it. Most tripods have a central column so that height can be adjusted without having to move the legs. On some models the column can be reversed so the tripod can be used for low-level work, and it may also be possible to fit a lateral arm to the top or bottom of the column for added versatility. For extra stability, some tripods have braces between the central column and the legs. A recent departure from the traditional design, found in the Kennett Bembo Mk1 tripod, is to have a central column that is continuously variable in position and not confined to the vertical plane. A useful feature found on some tripods is a device for ensuring level horizontal alignment. This may take the form of a ballbearing in a plastic compartment or a built-in spirit level.

TTL
Abbreviation for "through-the-lens", used to characterize (1) the viewing system of single-lens reflex cameras, in which the image seen on the viewing screen is formed by light that has passed through the lens and been reflected by a mirror; or (2) camera exposure metering systems in which the light is read by the photo-electric cell(s) after passing through the lens.

Tungsten lighting
General term describing artificial light sources using a tungsten filament. Tungsten (sometimes called wolfram) is a heavy metallic element with a very high melting point; this property, together with its resistance to corrosion, makes it highly suitable for use in electric lamps. There are several types of tungsten lamps, the most common for photographic purposes being PHOTO-FLOODS and **tungsten halogen lamps**. In the latter type, the glass envelope through which the filament runs contains a halogen gas (usually iodine and/or bromine). The halogen enables the lamp to maintain its colour quality throughout its life by preventing oxidized tungsten from migrating to the envelope and thereby causing blackening. Tungsten lighting is redder or "warmer" in tone than flash or daylight, and therefore must be used with

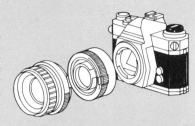

Teleconverter

Tone separation

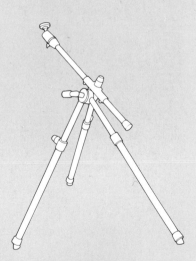

Tripod: Kennett Bembo Mk 1

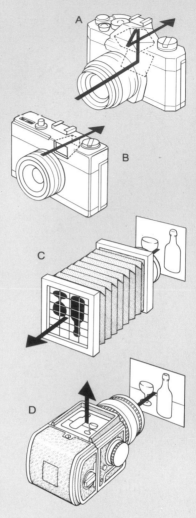

Viewfinders: A 35 mm single-lens reflex camera; B viewfinder camera; C large-format camera; D medium-format single-lens reflex camera

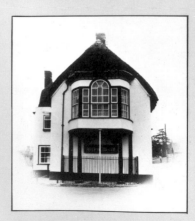

Vignette

film specially balanced to match its colour temperature or with correction filters over the camera or lights. Both flash and tungsten have certain advantages and disadvantages. The main advantages of tungsten compared with flash are that it is initially cheaper to install and that it is possible to study the effects of a lighting set-up before a photograph is taken. For flash's advantages over tungsten, see FLASH.

Type A colour film
Colour film balanced for tungsten lighting with a colour temperature of 3,400K. **Type B colour film** is balanced for tungsten lighting with a colour temperature of 3,200K.

U

Ultraviolet
Electromagnetic radiation of wavelengths shorter than those of violet light. Ultraviolet (UV) radiation is invisible to the human eye, but most photographic materials are sensitive to it to some extent. Ordinary photographic film may show UV radiation as haze or, in the case of colour film, as a blue cast; a UV FILTER can be used to counteract these effects. UV radiation is also put to positive use in several branches of scientific photography (see also FLUORESCENCE). In photomicrography, for example, the short wavelengths of UV radiation make possible better definition of fine detail than ordinary light. Conventional glass does not have a high UV transmission, so quartz lenses are used for this work. UV radiation is highly ACTINIC (the UV content of sunlight is responsible for sunburn), so to avoid harmful effects, great care, including the use of special protective goggles, must be taken by anyone who regularly works with it.

Underdevelopment
Failure to give sufficient development to a photographic material. Underdevelopment may be caused, for example, when the developing solution is exhausted, insufficiently agitated or at too low a temperature, or, more commonly, by premature removal of the material from the developer. An underdeveloped negative or transparency is thin in appearance, lacking contrast and some density. An underdeveloped print is flat, pale and lifeless.

Underexposure
Failure to allow sufficient exposure either in the camera or during enlarging. Where not used deliberately for effect, it may be caused, for example, by wrongly setting the appropriate controls; incorrect judgement in difficult lighting situations; a dirty lens; or failure to compensate for a dark filter. An underexposed negative or transparency is "thin"; an underexposed print is flat, with little density.

Universal colour film
Colour negative film designed to be used with light of a wide range of COLOUR TEMPERATURES, variations in colour balance being made during printing.

Universal developer
Term applied to certain developing solutions for black and white materials that are intended for use with both films and printing papers.

Uprating see PUSHING

V

Variable contrast paper
Photographic printing paper sensitized in such a way as to give a variable range of contrast, enabling acceptable prints to be made from a wide variety of negatives. The best-known paper of this sort is Ilford's MULTIGRADE.

Variable focus lens see ZOOM LENS

View camera see LARGE-FORMAT CAMERA

Viewfinder
"Window", screen or frame built into or attached to a camera, by means of which the photographer can see, exactly or approximately, the field of view of a lens and the area of a scene that will appear in the picture. Most viewfinders are optical (that is, they use a lens system of varying complexity) and usually incorporate a focusing mechanism and exposure information (see LCD and LED), but the simplest type of viewfinder is nothing more than a collapsible frame of wire or flat metal with a peep sight behind it. This arrangement, usually called a framefinder or sportsfinder, is often found incorporated in waist-level medium-format cameras to enable them to be used at eye-level, and is also used, for example, on old-fashioned press cameras and on many underwater cameras. Optical viewfinders are of two main types: direct vision (a framefinder is also a direct-vision viewfinder) and reflex. Direct-vision optical viewfinders use a lens system that is completely separate from the "taking" lens of the camera, whereas in single-lens reflex cameras light passing through the taking lens is reflected by a mirror via a pentaprism to the focusing screen so that viewing and taking functions are combined in the same lens. The single-lens reflex viewing system has the very great advantage over direct-vision finders that it displays, without PARALLAX ERROR, the same image that will be recorded on the film, showing the field covered by lenses of different focal lengths and taking into account the effects of filters or other lens attachments. Direct-vision viewfinders, however, have the advantages that it is easier to see the subject in dim light and that the subject is not blacked out at the moment of exposure as it is

with the single-lens reflex system. (Twin-lens reflex cameras use two matched lenses one above the other – an upper viewing lens and a lower taking lens – so they have some of the advantages and disadvantages of direct-vision viewfinders.) Direct-vision optical viewfinders often incorporate lines to indicate the correction that must be made to allow for parallax, and on cameras taking interchangeable lenses they may have lines indicating the field of view for various focal lengths. These types of viewfinders are sometimes known as bright-line, suspended-frame or ALBADA VIEWFINDERS. Sophisticated SLRs may have interchangeable viewfinder heads (the Pentax LX has eight) for such purposes as waist-level viewing or angled viewing, which can be useful in flat copying. Some large-format cameras have a direct-vision viewfinder or even a coupled rangefinder, but generally the viewfinder of such cameras is the ground glass FOCUSING SCREEN.

Vignette
Picture printed in such a way that the image fades gradually into the border area. The border may be either black or white, and is produced by using a suitably shaped mask effectively to DODGE or BURN IN the whole of the central area or by FLASHING the edges of the print. Vignetting is usually employed to give a romantic, old-fashioned appearance to a picture, but it can also be used to eliminate unwanted background detail. The term vignetting is also loosely used to refer to the image fall-off caused by loss of covering power, and should not be confused with cut-off caused, for example, by a too narrow lens hood.

W

Washing
Stage of processing that removes residual chemicals and soluble silver compounds from photographic emulsions after developing and fixing. All traces of chemicals must be thoroughly washed from negatives and prints, otherwise they will eventually attack the emulsion, causing it to decompose, and spots and stains to form (see PERMANENCE). The most effective modern print washing systems spray water in from all directions at the top and siphon off chemical-laden water from the bottom.

Water softeners
Chemicals that remove or render harmless the calcium or magnesium salts present in "hard" tap water. These impurities react with developers and may cause scum to be deposited on films. The most common water softener is washing soda (sodium carbonate), which works by precipitating the insoluble calcium or magnesium salts.

Wetting agent
Chemical that has the effect of lowering the surface tension of a solution, allowing it to spread evenly and quickly over a surface. Wetting agents are generally used in developers to prevent the formation of AIR BELLS, and in the final rinse to promote even drying.

Wide-angle lens
Lens having a shorter focal length than that of a STANDARD lens for any particular format, and consequently having a wider angle of view. The shorter the focal length of a lens the wider the view it will encompass. For 35mm cameras (in which the standard lens usually has a focal length of about 50mm), the most popular wide-angle lenses are of 35mm and 28mm focal length; their increased coverage is suitable for many subjects and they introduce little of the distortion noticeable with more extreme wide-angle lenses. At shorter focal lengths than about 16mm, wide-angle lenses are often of FISHEYE type and produce highly distorted images. Because of their short focal lengths, wide-angle lenses need to be placed nearer the focal plane than other lenses, and with reflex cameras this can cause a problem because they can project so far into the camera body that there is not sufficient room for the mirror to move freely. To overcome this problem, many wide-angle lenses make use of retrofocus (also called inverted telephoto) construction, which means that the elements are so arranged (with a diverging front group and a converging rear group) that the back focus is appreciably longer than the equivalent focal length. Some wide-angle lenses, however, can be used only on cameras with a MIRROR LOCK facility. Large-format cameras overcome the problem of short back focus by using BAG BELLOWS.

Working solution
Processing solution diluted to the strength at which it is intended to be used. Most chemicals are stored in a concentrated form, both to save space and to inhibit their deterioration through oxidation, but the chemical used with the Kodak Ektaflex print system, for example, is bought, used and stored at working strength.

X

X-rays
Electromagnetic radiation in the wavelength region 0·0001–10 nm. X-rays are shorter in wavelength than visible light and ultraviolet, but are longer than gamma rays. They are also known as Röntgen rays, after the German physicist Wilhelm Röntgen, who discovered them in 1895, but Röntgen himself gave them the name X-rays to indicate their unknown nature. Like light, X-rays can be reflected, diffracted or polarized, and like ultraviolet, they can produce fluorescence in certain substances; their most important property, however, is that they can penetrate solid, opaque matter. The degree of penetration depends on the density of the matter and the precise wavelengths of the rays; the shorter the wavelength, the more penetrative (or "hard") the rays are. This property of penetration makes X-rays useful in industry and scientific research, but they are best known, of course, for their medical role in photographing the tissues and bones of the human body. The "soft" X-rays used for this purpose are registered on special film, usually a coarse-grain emulsion coated on both sides of the film support to increase sensitivity and catch rays that pass through the first layer of emulsion. Research is currently being devoted to a method of converting conventional X-ray images into electronic information that can be stored on a computer image processor and called up for viewing on a television screen when required. X-ray films are not only bulky, but also very expensive because of their silver content, so there is a potential saving of space and money. A more important consideration, however, is that it should be possible to manipulate the electronic image so that particular parts of it can be seen more clearly, thus making diagnosis more precise. Because X-rays affect film, they can prove a hazard to photographers passing through airport security checks; the rays intended to detect weapons in baggage can fog film even through metal cassettes. Special lead-lined packets are available to protect film from this danger, but it is perhaps simplest and safest when passing through airports to keep all films in a separate, transparent plastic bag to be proffered for hand inspection.

Y

Yellow
One of the three colours used in the SUBTRACTIVE SYNTHESIS. It is formed by the combination of the red and green PRIMARY COLOURS; subtracting blue from white light leaves red and green, forming yellow, so yellow is sometimes called "minus blue".

Z

Zone focusing
Technique of presetting the aperture and focusing the camera so that the entire zone in which the subject is likely to appear is covered by depth of field. This technique is particularly useful in sports or other action photography in which there is not enough time to focus the camera more accurately at the moment of shooting. The term zone focusing is also applied to the system found on some very simple viewfinder cameras in which focusing is limited to a few settings related to symbols such as a head and a range of mountains for the shortest and longest distances.

Zone system
Complex system of relating exposure readings to tonal values in picture-taking, development and printing. It was devised by Ansel Adams, and both he and another celebrated American photographer, Minor White, have written extensively on the subject.

Zoom lens
Lens in which the focal length can be continuously varied between two limits. The focal length is altered by changing the position of a group or groups of movable elements inside the lens, and in nearly all models, changes in the focal length do not affect the focus. (Lenses in which the focus has to be adjusted every time the focal length is changed should strictly be called **variable focus lenses**, but in practice the terms variable focus and zoom tend to be used interchangeably.) Some zoom lenses have separate control rings for focusing and zooming, while on other designs a single ring serves for both purposes (twisting the ring focuses the lens, pushing or pulling it changes the focal length). The latter type is generally known as "one-touch". Various ranges of focal lengths are available in zoom lenses. Most typically, they extend from wide-angle to standard (say, 28–50mm); moderate wide-angle or standard to moderate telephoto (35–70mm or 50–135mm); or moderate to long telephoto (80–200mm). Zooms with wider ranges are also made, however, an extreme example being Nikon's 360–1200mm f11 zoom. Against the obvious advantages of having an infinitely variable range of focal lengths in one lens (some zooms also have a "macro" setting enabling them to be used for close-ups), must be set three disadvantages compared with fixed-focal length lenses of similar standard: (1) zooms are heavier because of their complex optical construction involving numerous glass elements; (2) they are of lower optical quality as in practice it is impossible to compensate to the same degree for all aberrations across the range of focal lengths covered; (3) they have smaller maximum apertures. The smaller maximum aperture is usually more noticeable at one end of the zoom range than at the other. Thus, in the case of a 80–200mm f4 zoom, the maximum f4 aperture is (by current standards of lens design and manufacture) moderate for a 200mm lens but slow for an 80mm lens. When using a zoom lens, it is advisable (if time permits) to focus at the longest setting before adjusting to the focal length desired; depth of field is more limited at longer focal lengths, so focusing can be more critical.

Wide-angle lens: it causes distortion in close-ups – note size of hands

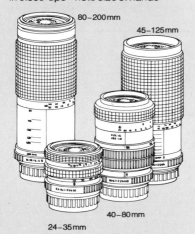
Zoom lenses

Zoom lens: altering the focal length (zooming) during exposure creates blur suggestive of movement

Index

Acknowledgments

The authors and publishers wish to thank the following people and organizations for their kind help in producing *Advanced Photography*:
Amanda McGaw, Debbie Travis, the Government of India, the tourist offices of Brazil, France, Gambia, Italy, Morocco and Peru, Ford Motor Company, Ogilvy Benson and Mather, British Airways, British Caledonian Airways, Laura Ashley (dresses), Harrods (hats), Frangipani (jewellery), Maples (furniture), Miracles (cushions), Hemlata Parma and Tina Parsons (clothes), Rider (shoes), RCA fashion students.

Information, equipment and technical assistance
Paul Brierley, John Cleare, Cochranes of Oxford, Durst, Electrosonic Ltd, Peter Grant and Keith Humsley of Gilchrist Studios, Gray Studios, Hasselblad, Brian Jones of Bowens Ltd, Kodak Ltd, E. Leitz, Felix Moore of Mindata Ltd, Oxford Scientific Films, Pentax, Polaroid, Research Engineers, Linda Ross of Nikon, Toay McAfee Associates, Vivitar, Roy Wales.

Genigraphics computer at Concept Marketing, Bourne End, Bucks. Telescopes and technical assistance on *Photographing the night sky* provided by Fullerscopes Ltd, London.

Artists
Kai Choi, Tony Graham, Haywood and Martin, Alan Jones, Tony Lodge, David Mallot, Nick May, Andrew Popkiewicz, Jim Robins, Venner Artists, Ron Thornton (modelmaker).

Photographers
Page 25 bottom, Hasselblad; 28 top, E. Leitz (Instruments) Ltd; 35 top, Alastair Black; 173 top and bottom, Stephen Dalton/Oxford Scientific Films; 175 right, David Hosking; 182, Courtesy AGA Infra-red Systems/Science Photo Library; 183 top, bottom left, bottom right and 184 top left, top right, bottom left, bottom right, Paul Brierley; 185 left, Dr Peter Stradling F.R.C.P., F.R.P.S.; 185 right, Paul Brierley; 194 right, Paolo Koch/Vision International; 196 top, Cochranes of Oxford Ltd; 197, Jerry Young; 200, Werner Braun; 201 left, Paolo Curto/Image Bank; 201 top right, Laurence Gould; 201 bottom right, Werner Braun; 202 centre left, Helwan Observatory, Egypt; 202 centre right, Henry Brinton; 202 bottom left, Peter Gill; 202 bottom right, R. W. Arbour/Pennell Observatory; 203 centre, Paris Observatory; 203 bottom left, Horace Dall; 203 bottom right, Palomar Observatory; 268 top, Electrosonic Ltd; 268 bottom left and right, Genigraphics; 269, Media Production Ltd; 289 bottom, Ian Chilvers/Mindata Ltd.

Equipment photographs by Gray Studios

All other photographs reproduced in *Advanced Photography* are by Professor John Hedgecoe

Index
Richard Bird